Caspar David Friedrich to Ferdinand Hodler: A Romantic Tradition
Nineteenth-Century Paintings and Drawings
from the Oskar Reinhart Foundation, Winterthur

Exhibition Tour

Alte Nationalgalerie Berlin
14 May - 12 September 1993

Los Angeles County Museum of Art
30 September 1993 - 2 January 1994

The Metropolitan Museum of Art, New York
10 February - 24 April 1994

The National Gallery, London
15 June - 4 September 1994

Musée d'Art et d'Histoire (Musée Rath), Geneva
30 September 1994 - 12 February 1995

Caspar David Friedrich to Ferdinand Hodler: A Romantic Tradition

Nineteenth-Century Paintings and Drawings
from the Oskar Reinhart Foundation, Winterthur

Peter Wegmann

With contributions by
William Vaughan, Franz Zelger and
Matthias Wohlgemuth
Edited and translated from the German
by Margarita Russell

Los Angeles County Museum of Art
The Metropolitan Museum of Art, New York
The National Gallery, London

Insel Verlag

First edition 1993
© Insel Verlag Frankfurt am Main und Leipzig 1993
All rights reserved.

ISBN 0-8109-6432-5 (hardback)

This book is distributed in hardback in the United
States and Canada by Harry N. Abrams, Inc., New
York.

Colour photographs:
Jean-Pierre Kuhn (Swiss Institute for
Art Research, Zurich)
Hans Humm, Zurich
Black and white photographs:
Jean-Pierre Kuhn (Swiss Institute for
Art Research, Zurich)
Oskar Reinhart Collection "Am Römerholz"
Klaus Burkard, Winterthur

Typeset by Satz-Offizin Hümmer GmbH,
Waldbüttelbrunn
Printed by Aprinta GmbH, Wemding
Printed in Germany

Front cover: Caspar David Friedrich, *Chalk Cliffs on
Rügen* (Cat. 30)

Contents

Preface

The works of art in the Oskar Reinhart Foundation Museum are a gift of the collector and art patron to his native city Winterthur. In the 1930s a plan was formed to put these works, which had been assembled over the span of nearly half a century, on show for the public. The buildings of the former Gymnasium for boys, built between 1832 and 1842 by Leonhard Zeugheer, and of the Library were to be adapted to house the painting collection. On 21 January 1951 the new museum was opened to the public, with many international visitors participating in the opening ceremony. Oskar Reinhart believed in collecting not for his own exclusive use but for the benefit of all. His credo was: "Even though such works may legally have one owner, in a higher sense they belong to the general public, and the owner should consider himself merely their trustee."

A few years ago a complete catalogue of the paintings and sculptures was published, which is now being supplemented by a new publication to accompany the present exhibition of paintings from the Oskar Reinhart Museum. Not only the works on show but many additional paintings and drawings are illustrated and discussed in the exhibition catalogue, providing extensive documentation for the major parts of the collection and an insight into its character.

Thanks for realising this publication are due, in the first place, to its author, Peter Wegmann, curator of the Oskar Reinhart Foundation, to the publishers for the careful preparation of the book, and to the National Gallery London for overseeing the English version. The exhibition could not have been mounted without the generous support of private benefactors, notably the Union Bank of Switzerland, the Winterthur Insurance Company and Swissair, the public patronage of the Canton of Zurich, the City of Winterthur and the Swiss Cultural Foundation Pro Helvetia (Art Council of Switzerland), and an indemnity granted by the U.S. Government Federal Council on the Arts and the Humanities.

Contacts with the participating museums in Los Angeles, New York and London have invariably been friendly and stimulating. Their willingness to exhibit the works of the Oskar Reinhart Foundation and their valuable co-operation in the extensive preparations are here gratefully acknowledged. Our warm thanks go to all collaborators, especially the directors of the museums and the responsible curators, Michael E. Shapiro and Philip Conisbee in Los Angeles, Philippe de Montebello, Mahrukh Tarapor and Gary Tinterow in New York, and Neil MacGregor, John Leighton and Michael Wilson in London.

Urs Widmer
Chairman of the Trustees

Foreword

It is a sad but indisputable fact that of all the great European schools of painting, the least known in English-speaking countries is the German. The proliferation of anonymous masters in the German Renaissance has proved an almost insuperable obstacle to any public enjoyment wider than the great names of Dürer, Cranach, Grünewald and Holbein. But even in later periods, when artists are well known and fully documented, the problem is no less acute. In the nineteenth century Caspar David Friedrich stands alone. Runge and Menzel, Thoma and Leibl, giants in their time and household names in German-speaking lands now, remain virtually unknown to the British and American public.

The reasons for this are not hard to find. In the eighteenth and nineteenth centuries German artists, like their British counterparts, painted above all for local patrons. Their works remained firmly in the domestic market, while their French and Italian equivalents were being exported across the western world. Two world wars compounded this early isolation. For much of this century, public collections in Britain and America have been extremely hesitant about buying German art. By the time we had overcome our hesitations, most of the great works were already in public galleries in Germany, Austria and Switzerland. Many of the best had found their way to the Oskar Reinhart collection in Winterthur.

The history of this remarkable collection is told in the present catalogue. It is no exaggeration to say that it offers a unique overview of German, Austrian and Swiss nineteenth-century art at the highest level. All the great artists of the period are here, all represented by fine, characteristic works. Thanks to the temporary closing of the galleries for renovation, these works are now able to leave the Canton of Zurich and can be shown in the United States and the United Kingdom. As a result our public will for the first time be able to enjoy the paintings produced by the compatriots and contemporaries of Goethe and Nietzsche, Beethoven and Wagner.

To our colleagues in Switzerland and to the sponsors who have generously enabled this exhibition to travel we owe a great debt of gratitude. And we are confident that our gratitude will be echoed by the tens of thousands of visitors on both sides of the Atlantic who, thanks to them, will be able to discover one of the great periods of European painting.

Michael E. Shapiro
Director, Los Angeles County Museum of Art

Philippe de Montebello
Director, The Metropolitan Museum of Art, New York

Neil MacGregor
Director, The National Gallery, London

A View from the Mountains
European Art and Switzerland
William Vaughan

Introduction

Ever since the Middle Ages, there have been close cultural links between most of the countries that form modern Europe. It is hardly surprising, therefore, to find artistic styles and movements developing in similar sequence across the continent. In the period covered by this exhibition – from the late eighteenth to the early twentieth century – almost every country has witnessed a progression from classicism to romanticism, and then through variant versions of naturalism and realism to aestheticism and symbolism. But within this overarching symmetry, there have of course been innumerable variations. At every point in Europe there has been a different view of the developments as they have taken place.

In Switzerland, there has been a particularly acute perception of this variety. From their mountains, the Swiss have looked down on communities that have distinctly different traditions and practices on every side, ranging from the Mediterranean culture of Italy to the northerly one of Germany. Nor has this been a matter of passive observation, for Switzerland has made contributions to every one. Some of these are quite surprising. Few people outside Switzerland remember now that Borromini – that master of the Roman Baroque – was Swiss. Contributions made to the cultures of the North are better known; particularly to those communities that shared with Switzerland a protestant religion. Protestantism may well be at the base of that persisting common-sense attitude towards nature and society that seems to mark Swiss culture. In the period covered by this exhibition, this has been an important consideration. It was, after all, the Swiss philosopher Jean-Jacques Rousseau who created a virtual religion out of nature in the eighteenth century, with his vision of the "noble savage" and of primitive societies governed by communal consent rather than through imposed restrictions. In the visual arts, too, an obsession with "the natural" is common. In the mountains themselves, there are also different emphases. For Switzerland is of course divided into Italian, French and German speaking areas, and it is natural that these areas should have strongest links with the country or countries below them that share the same language. This is, however, a matter of accent – for interconnections within Switzerland itself means that influences from all linguistic groups can be detected throughout the country.

Winterthur is no different from other Swiss towns in articulating international interests with a particular accent. It is situated in the northern part of Switzerland, in the canton of Zurich, close to the borders of Germany and Austria. Its links are strongest with these, though there are paths up to the North, even as far as Scandinavia.

In the case of the Reinhart collection there is a further accent to add. For – as related by Franz Zelger in the introduction – these pictures were brought together by one man, who had distinct views and tastes of his own. Collecting in the early twentieth century Oskar Reinhart belonged to a generation of industrialists who were turning Switzerland into a wealthy country, one that could support and patronise its own artists as never before. He had strong cultural and commercial links with Germany, and his own artistic taste was close to that of those German critics who supported Impressionism and naturalism in the arts in the early twentieth century, in particular Julius Meier-Graefe. While keen to build up a representative collection of European art, he tended to prefer works that showed what he considered the most important artistic direction of modern times. But in doing so, he was also doing no more than magnifying a tendency already present in Swiss art and taste. A practical man, he had little interest in the more adventurous abstractions and fantasies of the twentieth century. Thus – while generally sympathetic wherever he could be with artists of Swiss origins – he found himself unable to collect the work of Paul Klee. He also had a sense of community, and wished to leave a collection to his native town that would, he felt, be most relevant to its taste and culture. This is why he made a special collection of his Swiss, German and Austrian work and donated these to his local town. This is the collection that is represented in this exhibition. Thus, while there is a special personal accent to this survey of Germanic art from the late eighteenth to the early twentieth century, it is also one that comes very much out of the circumstances of Winterthur itself.

Reinhart also had a collection of French paintings and old masters that he kept in his own house, which was opened to the public after his death.

Science and Sensibility: Nature Painting in the Enlightenment

It is perhaps appropriate that this collection should begin in the eighteenth century, since this is a period when Switzerland seemed to be very much "in the movement". The country's position as an ancient and independent republic made it a source of admiration for the philosophers and rationalists of the day. The doctrine of natural goodness that marked the first step of the Romantic movement had its home here – most of all in the writings of Rousseau – but also through the work of many other Swiss poets and philosophers, such as Haller, Gessner, Bodmer and Sulzer. Their faith in good sense and nature had its visual counterpart in a clear and clean style of depiction which marked so many Swiss artists of the day, and which frequently stood them in good stead when they travelled abroad.

As well as contributing a philosopher to Romanticism, Switzerland also introduced a motif – the Alps. These huge mountains had been known to travellers from the north to the south from time immemorial; but they had not been much appreciated. The common view of them was one of fear and loathing; for they were usually associated with danger and loss of life. In the eighteenth century, however, they began to be seen in a different light. They became heroic forms of nature, inspiring visions of divine grandeur. This view was expressed as early as 1732 by the Swiss scientist Albrecht von Haller in his famous poem *Die Alpen*.

The combination of scientific and aesthetic interests – so evident in von Haller's approach – can be found in the most famous depictions of the Alps in the period. These were by Caspar Wolf. Between 1774 and 1778 he painted over 170 high mountain scenes for the Bernese publisher and pioneer alpinist Abraham Wagner.

Wolf had worked as an assistant to De Loutherbourg in Paris, and was strongly influenced by that artist's dramatic style of land-

scape painting. Yet he did not share the French artist's fascination with horror. He does not show people being killed by avalanches – as De Loutherbourg was to do in his alpine scenes. Instead his works are carefully depicted, often with tourists admiring natural phenomena safely – as in the view of the Staubbachfalls (Cat. 6). While celebrations of the sublime in one sense, they are also careful scientific records. Wolf used to make direct sketches of the mountains, and then would return the following year with pictures based on these to make corrections.

This combination of sensibility and observation can be seen in the work of Anton Graff, an artist who made a central contribution to painting during the Enlightenment in Germany. Born in Winterthur, he ended up as painter to the Saxon court in Dresden. He became famous throughout Germany for his sharply yet kindly observed portraits, producing a panorama of the age and of all conditions of society. Like Wolf, there was something of the scientist in his coverage of the physiognomies of man – particularly in an age where, under the influence of such theorists as Lavater, it was believed that the physiognomy could be the key to the understanding of human character. Graff was also a man of the Enlightenment in his attitude to the learned man, the "Gelehrter". His pictures often incorporated respectful references to the reformers and their ideas. This is hardly surprising since his own father-in-law was a noted Gelehrter – the educationalist and aesthetician J.G. Sulzer. In the group family portrait shown here (Cat. 10), the Graffs are depicted flourishing beneath a commemorative painting of the great man. In the foreground Mrs. Graff is instructing her daughters – a reminder of Sulzer's campaign for equal educational opportunities for women.

Common-sense didacticism can also be found in the work of St. Ours – a Swiss history painter active in Rome before the Revolution. A pupil of Vien in Paris, he absorbed the French artist's neat neo-classical manner. St. Ours's support of revolutionary action may well have been stimulated by the prejudice he encountered in his own career. For although he won the coveted Prix de Rome while a student at the academy, he was not allowed the stipendium that went with it by King Louis XVI because he was a foreigner.

His *Germanic Wedding* is a model of equality (Cat. 12). Based on a passage from Tacitus, it shows the even-handed sharing of possessions and destiny that was meant to have marked the marital state in early German society. The picture is also an image of community. Its broad survey of figurative groups contrasts strongly with the highly personalised psycho-dramas of the leading French history painter of the Revolutionary period – Jacques-Louis David.

While the art discussed so far might seem to reinforce generalisations about innate Swiss common sense, this can hardly be sustained with the work of the best known artist to come from the country in the late eighteenth century – J.H. Füssli. Like Graff and St. Ours, Füssli was an emigré. He spent virtually the whole of his mature career – from 1780 to his death in 1825 – in England, where he is better known as Fuseli. Any respect for indigenous fair-mindedness must have been shaken in this artist when he was expelled from his native Zurich at the age of twenty for having exposed corruption in local officials. A man of strong intellectual gifts and literary tastes, he fell under the influence of the German *Sturm und Drang* movement, a group of writers (including Herder and Goethe in his younger days) who emphasised the more emotive side of the nature worship of the period. While studying in Rome, Füssli found what seemed to him to be the appropriate visual analogue to the charged writing of the Germans in the heroic and expressive art of Michelangelo. It is perhaps not surprising that Füssli has no more than a walk-on part in the Reinhart collection. The work that represents him (Cat. 11) is rather more painterly than usual. But it is well up to par in its level of sex and violence.

Romanticism and Nature

It is noticeable that, despite their often key role in the development of early Romanticism, Swiss artists contributed relatively little to the more extreme and idealistic sides of the fully developed movement. There is nothing of the bold bravura of Delacroix or Turner on the one hand, nor of the visionary intensity of Caspar David Friedrich on the other. There is precious little, too, of the dreamy medievalism that can be found in Germany, England and France. The Reinhart collection, similarly, presents a view of Romanticism that

emphasises once again those elements that are based more on observation than on fantasy. Landscape painting and the depiction of daily life predominate. Even where painters of fantasy and medievalism from Germany and Austria are included, they tend to be represented by their nature studies, rather than by their more imaginative compositions.

Yet if this gives a one-sided view of Romanticism, it nevertheless has the virtue of enabling us to appreciate how much an obsession with nature was at the heart of the movement. For the Romantics did not turn their back on the nature worship of the eighteenth century. Instead they altered its emphasis, stressing the personal at the expense of the communal and utilitarian. In their pursuit of this individual experience they often made studies of nature of rare intensity.

The Reinhart collection provides an excellent opportunity for studying the most important and original developments in landscape painting that took place in Germany during the period: those that occurred in Dresden. The key figures were Philipp Otto Runge and Caspar David Friedrich. There is a link of a personal nature here, for Runge – the mystical landscape painter – owed a great deal to the protective kindness of Graff while he was in Dresden. Although epochs apart in their art, both shared an enthusiasm for nature. For Runge the love of nature was the key by which man could unlock the mystic secrets of the universe. He dreamed of creating a "universal" art, centred upon an elaborate and complex representation of the Times of Day. The vast majority of Runge's work is preserved in Hamburg – the city in which he died in 1810 at the early age of 33. The Reinhart collection possesses a real rarity. A painting representing the theme of Moonrise that is closely connected to his allegorical depiction of Night. In this painting (Cat. 25) – designed to be placed in an alcove above a sofa, two of Runge's characteristic infants sit beneath bowing poppies, as the moon rises between them. It would seem that the sofa below was intended for sleeping – or reverie at least. Sleep was one of the favoured motifs of the Romantics. For it was through sleep that the mysterious "dark side" of man was able to come into its own in the world of dreams.

The collection also has some fine works by Caspar David Friedrich, the principal painter

of visionary landscapes in Germany. Typically, little is seen here of Friedrich's more "gothic" works – his images of lonely monks and ruined abbeys. Instead Friedrich is shown as the observer of nature, of oaks and harbours and seashore and cliffs. In the *Chalk Cliffs on Rügen* (Cat. 30), a group of urban tourists are shown examining one of the phenomena of "wild" nature. Yet while catering for an audience of bourgeois people keen to enjoy the picturesque charms of nature, the artist also maintains a distinction between his vision and theirs. He is the figure in the floppy hat, who looks out towards the infinite while his companions examine the closer phenomenon of the cliff face.

This sideways view of everyday life can also be found in other artists in Friedrich's circle in Dresden. One of the most attractive of these is the genre painter Georg Friedrich Kersting. His *Man reading by Lamplight* (Cat. 32) shows a man reading alone in a sparse room at night, with strange shadows being cast by the lamp on the wall. One expects a Hoffmannesque fantasy to erupt at any moment.

There is perhaps already a hint of irony in this work. In later decades romantic themes tended to be treated more ironically. Artists in Berlin were particularly adept at this wry approach. A supreme master was Carl Blechen, a brilliant landscape painter who fell under Friedrich's influence in his early years, and then indulged in parodies of Romantic landscape. His view of the alpine Devil's Bridge (Cat. 42) shows one of the stock scenes of Romantic horror undergoing modernisation. The painterliness of Blechen's work is a reminder that, by the 1820s, many German landscape painters were responding to the bravura of the French and British Romantics. Blechen was in fact in Rome at the same time as Turner and may well have seen an exhibition of his work. Such brilliant studies as *Sunset at Sea* (Cat. 43) seem to show a debt to the English master of light.

Medievalism

While the art of spiritual – and then ironic – landscape developed in the north of Germany, the south saw the emergence of a medieval revival in painting. The centre for such art was Vienna, where the "Brotherhood of St. Luke" was established by a group of young students in 1808 with the aim of re-

turning to the golden age of the Middle Ages. Eventually they were to achieve international fame as the Nazarenes and to become the principal stimulant for the revival of medievalism in religious art in the early nineteenth century. Reinhart has collected relatively little of their work, although he was a little more sympathetic to the side of medievalism that connected with folk culture – particularly the portrayal of legends and fairy tales that was developed out of the medieval revivalist movement by Moritz von Schwind and Adrian Ludwig Richter. However, there was one aspect of the movement that he warmed to. This was their love of nature. For while imitating medieval art, they also imitated the careful observational drawing style of the fifteenth century.

Varieties of Naturalism

To a large extent the Swiss contribution of the early nineteenth century belonged to that continued strain of naturalist painting that persisted, so to speak, in the wings, while more dramatic developments were taking place in the "high" art of the period. This really is the groundswell movement of the nineteenth century. It is at the same time both international and local. International, because such painting can be found in every country in Western and Central Europe (and in most of Eastern Europe as well); local, because in each case it focused on a portrayal of local life and local scenery. It seems to have been motivated by the same desire to tell, the same faith in "nature" and the ability to observe exactly what underlay the Enlightenment and was carried on by Romanticism. Added to this, however, is a strain of nationalism, which grew in strength throughout the century.

In Switzerland – as elsewhere – this movement had highly specific local accents in different places.

The most important centre for such art in the period was in Geneva, in the French-speaking part of Switzerland. Many of these artists travelled and worked in France. One such was François Ferrière – who journeyed as far as Russia, where he lost all his goods and works in the burning of Moscow of 1812. Mercifully we have one early fine example of his view of the harbour of Geneva (Cat. 14), which reminds us how ubiquitous this style was. Another artist who went to France was

Agasse, who studied in the studio of David just before the Revolution. There is a particular interest for the English in Agasse, because he later came to London. In 1800 he was invited to England by Lord Rivers, after having to leave France on account of the Revolution. Agasse became an assiduous student of British art and manners. He practised the local genres – animal painting, vedute, scenes of daily life. Everything is recorded exactly and minutely, as though the artist was trying to understand what was going on by not missing a single detail. Agasse paints England with a Swiss accent. He has an emigrés eye – and was prone to the emigre's misfortunes. Apparently one of his most charming pictures, the *Playground* (Cat. 21) caused offence because of a social gaffe – that of having the gardener intruding into the children's play area! To add insult to injury, this old gardener has the features of Agasse himself. Another leading Swiss naturalist of the period was Töpffer, who also worked in Paris and London. In the former city he had the honour of being appointed drawing teacher to the Empress Josephine. Such contacts did little to help him after the fall of Napoleon, and in 1816 he moved to London to join his friend Agasse. Töpffer had more of an eye for an anecdote than Agasse. He had a great admiration for Hogarth, though he lacked that great satirist's streak of harshness. There is more Biedermeier humour in his work, as can be seen in the gentle comedy of his *At the Spring* (Cat. 16).

French influence can also be found in a number of other Swiss naturalists of this generation – such as Calame, Menn, and Robert. The last cut a new line in naturalistic representation of Italian peasants, and in particular brigands and pretty girls. The poet Heinrich Heine commented that Robert's bright scenes made you forget that there was a "realm of shadows". Both Calame and Menn enjoyed great success in their lifetimes for their fresh depictions of natural scenery.

The Reinhart collection also provides a sense of the richness and variety of naturalistic painting that flourished in Austria, Germany and Scandinavia in the period. There are the deliciously fresh portraits and landscapes of the Austrian Waldmüller and the fine watercolours of his compatriot Rudolf von Alt. From the south of Germany there are Kobell, Wasmann, Morgenstern and Spitzweg. From

the north, Gaertner and Krüger. Scandinavian naturalism is represented by the work of the Norwegian Johann Christian Dahl and the Dane Christen Købke.

One of the most interesting developments in landscape painting during the early nineteenth century is the reassessment of the Italian landscape. That talisman of naturalist painting – the *plein air* oil sketch – first developed amongst landscapists working in Italy. It was used in the first instance as a means of grasping the subtle atmospherics of the south. Pioneered by the French (or possibly the Dutch), it was used by artists of all nationalities by the late eighteenth century. Its effects can be seen in the work of many German landscapists of the period – such as Rohden, Dillis and Rottmann.

With the growing materialist mood of the nineteenth century, pictorial naturalism took on a greater urgency, eventually developing into the fully fledged doctrine of realism, in which more is aimed at than innocent description. In France such self-conscious realism was already evident in the 1840s, particularly in the work of Courbet. In Germany and Central Europe, however, it took another couple of decades to arrive. Meanwhile there were a significant number of painters coming to maturity in the middle years of the century who seem to have developed many of the practices of the French realists without formulating a self-conscious doctrine.

Most important of these is the Berlin painter Adolph von Menzel. Here there are some superb examples of his early style, in which he uses his superlative gifts of observation with a degree of tenderness – as in the portrait of his neighbour and friend, Frau Maercker (Cat. 65). It is unclear how much of Menzel's early work can be seen as having a political purpose. A solid member of the Berlin bourgeoisie, he shared his class's sympathy for the revolution of 1848. His gruesome study of the head of a dead white horse (Cat. 68) could be seen as a reference to these events. Menzel lived until 1905, but there is little evidence of his more elaborate later work here. True to his love of fresh and spontaneous naturalism, Reinhart concentrated on the artist's early works.

In Switzerland, too, naturalism developed in its later stages to take on a wider range of claims – as can be seen in the works of Zünd, Koller and Buchser. Their celebration of their native country and way of life are reminders that Switzerland was gradually becoming a more prosperous country at this time. It was easier for Swiss artists to make a living in their native country, and to work for local clients. They did not have to work for the tourists as Wolf had done a century before.

This is the context in which we must see Anker, the most popular of Swiss artists in Switzerland. He is as much the painter of Switzerland as Constable is the painter of England, yet significantly his principal theme is childhood. These charming pictures of children could be dismissed as sentimental. But to do so would be to overlook their real scope. Anker's homely naturalism has a touch of class about it. He was trained in Paris and spent as much of his life there as he did in his native town. One outcome of this is the classic portrait of his daughter in Paris in 1874 (Cat. 80) – the year of the first Impressionist exhibition – in which the life of the child is so well represented – half self-conscious, half innocent. It is Anker's negotiation of this area that makes his paintings more than simply appealing.

Towards Realism

As opposed to the celebration of local life, ideological realism – so evident in France in the mid-century in the work of Courbet and his associates – seems to have had little place in Swiss art. It is in German rather than Swiss works that the international impact of Courbet can be seen in this collection. This impact was particularly evident in the work of Leibl and his circle in Munich. A generation younger than Courbet, Leibl fell under the French master's spell when the latter came to Munich in 1869 for the International Exhibition of that year. But while Leibl responded enthusiastically to Courbet's example of painting the rural world in a positive and politically engaged manner, he soon developed his own methods. Characteristically, these combined a certain French painterliness with a re-interpretation of the old German realism of Holbein and other sixteenth-century masters. As well as some sensitive portraits, this collection has one of Leibl's seminal works, the *Village Politicians* (Cat. 99). The title is in fact misleading. Originally Leibl called it "The Peasants", and his stated intention was to show them as faithfully as he could in their environment. They are not reading a newspaper – as is sometimes supposed – but a *Kataster* (land register). They are not about to engage in some comic yokel debate about events in the great world outside. They are discussing matters to do with their own life and property. Leibl's insistent representation of peasants "as they truly are" is less overtly political than some of the works by Courbet with which they have been compared. But they did have a political implication in late nineteenth-century Germany. They represent the old way of life being swept away by modern industrialisation after the unification of Germany in 1870. Leibl himself painted the picture in Unterschondorf – the Bavarian village in which he had settled. In later life he moved to more and more remote rural sites to avoid the "artificial" modern world. Yet he himself brought to his perception of peasant life a thoroughly modern urban yearning. Other members of Leibl's circle – such as Schuch, Uhde and Trübner – celebrate the values of the old world in their sombre, sensuous paintings. It is perhaps significant that this group centred on Munich, the capital of Bavaria that was coming to represent the "old" world in contrast to the modern world of the Prussian capital, Berlin. Yet, as with Leibl himself, this sentiment is not overtly expressed in their pictures with the insistent veracity of their technique. Only one of their group – Hans Thoma – imbues this realist representation of rural life with a self-conscious lyricism. Such lyricism developed slowly – one almost thinks involuntarily. Some of Thoma's early works are remarkable for their sharp – if affectionate observation – notably the portrait of his mother (Cat. 93).

The ideals of the Leibl circle became known in Switzerland through the work of Fritz Schider, an Austrian-born artist who settled in Basel as a teacher after having studied in Munich, where he developed a close friendship with Leibl.

Impressionism and After

While the work of the Leibl circle promoted a growing painterliness in German art, their influence in Germany and Switzerland was increasingly supplanted by that coming directly from France. With the advent of the Impressionists, the ever present influence of French painting became an irresistible force, and naturalists of all kinds made their own

treaties with it. One can see different responses in the works of the great German naturalists of this generation – such as Liebermann and Slevogt, both of whom are represented here by fine and vivid scenes. Switzerland played its part in this international movement, with such figures as Cuno Amiet, Segantini and the post-Impressionist Giacometti (father of the sculptor) Examples of Giacometti's early impressionist work (Cat. 115) and his adventurous portrait of his daughter of 1912 (Cat. 116) can be seen here. But this was a direction that was not pursued. Giacometti had looked into the twentieth century, and pulled back abruptly.

Yet perhaps the best contribution came from a side that retained more of a balance between the German and the French cultures – especially in the work of Hodler. To reach this, one must go back into the nineteenth century, to consider an idealist strand that may be glimpsed in the collection.

Idealism and Symbolism

Throughout the nineteenth century, a strong tradition of idealist art continued to flourish alongside the tendency towards realism. But it, too, was influenced by the growing secular nature of society. In the place of the conventional religious ideals supported by the Nazarenes, there was a growing interest in reviving classical ideals, and in exploring the new dimensions of human experience being brought to light through psychology. The tendency can be found throughout Europe. In the German-speaking countries, however, it was tied up in particular with the familiar fascination with the culture and country of ancient Italy. A group of loosely interconnected artists, known as the "Deutschrömer" (or "German Romans") were the principal proponents of this complex world. They can be seen here in their different guises. There is the large and painterly work of *St. Martin and the Beggar* (Cat. 92) by Hans von Marées – the artist of the group most preferred in Germany on account of his painterly sophistication. And there is, as well, the more firmly classical work of Anselm Feuerbach – seen in the fine head of *Iphigenia* (Cat. 91). English viewers of this meditative representation of the tragic Greek heroine may be put in mind of some of the work of Frederic Lord Leighton. This is hardly a coincidence. For Leighton was trained by German artists in Rome and maintained contacts with the group. The model for *Iphigenia*, Nana Risi, was in fact used by Leighton for some of his pictures as well.

The development of a new sense of the tragic, and of the psychological complexity of the classical world, was a major feature in German culture in the late nineteenth century. But we should also remember that writers, scholars and artists working in Switzerland played a full part in this movement. Jacob Burckhardt – who produced the seminal book on the Renaissance emphasising its secular, rather than its religious nature – taught at Basel, where he profoundly influenced Nietzsche. The latter produced while he was there the *Birth of Tragedy*, which revolutionised the perception of Greek literature and culture, and drew attention in particular to the Dionysiac element lurking behind the façade of Appolonian beauty. And, amongst the Deutschrömer, it was a Swiss painter, Arnold Böcklin, who embodied this Nietzschean view of the classical world most fully. Coming from Basel, Böcklin was in fact a close friend of Burckhardt in his early life. But later, as he travelled – living and working in Germany and Italy (as well as returning for a time to Switzerland to live in Zurich) he seemed to absorb more of the Dionysiac vigour of Nietzsche's vision. His pictures are vigorous, yet strangely troubled. He was fascinated with the half-human figures of classical antiquity and showed them celebrating animal nature – sometime erotically – as in his sea pictures (*Triton and Nereid*, Cat. 89) – sometimes sinisterly – as in his image of the god Pan lurking in the reeds (Cat. 86) – and sometimes with childlike innocence – as in his *Children carving May Flutes* (Cat. 88). Böcklin was immensely popular in Germany in the late nineteenth century – where he seemed to epitomise the earthy expansionist mentality of the "Gründerzeit", that period of industrialisation roughly spanning the years between 1870 and 1900. Yet there was also a strong element of disquiet in his work. The earth spirits that he releases in his pictures are full of menace and fatality.

Hodler

In the late nineteenth century, the interest in reviving an art with symbolic and psychological dimensions was as strong in France as it was in Germany. It played a major part in the work of the best known historical painters of the day – such as Puvis de Chavannes and Gustave Moreau – and in the more progressive artists associated with Post-Impressionism – such as Gauguin and Van Gogh. This history can only be experienced indirectly in this exhibition, for – as has already been observed – symbolism was an area that Oscar Reinhart had little sympathy with. But its effect can be felt "offstage", so to speak, in the work of the most important Swiss artist of the period, Ferdinand Hodler.

Hodler's career in a way sums up the Swiss predicament. Coming from humble origins (his father was a carpenter who died when Hodler was young) he was intensely aware of his roots. He received his early training from Barthélemy Menn, and was from the start interested in naturalistic painting of his own and former periods. He also travelled widely – to France, Germany and Spain – and melded these influences in to his manner of painting. Already as a young artist he had an individual style, which had a brightness and immediacy, combining impressionist effects with the firm, matter-of-fact sense of form of the old masters, especially Holbein. Such work was viewed with suspicion by local critics, but worse was to come. In the mid of 1880s he came under the influence the poet Louis Duchosal, who introduced him to the ideas of French symbolism. Now he started to adapt his primitive-realist style to take in symbolic concepts. His first major achievement in this new and excitingly contradictory style was the large canvas *Night*, which shows naked couples asleep together, and has a self-portrait of Hodler himself in the middle starting in fear at a dark cloaked figure that creeps up on him through the bedclothes – a premonition of death. This open allusion to sex and death was too much for the administrative council of Geneva, who had the work removed "for the sake of public decency" when it was exhibited at the municipal art exhibition in 1891. Undeterred by this prudish censorship, Hodler showed the work in his studio, where it attracted a huge number of visitors. He later showed it in Paris and Munich, where it received medals and critical acclaim. From this time onwards, Hodler was an international figure – while still being viewed with uncertainty by the country in which he lived (his *Night* was rejected again when sent for exhibition in Geneva in 1896).

Eventually, after many setbacks, he began to be recognised at home as well as abroad and received commissions for the large-scale depictions of patriotic subjects that he had always longed to do. In 1918, a few months before his death, he received the freedom of the city of Geneva.

Reinhart appears to have shared the misgivings of the burghers of Geneva about Hodler's symbolist compositions. None of them is in his collection. But he did appreciate Hodler's qualities as a painter, and acquired important examples of the artist's early realist pictures, as well as some of the wonderful late landscapes. These give us an opportunity to see Hodler from a slightly unusual angle, to appreciate his qualities as an observer, as well as becoming aware of the more subtle ways in which he introduced symbolist concepts into his studies from nature. This process can be seen at work in the portrait of the sister of Louis Duchosal (Cat. 108). In this, the firm, slightly naive style brings out the anxieties and hopes of the thirteen-year-old. Her mood is echoed in the frail but delicate flower she is holding. The picture is at one and the same time a tribute to the realism of early German masters like Holbein, and an acknowledgement of the psychological complexities explored by the symbolists. Even in his fresh landscape studies – so full of impressionist effects – there is a sense of underlying order and purpose. His *Road to Evordes* (Cat. 110) offers a vivid evocation of a warm late summer afternoon in the countryside around Geneva. But it also has a sense of underlying order. Like Hobbema's *Avenue Middelharnis* in the London National Gallery, it faces us directly with a road flanked by trees. Characteristically Hodler has taken a visual liberty to emphasise the rectilinear relationship between the trees and the road. For while he has thick shadows falling from the trees across the road to form a series of horizontal bars, he has omitted the shadows of the trees on the left-hand side of the road, which would have dissipated the central effect. It was tricks like this that gave his symbolist work such power and firmness.

Selective omission is also evident in the views of alpine peaks that Hodler painted so obsessively in his last years.

The wonderful images he created share something of the meditative, yet awe-inspiring effect that can be found in Cézanne's views of Mont Saint-Victoire or in Hokusai's wood cuts of Mount Fuji. For Hodler, one feels, these are magical mountains. And it is a magic he has seen with his own eyes. The vibrant harmonies of blues and browns are ones that he has found on the slopes before him. A striking feature in these pictures is the way in which the alpine ridges stand out with firmness and clarity, while all below melts into mist or uncertainty. Perhaps it is significant that, as he painted these celebrations of symbols of his native country, Hodler was surrounded by disintegration. He was experiencing this on a personal level through growing ill-health, ageing, and the loss of his mistress and others he loved. He was experiencing it on a political level too. For as he painted, Europe itself was disintegrating, ultimately into war. Hodler's Alps, like those in the *Magic Mountain* – the novel by Thomas Mann set in a Swiss sanatorium just before the catastrophe – rise above the transience and uncertainties of human affairs. And yet (again as in Mann's novel) while seeming to be above it all, they are still somehow part of it. During the First World War Switzerland was neutral. But it was incubating the most powerful political and artistic movements of the twentieth century. In Zurich, beneath the lofty mountains, Lenin was plotting the revolution that changed the world; and close to him, at the Café Voltaire, there were Dadaists startling the bourgeoisie, subverting for ever the concept of what was Art. Hodler's pictures do not speak of these things. And yet, when you look at them, somehow you can sense their imminence.

Images of a Golden Age of Connoisseurship

Oskar Reinhart and his Concept of
Collecting
Franz Zelger

In the second half of the eighteenth century, when the famous portraitist Anton Graff was painting the members of the Saxon Court in Dresden, the artist's native city, Winterthur, was a dreamy provincial town, probably unknown to any of his patrons.[1] However, in the nineteenth century the rapid expansion of Winterthur's trade and industry carried the city's name to all continents. Within a few decades the second-largest city in the Canton of Zurich, long overshadowed by its mighty rival, developed into an internationally renowned centre of the arts. Semper's famous town hall became the architectural symbol of the city's golden age[2] that owed its reputation to the activities of a group of merchant art collectors who devoted part of their wealth to promoting the arts and their appreciation by the citizens.

Oskar Reinhart (1885-1965) was a successor of this pioneering generation, and in the first decade of this century, he began to assemble a collection destined to attain world fame. Reinhart was not given to speculation, nor did he try to influence art history; his collecting was in tune with his origins and station in society. In his parents' house, music, literature and the arts were cultivated. His father, Theodor Reinhart, head of the merchant firm Gebrüder Volkart, patronised numerous artists, amongst them Ferdinand Hodler, Karl Hofer and Hermann Haller. Theodor Reinhart's remarkable contribution to the arts was based on the belief that a small country like Switzerland could fulfil its cultural obligations only through the participation of the private sector. He described an exhibition he sponsored in 1892 as "a debt of honour due from the owners to dead and living artists, whose pictures are virtually buried in private houses but, through an act of public spirit, could raise the art consciousness of the neighbourhood by making them accessible for the enjoyment of people who could not afford to buy such works."[3] Theodor Reinhart's activities as a patron and collector set an example to his children. The

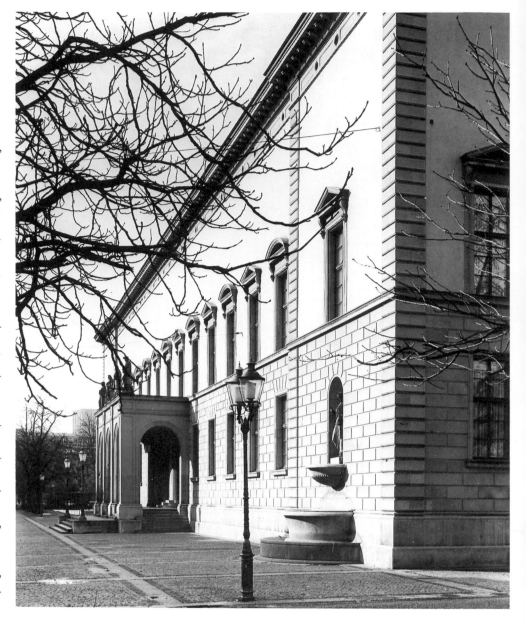

eldest son Georg became a collector of European and Asiatic art; Hans was a poet who devoted himself to promoting literature and the theatre; Werner concerned himself with music, personally assisting composers, such as Stravinsky, Schönberg, Webern, Berg, Křenek, Hindemith, Pfitzner and Richard Strauss, as well as Switzerland's Arthur Honegger and Othmar Schoeck. Werner Reinhart was receptive to the most divergent expressions of musical and artistic creativity – it was he who gave the Château Muzot in the Canton of Valais to the poet Rainer Maria Rilke for his last domicile.

The Oskar Reinhart Foundation, Winterthur

The youngest son, Oskar Reinhart, shared his father's and eldest brother's passion for collecting works of the visual arts, and this became the main interest of his life. For a few years he worked in the family firm where he managed to combine business trips to western Switzerland, London and Paris with extensive visits to museums, private collections and exhibitions. He purchased specialist literature and began scanning the auctions. In 1924, aged 39, he retired from business to devote himself entirely to the building up of his collection. In the same year he acquired the feudal seat "Am Römerholz", situated high above the city on the Lindberg, to which

Oskar Reinhart (c. 1940)

he immediately added a gallery extension. Subsequently, his collection grew into an organic whole, whose harmony and completeness render it a work of art in its own right. As early as 1930 Oskar Reinhart conveyed to the city council of Winterthur his wish to make a selection of his art treasures accessible to the public. This decision was based on the conviction that such works, though legally belonging to one owner, in a higher sense belong to the general public, with the owner fulfilling merely the function of a trustee.[4] The choice of a suitable building fell on the Alte Gymnasium, not far from Semper's town hall. In accordance with the founder's

wish a few small-scale rooms were installed next to the pillared halls, to display pictures in the setting of their period furnishings. This added an almost domestic atmosphere to the museum.

The Oskar Reinhart Foundation was opened in January 1951, displaying a coherent group of works selected from the donor's collection, to which he added important acquisitions over the years. This legacy today comprises around six hundred paintings and sculptures by German, Swiss and Austrian artists of the eighteenth to twentieth centuries. In addition there are nearly seven thousand drawings, watercolours and prints.

The gratitude and admiration evoked by

Reinhart's foundation and by an exhibition in Winterthur of other paintings from his private collection reinforced his intention to preserve his entire collection for posterity. The contents of the "Römerholz", comprising a wide range of high-quality works by old masters, predominantly French painters and sculptors, were thus left to the Swiss Federation, together with the estate. In 1970, five years after Reinhart's death, this donation was also handed over to the public.

An attempt to analyse Oskar Reinhart's concept of collecting reveals that he did not pursue works from a single, well defined area. Art-historical problems were of little interest to him – his major concern was artistic quality, which in his view was most fully represented in the works of French nineteenth-century painters. Thus French painting occupies a central place in the Reinhart Collection, from Poussin via Chardin to Van Gogh and Cézanne. Reinhart preferred "poetic and emotional content" to mere virtuosity of brushwork;[5] hence the Impressionists are somewhat neglected. There are only two works each by Sisley and Pissarro, and only one by Monet. Renoir, however, is well represented, with paintings such as *Confidences* and *La Grenouillère*, which are a feast of colour. It has been rightly pointed out that the writer and critic Julius Meier-Graefe had a decisive influence on Reinhart's collecting practice.[6] The *Entwicklungsgeschichte der modernen Kunst* (History of Modern Art, first published 1904) became virtually his guideline for the collection. Accordingly, Reinhart had a high regard for Daumier; in 1924 he wrote: "I have a passion for Daumier, Delacroix, Renoir and Courbet. Daumier should have a special place in my collection."[7] A series of letters testifies to the personal relationship between Oskar Reinhart and Meier-Graefe, which was not confined to the arts, but embraced other interests, including financial matters.[8]

Oskar Reinhart, the great collector of French painting, had an equally strong interest in German art. One of his first acquisitions, in 1913, was Liebermann's *Child with an Apple*, followed in 1916 by the artist's *On the way to School in Edam*. A little later, in 1922, while Swiss collectors were concentrating exclusively on French art,[9] Reinhart forcefully expressed his opinion: "Here French art rules supreme; the noted private collectors

buy only French pictures and exhibitions of French art abound. However, there are also German masters, and I am hoping to assemble, over the years, a small but select collection of German pictures."[10]

Oskar Reinhart realised this aim with impressive results: he succeeded in building up the most important collection of German paintings outside Germany. In 1955 Carl Georg Heise, former director of the Hamburg Kunsthalle, described the Oskar Reinhart Foundation as "the first and hitherto only all-embracing representation of our masters abroad."[11] Reinhart applied the same criteria to this area of collecting as he had to French art of the same periods, favouring painterly excellence. Meier-Graefe's principles were again crucial. Together with Alfred Lichtwark and Hugo von Tschudi, Meier-Graefe had developed the concept of the 1906 Berlin Centenary Exhibition, aiming at a reevaluation of German painting. The organisers purged the show of all academic and anecdotal content and focused on "the unknown or little known".[12] They rediscovered the painted poetry of the Romantics and the feeling for nature of the Realists, and searched for the "painterly" in art.

Inspired by the example of this exhibition Oskar Reinhart followed precisely this direction. Georg Schmidt observed: "The French painters from Poussin to Cézanne are by far the best known part of Oskar Reinhart's collection and they determine the boundaries of his susceptibility to German art."[13] Reinhart's foundation includes many artists, for instance Friedrich, Runge and Kersting, who had been saved from oblivion in Berlin, and others whose merit had only recently been recognised, amongst them Marées, Leibl and Thoma. Reinhart added more than twenty of the pictures he had seen in the Centenary Exhibition, including no less than seven works by Wasmann, four by Böcklin and three each by Feuerbach and Leibl. He also acquired versions or studies of several other paintings in the Berlin show, or bought paintings of similar subjects.

The Oskar Reinhart Collection "Am Römerholz"

Reinhart, characteristically, often showed an interest in one particular aspect of an artist's oeuvre, for instance the early work or sketches. From Menzel's paintings he chose only small-scale works from the first half of the artist's career: the famous *An Afternoon in the Tuileries Garden*, of 1867, was rejected because "the accumulation of details did not appeal" to him.[14] Blechen was represented by a few light-filled landscape impressions, and Leibl by his early painterly work rather than by his later linear style. The appeal of Leibl's portrait of *Lina Kirchdorffer* was probably its refined technique, resembling Manet's. As noted by Schmidt in his above quoted essay, Reinhart looked for "brightness rather than darkness, simplicity rather than sophistry, softness rather than harshness, sensual appeal rather than cerebral expression". In this way, however, the "fruitful tensions of the century" eluded him.[15]

His concentration on certain clearly defined groups, personalities and stylistic aspects meant that Reinhart largely excluded the Nazarenes from his high-calibre collection of Romantics. Outstanding paintings by Runge, Friedrich and Kersting compensate for this omission. Caspar David Friedrich's *Chalk Cliffs on Rügen* of 1818/19, one of "the most significant works of German painting in the early years of the century",[16] dominates this part of the collection. When selecting works by the Deutsch-Römer Reinhart also pursued his own path. His choice of works by Arnold Böcklin was confined to those praised by Meier-Graefe in his influential book, *Der Fall Böcklin*. The German art historian commented approvingly on Böcklin's *Pan amongst the Reeds*, *Children carving May Flutes*, and *Elysian Fields*, shown in the 1932 Basel exhibition of the Oskar Reinhart collection, observing that they "demonstrate better than most Böcklin's potential and its frustration."[17] Feuerbach is represented in the Foundation by only one of his antique figure paintings, the preliminary study head for the *Iphigenia* at Stuttgart. Georg Schmidt remarks that omitting Feuerbach's "Medea-like monumental paintings" amounts to ignoring Feuerbach altogether.[18] Reinhart always reserved for himself the collector's privilege to select arbitrarily cer-

tain periods of an artist's work. Thus the two paintings by Hans von Marées belong to the 1860s, and not to the artist's maturity. Like Feuerbach, Marées empathised with antique art, although his early Rembrandtesque *Self-portrait* does not yet express this tendency. The *St. Martin and the Beggar*, painted eight years later, already points to the simplified monumentality of the artist's later style. Marées is best represented in Winterthur by his drawings. In fact, the collection of drawings and watercolours always aims at complementing the paintings and compensating for gaps, as exemplified by the inclusion of the Romantics Schnorr von Carolsfeld and Ludwig Richter.

Reinhart's great love for Hans Thoma seems somewhat out of place in a collector of French nineteenth-century art. But here, again, he selected only works – thirteen paintings and several drawings – consistent with his interest in realism, which in Thoma's work was a realism based on Courbet's.

Artists of a later period are not as well represented as the Romantics and the Realists, and there is no continuity leading to German twentieth-century art. Liebermann and Slevogt mark the limit of Reinhart's interests. There are no works by Lovis Corinth, whose brushwork was considered too heavy, nor by Oskar Kokoschka, although Reinhart admired his city views. Understandably, neither the Fauves nor the German Expressionists found a place in his scheme. Petra Kipphoff rightly remarked that "a Max Beckmann in this collection would produce a sensation like scraping a nail over a piece of sheet metal."[19] The *Portrait of Mateu F. de Soto*, from Picasso's blue period marks the end of Reinhart's interest in twentieth-century avantgarde painting. Even the Swiss followers of the movement found no admission to the collection.

Reinhart's collecting instincts sometimes opened up new territory. For instance he rediscovered forgotten Swiss artists, such as François Ferrière, Caspar Wolf, Friedrich Simon, Frédéric Dufaux and Daniel Ihly, and was the first to recognise that Wolf was the most important Swiss landscape painter of the eighteenth century. He also highly esteemed the painters of Geneva: he had early plans for a special room devoted to Liotard, and acquired several works by Agasse, Töpffer and Massot. His diary of 1941 notes: "Agasse is already well represented in the Foundation collection, but it is my ambition to give his work the same prominence in Winterthur as it has in the Museum of Geneva."[20] Another highlight of the collection are the twenty-seven paintings by Ferdinand Hodler. Reinhart preferred Hodler's early realist work, renouncing the symbolic and historical-dramatic compositions. During the decades of Reinhart's collecting activities the critical assessment of Hodler's oeuvre underwent a change, as expressed in the monograph by Hans Mühlestein and Georg Schmidt of 1942.[21] These critics viewed Hodler's early "realistic" work as his artistically essential contribution, while the mature artist's "idealising" tendencies are considered artificial and pandering to success. Only the late portraits and landscapes escape this negative judgment. Oskar Reinhart followed these critical trends, adding three late alpine landscapes to the artist's early works. Reinhart thus counts amongst those who first

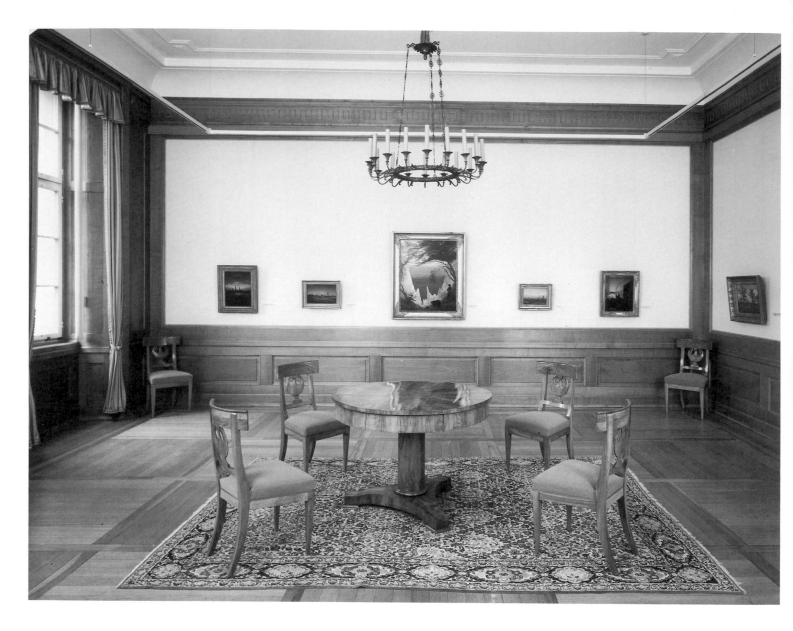

The Romantics Room in the Oskar Reinhart Foundation

discovered Hodler's early period, although his criteria differed from those of Mühlestein and Schmidt. He saw the artist through the eyes of Meier-Graefe, who focused on painterly quality, while the other two critics associated him with Marxist sociology and psychoanalysis.

Reinhart's preferences in contemporary art were mainly determined by his personal friendships and contacts. Without exception he identified with the adherents of the figurative school, including the painters Karl Walser, Wilfred Buchmann, Hans Schoellhorn, Alexandre Blanchet and the sculptor Hermann Hubacher, who was a close personal friend. None of these contributed to the collection's international reputation, but these friendships are characteristic of Rein-

hart's relationship with art: "To grow up amongst artists who taught me to see was the happy accident of my youth. They remain my best counsellors, also in everyday matters."[22] Thus the collector added his trust to the patronage which he bestowed on his Swiss contemporaries; like this closely knit circle of friends he believed in being guided by tradition rather than experiment.

Oskar Reinhart believed that we were too close to contemporary art to be able to assess it clearly, so it was hardly possible to acquire works by artists of enduring importance.[23] His reaction to the art trade is summed up in a letter written in 1935 to the Galerie Abels in Cologne: "To save us both unnecessary correspondence I would ask you not to offer me further pictures by living German painters."[24] To Will Grohmann he expressed his regret at "being unable to subscribe to the planned preferential edition of Paul Klee's drawings, since Klee's art is alien to me."[25] In contrast to his father, Oskar Reinhart never supported controversial artists of his own time. In 1899 his father vehemently advocated the purchase by the Winterthur Kunstverein of a painting by Hodler,[26] while his son, thirty years later, remarked to the same institution that "collectors did not sufficiently consider an important aspect, namely the popularity of certain paintings and their enjoyment by the public. Our public, no doubt, would gain more enjoyment from a landscape by Zünd than from a range of our foreign pictures."[27]

The Winterthur residents Arthur and Hedy Hahnloser-Bühler, who had started a collection of international repute some time before Oskar Reinhart, were at that time particularly interested in contemporary art.[28] On regular trips to Paris they visited painters and sculptors in their studios, forming many ties of friendship and offering the artists hospitality in their Winterthur house "Zur Flora". Their collection is based on purposeful selection, combined with coherence, similar to Reinhart's. "We are conscious of our deliberately restrictive approach, which we believe strengthens, rather than weakens, a private collection," wrote Mrs. Hahnloser in 1940.[29] The nucleus of the collection were the Nabis, Bonnard, Vallotton and Vuillard, the Fauves,
Matisse and Marquet, as well as the contemporary Swiss artists Hodler, Amiet and Giovanni Giacometti. In addition, many works by Rouault, Redon and Manguin found their way to Winterthur. From this friendly cooperation with the artists emerged a collection bearing witness to a discriminating and courageous support for new and controversial movements.

Encouraged by his cousin Hedy Hahnloser, the young Winterthur industrialist Richard Bühler became an almost equally enthusiastic collector of modern art. "I can assure you I always remember that your guidance led me to the French artists" [meaning the late Impressionists, the Nabis and the Fauves].[30]

The taste of Hermann and Margrit Rupf in Berne was even more radical: their collection grew simultaneously with Cubist art. In 1924 it contained more than twenty works by Friesz, Derain, Braque, Picasso, Gris and Léger, all purchased by the couple, with few exceptions, through their friend Kahnweiler in the year of their creation.[31]

Reinhart's aim of assembling a selection of masterworks from different epochs demanded a different method. Initially he envisaged his collection as a *musée imaginaire*, and he patiently waited, sometimes for decades, for the opportunity to acquire works he desired. For instance Böcklin's important painting *Paolo and Francesca* was on his list of *desiderata* as early as 1921, but entered the collection only in 1945. In 1948 he expressed his interest in an intimate landscape by Christen Købke. Twelve years later he succeeded in purchasing the *View of Østerbro from Dosseringen*, when the Copenhagen Museum renounced its own claim in favour of the internationally renowned Reinhart collection. In his speech at the opening of the collection the donor said: "A collection with a character of its own cannot be assembled in a few years but over decades."[32] Personal preference, harmony and quality thus mark the specific character of the Oskar Reinhart Foundation. In Carl Georg Heise's words, the collection portrays "a period of high artistic taste".[33]

Jean-Etienne Liotard
(1702-1789)

The choice of works by Liotard as an introduction to the paintings in the Oskar Reinhart Foundation is not accidental. Liotard was the first Swiss painter of international renown since Holbein and Stimmer (excepting perhaps Mola and Serodine, who were born in Ticino). Liotard, a celebrated pastel painter and portraitist, outgrew the Baroque formulae of Rigaud and Largillière and, initiating a new epoch, became one of the founders of the many realist movements that flourished in the nineteenth century, with the strong contribution of a succession of Swiss painters.

With his austere approach, attention to the essential, and meticulous technique, embracing every detail, Liotard's work seems far removed from the sensuous exuberance of the Rococo. Although he portrayed his sitters in the softly flowing fashions and coquettish poses of the eighteenth century, they do not present themselves as shepherdesses or shepherds. Liotard painted modern people with unselfconscious human emotions. The layers of powder covering faces and hair are rendered most successfully in pastel and do not detract from the sitters, but rather enhance their personality. Liotard created the ideal image of the man of letters, relaxed, yet mentally disciplined and alert, the opposite of the soulless puppets of the boudoirs. His pastel portraits do not have the affected sweetness often associated with pastel painting, and which can be seen for example in Rosalba Carriera's work. Liotard introduced to the medium new dimensions based on understated charm, a restrained palette and flawless execution. His anachronistic classicism was an influence on Ingres, his great admirer. Liotard fits well into Geneva's tradition of puritanical Calvinism, with its denial of sensuality. Nevertheless, his flamboyant personality and supreme mastery of his art ensured that his fame also spread to the Catholic principalities of Europe. He was the virtuoso chronicler, "the painter of truth", fulfilling portrait commissions in England, France, Italy, the Netherlands, Germany, Austria, the Orient and, of course, in Geneva.

Liotard's trip to the Orient was a turning point in his life. After training with a miniatu-

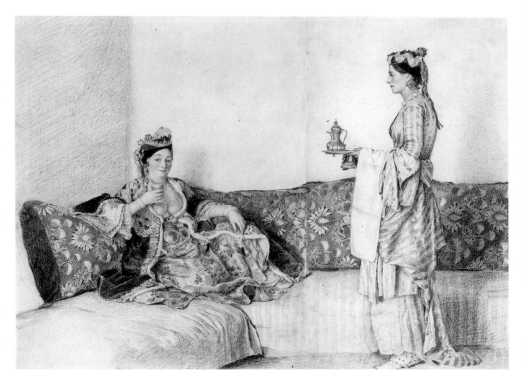

rist in Geneva, the artist moved to Paris in 1723, and in 1735 he accompanied the French Ambassador, Vicomte de Puisieux, to Naples. In Italy he met William Ponsonby, later Lord Bessborough, with whom he travelled to Constantinople in 1738. During his four-year stay he discovered the glittering world of the East, which he captured in many drawings. For these he often used only red chalk and black pencil with a fine point, which facilitated the miniature-like rendering of the figures and their surroundings. This process anticipated his later pastel technique.

fig. 1
Jean-Etienne Liotard
Maid serving Tea to an Oriental Lady (1740/42)
Red and black crayon over pencil, 20.5 × 28.5 cm
Provenance: Auction of the painter Richard's pictures, Lyons, 27 Jan. 1786
(de Herdt 43)

The drawing *Maid serving Tea to an Oriental Lady* (fig. 1) seems directly to involve the spectator, whom the lady, judging from her irritated look, regards as an intruder. The immaculate profile of the serving girl, an immediate precursor of Liotard's famous *Belle Chocolatière* in Dresden (Gemäldegalerie Alte Meister), seen against a neutral white background, radiates an aura of restrained dignity.[1] The hard-edged precision of the drawing, particularly noticeable in the severe contours of the teapot, belies the sensuous softness of the cushions, scattered everywhere.

Liotard developed the subject of harem scenes in occasional pastel and oil paintings, most of which exist in several versions. His pastel painting *Turkish Lady and Young Girl* (fig. 2) portrays a slave girl with her mistress. The lady is clearly not a Muslim, but possibly an inhabitant of the Galata district in Constantinople.[2] In one hand she holds a long pipe, and with the other points to the young slave, who is bringing a comb and a make-up

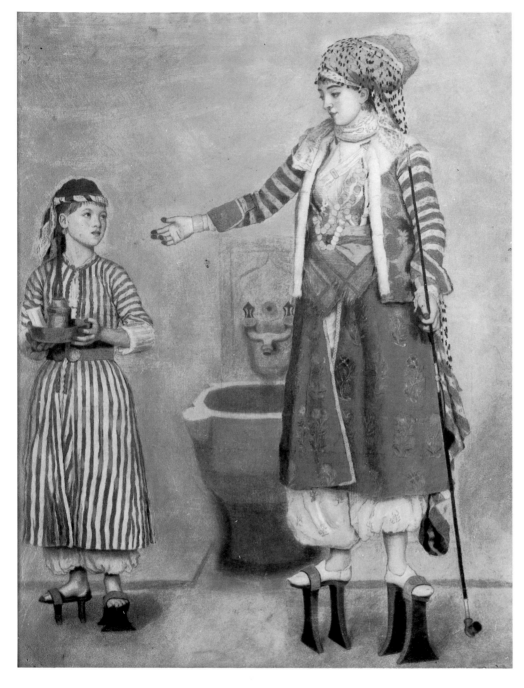

fig. 2
Jean-Etienne Liotard
Turkish Lady and Young Girl (c. 1743)
Pastel on parchment, 69.5 × 54.5 cm
Provenance: Heywood Johnstone, Bignor Park, Pulborough (?); Dr. Walter Hugelshofer, Zurich; acquired 1935
(Loche/Roethlisberger 52)

guishing him from the smoothly shaven ideal male image of the Rococo and thus enhancing his fame all over Europe. He repeatedly portrayed himself in this role of non-conformist and *enfant terrible* of the art world. The *Self-Portrait in Turkish Costume* (fig. 4), showing the artist holding a pastel chalk in front of his easel, is a replica in slightly narrower format of the 1749 pastel painting which he exhibited in the 1752 Salon of the Académie de Saint-Luc in Paris and then donated to the Geneva Library.[3]

1 Portrait of Marie-Justine-Benoîte Favart-Duronceray

Marie-Justine-Benoîte Favart-Duronceray (1727-72) was the daughter of two musicians in the orchestra of the Polish King Stanislaus Leszczynski. She performed in Paris under the name of Mademoiselle Chantilly, as *première danseuse du Roi de Pologne*, and in 1745 married the celebrated author of comedies, Charles Simon Favart (1710-62). Soon afterwards Moritz of Saxony, Marshal of France,[4] fell in love with her, and he engaged Favart's troupe to appear in Brussels while Favart had to spend a lengthy period in hiding near Strasbourg, to escape a summons for his arrest. His wife is said to have been detained for one year in the convents of Les Andelys and Angers, by order of the marshal. Only after the marshal's death in 1750 were the couple reunited and Marie subsequently appeared regularly in productions of works by her husband, who had become director of the Opéra Comique in Paris.[5]

During his third stay in Paris in 1757, Liotard painted Madame Favart at the height of her success. The pendant portrait of her husband (now lost) showed him looking up from a book in his left hand to admire his wife. Seated in an armchair, she is happily absorbed in her music.[6] Her head and smiling face are seen in three-quarter view and repeated in the silhouette-like profile of the shadow cast on the neutral back wall. This quasi-double portrait seems to illustrate

jar on a tray. Both figures are dressed in Turkish clothes, their fingertips are painted with henna and they are wearing high wooden clogs to avoid contact with the hypocaust (a system of under-floor heating). They stand in the antechamber of a Hammam, or Turkish bath, in front of a washbasin. This evenly lit scene, from which shadows are banished, anticipates Ingres's palette and orientalism.

In 1742 Liotard accepted an invitation from Prince Mavrocordato to visit Jassy, the capital of Moldavia. In the following year he was warmly received by the Empress Maria Theresa, who employed him as court painter. Liotard, known as "the Turkish painter", became a sensation at the Imperial Court. He dressed in Turkish robes and, in imitation of Turkish dignitaries, grew a long frizzly beard, speckled with grey. Together with his artfully unkempt hair, resembling a lion's mane, this gave him a formidable apearance. The beard became his hallmark and his pride, distin-

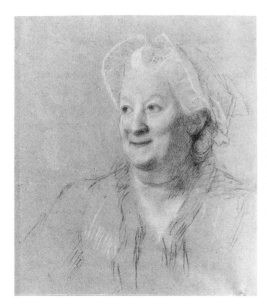

fig. 3
Jean-Etienne Liotard
Portrait of Madame Dufour
Black and white chalk on blue paper,
45.5 × 38.5 cm
Provenance: the artist's family; J. W. R. Tilanus, Amsterdam; acquired c. 1934
(de Herdt 173)

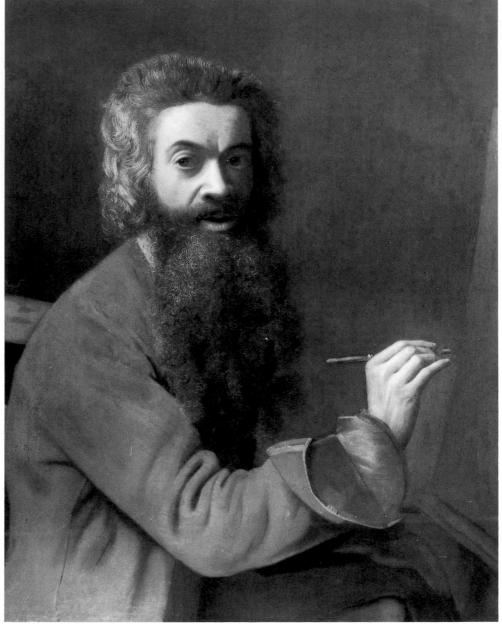

P. Clement's description in his *Cinq Années Littéraires* of 1749: "Her voice sounds somewhat shrill and off-key, but she performs with grace and her dancing, for an actress, is charming. Her features are unremarkable but pure; her expression is amiable and lively and her gestures suggest now hauteur, now complaisance, which won the hearts of her audience."[7]

In spite of his restless activity all over Europe, Liotard always maintained his connections with Geneva, where he died in 1789, just before the outbreak of the Revolution. Geneva's republican tradition strengthened Liotard's self-assurance and his craving for independence. Lacking poetic inclinations and unable to paint anything he could not see, he had the capacity for exact analysis which distinguished so many Geneva scientists of the eighteenth century, who described in minute detail the forms and functions of nature.[8] Geneva artists almost invariably emerged from the city's prosperous and industrious circle of craftsmen. The specialist skills of the clockmakers, jewellers and goldsmiths find an echo in the art of Liotard, the trained enamel craftsman. On this sole foundation grew the so-called School of Geneva,

embracing a series of talented painters, from Saint-Ours (q. v.), Ferrière (q. v.), Agasse (q. v.), Töpffer (q. v.), Calame (q. v.) and Menn (q. v.) to Hodler (q. v.), who always remained committed to an impressive clarity of representation, based on the visible world. Liotard, who sparked off this artistic development, was meticulous in his search for accuracy. He regulated his models' outward appearance, as well as their expressions. He associated his fellow-citizen Rousseau, who sat for his portrait, with a similar striving for truth, which prompted him to initiate an exchange of ideas by correspondence.[9] He felt a certain spiritual bond with some members of

fig. 4
Jean-Etienne Liotard
Self-Portrait in Turkish Costume
Pastel on parchment, 79 × 62.5 cm
Provenance: Liotard legacy; private collection, Geneva; Rodolphe Dunki, Geneva; acquired 1946
(Loche/Roethlisberger 103)

1
Jean-Etienne Liotard
Portrait of Marie-Justine-Benoîte Favart-Duronceray, 1757
Pastel on parchment, 70 × 55.5 cm
Signed top right: par J. E. Liotard/ 1757
Provenance: Henri Pannier, Paris; M. Kaganovitch, Paris; acquired 1935
(Loche/Roethlisberger 213)

Geneva society (fig. 3), particularly the Tronchin "clan," whose portrait commissions inspired some of the artist's most felicitous works, amongst them the portraits of the Thellussons.

2,3 Portraits of the Married Couple Isaac-Louis and Julie de Thellusson

These pendants are amongst the most outstanding of Liotard's husband-and-wife portraits. Isaac-Louis de Thellusson (1727-1801), Master of La Garra, was the son of the Paris banker and politician Isaac de Thellusson, who had settled in Geneva. From 1750 he was a member of the Council of Two Hundred, from 1773 State Councillor, and from 1785 to 1789 mayor of the Republic of Geneva. The two portraits were painted in 1760, the year Thellusson married Marguerite-Julie Ployard (1740-1820), who was born and raised in Marseilles, where her Geneva-born father, Jean-Louis Ployard, had founded an important trading firm and was active as consular agent for Denmark and Norway.[10]

Liotard shows the attractive couple in a happy and relaxed mood. Madame Thellusson, wearing a silk ribbon in her grey-powdered hair, is elegantly dressed in a profusion of lace, ribbons and bows, which harmonise in a symphony of blue and mother-of-pearl tones. With a playful movement, characteristic of the period, she is about to remove her cape, having loosened its blue silk ribbon. At the same time she displays on her wrist a medallion, set in precious diamonds, with a male portrait, no doubt of her husband. He, in turn, wears a ring with a lady's portrait painted in enamel. Dressed in a costly blue silk gown, embroidered with flowers, he responds with a warm expression to his wife's affectionate smile. His arm rests nonchalantly on the back of an armchair, with his hand, framed in white lace, idly hanging down. Everything points to the sitter's concern with appearance. His soft, rather feminine features are set off by an elaborate coiffure, powdered and curled, with an artificial hairpiece attached to the back.

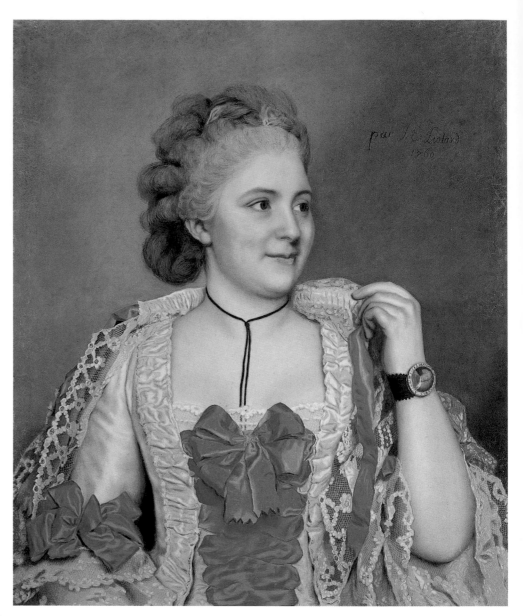

It is noteworthy that, reversing heraldic traditions, Liotard placed the woman's portrait on the left, and the man's on the right, as he had done in the Favart-Duronceray marriage portrait and other pendant portraits.

Both paintings are dominated by bright tones of white, blue and a warm shade of pale brown, interspersed with restrained accents of red and green, notably in the man's costume and the lady's medallion. Liotard was interested in theoretical studies of colour harmony and luminosity. Towards the end of his life, in 1781, he published his *Traité des principes et des règles de la peinture* with the motto inspired by Rousseau "everything emerging from the hands of nature is good, but in the hands of man everything degener-

2
Jean-Etienne Liotard
Portrait of Julie de Thellusson-Ployard, 1760
Pastel on parchment, 70 × 58 cm
Signed top right: par J. E. Liotard/ 1760
Provenance: Henri Faesch, Geneva; A. Faesch-Micheli, Geneva; Mme Faesch-de Beaumont, Geneva; Rodolphe Dunki, Geneva; acquired 1935
(Loche/ Roethlisberger 240)

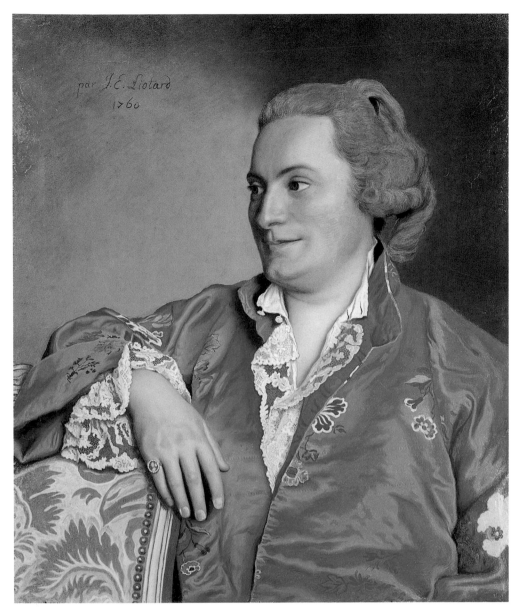

In his *Règle XVI* Liotard urges painters to apply the highest degree of finish, naming as examples the Dutch painters he admired, such as Van Huysum, Terborch, Van der Werff, Van der Heyden, and praising the perfectionism of the *fijnschilders* ("fine painters"), such as Dou and Van Mieris.[15] Not surprisingly, Dutch paintings are occasionally included in the background of portraits, for instance a Rembrandt in the *Portrait of François Tronchin* in Cleveland and a De Witte in the *Chocolatière* (Collection Earl of Bessborough).

4 Still Life with Peaches and Pumpkin

Towards the end of his successful career, the octogenarian artist unexpectedly took up a new speciality, the still life. Still-life motifs had played an important part in his earlier portraiture, but they now assumed an independent status. Liotard reversed the progression of Chardin's career who, after a lifetime of still-life painting, in old age produced a few pastel portraits.

Liotard's still lifes (mostly pastels but a few painted in oil) are usually small in format and include a limited number of motifs. On 24 September 1782 he wrote to his son about his recent efforts in this genre: "These four paintings have more freshness and vivacity, their objects are more clearly defined and more truthful than those of Van Huysum, although they are less finished. When I was thirty I would not have painted them so well, as my art has since much improved. They have been so much admired that I found myself obliged to add my name and my age of 80 years ..."[16]

Liotard sought to rival Jan van Huysum (1682 - 1749), born twenty years before him, the undisputed master of the flower still life, whose works fetched the highest prices. In his *Traité* of 1781, Liotard had praised Van Huysum as the artist who had "elevated oil painting to its highest level of perfection,"[17] but he now chose a new direction for his own still lifes, departing from his beloved Dutch painters who seemed to have reached a dead end. He was searching for new painterly qualities and found them in strict optical truthfulness, to the extent of illusionistic deception. He was proud that his trompe-l'oeil still life with grapes deceived the public into thinking the grapes were real, thus making him a successor to Xeuxis whose painting of

3
Jean-Etienne Liotard
Portrait of Isacc-Louis de Thellusson, 1760
Pastel on parchment, 70 × 58 cm
Signed top left: par J. E. Liotard/ 1760
Provenance: Henri Faesch, Geneva; A. Faesch-Micheli, Geneva; Mme Faesch-de Beaumont, Geneva; Rodolphe Dunki, Geneva; acquired 1935
(Loche/ Roethlisberger 239)

ates; truth is succeeded by errors ..."[11] He considered drawing as the first step in artistic creation, and "to imitate as perfectly as possible all the colours offered to us by nature" as the most difficult achievement.[12]

The many carefully observed details help to characterise the sitters: for instance the thin black ribbon around the lady's neck probably holds a crucifix, as in the *Portrait of Mademoiselle Lavergne*.[13] Liotard's observation is so precise as to include recognisable symptoms of mycosis (a fungal disease) on M. Thellusson's fingernails. In his *Traité* he remarks on the time and patience necessary to achieve all the subtleties required in painting, adding that "the small details, if well reproduced, give the greatest pleasure ... "[14]

4

Jean-Etienne Liotard
Still Life with Peaches and Pumpkin, 1783
Pastel on paper, mounted on canvas, 32 × 35.5 cm
Signed top right: par J. E. Liotard a 81 1783
Provenance: J. E. Liotard-Crommelin, Amsterdam;
Mlle M. A. Liotard, Amsterdam; J. W. R. Tilanus,
Amsterdam; Mlle E. Tilanus, Elspeet (Holland); Paul
Cassirer, Amsterdam; acquired 1957
(Loche/Roethlisberger 344)

grapes had deceived the ancient Romans. Liotard found Xeuxis even superior to Parrhasius, because it was easier to paint a flat curtain than three-dimensional fruit: "there are few modern painters, in fact I know none, whose paintings of fruit could deceive everybody. Jan van Huysum has painted them to utmost perfection, but they produce no illusion."[18]

The *Still Life with Peaches and Pumpkin* is dated 1783 and clearly inscribed by the artist with his age. A curvaceous Guéridon table, set in an undefined space, holds a plate with five peaches, arranged in a pyramid. The smooth surface of the pumpkin, placed nearby, seems to compete with the velvety skins of the peaches for the prize of truthfulness.

sum's traditional formal bouquets, Liotard's still lifes lack any vanitas elements and do not emphasise technical virtuosity or botanical interest. Liotard aimed at an aesthetic experience independent of space and time. His works, in their clarity, sobriety and restricted subject matter, radiate an aura of modernity that has inspired frequent comparisons with Cézanne.[19]

The still lifes *Bowl with Fruit* (fig. 6) and *Apples in a Bowl* (fig. 5), painted in pastel and oil respectively, are further examples of formal unity and geometric discipline. Liotard used the most everyday types of fruit to conjure up an illusion of reality, as in the velvety blue plums, whose black patches betray the places where they have been touched. This effect is even more noticeable in the pumpkin that has to be viewed from a distance to make the dark blue shadowed half merge with the rest into a whole. In contrast with Van Huy-

5 Footbridge over the Lütschine near Gsteig

In the early days of eighteenth-century tourism the most popular place to visit was the Bernese Oberland with its easily accessible attractions, such as the Staubbach Falls and the two Grindelwald glaciers, nicknamed "glaciers for dandies and women" because their gentle slopes extended well into the green valley.[8] Thus the first series of Wagner's ten engravings, published in 1777, was devoted entirely to views of the Lauterbrunnen Valley. The village of Gsteig, with its footbridge over the Lütschine, is situated at the narrow entrance to this valley, south of Interlaken.

Wolf's painting leads the eye into the depths of the valley, past the slopes of the Schynigen Plateau on the left, towards the diaphanous silhouette of the Männlichen mountain in the background. The apparently conventional composition recalls landscape paintings by seventeenth-century Dutch and Netherlandish artists, such as Jan Both and Roelant Savery, whereas the animal staffage evokes the pastoral idylls of the Rococo in the manner of Salomon Gessner. However, the painting does not lack progressive features. The two alpine peasants crossing the crown of the bridge, which is supported by a huge rock, are daringly silhouetted against the radiance of the sky in the centre of the composition. They are like a monument to the free spirit of alpine dwellers which had been emphasised by Haller. The rough mountains of Europe were seen as the original abode of a society living in harmony with nature, survivors of Virgil's and Ovid's Golden Age in faraway Arcadia.[9]

Thus the image of the Alps as a stronghold of liberty gained momentum. In contrast with the effete principalities of suppressed, feudal Europe, the mountain dwellers determined their own frugal existence. Not surprisingly William Tell had become known all over Europe as a hero of freedom (see fig. 7). Voltaire, in his *Epître au Lac de Genève*, paid homage to him as the legitimate heir to Greek and Roman liberty.[10] Friedrich Schiller created the most poignant monument to William Tell in his drama, later set to music by Rossini.

6 The Staubbach Fall in the Lauterbrunnen Valley

The painting features one of the highlights of any tour of Switzerland. A group of travellers, armed with umbrellas, have assembled at the foot of the Lower Staubbach waterfall to experience the intoxicating phenomenon as closely as possible. Their diminutive figures, reduced to the size of ants, set the scale for the awesome height of the fall, at the foot of which a rainbow has formed.

On 9 October 1779 Goethe was one of those visitors. He expressed his fascination with the overwhelming sight and the interplay of wind and water in his poem *Song of the Spirits above the Waters*, which ends by likening man's soul to the water and man's destiny to the wind:

"Soul of man,

"how like you are to water!

"Fate of man,

"how like you are to the wind!"

Ten days later Goethe had a lively discussion about geology in Berne with Wyttenbach, who seems to have promised him a copy of the 1777 edition of prints containing an engraving of the *Staubbach Fall*.[11]

Young English aristocrats on their Grand Tour to Italy also liked to stop at the waterfall. Wolf's engravings and the painted replicas were probably intended for such purchasers.

While touring with Wagner and Wyttenbach, Wolf himself helped to measure the height of

fig. 7
Johann Heinrich Füssli
Tell shooting Gessler, 1798
Pen and brown and black ink over crayon and pencil, 18.5 × 28 cm
Inscribed bottom left: Jun. I. 98
(Schiff 1001)

the fall. The frontispiece of the first edition of prints (1777) shows Wolf at his easel in front of the waterfall, confirming that the paintings begun in the studio were indeed finished in *plein air*. Wyttenbach comments on this print in an *album amicorum*: "When Wolf was painting this view, Wagner was standing on one side of him, and Miss Müller, a fervent admirer of the Alps, on the other. In another corner of this vignette the mountain folk of Lauterbrunn, bringing the ropes with which I measured the height of the Staubbach, are seen next to a miserable portrait of myself writing."[12]

In his description of Wolf's paintings Wyttenbach particularly mentions the painter's precarious vantage point, very near to the motif, where a stream of water from the "Kupferbächlein" next to the great fall threatens to "come down on the head of the artist standing close by."[13]

Even winter could not prevent Wolf from painting out of doors. His view of *The Staubbach Fall in Winter* (fig. 8), where the motif is transformed into a vision of snow and ice, includes a self-portrait of the artist, sitting with his painting equipment on a stone, a mo-

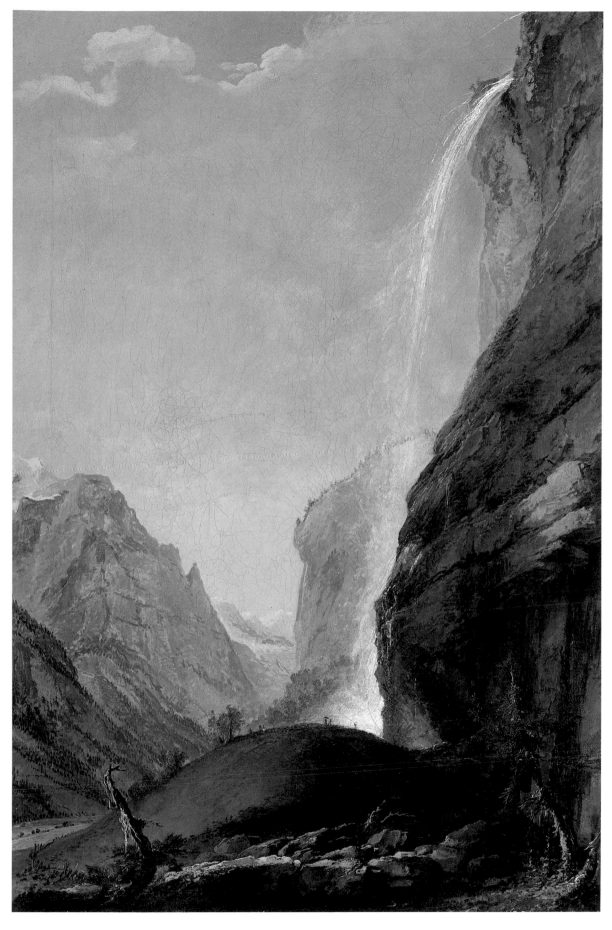

6
Caspar Wolf
The Staubbach Fall in the Lau-
terbrunnen Valley (1774/77)
Oil on canvas, 81.5 × 54 cm
Signed centre bottom: C. Wolff
Provenance: Keukenhof near
Lisse, Holland; Galerie Dr. Rae-
ber, Basel; acquired 1947
(Raeber 177)

fig. 8
Caspar Wolf
The Staubbach Fall in Winter (1774/78)
Gouache, 30 × 20 cm
Signed bottom left: C. Wolff.
(Raeber 180)

nument to his martyrdom in the cold. It has been suggested that his health was affected by such exposure, causing his premature death in 1783, four years after completing the commission. In a report dated 1839, the geographer Robert dramatically describes the effect of winter in this location: "When frost grips the waters of the Staubbach, water and spray are transformed into thundering hail showers and a rigid column of ice forms in the upper part of the fall. This giant ice cone increases in height and volume until, broken by its weight and detached from the rock, it tumbles down to the valley in a horrendous crash."[14]

Wolf painted the *Schiltwaldbach in the Lauterbrunnen Valley in Winter* (fig. 9) from a much higher vantage point. The waterfall is seen gushing down, partly as a rain of ice, with the Staubbach Falls across the valley in the background; the foreground, again, contains the artist's self-portrait.

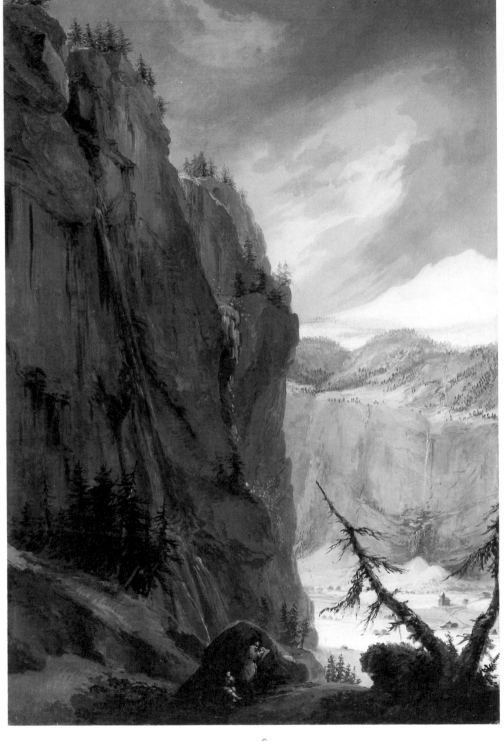

fig. 9
Caspar Wolf
The Schiltwaldbach in the Lauterbrunnen Valley in Winter (1774/77)
Oil on canvas, 82 × 53.5 cm
Signed bottom right: C. Wolff
Provenance: Keukenhof near Lisse, Holland; Galerie Dr. Raeber, Basel; acquired 1947
(Raeber 187)

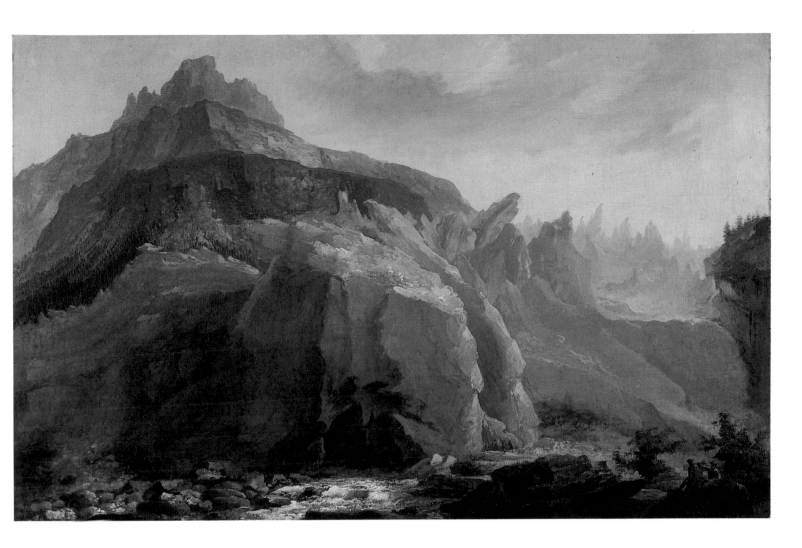

7
Caspar Wolf
The Lower Grindelwald Glacier with Lütschine and
Mettenberg (1774/77)
Oil on canvas, 53.5 × 81 cm
Signed bottom right: C. Wolff.
Provenance: Keukenhof near Lisse, Holland; Galerie
Dr. Raeber, Basel; acquired 1947
(Raeber 196)

7 The Lower Grindelwald Glacier with Lütschine and Mettenberg

Unlike earlier painters, Wolf did not confine himself to painting popular views which could be admired from the inhabited valleys; he penetrated into hitherto unknown regions, as witnessed by his paintings of the Lower Grindelwald glacier, with its then greatly expanded mass.

In this painting the glacier ends in a kind of steep pyramid, with an ice grotto opening in the centre from which a stream of water gushes towards the Lütschine. The bizarre forms of the glacier tower above, suggesting the force with which the masses of ice are pressed up against the rocky flanks of the Mettenberg mountain. The three men standing gesticulating near the grotto seem to be scientists examining the processes of melting ice, while in the foreground two men are sitting on a rock, apparently discussing their impressions of this sublime aspect of nature. Wolf made two trips to Grindelwald in 1774 and 1776 with his publisher Wagner, but during this span of time, according to Wagner, the appearance of the glacier had altered: "The ice grotto changes almost every year; in 1774 only an ice-wall, cut off at its apex, was visible, but in 1776 an exquisitely rounded opening reappeared, hollowed out by the waters of the Lütschine."[15]

The coloured aquatint after this painting is dedicated to Joseph Vernet, who acquired five gouaches by Wolf and under whose direction the Paris edition of prints was made.[16]

In an overwhelmingly dramatic painting (Aarau, Kunsthaus) Wolf captured the same view in a thunderstorm: from dark clouds suspended between the mountain peaks a flash of lightning hits the ice, driving a herd of frightened chamois into flight. With such romantic works Wolf evoked the spirit of the epoch, for the wildness of mountains was ideally suited to express the turmoil of men's feelings on the eve of the Revolution.

The concept of the Sublime developed in the mid-eighteenth century became a key to contemporary philosophy and aesthetics, including Kant's and Schiller's, and grew into a veritable cult in which artists participated. In 1757 Edmund Burke published his essay *A Philosophical Enquiry into the Origins of the Sublime and Beautiful*. Based on antique texts, this treatise was the first to explore systematically the effect of untamed nature on the human mind, suggesting that "whatever is terrible with regard to sight, is sublime too."[17] The Swiss aesthetician Johann Georg Sulzer, in the chapter on "The Sublime" in his

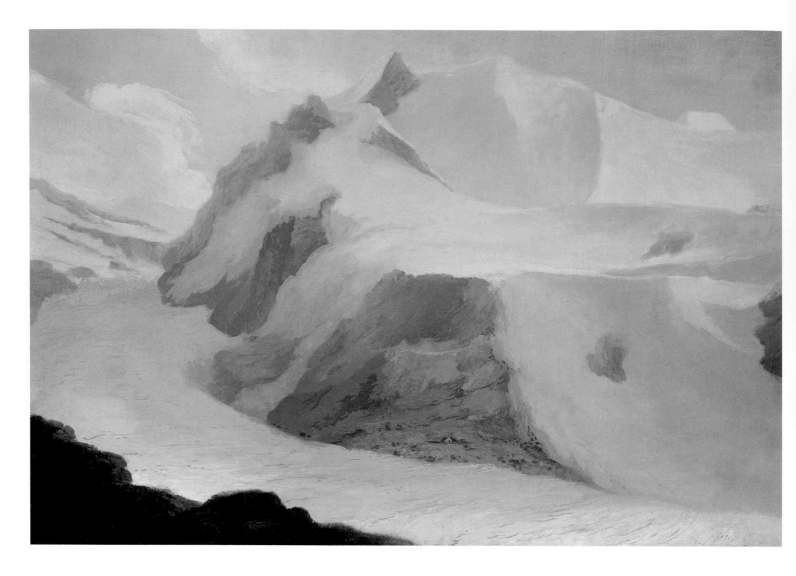

Allgemeine Theorie der Schönen Künste (General Theory of the Fine Arts) of 1771, also examined the effect of nature on the human mind: "The beauties of inanimate nature instruct those who are unused to thinking that man is not a mere earthbound physical being. Certain feelings of a moral and passionate kind develop through contemplating inanimate nature, which teaches us to admire the great, the new and the extraordinary. Some aspects of nature awaken fear and horror...Who can fail to experience a feeling of weakness and dependence on higher powers when viewing the gigantic mass of overhanging rocks."[18]

8 View from the Bänisegg over the Lower Grindelwald Glacier and the Fiescherhornmassiv

The even more dramatic view of the Grindelwald glacier from Bänisegg is captured by Wolf in three paintings which, allowing for a gap and an overlap, together form a circular panorama.[19] In two of the paintings, three mountaineers are seen sitting on a jutting-out rock and holding sticks; presumably they are Wyttenbach, Wolf and Wagner, who went on this adventurous mountain tour in August 1776.[20] The Winterthur painting has no staffage and features a landscape consisting solely of rock and ice, eternal evidence of God's sublime creation. Prince Hermann von Pückler-Muskau's 1808 description of the Rhône glacier accurately describes the mood evoked by this painting: "A white cloak was spread over all of nature, with the blue of the sky the only contrast... No stretch of the

8
Caspar Wolf
View from the Bänisegg over the Lower Grindelwald Glacier and the Fiescherhornmassiv (1776/77)
Oil on canvas, 54 × 76 cm
Signed bottom left: C Woff. [sic]
Provenance: Keukenhof near Lisse, Holland; Galerie Dr. Raeber, Basel; acquired 1949
(Raeber 201)

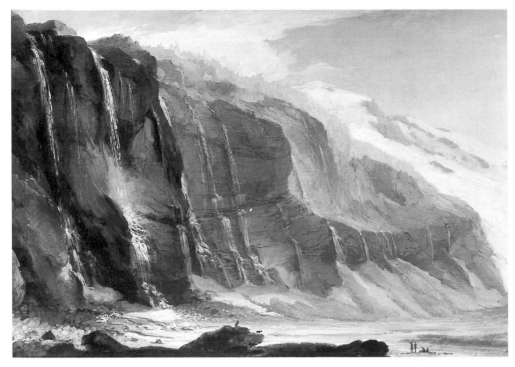

fig. 10
Caspar Wolf
Falling Waters of the Lauenen Valley (1776/77)
Oil on canvas, 53.5 × 75.5 cm
Signed bottom left: C. Wolf.
Provenance: Keukenhof near Lisse, Holland; Galerie
Dr. Raeber, Basel; acquired 1963
(Raeber 297)

Schiller, in his drama *The Bride of Messina* (IV/17), admirably expressed the romantic feeling of freedom and elation associated with the remoteness from everyday matters to be found in the clear air of the mountains:

"Auf den Bergen ist Freiheit! Der Hauch der Grüfte
"Steigt nicht hinauf in die reinen Lüfte.
"Die Welt ist vollkommen überall,
"Wo der Mensch nicht hinkommt mit seiner Qual."
(In the mountains is freedom! / The breath of tombs / does not rise to their pure air. / The world is perfect everywhere, / where man with his pain cannot enter.)

9 The Geltenschuss in the Lauenen Valley with a Bridge of Snow

Wolf was fascinated by geology and understood the effects of erosion through water, air and ice on various types of rock layers. Thus in the *Falling Waters of the Lauenen Valley* (fig. 10) the water tumbles down deep crevices between the layers of rock that form a dynamic wall across the entire picture plane, with debris piling up at the foot. Eroded by water from all sides the wall of rock is turned into a gigantic ruin.[25]

Wolf was also eager to explore the interior of the rocks; his preoccupation with caves, shared with other painters of the era, earned him the nickname "Cave-Wolf". Penetrating the surface of the earth was thought to yield a knowledge of the history of the world,[26] an understanding of, in Goethe's words, "the innermost forces holding the world together." In this spirit, the title page of the second edition of Wolf's engravings of 1777, designed by Balthasar Dunker, features fossils and minerals in the foreground, relics of the earth's history which, since Scheuchzer's pioneering work, had been systematically researched.

The Geltenschuss in the Lauenen Valley, with its modest height and restricted flow of water, situated in the west Bernese Alps, outside the popular tourist routes, was a less

imagination could conjure up the majestic and horrific greatness here produced by nature in the eternal silence of her lonely workshop; no living being, no tree, no plant can be discerned by the numbed gaze, no sound interrupts the deadly silence, nothing moves except the mysteriously drifting clouds."[21]
From the artist's vantage point above the tree-line, at about 2040 metres, an overwhelming view of the confluent glacier streams is revealed. From its greater height, behind the Zäsenberg, the Fiesch glacier extends spurs that resemble the paws of some mythical animal. The sight justifies medieval man's fear of the devil's presence, which Wyttenbach recalls in his travel diary of August 1776: "Here the glacier forms a gently sloping wavy plain whose incorrect description as an ice sea has led to the invention of various fables." As an enlightened scientist Wyttenbach searched for natural explanations of such folkloristic beliefs, one of which concerns the phenomenon of the "Hot Plate" or "Black Board," a portion of the glacier, visible from the valley, which "since time immemorial has never been covered by ice, giving rise to the belief that the mountain held sulphur stones producing fumes and heat, or even hot springs." Sulphur fumes were traditionally associated with the devil, but Wyttenbach soberly put an end to these speculations: "From Bäniseck I could clearly observe

the explanation for this mystery: a vertical break in the rock where ice cannot adhere. During two hours of observation I noted large masses of ice tumbling almost continuously from this rock, to fall with a thunderous roar into the gorges below the glacier."[22]
A year later, in 1777, Horace-Bénédict de Saussure, the great pioneer of alpine research and the first mountaineer to climb Mont Blanc, came to the same conclusion when visiting the glacier.[23]
To the left of the Fiesch glacier, in the centre of the composition, the ice-enveloped Zäsenberg Alp and its mountain hut can be seen. The site is mentioned in the subscription brochure to Wagner's painting cabinet: "Not without great danger the sheep and goats are sometimes driven across the glacier to this spot."[24]

spectacular motif, which Wolf enhanced by his painterly treatment. A waterfall cascades over two rock steps where the water had formed hollows in the softer stone strata. The picture must have been painted in spring: a few iceblocks remaining at the foot of the fall, pierced by rivulets of water and slowly melting in the warm air, form a natural bridge of ice curving elegantly across the bottom of the stream. Debris strewn across the ice indicates the incessant erosion at work in this arid rocky gorge. The absence of trees and staffage figures leaves the scale undetermined; nature has lost any reference to humanity and the onlooker is isolated in the midst of whirling primeval forces. Only a small slice of cloudy sky appearing high above lets the eye escape from this desert of stone and ice.

By comparison, the not dissimilar painting *The Upper Staubbach Fall in the Lauterbrunnen Valley* (fig. 11) seems more conventional. Painted about three years earlier, this picture belongs to the first series of ten paintings of which engravings were made in 1777. Wolf introduced the rhythmic scrolls of the rocaille into his rock formations, betraying his roots in the art of South German Rococo decoration. The oil sketch for this painting,[27] however, captures in broad spontaneous brushstrokes the scene in the light of a late morning, as confirmed by the inscription *11 Uhr* (11 o'clock).

Wolf's close involvement with nature and her changing moods and constant renewals makes him one of the forerunners of romantic landscape painting. He is also the pioneer of a series of alpine painters, from Birmann (fig. 57) and Koch (q.v.) to Diday and Calame (q.v.), and culminating with Segantini (q.v.) and Hodler (q.v.).

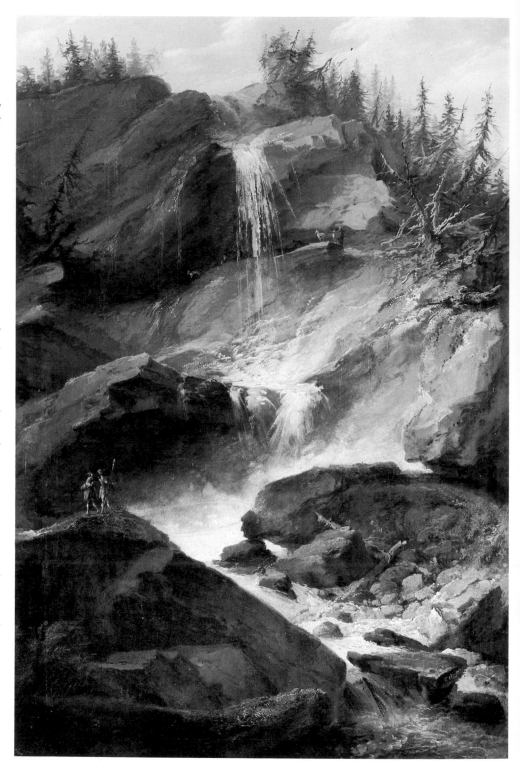

fig. 11
Caspar Wolf
The Upper Staubbach Fall in the Lauterbrunnen Valley (1774/77)
Oil on canvas, 81 × 53.5 cm
Signed bottom right: C Wolff.
Provenance: Keukenhof near Lisse, Holland; Galerie Dr. Raeber, Basel; acquired 1947
(Raeber 182)

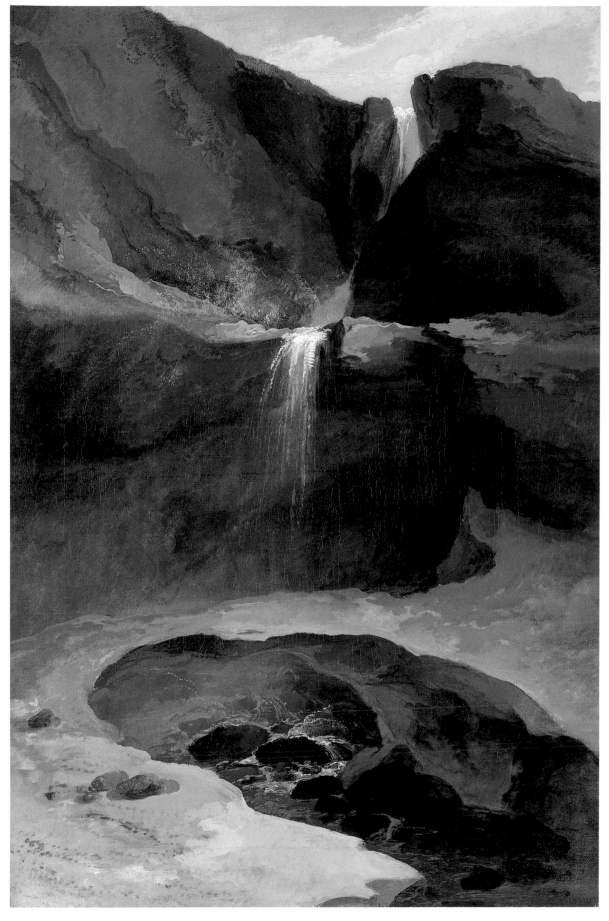

9
Caspar Wolf
The Geltenschuss in the
Lauenen Valley with a Bridge
of Snow (1778)
Oil on canvas, 82 × 54 cm
Signed bottom left: C. Wolf.
Provenance: Keukenhof near
Lisse, Holland; Galerie Dr. Rae-
ber, Basel; acquired 1947
(Raeber 384)

Anton Graff
(1736-1813)

Objective observation, as practised by Liotard (q.v.) and Wolf (q.v.), was a characteristic trait of Swiss painting of the later eighteenth century, which consequently played an important role in the development of nineteenth-century realist movements. It also determined the character of Anton Graff's work, whose portraits have a fascinating directness. Observing the faces of many famous contemporaries with sympathy, but without flattery, he producded a comprehensive survey of German society, ranging from kings and princes through the aspiring bourgeoisie, with their merchants, judges and clerics, to a strange portrait of a Dresden shoemaker.

Graff's life, as well as his art, followed a quiet, orderly course. He was born in Winterthur, where he attended the painting school of Johann Ulrich Schellenberg, continuing his studies in Augsburg, Ansbach and Regensburg. In 1766 he was appointed court painter to the Elector of Saxony and made a member of the Dresden Academy. Apart from regular trips to Berlin, Leipzig and Switzerland, he remained in Dresden until his death in 1813 amidst the chaos of the Wars of Liberation.

As court painter and professor of the Dresden Academy, the prolific artist fulfilled his task of painting the members of the Elector's family and of the Saxon and Prussian nobility. The portraits of the Von Beusts (figs. 12 and 13) are a good example of his early work. The man is still frozen in a pose of aristocratic superiority, while his wife's likeness already displays the gentle relaxation which emphasises the humanity rather than the rank of Graff's female portraits.

Graff's greatest merit, however, consists in creating a panorama of German culture in a series of portraits of the best known poets, philosophers and musicians, from Lessing, Herder, Wieland and Schiller to the young Heinrich von Kleist. Renouncing conventional poses, Graff captured their human and spiritual qualities and to this day these portraits convey the essential spirit of those enlightened minds of German classicism. Graff achieved his humanistic ideal most successfully with sitters he knew well, such as his friends and family, whose likenesses outshine the many competently but routinely executed, somewhat dull commissioned portraits. Relaxed and well adjusted, Graff's sitters have a certain inner radiance. His father-in-law, Johann Georg Sulzer, vividly described Graff's ability to look into the soul: "I have observed more than once that various persons, when sitting for their portrait to Graf [Graff] ... can barely tolerate his piercing and searching glances, each of which seems to penetrate the innermost soul."[1]

Sulzer, like his much younger protégé Johann Heinrich Lavater, was fascinated by physiognomic studies: "Nothing is more certain than the fact that the shapes of men, particularly their facial features, reveal something of their soul; we see the soul in the body. For this reason we can say that the body is the image of the soul, or the soul itself made visible."[2] From this he deduced the task and importance of portraiture, concluding that "every perfect portrait is an important painting because it reveals a human soul with its own personal character. We see a being incorporating his own peculiar mixture of intelligence, attitudes, beliefs, passions, good and bad qualities of the spirit and the heart ... This easily determines the dignity and status which portraiture holds amongst the categories of painting. Its place is immediately next to history."[3]

Unlike Goya, whose work reflects both the courtly Rococo and the cataclysmic epoch of the Revolution, Graff's portraiture is unchanging in character. Although his style evolved towards a very painterly free manner in old age, he remained faithful throughout to his humanistic ideal. Conforming to Sulzer's *Theorie*, his portraits are distinguished by the concentration of light on the face as a focal point, from which neither costume, nor other incidentals, are allowed to distract. The sitter appears in everyday clothes and in a restful pose, since "rest facilitates the revelation of the whole character."[4]

Anton Graff decisively influenced the development of the bourgeois portrait in Germany and he became a quasi-cult figure for the circle of young Romantics in Dresden, above all Philipp Otto Runge (q.v.), who found a friendly reception in Graff's family.[5] His noble image of mankind was not mere theory but provided the guidelines regarding friendship and truth, and a sympathetic receptiveness towards all promising new ideas. Like Joseph Anton Koch (q.v.) in Rome, he became an authority on more than purely artistic matters, always ready to welcome visitors and to give them advice.

10 The Artist's Family before the Portrait of Johann Georg Sulzer

No painter of the eighteenth century left so many self-portraits as Anton Graff, the first painted when he was about seventeen, and the last, his *Self-Portrait at the Easel* (Berlin, Nationalgalerie) in the year of his death, 1813. This was not prompted by Narcissus-like vanity – he studied his own features in constant pursuit of artistic perfection. Objectively observing his own image, he tried to explore hidden characteristics and changes brought about by age. His fame made his portraits collectors' items, encouraging him to produce reproductions. The present work, one of his largest and most ambitious portraits, according to a letter by the famous Berlin engraver Chodowiecki dated 6 January 1785, was painted for an admirer, Peter Count Biron, Duke of Kurland and Sagan, who commissioned this bourgeois portrait for the aristocratic interior of his castle, Friedrichsfelde, near Berlin, or possibly for his Berlin palace. In another letter to the Countess von Solms-Laubach, Chodowiecki gives an accurate description of the picture, which was shown in the 1788 exhibition of the Berlin Academy.[6]

fig. 12
Anton Graff
Portrait of Frau von Beust (c. 1773)
Oil on canvas, 74.5 × 61 cm
Provenance: Dealer Curt Naubert, Leipzig; acquired 1931
(Berckenhagen 80)

fig. 13
Anton Graff
Porträt of Herr von Beust (c. 1773)
Oil on canvas, 74.5 × 61 cm
Provenance: Dealer Curt Naubert, Leipzig; acquired 1931
(Berckenhagen 79)

Graff, sitting at an easel with Sulzer's portrait in progress, has interrupted his work to turn around and look at the spectator. Next to him are his three children, presided over by their mother, who has taken on the role of a governess and is teaching her little daughter to read by guiding the child's finger along the letters, while the two boys are looking at prints in a folder. The elder, Carl Anton, who also became a painter, thus had an early introduction to his metier. The composition, a pyramidal structure of overlapping triangles, suggests a hierarchical order. The triangle formed by the two boys is contained in a larger one formed by mother and daughter. The group is held together and dominated by the figures of Sulzer and Graff. Graff represents not only the artist but also the head of the family. The spinet in the background, hinting at joint music-making, is a further token of the family's harmony.

Johann Georg Sulzer (1720-1779), portrayed in an oval format, is a key to the composition. He was a philosopher, mathematician and art theorist with closely linked interests, called "worldly-wise" by his contemporaries.[7] His best known work, the *Allgemeine Theorie der Schönen Künste* (General Theory of the Fine Arts), 1771-74, went

through several editions well into the nineteenth century, giving important impulses to the theory of art, including the Romantic movement.[8] Sulzer, like Graff a native of Winterthur, also settled far away from his homeland. At the beginning of 1771 Graff travelled to Berlin in the company of the Leipzig publisher and bookseller Philipp Erasmus Reich, for whose *Gallery of Scholars* he was to paint the portraits of Moses Mendelssohn, Spalding, Ramler, Lessing and also Sulzer, who received the young artist kindly. Graff fell in love with Sulzer's younger daughter Auguste, then eighteen years old, and married her a few months later.

Sulzer, a widower, had tried many times to lure Graff to Berlin, but died six years before the family portrait was painted in 1785. For this reason his unfinished portrait looks like a memorial, with the grandfather presiding over the hierarchy of three generations. Not only the picture within a picture, but the whole painting pays homage to the deceased, who in his *Theory* had postulated the veneration of ancestors: painting was to be the powerful means of "maintaining the bonds of respect and love, as well as all other spiritually beneficial moral relationships between us and our forefathers as if at times they were still with us."[9]

One line in the composition connects Sulzer, Frau Graff and her daughter Caroline Susanne, who is seen receiving an ideal education. The little girl, expectantly looking up to the woman, who carefully guides her finger, demonstrates the harmony between mother and daughter. Sulzer in his early career had produced pedagogical writings which anticipate the ideas of Pestalozzi and Rousseau's *Emile*.[10] He was interested in man's attitude as a social being which, according to his view, was determined by environment and education. Appointed by Frederick the Great as reformer of several educational institutions in Prussia, he was in a position to collect suitable examples. His 1781 posthumous publication *Instructions for the Education of Daughters*, probably used as practical guidelines by the Graff family, summarises the most important pedagogical principles, which seem to be echoed in the 1785 family portrait. Sulzer called for a reasonable education, based on insight and explanation, and not on punishment. "The basis of all education rests on the children's confidence, affection and complete obedience towards their guardians."[11] A woman could most benefit her children "if she appears to them in all things as a benevolent mother."[12]

Frau Graff's gentle features and simple clothing are well suited to Sulzer's theory: "The first virtue of their sex must be gentleness, without which no woman can be praiseworthy or amiable."[13] Sulzer suggests further that "the glitter of jewellery distracts the eye from true personal beauty ... Children must be constantly reminded that true beauty, which alone matters to people of taste and discrimination, consists in facial features indicating a pure and beautiful soul, in which

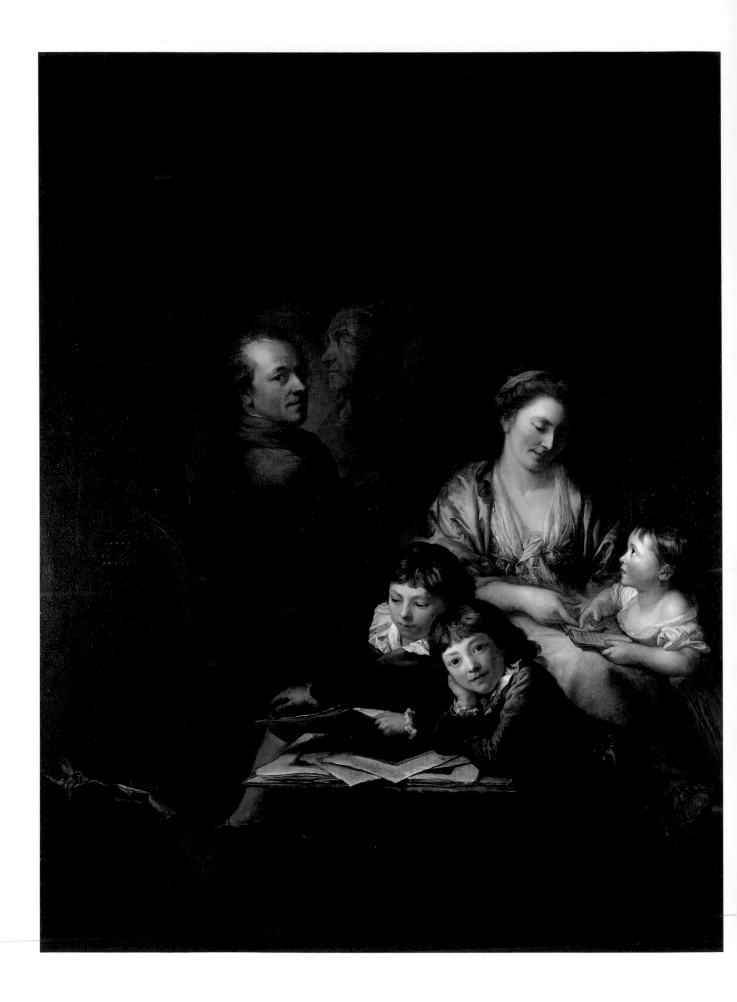

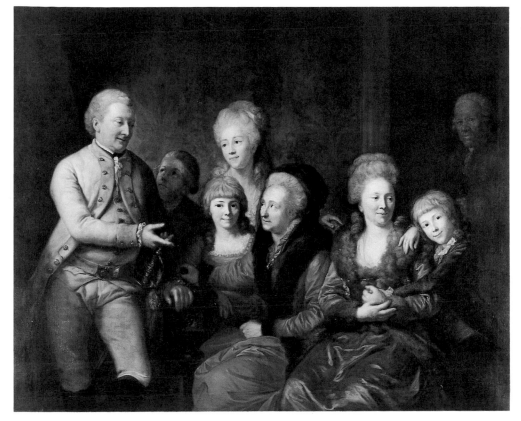

fig. 14
Anton Graff
The Von Stieglitz Family
Oil on canvas, 165.5 × 204.5 cm
Provenance: von Gablenz (1891); von Stieglitz, Dresden; Georg von Stieglitz, Munich; acquired 1931
(Berckenhagen 1308)

the elder one, standing next to the father, looks up at him with due respect. The younger daughter, looking out of the picture with an inquisitive and cheeky glance, is dressed and coiffed simply and naturally, in contrast with her elder sister who, with her artful pose, seems to be practising the part of a lady of the court. The "Rittmeister", with a noble gesture, indicates his reverence for his mother, sitting in the centre of the picture.

gentleness, amiability, friendliness and high-minded thinking combine to produce pleasing and noble manners. With such qualities ornament becomes superfluous; the plainer the clothes, the more noticeable becomes such beauty."[14] The women in Graff's most successful female portraits consequently display no ornament and wear simple, tasteful clothes.

Attention and reflection are fundamental to education. Development and independent thinking should be encouraged by good example. Thus, not surprisingly, the two sons contentedly look through the prints.

Sulzer's pedagogical principles, as demonstrated in this showpiece of enlightened domestic education, apparently failed to pro-

duce the desired durable success, even within his own family. According to Ludwig Richter, Carl Anton developed into a prime example of a good-for-nothing: "One of papa's intimate friends was the landscape painter Graff, son of the famous portrait painter. He visited us almost every Sunday for about an hour, reminiscing with father about their school days . . . However, Graff had inherited none of his father's talent . . . His entire studio was hung with innumerable views of the Tetschen castle, taken from all thirty-two directions of the weather-vane, with an eternally blue, mostly cloudless sky smiling on the long smooth façades of the castle, with its regular rows of windows. As Graff had a small fortune, sufficient to live the life of an elegant confirmed bachelor, he painted only when his boredom became too tedious; he spent his summers in the pleasant social circle of Count Thun at Tetschen, not caring much about his art."[15]

In the portrait of the aristocratic *Family of "Rittmeister" von Stieglitz* (fig. 14) the relationship betweeen the children and grown-ups is not quite so intimate, but nevertheless more familiar than formal. While the younger son is still closely attached to the mother,

10
Anton Graff
The Artist's Family before the Portrait of Johann Georg Sulzer, 1785
Oil on canvas, 196 × 148 cm
Signed bottom left: A. Graff pinx: 1785.
Provenance: Peter Count Biron, Berlin; Sagan Castle (1881); auction Duc de Talleyrand, Paris, 2 Dec. 1899; Count Jean de Castellane, Paris (1901); Victor Mandl, Paris; acquired 1949
(Berckenhagen 556)

Johann Heinrich Füssli
(Henry Fuseli)
(1741-1825)

fig. 15
Johann Heinrich Füssli
A Woman's Hand crossed over a Man's
Pencil, 17 × 23.5 cm
(Schiff 507)

Füssli belonged to the largest and most important family of artists in old Zurich, whose members had been active as bell-founders, goldsmiths and painters since the fourteenth century. His father was the portrait painter, draughtsman and art historian Johann Caspar Füssli, who published writings by his friends Winckelmann and Mengs, as well as the three-volume *History of the Best Artists in Switzerland*. Originally destined to become a theologian, Johann Heinrich Füssli moved in the circle of such enlightened Zurich literati as Johann Jakob Bodmer and Johann Jakob Breitinger, who introduced him to Homer, the Nibelungs, Dante, Shakespeare and Milton. With Johann Caspar Lavater, who was later to write the *Essays on Physiognomy*, to which Füssli contributed illustrations (fig. 15),[1] he produced a pamphlet exposing the machinations of the corrupt *Landvogt* (governor) Grebel, which necessitated the absence of the two friends from Zurich for some time. In Berlin they met the theologian Johann Joachim Spalding, and Johann Georg Sulzer. On Sulzer's advice, Füssli moved to England, since his spiritual "fathers," Bodmer, Breitinger and Sulzer, had chosen him to act as an intermediary between English and German literature.[2] From 1764 until his death England remained his chosen home. In 1768 he met Joshua Reynolds, who encouraged him to take up an artistic career. Füssli travelled to Italy to prepare himself for becoming a painter. From 1770 to 1778 he lived in Rome, where the antique art treasures, as well as Michelangelo's frescoes in the Sistine Chapel, provided decisive stimuli. After his return he gained a place in the world of English art and humanities. He became professor of painting and keeper of the Royal Academy. His *Lectures of Painting*, published from 1801, contain his theoretical discussions of art.

Füssli is considered the major exponent of the *Sturm und Drang* movement in painting. With his lofty ideas and grand gestures he is the apostle of the era of genius. Lavater describes him in a letter to Herder as "in everything extreme – always original ... His glance is like lightning, his speech like thunder – his joke is death and his revenge is hell... He does not draw as a portrait – but all his features are truth and yet caricature."[3] Goethe commented: "What fire and rage dwell in this man!"[4] And Salomon Gessner, Füssli's godfather, states in a letter to Anton Graff, of 1781: "They asked Füssli to paint Bodmer's portrait, but it looks more like his own ... One can see everything the man was striving for but did not achieve, a man of great gifts, capable of great ideas, but neglecting or despising all studies that could be useful in securing accuracy and beauty of execution. The painting is far below the standard expected from someone whose nonsensical pride overrides everything that is great."[5]

Since his years in Rome, classicist trends had been a firm foundation of Füssli's work, but he now moved away from Classicism by adding flesh and blood to the shining white ideal of beauty derived from antique sculptures, replacing pure line with passionate pathos. In his *Lectures*, he found fault with Winckelmann's "frigid fantasies and platonic dreams of beauty", which manacled the arts,

fig. 16
Johann Heinrich Füssli
Lady at the Spinet being kissed by a Man
Crayon, 22 × 17.5 cm

11
Johann Heinrich Füssli
Jealousy (1819/1825)
Oil on canvas, 91.5 × 71.5 cm
Provenance: Walter Unus, Berlin; acquired 1931
(Schiff 1501)

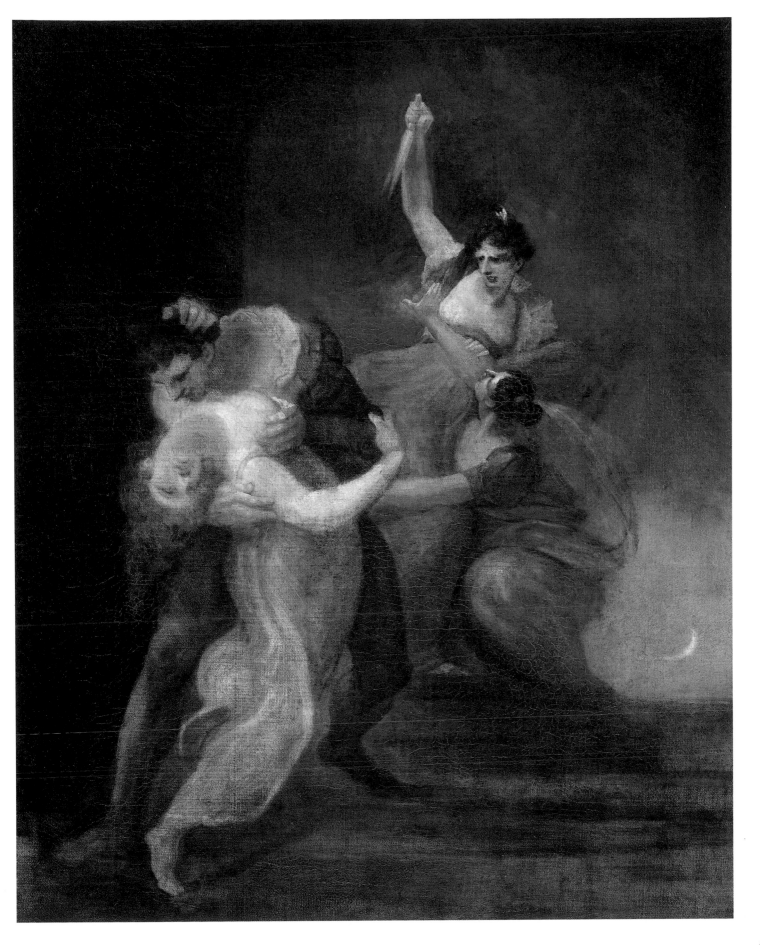

fig. 17
Johann Heinrich Füssli
Portrait of the Sixteen-year-old Lavinia de Irujo,
1810
Crayon, 22 × 28 cm
Inscribed bottom right: L de Irujo. Q. E. april.-10
(Schiff 1656)

and insisted that the only source of beauty is
"expression and spirit".[6] He reduced colour
in his paintings in order to emulate the sub-
dued tones of Michelangelo's Sistine ceiling,
then covered in dirt. By mixing bitumen with
his colours[7] he tried to speed up the effect of
aging, thus producing "old master" paint-
ings of his own. Füssli was overwhelmed by
the works of antiquity,[8] finding examples of
the heroic era described by Homer and Os-
sian. In his paintings he recreated a new race
of giants: ancient heroes, moved by the pas-
sionate feelings of the *Sturm und Drang*. An
enthusiastic admirer of English literature, he
found many subjects for his paintings in the
works of Shakespeare (see fig. 20) and Mil-
ton. He also painted themes from the Nibe-
lungs and from the writings of Uhland,
Cowper and others.

11 Jealousy

In this painting Füssli, like a brilliant theatri-
cal producer,[9] presents a constellation of
high drama, involving a man and three wo-
men. The main subject is the pair of lovers,
with the woman abandoning herself to the
powerful arms of the man, the intended vic-
tim of the jealous female rival holding a dag-
ger behind his back. He is saved from her
assault by the third woman who throws her-
self in the path of the aggressor. The women
represent widely differing emotions, ranging
from absolute, nearly swooning abandon to
the crazed fury of attack and the self-sacrific-
ing attempt at defence. The man, though in-

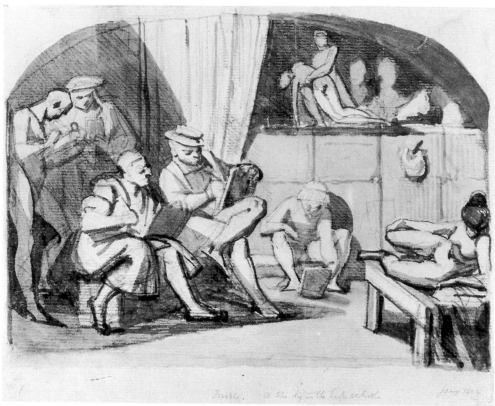

tending to act, is dominated by his own pas-
sions and by the women. He represents one of
Füssli's many fantasies, nurtured since the
days of his youth: the man as victim of female
cunning and power. Füssli depicted the
storms of passion in all aspects, including de-
monic possession: physical power collides
with female cruelty and cunning, and jea-
lousy ends in murder and insanity.

The heightened theatricality of the picture is
highly anti-classical. The eerie silvery shine of
the moon's sharp sickle provides a cool con-
trast to the overheated passions. The moon
often appears in Füssli's works, symbolising
yearning, unfulfilled desires and insanity.[10]
The diadem in the form of a crescent moon,
worn in the hair of the woman with the dag-
ger, could be interpreted accordingly.

The literary source of this late work, if there is
one, has so far not been established. Two
dated preliminary studies prove that the sub-
ject had preoccupied Füssli for several years.
One drawing dating from 1813 (Basel, Kup-
ferstichkabinett) shows the closely entwined
couple on their own, with their arms in a dif-
ferent pose; in the sheet of 1819 (Zurich,
Kunsthaus) the woman with the dagger has
been added. By introducing the rival wielding
the dagger Füssli transformed the impersonal

fig. 18
Johann Heinrich Füssli
Instruction in a Renaissance Academy, 1804
Brush and black ink, washed, over crayon,
17 × 21 cm
(Schiff 1487)

representation of passionate love into a
drama with individual actors: the whole de-
velopment reaches its climax in the baroque
exuberance of the painting, where yet an-
other woman stays the arm of the jealous
rival, to prevent a murder.[11] The different fig-
ures in the preliminary studies seem to sug-
gest the lack of a literary subject. Füssli
probably developed a pictorial idea over a
certain period, as he used to do in his late
work, before reaching a final solution in the
painting. There are frequent scenes of stolen
kisses and love-crazed violence,[12] which have
to be classified within the theme of the strug-
gle of the sexes. This includes several versions
of the drawing *Lady at the Spinet being
kissed by a Man* (fig. 16).[13]

The artist's ability to test a concrete idea in
ever new variants[14] explains the great num-
ber of variations of content and form, which
he described as "philosophical ideas made in-
tuitive, or sentiments personified".[15] "Mas-
querading as numerous heroes from mytho-

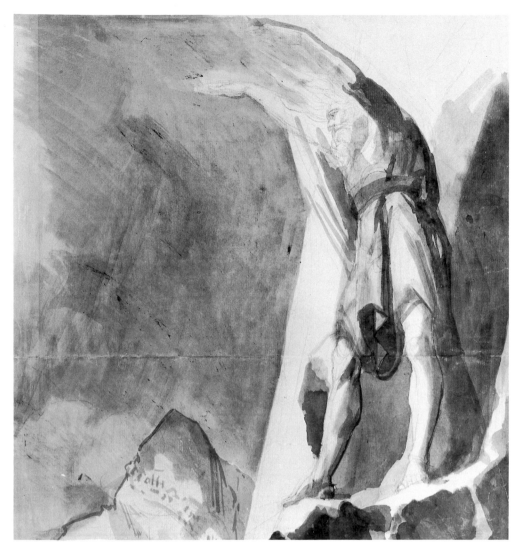

ing a female nude model in front of a niche, which contains a reproduction of the Pasquino group and heads, shows a tendency to caricature hovering between Hogarth and Rowlandson.[18] The *Portrait of the Sixteen-year-old Lavinia de Irujo* (fig. 17) is one of several pictures by Füssli showing the daughter of the Marques de Casa Irujo, Spanish Ambassador to the United States. Here the girl is determined to draw on a large white sheet nothing but a mouth with sensuously full lips.[19] Füssli turned to Gray's *Poems* for his depiction of *The Bard* who, cursing the King, looks down on Edward I's troops from a cliff on Mount Snowdon (fig. 19).[20]

logy and poetry, the tragic basic elements of human behaviour keep reappearing, such as jealousy and infidelity, abuse and violence, sensual confusion and yearning for redemption, greed for power and instinctive subjection."[16]

The painter's love of freedom found its symbolic expression in the William Tell legend, for instance in the lost painting *Tellsprung*. The drawing *Tell shooting Gessler* (fig. 7) shows the success of the accomplished heroic act, as the tyrannical *Landvogt*, riding through the sunken lane, falls dead from his horse. The incident recalls Füssli's own accusatory pamphlet *The Unjust Landvogt, or the Lament of a Patriot*, which had caused the downfall of a modern tyrant, with its impassioned cry: "Is there no longer a patriot in Zurich? No one to resent injustice amongst the descendants of heroes, whose fathers had been *Burgers*?"[17]

Füssli's emotional language of gestures and his unbridled dramatising are particularly evident in his drawing, the most spontaneous outlet of his inner turmoil. His figure sketches often trace the innermost processes, as if the skin had been removed to reveal nerves, sinews and muscles. In his youth, before taking up painting on his return from Rome, he had been an accomplished draughtsman, continuing the tradition of the Swiss Renaissance masters, such as Tobias Stimmer, Christoph Murer and Jost Amman.

The drawing *Instruction in a Renaissance Academy* (fig. 18), featuring five men draw-

Jean-Pierre Saint-Ours
(1752-1809)

The Geneva painter Jean-Pierre Saint-Ours came from a cultured milieu with artistic and literary interests, oriented towards Calvin's reformed theology, classical literature and the philosophy of the Enlightenment. Trained by his father, an enamel painter in Geneva, the seventeen-year-old Saint-Ours went to Paris and enrolled in the Academy as a pupil of Joseph-Marie Vien, the *restaurateur de l'art en France*. This was probably the most famous atelier of its time, where history painting of a classicising tendency was practised according to the doctrine of the *beau-idéal*. The study of classical literature, as well as J. J. Winckelmann's new theories, encouraged a return to antiquity. While the Academy was totally controlled by the monarchy, Vien's atelier kept its distance and became a breeding ground of new ideas; one of its students at the time was Jacques-Louis David.

In Paris the artist's career followed an upward path: in 1774 he received the Prix d'Expression, in 1778 the Second Prix de Peinture, and in 1780 he achieved the highest distinction, the Grand Prix de l'Académie, called the Prix de Rome, since it normally opened the door to the French Academy in Rome. In this case, however, because the artist was a foreigner and a Protestant, the customary Pension du Roi was withheld. Aware of the injustice done to him, Saint-Ours nevertheless travelled to Rome. He may have felt a renewed pride in his Geneva citizenship, remembering his famous fellow-citizen Rousseau and his *Social Contract*. At the same time he continued reading the classics, notably Plutarch's *Lives*, the favourite work of many French Revolutionaries.[1]

In Rome Saint-Ours frequently exhibited his works in the residence of the French Ambassador, Cardinal François-Joachim-Pierre de Bernis, and also in the French Academy, where Goethe noticed him in August 1787. In his *Italian Journey* the German poet gave a detailed account of the international art scene in Rome at the time when Saint-Ours was working on his *Germanic Wedding*: "The exhibition at the French Academy at the end of the month marked an epoch-making event in the flourishing artistic life of the city. With David's *Oath of the Horatii* the French

were taking the lead. Tischbein accordingly felt the need to attempt a life-size figure of Hector challenging Paris in the presence of Helen. Drouais, Gagneraux, Desmares, Gauffier and St. Ours are establishing the fame of French art, and Boguet is making his name as a landscape painter in the manner of Poussin."

In 1792, when Rome was becoming uncomfortable for French-speaking people, Saint-Ours returned to the revolutionary city of Geneva, in order to "defend his fatherland."[2] Politically as active as David in Paris, he became a member of the new National Assembly, devoting himself to cultural politics. His late career was entirely given to portrait painting.

The most significant legacy of his Roman years consists of three large-scale paintings with subjects taken from Greek and Roman history, illustrating the character traits of various ancient peoples.[3] All three are clearly inspired by the revolutionary ideology of Rousseau. The first picture, *The Selection of Sparta's Children* of 1786,[4] based on a text by Plutarch, shows the state officials selecting children deemed fit enough to be brought up, while the rest are abandoned. This was followed in 1788 by the *Germanic Wedding*, and finally, in 1790, by the *Olympic Games*.[5] These three works were exhibited in 1791 in the Salon de la Liberté in Paris, the first salon under the sign of the Revolution, which freely admitted not only members of the monarchist Royal Academy but all artists, a privilege for which Jacques-Louis David had vehemently campaigned. Instead of showing only the 321 works chosen by the Academy, a total of 794 were exhibited.[6]

12 The Germanic Wedding

The history of this painting is well known: it was commissioned by the French art collector and architect of the Maltese Order, Godefroy, who had acquired the *Selection of Sparta's Children* in 1786. In his autobiography Saint-Ours mentions a smaller version of the picture,[7] completed in February 1787, and for the year 1788 he notes: "This 5th of June I finished my painting of the Germanic Wedding, which the public found more appealing than the Selection of Sparta's Children. I have shown it to the Cardinal [de Bernis], receiving his warm compliments. This picture, less monotonous in tonality and better painted than the other, should further my progress."[8] The success of the painting was soon noted in Paris; on 16 June 1788, Charles-Claude d'Angiviller wrote in a letter to the painter Ménageot, who was appointed director of the French Academy in Rome in that year: "I have heard from your predecessor [Lagrenée l'Aîné, director of the French Academy in Rome 1781-87] that the painting by Saint-Ours showing the wedding ceremonies of the Germans had a great success with the Cardinal. I am delighted at this news and I observe with pleasure the progress of painters who promise one day to become a credit to the French school; the subject seems to me well chosen and likely to make an impact."[9]

D'Angiviller, since 1774 director of the royal palaces and collections, was a man of the Enlightenment, but loyal to the monarchy; he was the most powerful art politician of the time, exercising a decisive influence over the Paris Academy through his association with its director, Pierre.

The literary source for the *Germanic Wedding* was Tacitus' *Germania*, the first work to describe the customs and habits of these people living beyond the domain of Rome, including their strange wedding rites: "The dowry is not given by the woman to the man, but vice-versa by the man to the woman. Parents and relations witness and approve the nuptial gifts. These, however, contain nothing to adorn or satisfy the vanity of the bride. They consist of cattle, a bridled horse, shield, sword and spear. With these gifts the bridegroom obtains his bride who, in her turn, presents him with a piece of arms. The Ancient Germans saw in this exchange of presents a strong bond, blessed by the heavenly

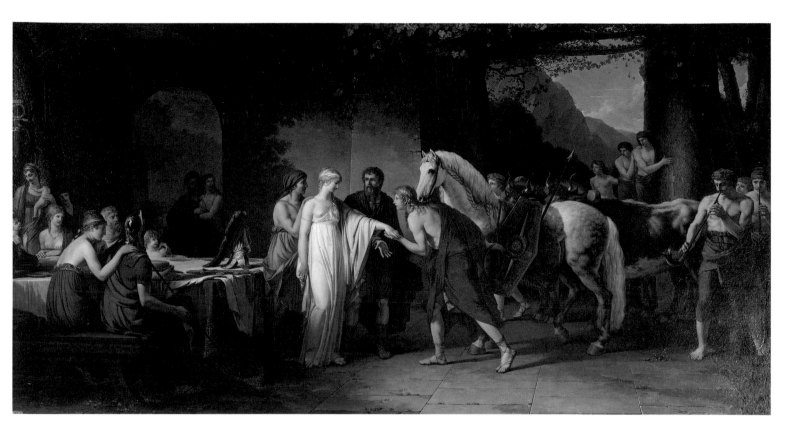

power. The young bride is reminded through this wedding ceremony that the manly deeds of her husband in war and battle will affect her life. In war and peace, in danger and need, she is to be her husband's companion, equal in bravery and steadfastness. This is the meaning of the pair of oxen, the bridled horse and the gift of arms."[10]

Saint-Ours is also guided by Tacitus in the details, such as costumes and scenery. "Women's clothing does not differ much from the men's, except that they often drape themselves in linen cloaks with purple-red borders, but without sleeves, thus leaving the arms and a part of the chest uncovered."[11] Even the architecture is adapted to the theme: unlike the giant hall modelled on the architecture of the French Revolution in which the *Selection of Sparta's Children* takes place, and the Doric temple setting of the *Olympic Games*, there are no classical columns in this painting, only a plaster wall with an archway adjoining an arbour supported by a tree trunk. Tacitus mentioned that the Ancient Germans used mainly wood for building.[12]

The simple way of life and unspoilt morals of a whole people, as described by Tacitus, recall Rousseau's "return to nature". Unlike Jacques-Louis David's paintings which are dominated by a few large-scale heroic figures fighting for an ideal (*Brutus, The Oath of the Horatii*), the *Germanic Wedding* is enacted by an assembly of equally important individuals who have already achieved an ideal state of existence. Saint-Ours is less interested in history dictated by a heroic figure, than in the history of peoples living in harmony, as in Rousseau's "natural state of man". The picture also seems to refer to Rousseau's *Discours sur les Sciences et les Arts*, which mentions "a small number of peoples who, untouched by vain knowledge, through their virtues achieved their own happiness, setting an example to other nations;" amongst these were the Ancient Germans with their characteristic simplicity, innocence and virtue.[13]

12
Jean-Pierre Saint-Ours
The Germanic Wedding, 1788
Oil on canvas, 136.5 × 259 cm
Signed bottom left: f.t par S.t Ours Rome. 1788
Provenance: Godefroy sale, Paris, 2 April 1794;
Count Jean-Jacques de Sellon, Geneva; G. Rüefli, So-
lothurn; acquired 1947

Saint-Ours is said to have originally planned four paintings illustrating the ages of man, according to the customs of various peoples of antiquity, but only two were painted. The first, the *Selection of Sparta's Children*, featuring the conflict between common good and cruel individual fate, stands for birth; the second, the *Germanic Wedding*, represents marriage.[14] Here again the individual is subordinated to the welfare of the tribe, as symbolised in the wedding presents. However, in spite of its emphasis on discipline and decorum, this painting does not lack a human touch. The gesture with which the bridegroom takes hold of the bride's shyly extended hand expresses true affection, lending an unexpected charm to this otherwise purely ceremonial scene.

Jacques Sablet
(1749-1803)

Jacques Sablet was one of the great number of Swiss artists who pursued their careers away from home. After training at Lausanne with his father, a commercial painter, dilettante and art dealer, he moved to Lyons to learn the craft of a decorative painter. From there he went to Paris in 1772, to join his elder brother François (1745-1818) as a student of the history painter Joseph-Marie Vien (1716-1809). With his brother, Jacques Sablet followed Vien to Rome in 1775. At times he stayed with Saint-Ours (q.v.). In 1793, prompted by the expulsion of the French from Rome, he returned to Switzerland, but he soon travelled on to Paris, while his brother settled in Nantes, where he became a successful portraitist. In 1799, Lucien Bonaparte and his uncle, Cardinal Fesch, became Sablet's most important patrons. When Bonaparte was made ambassador to Madrid, in 1800, Sablet accompanied him there, but returned to Paris the following year, where he died in 1803.

Originally a history painter, Jacques Sablet turned more and more to portraiture. In Rome, full-length portraits, single or in groups, in which landscape and figure complement each other, became his speciality and he readily found clients amongst the many European visitors to the city.[1]

Full-length portraits set in a landscape, in the tradition of Van Dyck, were much appreciated, particularly by aristocratic patrons, in eighteenth-century England. Sablet had learnt about the popularity of this genre from the many English travellers who, stopping in Rome on their Grand Tour, sat to him for their portraits.[2] Sablet reduced the size of paintings in the style of Reynolds and Gainsborough, following the practice of other artists before him, such as Arthur Devis and some of the miniaturists. Sablet favoured this "cabinet size", which made it easy for travellers to take their paintings home. After his return to a Paris rocked by the Revolution, he gave this type of portraiture a bourgeois character: the aristocratic sitters he had painted in Rome were transformed into citizens, still affecting the same pose, but with a changed personality.

13 Portrait of an Unknown Gentleman

The painting presumably dates from after Sablet's move to Paris in 1793, since the buildings in the background appear to be French. The building on the bridge might be a textile factory, several of which could be found in the vicinity of Nantes, where his brother François lived.[3] The workers handling cloth on the right bank of the river also suggest the presence of a textile plant.

The elegant gentleman, dressed in stylish 1800 fashions, with stiff collar, white cravat, dark jacket and narrow white trousers, might be the owner of the plant and the villa on the left. His right hand rests on his stick, while in his left hand, somewhat incongruously, he holds a small bunch of flowers. He stands on a bleak patch of grass in front of his property, which closes the view into the distance.

The vertical figure is balanced by the horizontal lines of the architecture, which give it stability. The progression into depth is abrupt, without transition, so that the background figures, standing on the same patch of grass, appear incongruously small. Presumably they are the family of the sitter, on a walk: according to custom, the marriageable daughters walk in front, followed by the mother with the youngest child and, in the rear, the grandfather with a dog and an elder son, blowing the clarinet. Behind them is their stately home, built in classical style.

The figure seems superimposed on the landscape, which is divided into two halves: the left area representing house and family, the right industry and work. There is much activity on the bank of the river, with its many boats. It is the beginning of a new era. The sober features of the sitter know nothing of aristocratic nonchalance but suggest the pioneering spirit of entrepreneurship, which was to shape the dominant class of the new century.[4] The somewhat awkward pose betrays his unfamiliarity with his new role. His life consists of hard work, planning and initiative.

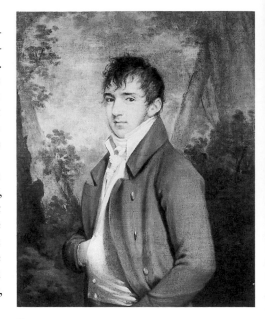

fig. 21
Firmin Massot
Portrait of a Gentleman, 1803
Oil on canvas, 43 × 34.5 cm
Signed bottom left: FM/1803
Provenance: Walter Andreas Hofer, Munich; acquired 1961

The painter tried to present this vigorous entrepreneur as a dandy, a role which clearly makes him feel uncomfortable. He would much prefer to return to work. His head does not quite fit his clothes; his nonchalant pose seems to require a face different from the serious features, framed by grey hair. Sablet's translation of his successful Roman formula into the bourgeois French milieu has resulted in a charming incongruity.[5]

During the same period Firmin Massot painted a gentleman whose dandyish appearance fully harmonises with his superior condescending expression and proud demeanour (fig. 21).

13
Jacques Sablet
Portrait of an Unknown Gentleman (c. 1800)
Oil on canvas, 62.5 × 50 cm
Provenance: Mme Donath, Paris; Dr. Fritz Nathan, St. Gallen; acquired 1950

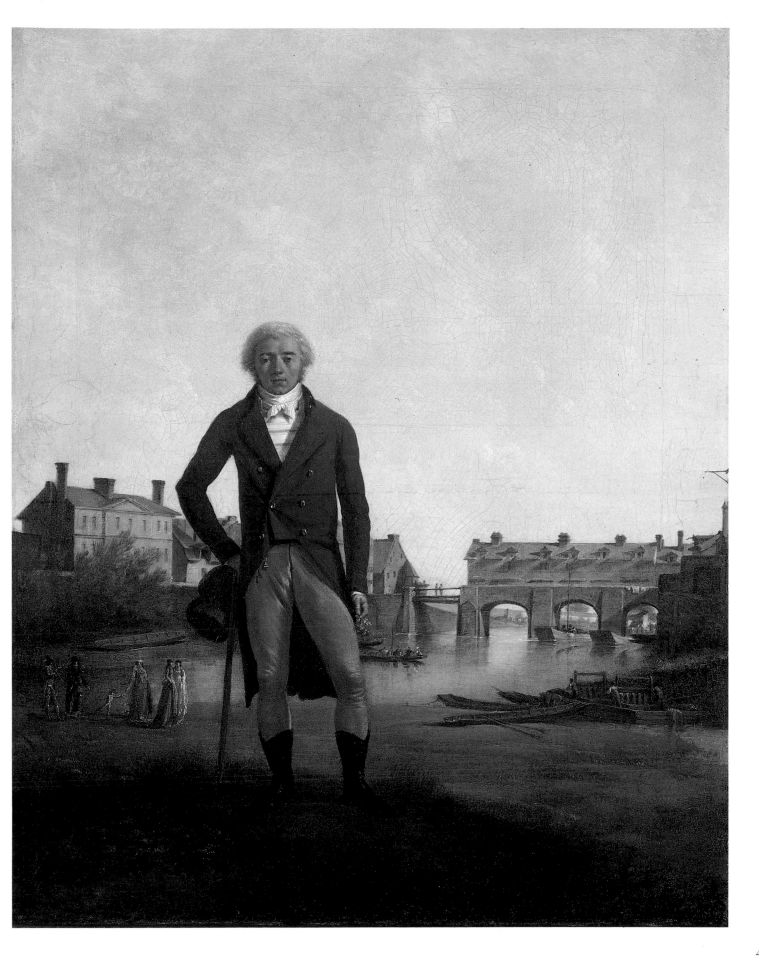

49

François Ferrière
(1752-1839)

The son of a Geneva clockmaker, Ferrière probably had his first training with Jean-Etienne Liotard; this was followed by a stay in Paris with Joseph-Marie Vien, after which he began his career as a painter of portraits in oil, pastel and enamel.[1] The precise technique he inherited from his father was a particular asset to his miniature painting, which increasingly became his speciality. In the winter of 1792/93 he moved to England, where he acquired a reputation as a painter of portrait miniatures. He portrayed personalities at the court of George III, and exhibited at the Royal Academy. In 1804 he moved to St. Petersburg and then to Moscow, where he successfully continued his career. During the French occupation in 1812 he lost his art col-

lection and his fortune in the fire of Moscow. He returned to England and, in 1821, finally settled in Geneva.

Apart from portraits, the mainstay of his production, he also specialised in trompe-l'oeil compositions, imitating ivory, marble and bronze reliefs.

14 The Old Port of Geneva

Amongst Ferrière's few landscape paintings, some of them early works, others belonging to his English period, *The Old Port of Geneva* is the best known. Jean Sénebier, in his *Histoire Littéraire de Genève* (1786), recalls that during the previous winter Ferrière had published four coloured line engravings with views of the surroundings of Geneva.[2] One of these reproduces the Winterthur painting which must therefore have been painted in 1785 or earlier. The technique of hand-coloured line engraving suggests the influence of

14
François Ferrière
The Old Port of Geneva (c. 1785)
Oil on canvas, 36.5 × 51 cm
Signed bottom right on the gate: F.F.
Provenance: Isaac Mayor; Rodolphe Dunki, Geneva; acquired 1934

works by the Swiss "little masters", above all Johann Ludwig Aberli, the inventor of the so-called Aberli manner, which facilitated the increased production of coloured Swiss views, highly popular with tourists.

The painting does not show the panorama of the city, with its well known landmarks such as the cathedral of St. Pierre, but features the old port near Les Pâquis, with the hills of Cologny on the opposite lake shore and the chain of the Voirons mountains on the horizon. It is a casual view; only those familiar with the locality would recognise the proximity of Geneva. The same view, seen from

fig. 22
Adam-Wolfgang Töpffer
View of Lake Geneva and Salève (c. 1817)
Oil on paper, mounted on panel, 27 × 35 cm
Provenance: A. Grünbaum, Petit-Lancy; acquired 1937

Ferrière's veduta, in the tradition of Jan van der Heyden and Bernardo Bellotto, but with a shift of emphasis from the centre of the city to the periphery, anticipates the nineteenth century. Olivier's drawings of the Vienna suburbs (fig. 46) are closely related, and Købke (q. v.) explored the attractions of the landscape outside the gates of Copenhagen in a similar manner. Indeed, there are interesting links between Geneva and Danish painting. In the spring of 1777 the two Danes Jens Juel and Simon Malgo, the latter a pupil of Joseph Vernet, moved from Paris to Geneva, "to see this land, so richly endowed by nature."[4] Juel remained three years, and Malgo five. Juel frequently visited Liotard and painted a portrait of him in dressing gown and slippers. Overwhelmed by the magnificence of nature, Juel painted his first portraits in Geneva in landscape settings, including realistic motifs from the city's surroundings; he also painted a few pure landscapes.[5] Two of Simon Malgo's views of Geneva are known today; both show the panorama of the city, with its widespread hinterland (Geneva, Musée d'Art et d'Histoire).

Adam-Wolfgang Töpffer (q. v.) followed Ferrière's direction towards a realistic view of nature in his landscapes of the environs of Geneva, submitting his randomly chosen prospects to even stronger atmospheric effects (fig. 22).

the same vantage point, appears in the first topographically correct European landscape painting, part of the Geneva Altarpiece by Conrad Witz, representing *Christ on Lake Tiberias* (1444; Geneva, Musée d'Art et d'Histoire). Both paintings include similar details, such as the houses on piles, the palisades in the water and the buildings rising on the right. It is not inconceivable that Ferrière's choice of view was a deliberate reference to Witz.

The meticulous execution of the *Old Port of Geneva* points to the art of the miniaturist. It is a picture of relaxed activity, describing life outside the city gates, where the less desirable elements, or people without a place in the city, had settled, pursuing noisy, bulky, or less salubrious trades. Their utilitarian buildings, the port warehouses, stores, washhouses and craftsmen's sheds occupy one of the most attractive sites on the lake. Drenched in sunlight, the scene radiates a peaceful atmosphere, where work seems to have no place. The washerwoman, the angler and the load carrier appear to be engaged in leisurely activities, rather than hard work. The light clouds in the sky, heralding a storm, add to the impression of a warm summer's day, with gleaming sunlight casting dark shadows over the foreground buildings. The

clear atmosphere makes the comfortable country houses hidden amongst the green woods and fields on the opposite shore appear quite close, while the far mountains are veiled in mist. All these features speak for Ferrière's freshness of observation, free of conventions.

Certain similarities suggest that Ferrière had closely studied Liotard's pastel painting *View from the Window with Self-Portrait*, of around 1770 (Amsterdam, Rijksmuseum). However, Liotard, whose pastels considerably influenced Ferrière, put more emphasis on life in the gardens and country houses outside the city gates. Ferrière concentrates on the everyday life in the port, and omits the distant alpine panorama with Mont Blanc, which adds a hint of the sublime to Liotard's scene.

More than seventy years later, Corot chose a virtually identical view from the Quai des Pâquis on the right bank of the Rhône for one of his most brilliant landscapes, reputedly painted in twenty different sessions (1859-63; Geneva, Musée d'Art et d'Histoire). Although quay installations were erected in the nineteenth century, some of the buildings are still recognisable, such as the tower built in the water, which can be seen in both pictures.[3]

Adam-Wolfgang Töpffer
(1766-1847)

Töpffer, a close friend and almost exact contemporary of Agasse (q.v.), was born in Geneva, the son of an emigré tailor from Schweinfurt. He first worked as an engraver and illustrator and went to Paris in 1789, but the turmoil of the French Revolution forced him to return to his native city. In 1791 he was again in Paris, as a student of Joseph-Benoît Suvée. On his return to Geneva he joined Pierre-Louis de la Rive in painting expeditions (*campagnes de peinture*) to the Savoy and the Vaud region in search of motifs. However, Töpffer soon rejected De la Rive's concept of classical landscape, discovering the bucolic poetry of life in the country, with its festivals, village fairs, weddings, and harvests, although such scenes had little to do with realism.

Töpffer often returned to Paris, accepting in 1807 a position as drawing master to the Empress Josephine. In 1812 the Salon awarded him its gold medal.

Following Agasse's invitation, he visited England in 1816 and exhibited at the Royal Academy. His letters express his great admiration for the English painters there: "Their daring knows no bounds, often resulting in successful works of great originality. These have nothing to do with Paris, where everybody copies everybody else. Here every painter indulges in the liberty of being himself. He shows the same individual spirit in using his brush as his fellow citizens in expressing their thoughts and opinions."[1] He communicated his enthusiasm to his wife: "I have greatly benefited from seeing the London painters and when I resume painting in Geneva you will notice how much I have gained in vigour and richness of colour."[2] The stimuli received in England continued to nourish him for some time, inspiring a series of *plein-air* studies with a newly-found sensibility for atmospheric light effects (fig. 22).

Töpffer, skilled in all the graphic techniques, produced many caricatures, often inspired by English examples, particularly by Hogarth. Embracing the cause of the Liberals, after the period of French occupation, he poked fun at the government and the conservative constitution of 1814.[3] In 1817 he published his *Album de Caricatures*. Before that he had made a few painted caricatures, for instance *Reviewing the Troops* (fig. 24), probably dating from 1804. An officer in Napoleonic uniform imperiously confronts four ragged, wild-looking fellows standing smartly at attention. The rifle barrels, with the attached bayonets above their heads, however, stray in all directions.

15 The Fair

This anecdotal depiction of country life in the vicinity of Geneva and the nearby Savoy is equally full of caricatural elements.

The colourful scene takes place outside the gates of a small sleepy country town, dominated in the left background by a tower, part of the obsolete fortifications now being used as a quarry, with a wooden hut built into its side displaying a bawdy shop sign. The two hundred or so figures in the painting are taken from Töpffer's rich hoard of motifs, many of them single sketches made during his painting expeditions. His sometimes grotesque humour embraces a cross-section of everyday rural life. The theme of the fair contains many lively contrasts and bizarre constellations involving all strata of society: soldiers, vagabonds, magicians and their public, fist fights, daring youngsters on horseback, the beggar in rags, oddly contrasting with the display of rich materials behind him, the quack with his mummified lizards, the ill-matched couple, with the old man still wearing a plait, sign of a bygone age, a drunkard, ridiculed by children, being dragged away by his nagging wife – the list could be endlessly continued.

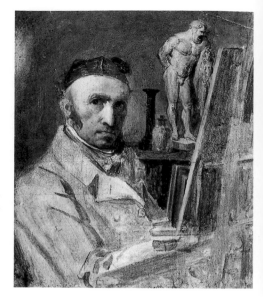

fig. 23
Adam-Wolfgang Töpffer
Self-Portrait in the Studio (c. 1830)
Oil on paper, mounted on cardboard, 24 × 20 cm
Provenance: A. Aubert, Geneva; Rodolphe Dunki, Geneva; acquired 1934

fig. 24
Adam-Wolfgang Töpffer
Reviewing the Troops (1804)
Oil on cardboard, 24.5 × 20 cm
Signed bottom left: AT. fec.
Provenance: E. Duval; Dr. Laurent Rehfous, Geneva; acquired 1932

His talent for pictorial organisation, which he demonstrated again in the *Rural Feast* (fig. 25), saved Töpffer from getting too absorbed in details. He always provided a firm framework for the composition through architecture and landscape. In *The Fair*, the composition progresses diagonally from the tall building on the left. The heavily laden carts in the middle distance provide a transition to the landscape background, where a meandering river leads towards the distant mountains on the horizon, veiled in blue mist.[4]

As well as drawing on his many study sketches, Töpffer also found inspiration in earlier schools of painting, particularly Dutch genre paintings and Italianate landscapes (by Dujardin and Pijnacker for instance). *The Fair* suggests a knowledge of Bruegel's *kermesse* scenes, Jacques Callot's beggars and above all his etching *The Fair at Impruneta* (1620).[5] Töpffer was also influenced by the paintings of fairs which his friend Jean-Louis Demarne regularly exhibited at the Paris Salon from 1785.[6]

The huge dimensions of the old fortifications, dwarfing the figures, hint at a heroic past, which fascinated the artist. In a letter he explains: "I find myself in an old castle on top

15
Adam-Wolfgang Töpffer
The Fair, 1806
Oil on canvas, 86.5 × 105 cm
Signed bottom left: ATöpffer f. Genève. 1806.
Provenance: Private collection, Paris; acquired 1935

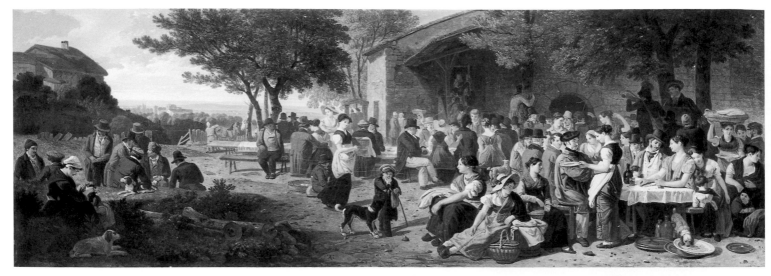

fig. 25
Adam-Wolfgang Töpffer
Rural Feast (c. 1820)
Oil on canvas, 26 × 73 cm
Signed centre bottom: AT:
Provenance; Auction Hôtel Drouot, Paris, 25 March
1953; J. L. Reichlen, Lausanne, acquired 1953

of a mountain, surrounded by forests. I am particularly fond of ruins. I don't quite know why I seek them out... imagining myself living at the time when these castles were built."[7]

Töpffer clearly preferred ruined fortified buildings to preserved ones: in his caricature *The Taxation Mill* (c. 1817) he lashed out against the expensive upkeep of Geneva's fortifications, which devoured about a quarter of the Canton's budget.[8]

16 At the Spring

Under the spreading branches of trees, flooded with light, a group of young village girls have gathered around a spring. They are listening to the tales of an old man with stubbled beard and protruding tooth, who clearly enjoys their company. A mother, wearing a straw hat and seated on a tree trunk, watches over her two children at play. On the right, half-hidden by a tree, a girl is flirting with a man in a tall hat, seen only from behind. The faces are executed with enamel-like finesse.

The abundant fanciful vegetation, the buxom girls, the juicy green of the leaves and the glittering light suggest an overflowing cornucopia of nature's bounty, oddly contrasting with the emaciated figure of the old man. He has chosen a position near the meagre flow of the spring, where the girls must patiently await their turn to fill their buckets.

The relaxed atmosphere resembles a scene from a comedy. The uninhibited *joie-de-vivre* of the Rococo appears to have survived through the Revolution into the Restoration period. Nothing distracts from man's idyllic

fig. 26
Adam-Wolfgang Töpffer
View of Upper Lake Geneva
Oil on canvas, 53 × 68.5 cm
Signed bottom right: AT..
Provenance: Rodolphe Dunki, Geneva; acquired 1943

16
Adam-Wolfgang Töpffer
At the Spring, 1823
Oil on canvas, 44 × 52.5 cm
Signed bottom left: AT: 1823./G[...]
Provenance: Donath, Paris; Walter A. Staehelin,
Berne; Dr. Fritz Nathan, St. Gallen; acquired 1950

harmony with nature. The play of light dancing through the green vault of the leaves creates a Watteauesque serenity, translated into a rustic setting.

The picture harks back to many mythological themes. The motif of a faun or satyr with nymphs at a spring is here transformed into an everyday Biedermeier context. Or has Töpffer perhaps intended an oblique parody of the Judgement of Paris? Far removed from classical antiquity, the beautiful youth Paris has turned into an ugly old man, and the three goddesses into sturdy wenches, who mockingly parade before him in the presence of other observers.

The *View of Upper Lake Geneva* (fig. 26),

with its similar light effects, probably dates from the same period. However, the airy panorama of Lake Geneva and the Alps dominates the picture, with the figures relegated to mere staffage.

Jacques-Laurent Agasse
(1767-1849)

Agasse was the son of a wealthy Geneva citizen of Scottish descent. He grew up partly in the country, where he could observe horses and dogs in their natural habitat. This may have encouraged his early specialisation in depicting animals. He maintained a lifelong friendship with his close contemporaries, Firmin Massot and Adam-Wolfgang Töpffer (q. v.). The three young artists often worked together on the same painting, with Massot contributing the portraits, Töpffer the landscape and Agasse the animals, and their relationship continued after Agasse had moved to England. Massot's portrait of Agasse with a bulldog, in which the sitter himself had painted the animal (fig. 27), is evidence of their youthful friendship.

From 1786 to 1789 Agasse studied in Paris with Jacques-Louis David, who impressed on him the importance of careful drawing and close observation of nature. At the same time he attended museum courses in anatomy and dissections of animals. His intensive study of animals, their movements and expressions, found an outlet in the 1790s in numerous oil sketches of dogs, goats and foxes (figs. 28 and 29).

The chaotic conditions resulting from the Revolution forced Agasse, as well as Töpffer, to return to Geneva. There he met his future patron, Lord Rivers, who invited him to England in 1790. However, Agasse had to return to Geneva again when his family was ruined by the Revolution. In 1800, at the persistent exhortations of Lord Rivers, he made his final move to England, to paint horses and hounds *"pour des riches sportsmen"*.[1] Nevertheless, he always maintained his connections with Geneva.

From 1801 he regularly participated in the exhibitions of the Royal Academy in London. After George Stubbs he became England's most talented painter of horses. He was patronised by the aristocracy (Lord Rivers, Lord Heathfield), as well as by the English royal family. George IV commissioned him to paint exotic animals in the London menageries.[2]

His specialist status as an animal painter did not prevent Agasse from adding other subjects to his repertoire: he regularly painted portraits and occasionally still lifes. His favourite subjects were children, who feature prominently in his few enchanting genre paintings.

fig. 27
Firmin Massot and Jacques-Laurent Agasse
Agasse with Bulldog (c. 1795)
Oil on cardboard, 35 × 30.5 cm
Provenance: Ludwig de Geer; Baron Carl de Geer, Geneva; Rodolphe Dunki; acquired 1940

fig. 28
Jacques-Laurent Agasse
Sleeping Fox, 1794
Oil on cardboard, 22 × 29 cm
Dated bottom right: 1794
Provenance: Duval-Plantamour; Rodolphe Dunki, Geneva; acquired 1933

17 White Horse in Pasture

Agasse spent part of the summer of 1806 as a guest on Lord Rivers' estates in Stratfield Saye in Hampshire. George Pitt (1751 - 1828) had succeeded his father, the first Baron of Stratfield Saye, in 1803 with the title of Baron Rivers. He was a friend of the Prince of Wales and is described by Lady Charlotte Perry as "a pleasant, elegant man, one of the last of that breed of dandies from a bygone age."[3] A famous breeder of horses and greyhounds, he shared a passion for animals with Agasse, who painted, or began, many pictures of horses on his enormous stud farm. A painting more than two metres wide gives a sweeping view over the entire terrain with its thatched stables and pasture fields, interspersed with occasional groups of trees, where about a hundred horses graze.[4]

The *White Horse in Pasture* probably belongs to the works painted at Stratfield Saye, as the landscape background with thatched huts and grazing horses suggests. The majestic pose of the animal is enhanced by the cut mane and cropped tail, and the radiant light apparently emanating from its body. Traditionally considered a commission by Lord Rivers, this is one of Agasse's most successful horse portraits. The subject may well be one of Lord Rivers' favourite horses, perhaps a legendary winner of Derbys or Gold Cups.

The picture cannot be securely associated with any particular entry in the artist's *Catalogue autographe*, a more or less reliable work register kept from 1800, because the individual entries frequently lack precise data.[5]

The strange fascination of Agasse's horse paintings lies in their quiet, solemn serenity. The artist sometimes combines his disciplined precision with near-magical effects, as in the painting *In the Stable* (fig. 30), where the groom leads a brown horse towards its place beside a magnificent white horse, with an almost ritual solemnity.[6] In a similar stable interior Agasse portrayed Henry Wellesley, the youngest brother of the Duke of

fig. 29
Jacques-Laurent Agasse
Sleeping Dog (1800)
Oil on cardboard, 19 × 26 cm
Provenance: J. L. Lugardon, Geneva; Rodolphe Dunki, Geneva; acquired 1936

17
Jacques-Laurent Agasse
White Horse in Pasture (1806/07)
Oil on canvas, 85 × 112.5 cm
Signed bottom right: Agasse
Provenance: Lord Rivers, Stratfield Saye; J. R. Lane-Fox, Bramham; Lord Bingley, Bramham; Rodolphe Dunki, Geneva; acquired 1937

Wellington, with his immensely valuable grey Arab thoroughbred, which he had acquired in 1803.[7]

18 The Last Stage on the Portsmouth Road

A stage-coach stands outside an inn with the sign of St. George and the Dragon. The passengers have mounted and a groom prepares the horses for departure; behind, another coach has just arrived.

Charles Rosenberg made an aquatint after this painting, which was published by J. Watson, 7 Vere Street, Cavendish, London, on 21 February 1832, with the above title. It thus depicts the last stage of the 72-mile road between London and Portsmouth.[8] In a book by Charles G. Harper, *The Portsmouth Road and its Tributaries*, the old coachman Sam

Carter relates the following: "We only changed [horses] once between Portsmouth and Godalming, and that was at Petersfield, but the stages were terribly long, and we later used to get another team at Liphook. The night coaches to London used to do the distance in about twelve hours; and the day coaches in nine hours, but the mails were ten hours on the road."[9]

Accordingly, the legend on the aquatint could describe the change of horses at Petersfield, in whose immediate vicinity, at Horndean, there is an inn called The George and Dragon. Alternatively, the subject may be The George at Portsdown Hill, a few miles outside Portsmouth, depending on whether a change of horses or a mere intermediary halt had taken place.[10]

Not only the coach horses, but also the pigs, chickens and dogs in the street, as well as the colourfully dressed people, are rendered with meticulous care. A heavy carriage, drawn by six horses, moves off into the background, its broad wheels slanted inwards, presumably to prevent them from sinking into the mud.

The fine weather explains the fact that passengers are crowded on the roof of the coach. Karl Friedrich Schinkel wrote about his own experience of a coach trip from London to Brighton in June 1826: "I tried to position myself outside for part of the way, thus gaining an infinitely better view. In the summer almost everyone travels outside."[11] On his tour of England, Schinkel was greatly impressed by the speed of the stage-coaches: "The coach is extremely elegant, drawn by four handsome horses on a loose rein, wearing the finest harness of the kind used by the English Ambassador in Berlin. A very large, sturdy coachman on a high seat drives the horses; he looks like the finest gentleman, wearing many colourful neck cloths, a fine

fig. 30
Jacques-Laurent Agasse
In the Stable (c. 1810)
Oil on canvas, 71 × 90.5 cm
Signed top left: JLA
Provenance: de Sévery, Lausanne; J.L. Reichlen, Lausanne; Galerie Bollag, Zurich; Dr. S. Guggenheim, Zurich; acquired 1941

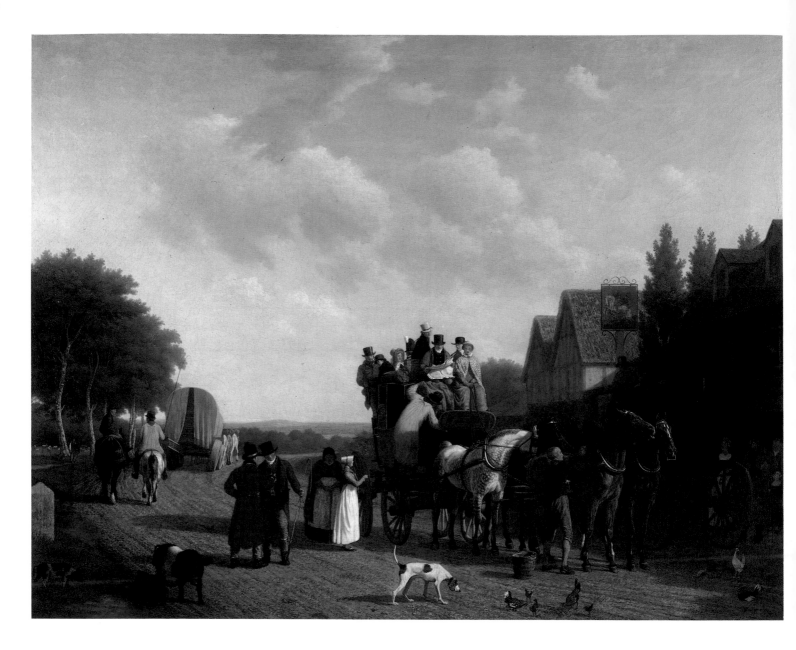

18
Jacques-Laurent Agasse
The Last Stage on the Portsmouth Road (1815)
Oil on canvas, 103 × 128 cm
Signed bottom left: J. L. A.
Provenance: Private collection, England; Marshall C. Spink, London; H. I. Koblitz, Lugano; Dr. Fritz Nathan, St. Gallen; acquired 1947

hat, good boots, black trousers and a large light-coloured greatcoat. Every two miles [probably an error for 20 miles] a new team of horses is supplied, changing from white horses to chestnut, brown and black."[12] A similarly elegant coachman is seen standing in the centre of Agasse's painting, chatting with a colleague dressed in a splendid red coat, who perhaps will relieve him. In the meantime a young lady, sitting on the coachman's seat, is holding the reins of the horses, while the gentleman beside her is ungallantly engrossed in his reading.

There are three versions of this subject and Agasse entered all three under the same date, 10 November 1815, in his *Catalogue autographe*.[13] The first and largest version, the Winterthur painting, was exhibited in 1816 at the Water-Colour Society in London under the title *Coachmen meeting and comparing Notes*. The two smaller versions are in English private collections.

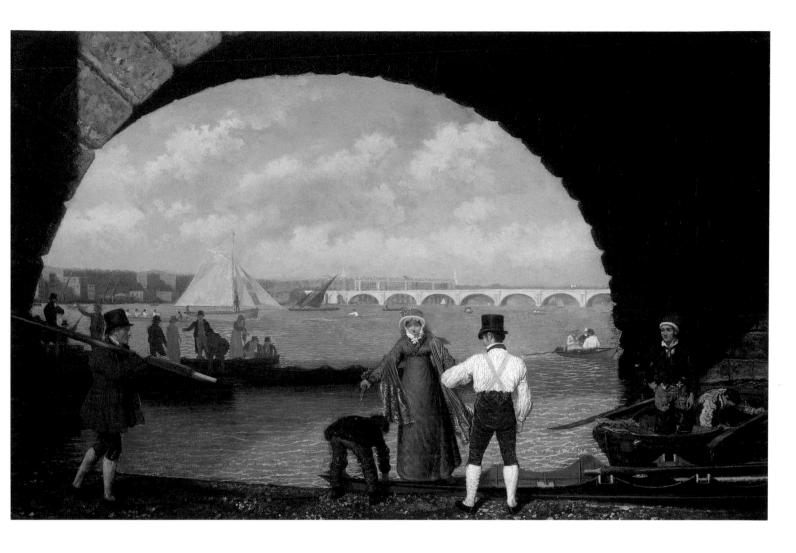

19 Landing at Westminster Bridge

In 1818 Agasse turned to a new, hitherto untried theme: the city in which he had lived for nearly twenty years. He focused his interest mainly on the river Thames and the activities on the water. Two of these views are concerned with rowing,[14] and anticipate by some fifty years the river scenes of Renoir, Caillebotte and Monet.

The originator of this popular pictorial motif was probably Canaletto, with his painting *London seen through an Arch at Westminster Bridge* (Duke of Northumberland Collection), which became widely known through the engraving by Parr, published in 1747 by John Brindley. It inspired similar views by Philippe-Jacques de Loutherbourg, Samuel Scott and other artists.[15]

Agasse chose a most unusual vantage point: through the dark framework of an arch of Westminster Bridge the new Waterloo Bridge, opened on 18 June 1817, is seen in full sunlight, spanning the water. On the left bank is the façade of Somerset House, built between 1776 and 1786 and used at the time for the Royal Academy exhibitions, where Agasse exhibited a larger version of the painting.[16]

The artist was more interested in the lively activities on the Thames than in the splendid façades of the buildings. He chose a stretch of river free of the traffic of large ships and taken over by small sailing craft and rowing boats, many of which were used for pleasure rather than commerce. Long before such activities became known on the Continent, the British organised regattas on the Thames. Here amidst the more leisurely rowing and sailing parties, the rival oarsmen, in top hats and shirt sleeves, are trying to finish the course, some rowing singly and some in crews, complete with cox. In the foreground

19
Jacques-Laurent Agasse
Landing at Westminster Bridge (1818)
Oil on canvas, 35 × 53.5 cm
Provenance: Louise-Etiennette Agasse, Geneva; Binet-Hentsch, Geneva; Lachenal-Maunoir, Geneva; Horneffer-Maunoir, Geneva; Rodolphe Dunki, Geneva; acquired 1941

one of the top-hatted oarsmen gallantly offers his arm to a lady, elegantly draped in a yellow cashmere shawl, to help her ashore from a boat. The sport of rowing had been in existence for more than a hundred years. In 1715 the actor Thomas Doggett organised the first regatta for Thames watermen, which subsequently became an annual event.[17] The prize for the winners was an orange-red coat, the "Doggett Coat and Badge", which may have inspired the attire of the gentleman shouldering an oar in the left foreground. Perhaps unintentionally, Agasse's picture underlines the contrast between the aristocratic pastime of rowing as a sport, and the hard work it involved for the pair of poorly dressed watermen who have pulled up their boat under the shadow of the arch on the right. One is bending down to his work, while the other contemplates with a melancholy

expression the world of nobility within easy reach, and yet so inaccessible to him.

Agasse resumed the theme of the veduta along the Thames in 1823, this time turning to the medium of watercolour. This choice of medium may have been inspired by the many English watercolourists who lived near him in Newman Street, and it resulted in some enchanting down-river views.[18] They include the airy *View of Greenwich Hospital* (fig. 31), which features a sweeping panorama of Greenwich, seen from Croome Hill, with the famous naval hospital on the bank of the Thames. A few sailing boats are lying at anchor to the left of the Baroque church tower, while innumerable ships' masts appear along the far horizon, beyond the wide expanse of water.

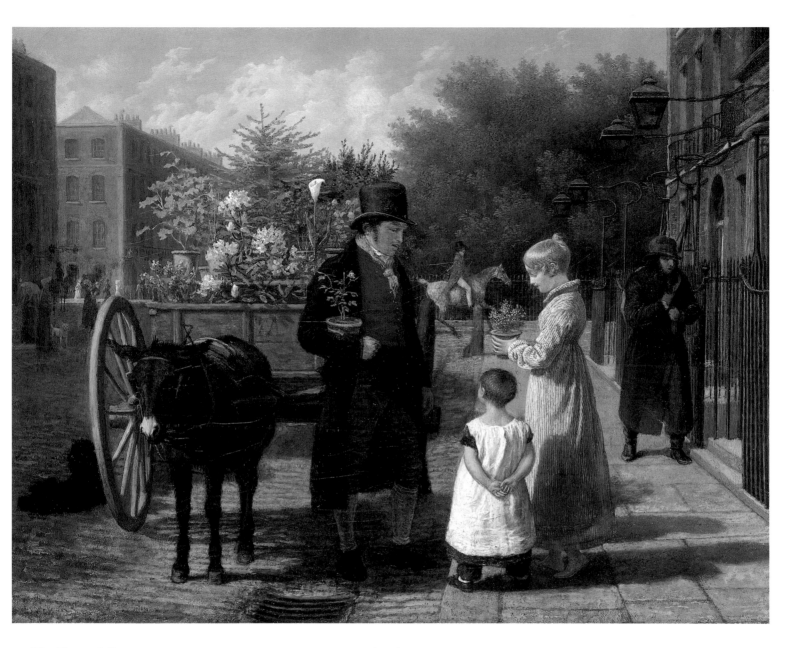

20 The Flower Seller

Flower sellers were the most popular street vendors in nineteenth-century London, and were often represented in paintings. "There were many of them about, since it was more practical to sell flowers in the open than indoors. They invariably evoke favourable associations ... with the delights of the countryside, with refined sensibilities and with giving pleasure ... Agasse's subject would have been a reasonably prosperous seller who could afford a donkey and the outlay necessary to buy shrubs and potted plants. By the middle of the nineteenth century, flower sellers were invariably depicted as appealing young girls ..."[19]

From 1810 Agasse lived at No. 4 Newman Street, renting premises above the stables owned by George Booth. He soon became a close friend of the family. He had a particular affection for his landlord's numerous children, who treated the unmarried artist as a kind of uncle and became the subjects of various genre portraits. They also inspired other genre paintings, amongst them the present painting and *The Playground* (Cat.21). Newman Street in those years was a popular address for artists; Benjamin West, then President of the Royal Academy, lived at No. 14, not far from Agasse's house.[20]

Agasse placed his *Flower Seller* in his own immediate neighbourhood in Soho Square. The square, filled with trees, can be seen in the

20
Jacques-Laurent Agasse
The Flower Seller (1822)
Oil on canvas, 35 × 42.5 cm
Signed on the cart: JLA
Provenance: H. Arthurton, London; Th. Agnew & Sons, London; acquired 1954

background between rows of red-brick apartment buildings. The flower seller has stopped his cart to sell some potted plants to a young woman, happily absorbed in admiring them, while a small boy, seen from the back, watches attentively. The donkey hitched to the cart is waiting patiently to continue on his way. The cart holds a rich flower still life, adding colour and gaiety to the scene. Life does not stand still around the group: a sinister looking rag-and-bone man, carrying his load over his shoulder, is sneaking along the iron fence on the right. The lonely figure of a rider on a white horse is seen in the right background, and more people, dogs and horses are on the left. Agasse seems to conjure up a Dickensian aspect of the city. He also includes features of the new technical age, such as the cover over the sewers and the rows of gas lanterns.[21]

The artist portrayed his own features in the flower seller, and Johnny Booth, his landlord's son, is traditionally believed to have posed for the young boy seen from behind.

According to the *Catalogue autographe*, Agasse painted two versions of this motif, one in May 1822, the other in September 1825.[22] The first version, almost certainly the Winterthur painting, was exhibited at the Royal Academy in 1823. Another version, in vertical format, is in a Geneva private collection. This painting could be the "copy" Agasse noted in his *Catalogue autographe*, with the date "september 1825". Opinions as to which version is the first have vacillated in the literature.[23] The measurements given in the *Catalogue autographe* should help to solve the problem once and for all: for the 1822 version Agasse entered the measurements 18 x 14 inches, which conforms to the dimensions of the Winterthur painting. The 1825 version he called "small". This term describes a type of canvas measuring some 16 x 20 inches,[24] approximating the size and proportions of the Geneva picture.

The Winterthur painting, with its open space and casual arrangement of figures, also appears to be the first version on stylistic grounds. Occasional pentimenti point to Agasse's struggle to find the final composition. The Geneva version, in contrast, presents the foreground figures as a clear and coherent group, with the vertical format eliminating incidental details, the only exception being the rag-and-bone man. Next to the flower vendor is another figure of a boy with a shiny top hat, possibly the same Johnny Booth as in the 1822 version, who is still present, but shown as he was three years later. This more compact version loses some of the charm produced by the lively staffage and playful diversity of motifs in the Winterthur picture.

21 The Playground

One of Agasse's most enchanting genre scenes, full of happy relaxation, is enacted in a delightful park landscape, possibly on Hampstead Heath. In the luminous distance, beyond the glittering surface of a lake, sheep are grazing on a sunny pasture. Under the shade of the trees a boy pushes a girl aloft on a swing, her figure appearing weightlessly suspended amidst the green vault of the leaves. The scene inevitably evokes memories of Fragonard's *The Swing* (London, Wallace Collection), which Agasse may have known from a reproduction.

An elderly gardener, resting on a roughly carved wooden bench, watches the pair occupied with the swing. They also attract the attention of a young governess, seen as a white figure from the back, holding her sun hat, temporarily forgetting her duty. Her charges, two little girls engaged in lively chatter, are seated on the ground next to her. Another nurse in the foreground is busy restraining two youngsters in her care from upsetting the gardener's wheelbarrow. A rake, shovel and straw hat form a still life in the front plane. The tools are the gardener's, while the hat probably belongs to the smartly dressed boy pushing the swing.

The painting is a tender expression of the artist's love of children, who are portrayed happily at play, as if in a garden of paradise. The governesses provide motherly care and protection rather than discipline. As in the *Flower Seller*, Agasse included in the composition the children of the Booth family, whose house in Newman Street he inhabited from 1810 to nearly 1836. The two seated girls are Louisa Booth and her sister Ellen. As if to underline the easy familiarity of the scene, the gardener, on the left, is a self-portrait. Lionel Booth, a son of Agasse's landlord George Booth, remembered his father's shock at the republican impropriety of showing the gardener comfortably seated amidst his master's children.[25]

The casual appearance of the happy scene has led to criticisms of a certain lack of unity.[26] However, a closer analysis reveals a composition carefully constructed along diagonal lines, some leading into depth, others upwards with the zig-zag movement of the swing. The strong vertical of the massive tree provides a stabilising element against which the playful diagonals are anchored.

The Winterthur picture is the first of two versions Agasse painted of this motif (both entered in his *Catalogue autographe* in July 1830). The other, smaller version is in the Musée d'Art et d'Histoire in Geneva;[27] its only difference is the pose of the boy sitting in the foreground. The first version was exhibited in the British Institution in 1832, and in the Society of British Artists in 1833.

21
Jacques-Laurent Agasse
The Playground (1830)
Oil on canvas, 53.5 × 44.5 cm
Signed bottom right: JLA:
Provenance: (Louise-Etiennette Agasse; Binet-Hentsch; Lachenal)?; Bautte (1938); Rodolphe Dunki, Geneva; acquired 1938

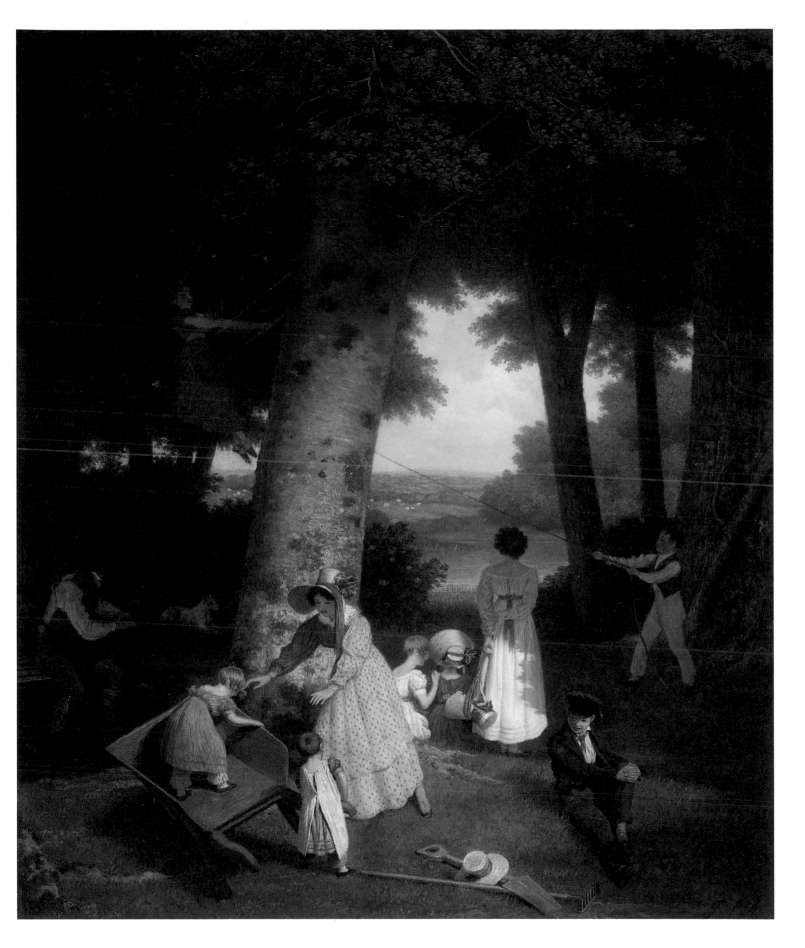

Louis-Léopold Robert

(1794 - 1835)

At the peak of his fame, Robert was involved in an ill-starred love affair in Venice with Princess Charlotte Bonaparte, which led to his suicide in 1835. His works caused a furore in the Paris Salon, and attracted the enthusiasm of collectors from Russia to Scotland. His scenes from Italian everyday life, often verging on the sentimental, became very popular, raising the genre to new heights. After his death he was soon forgotten, but his artistic influence was considerable. His themes found followers not only in France, where they clearly made an impression on, amongst others, the young Delacroix, but also in Germany and Denmark. The light-filled scenes of southern life by Jørgen Sonne and Wilhelm Marstrand were clearly indebted to him; both these two Danish artists had moved in Thorvaldsen's circle in Rome, and would have had an opportunity to see works by Robert then in Thorvaldsen's possession.

Robert, the son of a homeworker near La Chaux-de-Fonds, became a student of Jacques-Louis David in Paris in 1812. In 1818 he settled in Rome, the scene of a number of important innovations in European art between 1770 and 1830. The last of these concerned genre painting. Depictions of peasant life had existed for a long time, but they were considered a low category of painting.[1] Robert was destined to raise the subject to a higher sphere, and in this he was inspired by Bartolomeo Pinelli's scenes of peasant life and shepherds in the Campagna.

The foundation of Robert's success were depictions of brigands. In 1819 a group of brigands from the surroundings of Rome were captured by the papal troops and put in the Roman prison I Termini, where the painter, for two months in the summer of 1820, made daily study sketches.

Subsequently he painted ideal portraits of girls in colourful native costumes, fishing idylls and other sentimental genre scenes, sometimes with allegorical implications, as for instance in the unfinished large-scale series of the *Four Seasons*.[2] Historical themes such as the designs for Romeo and Juliet (figs. 33 and 34) remained exceptions.[3]

As a Romantic who remained faithful to the artistic laws of classicism, Robert strove to find the happy medium between Ingres and Delacroix, the reconciliation of line and colour which the elderly David had observed in the work of his student: "I hear that Léopold paints enchanting pictures; he showed an early talent for colour, and I have always let him follow his own taste. He has succeeded, he is being noticed. I am pleased with his success, for I have always loved him well."[4]

Heinrich Heine, one of Robert's most prominent admirers, in his review of the 1831 Salon, tried to explain the fascination exercised by Robert's *Rest of the Reapers in the Pontine Marshes* (Paris, Louvre, and see fig. 32) which, together with Delacroix's *Liberty leading the People*, was the sensation of the Salon. His extensive and fundamental analysis is valid for almost all of Robert's works. Heine first discusses the difficulties of showing contemporary costumes and criticises, with an eye to the Nazarenes, the prevalent preference for historical subjects: "We find in Germany an entire school,... inexorably trying to clothe the most modern of people, with the most modern of feelings, in garments of the Catholic and feudal Middle Ages, in cowls and armour. Other painters have tried other means of expression, choosing for their subjects tribes not yet stripped by civilisation of their originality and their national costumes. Hence the scenes from the Tyrolese mountains, so often seen in pictures of the

fig. 32
Louis-Léopold Robert
Study for The Rest of the Reapers in the Pontine Marshes
Pen and brush in brown over pencil, 17 × 24.5 cm
Signed top left: L.ld. Rt.

Munich painters. These mountains are close to them and the costume of their inhabitants is more picturesque than that of our dandies. Hence, also, the joyful representations of Italian folk life, with which many painters are familiar through their stay in Rome, where they find those ideal and genuinely noble expressions of humanity and picturesque costumes craved by their artist's heart."[5]

Heine sees in Robert's painting an approximation of the "apotheosis of life, at the sight of which one forgets the existence of a realm of shadow, and one doubts whether there is a place more magnificent and bright than this earth. 'The earth is heaven and people are full of god-like holiness,' this is the great revelation of this picture with its blessed colours... The figures marvellously reflect heaven's radiance, shining in joyful bright colours, but with their contours strictly delineated. Some figures appear to be portraits, but the painter did not choose the faithful manner of some of his colleagues, who slavishly imitate nature and diplomatically mirror the faces... He first embraced the forms given by nature in his mind, where, like souls in purgatory being

fig. 34
Louis-Léopold Robert
Study for Romeo and Juliet
Pencil, 24.5 × 18.5 cm

Heine admired Robert's idealisation of simple, real life, which raised everyday subjects to the category of history painting. Robert seemed to build a bridge to Courbet, whose *Stonebreakers*, for instance, also lends an aura of sublimity, tragedy and monumentality to a simple subject. Later, however, Heine noticeably succumbed to anti-clerical polemic, using the painter more and more as a tool for his own purpose: "Robert ... unconsciously worships a still-hidden doctrine, which does not acknowledge the battle between spirit and matter, which does not forbid earthly pleasures while consistently promising vague heavenly joys; which aims at a blessed state of man while still on this earth, and considers the world of the senses as holy as that of the spirit: 'for God is everything there is'."

fig. 33
Louis-Léopold Robert
Studies for Juliet
Chalk and pencil, 53 × 36.5 cm

cleansed of earthly blemishes ... before rising to heaven, they are purged and purified by the glowing flames of his artistic spirit, to rise radiantly to the heaven of art, equally dominated by eternal life and beauty. There Venus and Mary never lose their worshippers, Romeo and Juliet never die, Helen remains eternally young and Hecuba does not age."

22 A Girl from Procida

This ideal portrait of a beautiful Italian girl wearing the costume of the island of Procida is distinguished by a clear, compact composition and a warm tonality. She proudly turns her head, which extends above the horizon into the blue sky, towards the spectator – a pose which gave the picture its subtitle "The Mona Lisa of Romanticism".[6] The costume, with its saturated colours standing out against the cool tonality of the landscape, was selected from clothes Robert had purchased, at a high price, during a study trip to the Gulf of Naples the previous year, to be worn by his sitters in the studio.[7]

The origin of this painting, marking the beginning of Robert's meteoric rise, is documented in numerous letters by the painter and his brother Aurèle to their family in La Chaux-de-Fonds. While working on it he learned that his pictures in the Salon of 1822 had received a gold medal, his first great success in Paris.[8]

Following an invitation from the Prussian Consul General Bartholdy, uncle of the composer Mendelssohn, Robert exhibited some of his paintings in the Palazzo Zuccari, also called Casa Bartholdy, together with fourteen Prussian artists considered the most prestigious in Rome. On 26 November 1822, Léopold wrote: "The Prussian King returns from Naples the day after tomorrow. He has visited an exhibition organised by artists he patronises. I was invited to show a few works. They attracted considerable interest. I was there during the King's visit. He talked to me and I received compliments from persons who accompanied him. I was very glad that M. Torvalzen [Thorvaldsen], a sculptor of colossal prestige in Europe, told me he would like a painting by me. I am more flattered than if a crowned head had asked me this ... He is surrounded by Germans, who consider me a bastard[9]."[10]

As early as 15 December 1822, Aurèle could report home on his brother's success: "The King of Prussia, advised by [Alexander von] Humboldt, purchased paintings for 12,000 francs at the exhibition ... Léopold obtained for his two works 40 and 20 Louis d'or ... The first was the life-size bust of a young woman wearing the costume of one of the Neapolitan islands, which is very rich and reminds me a little of Greek costumes. The gentle expression and the beauty of colour are charming and were highly praised by connoisseurs; the King, as soon as he saw it, fell in love with it and marked a cross on the frame, to reserve it for himself (you must know that the King falls madly in love with all the beautiful women he sees, and wants to marry them ...). The King saw the exhibition twice; on the first occasion Léopold's painting was not there, because it was still incomplete; never satisfied, he was still working on it and refused to send it, but Schnetz, arriving on the morning of the King's return to the exhibition, encouraged him to show the picture."[11]

Thus Robert, a representative of the French school, succeeded in penetrating the "enemy" bastion of the German Nazarenes.

Aurèle also had information about the model: "Léopold used a very charming girl for his model. He painted her frequently, amongst others in the picture for the King of Prussia. She spent all the money she earned for this to acquire golden earrings, a gorgeous coral necklace, a beautiful hat, merino-wool clothes and other things."[12]

Robert probably painted not only from the model in front of his eyes, but from artistic examples in his mind's eye, such as paintings by Leonardo, Raphael's Doni portrait, and above all, Ingres's *Mademoiselle Rivière* (Paris, Louvre), which shows astonishing similarities. Ingres's portrait, however, depicts a lady of high society, dressed according to her rank, whereas Robert bestowed on a simple country girl all the attributes of great Renaissance painting, and she emanates Raphaelesque dignity and grace.

23 Neapolitan Fisherman with a Girl from Ischia

A fisherman, with his cloak half-falling from his shoulder, is sitting on a rock on the shore, playing the mandolin and singing to a beautiful fisher girl, dressed in a sumptuous costume. His eyes are longingly raised to her, trying to solve the riddle of her Sphinx-like smile. With feigned indifference she loosens with her left hand a strand of her artfully plaited hair, while her right holds a spindle behind her back. Her dark eyes are not turned towards the youth at her feet, but flirt with the spectator, who may be an intruder or a liberator.

Robert again produced several versions of the motif, each showing slight variations. The first version (now at La Chaux-de-Fonds, Musée des Beaux-Arts), whose subject had been anticipated in the *Improvisateur avec deux jeunes filles*[13] of 1823, was painted for the artist Pierre-Narcisse Guérin, then director of the French Academy in Rome. Robert informed his painter colleague Navez: "I am engaged in completing a picture, quite large compared with my usual sizes. It is destined for M. Guérin. He has seen it some time ago in my studio and, since he liked the subject, he asked me if he could have it. It already had a buyer, but I was able to arrange the matter to his and my own satisfaction."[14]

While still working on this picture, Robert received the order for a second version. "Since Léopold has to make a copy of M. Guérin's picture for the Comte Hahn, the richest Prussian seigneur, I shall speed him along," Aurèle writes on 26 February 1825.[15]

On 26 June 1825 Robert mentions two copies he had to make after the painting, which he had finished in mid-May. For these he borrowed Guérin's original, a procedure apparently not appreciated by the owner: "One evening Schnetz told me he assumed that Guérin was not happy to see his painting repeated, as it would lower its value. He could

22
Louis-Léopold Robert
A Girl from Procida, 1822
Oil on canvas, 81 × 68.5 cm
Signed bottom left: L.LD ROBERT..F.$^{T.}$ ROMA./ .1822
Provenance: Friedrich Wilhelm III, King of Prussia, Berlin; Otto Buel, Lucerne; acquired 1949
(Gassier 18)

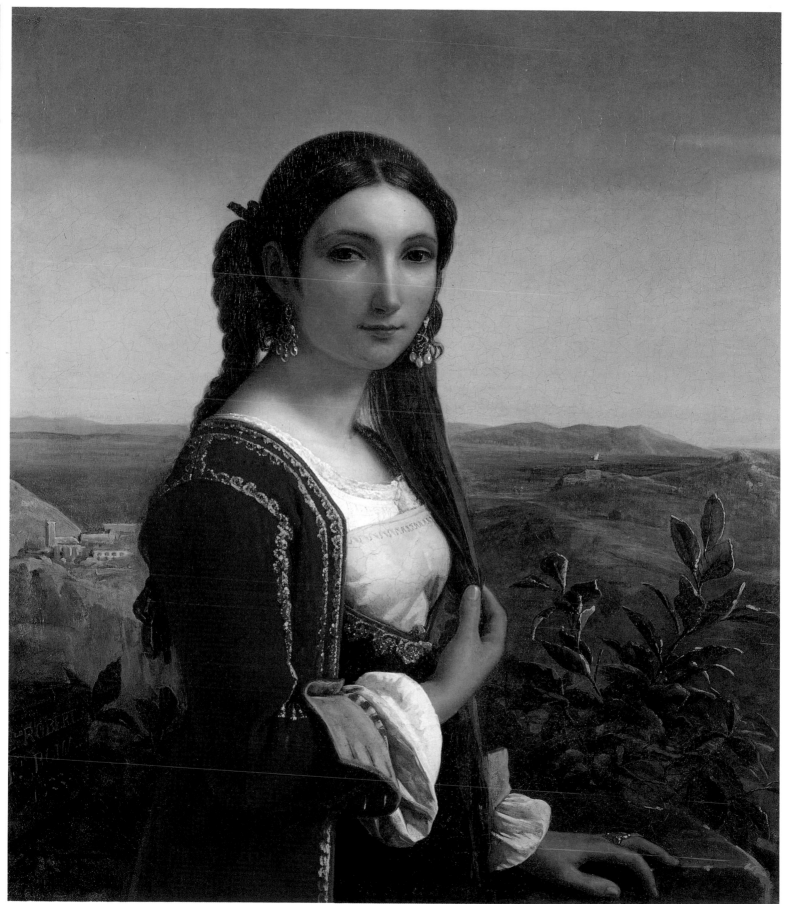

23
Louis
Neap
Oil on
Signea
Prove
burg;
Kron
Galle
(Gass

69

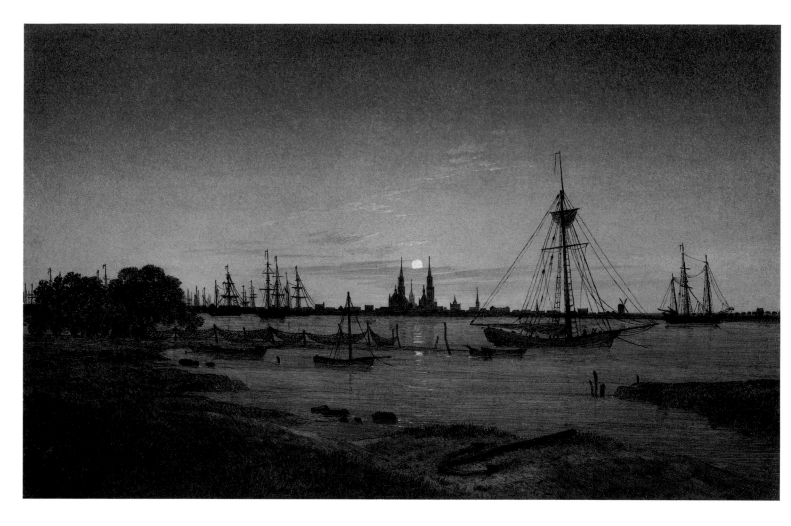

27
Caspar David Friedrich
Port by Moonlight (1811)
Oil on canvas, 24 × 36.5 cm
Provenance: Ludwigs Galerie, Munich; acquired 1934
(Börsch-Supan 198)

at patriotic ideas,[19] remains an open question.

At this period Friedrich seems to have found a source of inspiration in Jacob van Ruisdael's landscapes in the Dresden Gemäldegalerie. The *Journal des Luxus und der Moden* in 1812 noted the dependence of *Landscape with Oak Trees and a Hunter* on Ruisdael, whose *Hunt in an Oak Wood* seems to have been the immediate source for Friedrich's painting, including the motif of the hunter. Other paintings, such as the *Mountain Landscape* in Dresden, were inspired by Ruisdael's northern waterfalls in vertical format. Friedrich's connection with Goethe may have stimulated this interest. Goethe visited Friedrich's studio in Dresden on 18 September

1810 and Friedrich returned the visit in Jena on 9 July 1811, immediately on completion of the two pairs of paintings. In 1810 Friedrich had sent five picures to Weimar which, probably on Goethe's recommendation, were acquired by Karl August von Sachsen-Weimar. A little later Goethe began to find fault with Friedrich's paintings, whose "gloomy religious allegories do not lend themselves to grace and beauty of representation."[20] In his 1813 essay *Ruisdael as Poet* Goethe explained, clearly not without a sideways glance at Friedrich, how landscape symbolism should be deployed in painting.

In preparation for the *Landscape with Oak Trees and a Hunter* the artist turned to his rich fund of nature studies. Three drawings used for the picture have been preserved: one, dating from 1806, features the great oak on the left, which reappears in several other works, including winter landscapes.[21] The background is based on two drawings made in Breesen, near Neubrandenburg: the tiny group of trees in the right middle distance, adjoining the wood to the left, was sketched on 9 June 1809, while the group of oaks on the right, together with the oak on the left and a further tree standing in a field, are captured in a drawing of 14 June 1809.[22] A study for the large oak on the right is lost. Friedrich

28
Caspar David Friedrich
City at Moonrise (c. 1817)
Oil on canvas, 45 × 32 cm
Provenance: Johanna Friedrich, Greifswald (c. 1900); Anna Siemssen, Greifswald; Ludwigs Galerie, Munich; acquired 1931
(Börsch-Supan 227)

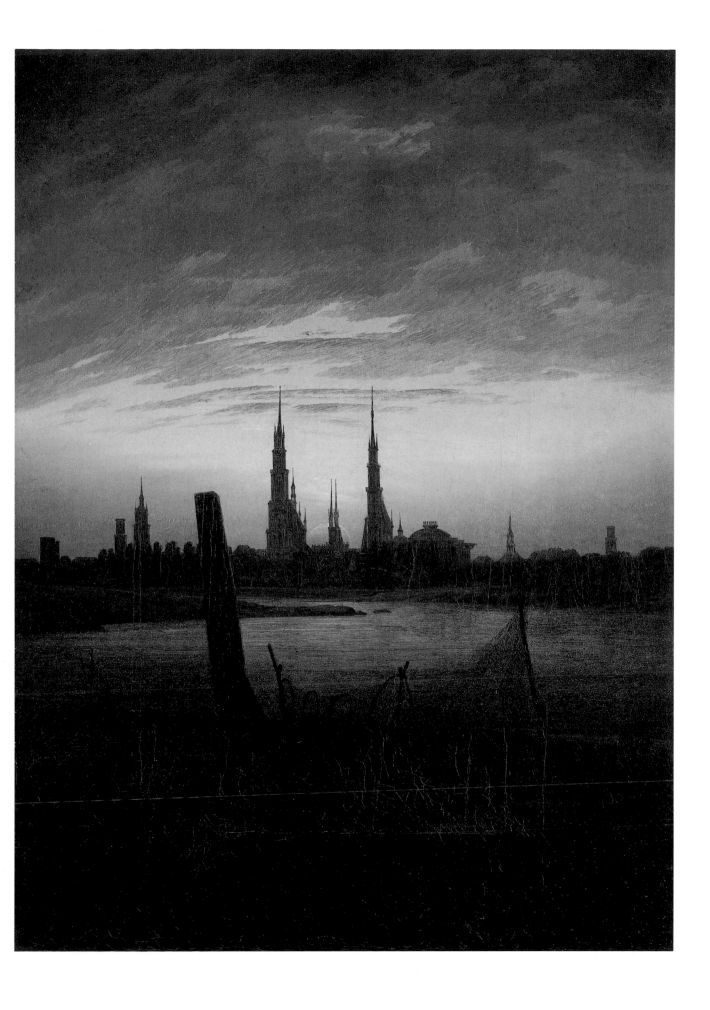

explained that, when constructing a picture, the painter must "follow his inward voice," which is "the divine within us and does not lead us astray."[23] The drawings are the instruments for giving concrete form to this inner voice. Their precision guarantees truth to nature, making the picture credible, but free of slavish imitation. "Every true work of art is conceived, often unconsciously, in a state of blessedness and born in a state of happiness, out of the yearning of the artist's heart … Close your physical eye so that you can first see your picture through your spiritual eye. Then bring to light what you have seen in the dark so that it may affect the viewer through its external appearance."[24] Friedrich regards the artist as a medium for transmitting the divine, which has revealed itself to his "pure heart" and "childlike mind".

27 Port by Moonlight

This picture was shown in the Weimar Art Exhibition of late 1811, together with a pendant, *Port after Sunset with Shepherd and Sheep*. In the 1812 Dresden Exhibition, however, the painting hung without its pendant, which has been lost.[25] Here again the interpretation of the work must allow for two complementary scenes, and be based on comparison with related compositions.

The painting seems to be the first of various depictions of a port by moonlight. The almost symmetrical city profile along the horizon, though resembling Greifswald, is not intended as a topographically accurate view, but as the vision of an ideal city. There is a stretch of shore in the foreground with nets, rowing boats, an anchor and trees. Beyond this ships are anchored in the bay. The position of the moon in the exact centre of the composition between the two Gothic church towers is significant, marking the culminating point of a sequence, as shown in the picture planes moving from foreground to background. In the foreground, nearest to the viewer, a barren strip of coast marks the dying present, with a prominently displayed anchor adding a traditional Christian symbol of hope. The ships anchored in the background again refer to an ancient Christian image, the ship of life. Their voyage completed, they lie in the port, unrigged, a reminder of death, which is negated, however, by the vision of the two church towers in the

centre background, promising the heavenly Jerusalem. The pristine Gothic city, in contrast with Gothic ruins, was for Friedrich a symbol of hope and of eternity. He even used to draw designs for architecture in Gothic style, and Gothic structures appear in other paintings, such as *Memorial for Johann Emmanuel Bremer* (Berlin, Schloss Charlottenburg), and the *Sisters on the Harbour-View Terrace* (St. Petersburg, Hermitage).[26]

The cool light of the full moon brings consolation, for it gently reflects the overpowering light of the sun, making it bearable to the human eye. The function of the moon in transmitting light as a recognisable symbol of God's actions is analogous to that of Christ acting as intermediary between God and mankind.[27] This is not to be undestood as an allegory of the moon representing Christ, but as pure symbolism. The significance of the moon can only be understood in conjunction with the content of the painting. Friedrich saw himself as an intermediary – a concept central to his thinking – between an inner voice, which he recognises as divine, and the viewer, whom he wants to guide through his art to the right way of thinking. "Art acts as intermediary between nature and man."[28] Friedrich Schlegel, in the *Atheneum Fragment 234*, made a similar statement: "It is arrogant and one-sided to assume that there is only one intermediary. The complete Christian, best represented in this respect by Spinoza, should see everything as intermediary." This aphorism confirms that pantheistic currents in Romanticism are frequently linked to Spinoza. Not only the book of the Bible, but also the book of nature manifests the Divine. Friedrich expressed this in a fascinating interplay of revelation and camouflage. His works often feature nets, fish traps, tree trunks, branches, latticed railings and mist, all of which hint at hidden and inaccessible objects behind.

28 City at Moonrise

The composition of this painting, dating from around 1817, noticeably resembles that of the *Port by Moonlight*, justifying a similar interpretation, but a few differences can be observed. The vertical format intensifies the effect by emphasising the heavenwards thrust of the two church towers and in an effort to simplify, the ships are omitted. The city appears more unreal, less like a veduta, anticipating the visionary cities in the subsequent paintings *Sisters on the Harbour-View Terrace* and *On the Sailboat* (both St. Petersburg, Hermitage). Again, there are nets like transparent veils and fish traps in the foreground.

The strict verticality of the format also draws attention to the now prominent anchor and its relationship to the church towers in the centre. Through the concentrated grouping of his motifs Friedrich increases the clarity of his message, which consists in the juxtaposition of death with hope and resurrection.

The colours, too, are more developed, although mainly confined to the sky and its reflection in the water. In the centre of the picture the clouds open like the vault of a dome to create a bright elliptical form resembling an eye. Friedrich repeatedly used the "all-seeing eye of God" within a triangle (perhaps also indicated in this picture) as a symbol of the Trinity, for instance in the carved frame of the *Tetschen Altarpiece* and in the painting *Mist in the Valley of the Elbe* (Berlin, Nationalgalerie), where rays of light break through the clouds. The structure of the sky, radiant in warm tones of red and yellow, can be compared with the *View of Neubrandenburg* (Kiel, Pommern Foundation), painted at the same time. The moon, which is the source of light in the painting, appears between the strongly silhouetted church towers which seem to form a gate, a doorway of faith.

Such clear imagery predominated in the early works of the 1810 decade and later gave way to more subtle expressions of meaning, and Friedrich moved away from the concept of a division of landscape into heavenly and earthly zones in favour of a pantheistic unity. From about 1820 he developed a greater painterly freedom.

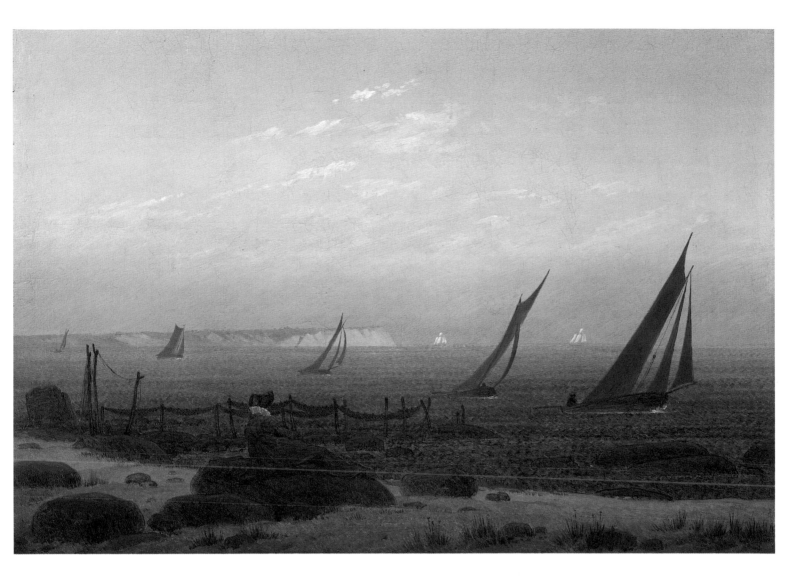

29

Caspar David Friedrich

Woman on the Beach of Rügen (c. 1818)

Oil on canvas, 21.5 × 30 cm

Provenance: Private collection, Berlin (1926); Ludwigs Galerie, Munich; acquired 1932

(Börsch-Supan 245)

29 Woman on the Beach of Rügen

This work seems to derive its enchanting gaiety from the artist's unexpected marital happiness and was probably painted at the same time as the *Chalk Cliffs on Rügen*.[29] The woman in a red dress, resting not too comfortably on a rock smoothed and rounded by the surf, might be Friedrich's wife. Her pose, turning away from the viewer and looking out over the sea, suggests a reflective mood. Her thoughts follow the sailing boats along Cap Arkona, seen curving into the picture from the left background towards the far distant horizon, where the ships with white sails pursue their course into the unknown. In front of them five small fishing boats are lined up diagonally across the picture, as if on parade. Their dark sails reflect none of the luminosity in the distance, for they are close by, belonging to the present, their radius of movement limited to this world. Their course, crossing the direction of the woman's glance, is set towards a point in the right foreground, outside the picture space.

The red of the woman's dress dominates the colour scheme; her head, with the dark bonnet resting somewhat awkwardly on the white collar, seems caught in the strung-out fishing net.

Friedrich combines in this picture motifs he usually juxtaposed in pendants, such as the small fishing boats near the coast and the sea-going vessels along the horizon. The colour contrasts of white and dark sails add a special emphasis, comparable to that in the later painting *The Cycle of Life* (Leipzig, Museum der Bildenden Künste). The figure in city dress looking yearningly at the sea seems a stranger in this environment; her pose, expressing a "sentimental reflection" in Schiller's sense, resembles that of the two fig-

Georg Friedrich Kersting

(1785-1847)

After the paintings of Caspar David Friedrich (q. v.), Kersting's much-admired interior scenes were one of the surprise discoveries of the 1906 Berlin Centenary Exhibition. The small number of his paintings then known has hardly increased, amounting to little more than a dozen.

On completing his studies in Copenhagen, Kersting moved in 1808 to Dresden, where he soon found friends within the circle of Romantics. His first independent works, the portraits of Gerhard von Kügelgen and of Caspar David Friedrich in their studios (Karlsruhe, Kunsthalle, and Hamburg Kunsthalle), attracted much attention at the 1811 exhibition of the Kunstakademie. Friedrich was a close friend with whom he had explored the Riesengebirge mountains in 1810. Goethe admired Kersting's works and negotiated the sale of the *Elegant Reader* and of the *Embroideress*, a portrait of the poet's friend Louise Seidler, which was acquired by Duke Karl August of Weimar.[1] In 1813 Kersting joined the freedom fights as a member of the Lützow Freikorps, to whose fallen soldiers he dedicated two commemorative paintings in 1815. The 1813 war put an abrupt end to his productive career, and on his return to the war-torn city of Dresden the difficult economic situation led him to accept a position as drawing teacher in Warsaw. From 1818 he enjoyed a secure existence as artistic director of the Meissen porcelain manufactory, which, however, left him little time for practising his art.

32 Man reading by Lamplight

Together with *Elegant Reader* and *Man at a Writing Desk*,[2] this painting completes a quasi-trilogy of Romantic erudition, representing the quintessence of Kersting's oeuvre. In these "room portraits" the sitter and the interior space merge into one unit. The amateur painter Louise Seidler commented approvingly in her memoirs: "It is indeed interesting to see beloved or distinguished personages in a milieu characteristic of their profession and consequently of their whole personality."[3] These works reflect the situation of the Romantic scholar, author or artist trapped in a "secure" profession, as for instance Novalis and E. T. A. Hoffmann.

The reading man, seen in profile, is seated at his desk, with his head resting on his hand, absorbed in his book. His coiffure, resembling Friedrich's, is artfully dishevelled. The austere order and Spartan simplicity of the interior preclude any distraction from his spiritual concentration. There are no ornaments, no flowers. The walls are bare of pictures, prints or maps through which the outside world might intrude. In this Kersting's interiors differ decisively from Vermeer's, whose similar rarity and aura of mystery have sometimes invited comparisons. A map is indeed present, but it stands rolled up in a corner.[4] Nothing penetrates into this completely self-absorbed space, where an inner world unfolds. The creative concentration of the reader benefits from the nocturnal silence, undisturbed by any noises in the house or from the street. It is an almost palpable silence.[5]

However, the reader is not entirely alone in these surroundings of "enchanted purity and whispering pedantry".[6] To the left of the lamp and in its brightest light we see an open box containing a miniature portrait of a woman: is it his sweetheart, bride or wife the reader keeps before his eyes?[7] The desk holds letters, pots and a writing pen. A jewellery box, though open, does not reveal its contents. An object wrapped in a cloth lies next to it. Two full book cases, one with a lectern attached, are aligned at right angles in the corner of the narrow room, and another shelving unit on wheels, holding more books and boxes, has been pushed in front of them. The controlled order of the composition relies on a strictly geometric structure of verticals and horizontals. Diagonal perspective

lines open up the space, with their vanishing point marked by the brightest spot of the lamp. Only the window wall is left out of this scheme and hence appears at a slightly oblique angle. The bright glare reflected from the white inside of the lampshade is the main source of light.

Light plays a major part in this orderly temple of bourgeois enlightenment. It projects the complementary colours green and red, which dominate the picture like a *leitmotif*, their intensity being determined by the nearness of the light. The long shadows cast by the lampshade and the bell rope dance like spirited goblins across the large green area of the back wall. Goethe said of the colour green: "Our eye finds in it real satisfaction ... One does not wish to, and one cannot, advance any further. For this reason green wall hangings are mostly chosen for rooms in constant use."[8] Red accents are used more sparingly; subdued in the shadow on the closed box on the right, they unfold their full luminosity in the bright light on the box on the left. Isolated red specks, such as the letter seals, mark the transition from shadowy to highlighted zones.

In the absence of light, the books lead a shadowy existence, their accumulated knowledge locked up in the dark until, re-awakened by the glow of the candle, the pages will add their own light of reason.[9] But light also seems to have an existence of its own; it is a living light, requiring constant attention: the lampshade has to be adjusted to the diminishing height of the burning candles, the dripping wax removed, burnt-out candles replaced and smouldering wicks cut back. But Kersting's representation lends equal emphasis to the shadows, messengers of the dark mysteries of night, threatening the unwary reader. The graceful interplay of light and shadow on the wall is characteristic of the effects favoured by the artists of the period.[10]

32
Georg Friedrich Kersting
Man reading by Lamplight, 1814
Oil on canvas, 47.5 × 37 cm
Signed bottom left: 18 GK 14.
Provenance: Dr. Herzig, Vienna; Fritz Nathan, St. Gallen; acquired 1948

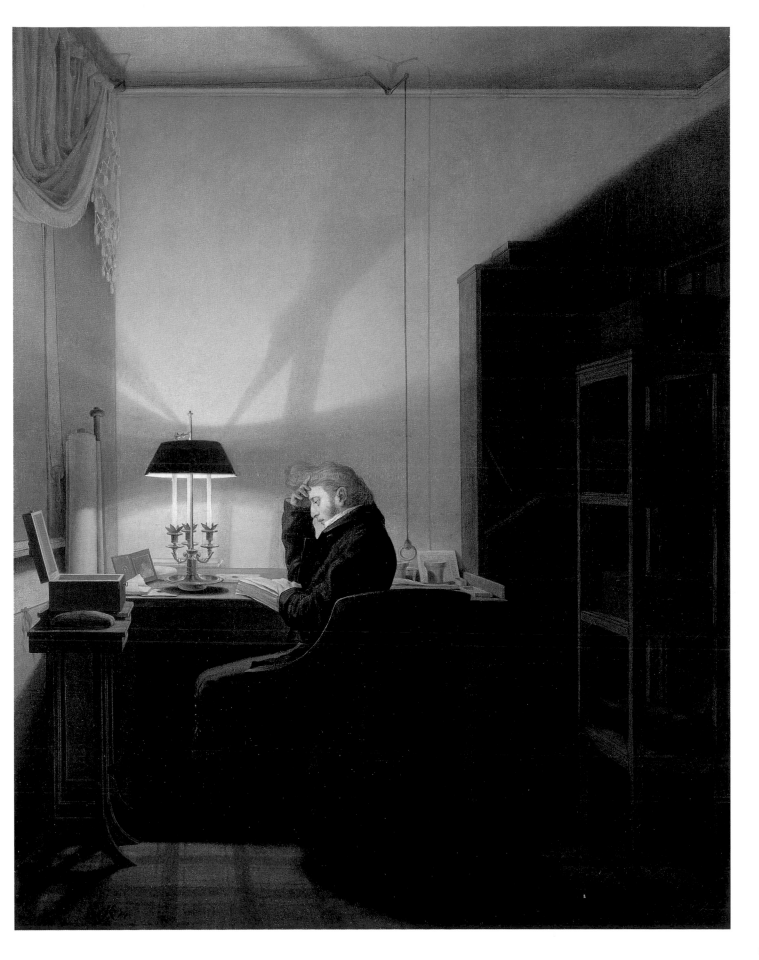

89

Johann Martin von Rohden
(1778 - 1868)

In 1795 at the age of seventeen Rohden travelled to Rome and joined the circle around Johann Christian Reinhart. He was among the first painters visiting Italy to introduce romantic elements in his work. At the time of his arrival the classicists, deferring to Claude and Poussin, still dominated the scene unchallenged. At first Rohden was strongly influenced by Asmus Jacob Carstens in history painting, and by Jakob Philipp Hackert, a favourite of Goethe's, and Reinhart, active in

Rome from 1789, in landscape.[1] He maintained friendly relations with Koch (q.v.), who had arrived in Rome in the same year as Rohden, and with Thorvaldsen and the many young artists from the Nazarene circle. Apart from a few interruptions he spent the rest of his life in Rome; he was converted to Catholicism and married the daughter of the landlord of the inn at the Temple of Sibyl at Tivoli. However, he still retained his ties with Germany.

Ludwig Richter, in his *Lebenserinnerungen* (memoirs), mentions that Rohden assumed more and more the role of an outsider in the German colony of artists, and remembers his slow manner of painting: "I often went with Rohden for an evening walk. He was at that time frequently in a bleak mood, no longer enjoying his work, for which he had lost all

35
Johann Martin von Rohden
Aqueduct near Rome, 1796
Oil on canvas, 80 × 108 cm
Signed bottom right: Rohden. pinx. Romae./1796
Provenance: Ludwigs Galerie, Munich; acquired
1936
(Pinnau G 4)

inclination. Perhaps he was sometimes depressed about the dominance of Koch who, because of his geniality, was held in high esteem and his studio much frequented by artists. By contrast Rohden attracted little attention, not least because for nearly two years one found the same picture on the easel in his studio."[2]

fig. 40
Johann Martin von Rohden
View of Tivoli (c. 1798)
Oil on cardboard, 28 × 41 cm
Provenance: Art dealer Hermann Abels, Cologne;
acquired 1932
(Pinnau G 9)

sketching outdoors, together with his meticulous depictions of nature, pointed the way for the increasing numbers of young artists, predominantly from the Nazarene circle, arriving in Rome from around 1810.

The elderly Goethe, convinced that he had found a permanent ideal of landscape painting in the work of his friend Hackert, rejected this development. As late as 1831 he wrote in a letter to Johann Gottlob von Quandt: "Much would be gained if one could wean the landscape painter from sketching after nature, so that he might learn to treat a worthy subject directly, tastefully restrained within a frame."[5] Quandt had ordered from Rohden in Rome an Italian landscape for which C. D. Friedrich (q. v.) painted a now lost pendant of a shipwreck on the ice in 1821/22, *Defeated Hope*. It was Quandt's idea to juxtapose in the pendant pictures the luxuriant splendour of southern nature with the terrifying rigour of the north.[6]

Another early outdoor oil sketch from nature is the *View of Tivoli* (fig. 40), in which large areas on the right were left unfinished to emphasise its study character.[7] The wide Campagna, with the chain of hills on the horizon flooded in southern light, is set against the dark strip of land in the foreground. It seems that immediately on arriving in Italy Rohden was introduced to *plein-air* sketching, as practised by the English and French. Tivoli, famed for its waterfalls, was a constant inspiration for the artist. The 1820 drawing *In Tivoli* (fig. 41) does not emphasise atmosphere but, with its delicate hatching, attempts to analyse the interlocking cubic forms of the houses built on the hillside.

fig. 41
Johann Martin von Rohden
In Tivoli, 1820
Pencil, 16 × 21 cm
Signed bottom right: Mv Rohden./ Tivoli 1820

55 Aqueduct near Rome

At the very beginning of his stay in Rome Rohden produced this picture, which is based on a slightly smaller version painted on paper (Hamburg, Kunsthalle).[3] A drawing in the artist's sketchbook shows the same aqueduct, inscribed *On the Road from Tivoli to Subiaco*.

The Winterthur picture is thus the end product of a development leading from the drawing via the oil sketch to the composition finished in the studio. Compared with the Hamburg version, possibly painted entirely outdoors, the area of the finished painting has been considerably increased at the sides and lower edge. Rohden added a tree on the left and a path with staffage figures in the foreground, including resting shepherds, a woman carrying water and holding a child by the hand, as well as a man riding a donkey. On the right the aqueduct has been extended by one arch. The artist simply expanded the original motif of the study all round. Irmgard Pinnau has described the dualism between the "centre scene", based on the Hamburg version, and the newly added framing zone.[4] Rohden changed a spontaneously observed view of the Roman Campagna into an ideal composition, with a resulting loss of freshness and immediacy, most noticeable in the vegetation. The rampant leafy thicket has been transformed into orderly formations of shrubs and lawns, their ornamental foliage and grass representing the ideal of regular plant growth. In the study, background and foreground are differentiated only by light and aerial perspective, whereas in the painting the depth of space is opened up by means of the path and the single motifs placed in isolation, thus adding monumentality. Rohden's process of idealising and enriching the scene with motifs from classical landscape painting, strongly dependent on Hackert's example, lends a timeless quality to the Campagna, in spite of the motif of the ruin, a symbol of transitoriness. On the other hand Rohden endeavours to accommodate wherever posssible realistic elements based on exact studies from nature. His practice of

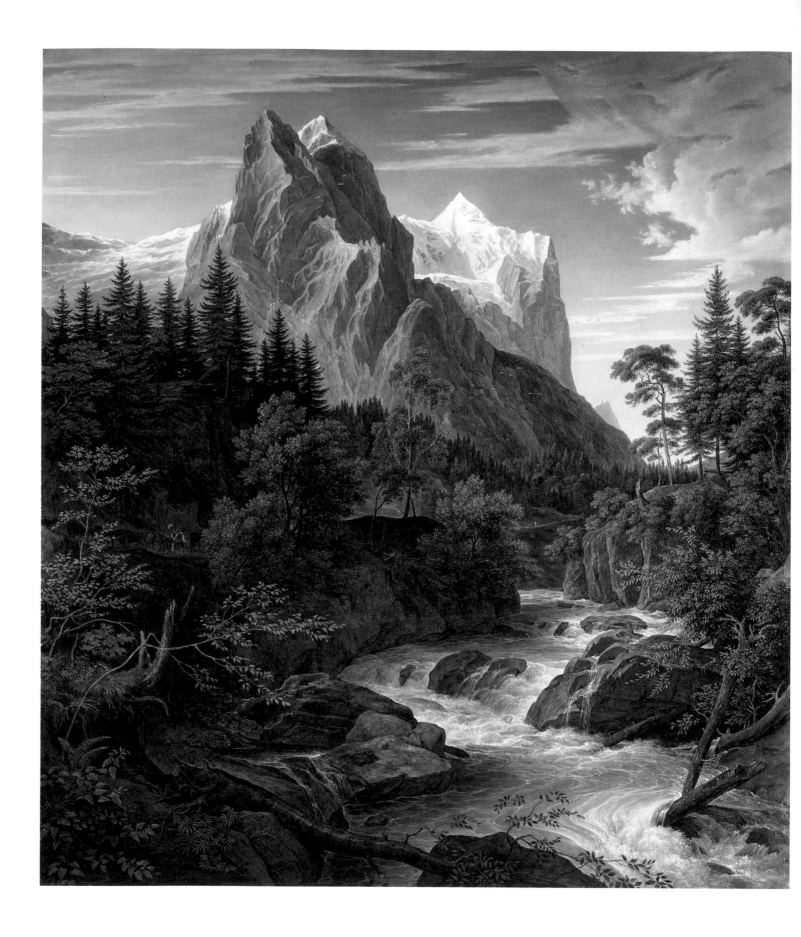

fig. 45
Ludwig Richter
The Shepherd and his Girl, 1865
Pencil and watercolour, 12.5 × 22 cm
Signed bottom left: L. Richter. 1865.

fig. 53
Carl Blechen
Street in Arien
Pen and brush
Provenance:
Galerie Arnol
(Rave 1132)

romantic loneliness of the forest identify the motif as a *locus amoenus* ("lovely place"). This impression is enhanced by the graceful plants in the foreground, which were painted by Ludwig Richter.

Richter, who grew up in the conservative late Romantic milieu of Dresden, was in Rome from 1823 to 1826, joining the group of young artists who received instruction in Koch's studio. In his *Lebenserinnerungen*, a masterly account of the life of contemporary artists in Rome, he described his relationship with Koch, whom he admired as one of the last representatives of the age of genius, but whose work left him cold: "Koch's landscapes would have more appeal for me if they were less stylised. This renders them remote from nature, something to be admired by the artist but leaving the non-connoisseur unmoved. Koch has plenty of fire, liveliness and spirit, but little love, feeling and understanding of nature. Few of his paintings, in spite of their beauty, touch the heart." Of the *Wetterhorn*, which he saw in Koch's studio, he remarked: "Koch was painting a repeat of his so-called *Greek Landscape with the Rain-*

36
Joseph Anton Koch
The Wetterhorn with the Reichenbachtal, 1824
Oil on canvas, 91 × 81 cm
Signed bottom left: I. Koch. f./1824.
Provenance: Gustav Parthey, Rome (1824); Minchen Parthey, Rome/Berlin; Elizabeth Trewendt-Parthey, Berlin (1940); Galerie Heinemann, Munich; Fritz Nathan, St. Gallen; acquired 1950
(Lutterotti G 60)

bow... He was also working on a Swiss landscape, the Scheidegg, for which he used the insignificant watercolours of a young Swiss artist, since he had never been to Switzerland himself and had no other models. He composed the picture in his own manner and I painted a piece of the foreground at his request: 'I cannot paint the little plants with my damn clumsy paw; they must be light and graceful.' Thus I put in the little plants."[11]

A carefully prepared, squared working drawing (Nuremberg, Germanisches Nationalmuseum) helps to distinguish Richter's share in the painting, which seems confined to the finely drawn leaves in the left and right foreground.[12] Richter's remark that Koch had never been to Switzerland is incorrect, since Koch had carefully observed the Swiss landscape during his youthful sketching tours in the Bernese Oberland. It seems more likely that he used his own sketches, rather than those of an unknown artist, for the composition of this painting. Richter's later career tended towards folkloristic graphics and late Romantic illustrations, which delighted unsophisticated minds (fig. 45).

Koch produced Italian landscapes at the same time as his alpine scenes. "The heroic idealism of Italian city views, representing his new spiritual home, merged with the monumentality of his native alpine world, thus combining the opposite poles of his nature ..."[13] The majestic greatness of this mountain realm seems to be made for eternity, inspiring awe but not horror. Man can find a place to live in this confined, yet acces-

sible place. Hence the staffage on the left of the picture features herdsmen with cattle, evoking the enduring image of the free mountain dwellers, probably familiar to Koch from Schiller's *William Tell*. On his very first trip to Switzerland, a school excursion to Lake Constance and the Rhine Fall in 1791, the young Koch entered in his diary: "Slaves of despots, you have every reason to envy the dwellers of the ice-clad Alps. This is a healthy, airy region where men, unscourged by the scorpion whips of tyranny, live free and happy lives."[14] The ideal of freedom may be inherent in the landscapes painted for Parthey. The *Heroic Landscape with Rainbow* perhaps alludes to the democracy of ancient Greece, while the *Wetterhorn* could be seen as a place of freedom in the mountains.

fig. 56
Carl Blechen
Near Schwyz (1829)
Pen and black ink, washed, over pencil, 22 × 33 cm
Inscribed top right: bey Schwyz
(Rave 1466)

as his description of a trip to Fiumicino confirms: "In the evening we had a marvellous view of the sea; after sunset the sky was still bright and the thunderous waves of a high sea mingled with the sunset colours in a miraculous vista."[18] He frequently painted the sun in full view, boldly confronting its elemental force, unlike Caspar David Friedrich, for whom the sun was a symbol of the absolute, to be rendered not in direct observation, but only in its colourful effects in the sky.

The innovative paintings of Italian views which opened up a new epoch of landscape painting found not only critics but also admirers. Ernst Heinrich Toelken, Secretary of the Academy of Arts, wrote in his memorial speech (printed in 1841): "There is a tradition in all the arts which, though not prescribed, occupies so exclusively the position of truth as to render it vitually invisible to the glance. Its principle in general is the moderation of all extremes, the exclusion of the unusual, and rightly so. The extraordinary is not in order because it oversteps the mark of the usual, thus abolishing the existing rule. For that reason alone every step forward in the arts rests on the liberation from hitherto valid principles, which need not thereby lose their own validity. The traditional image of Italy is derived from Caspar Dughet's and Claude Gelée's immortal works, with perhaps additional traits from Hackert and Catel. Blechen's paintings have now revealed an astonishingly different view of Italy: the dark saturated green, the sky-high cypresses, the radiance of the light, the sky and the sea, the vibrant local colours, the overpowering contrasts. Over barren stretches of rock with only traces of parched dusty and expiring vegetation hangs the glow of a spent summer's day; dry stones tremble in a blinding light. Art lovers were moved by the poetic force of these representations, but were too timid to embrace them."[19]

The sensation caused by Blechen's Italian landscapes brought him professional suc-

42
Carl Blechen
The Building of the Devil's Bridge (c. 1833)
Oil on paper, mounted on panel, 15 × 22.5 cm
Provenance: Coll. H. F. W. Brose, Berlin (before 1863); M. Grosell, Copenhagen; Ludwigs Galerie, Munich; acquired 1932
(Rave 1459, 1460)

cess. In 1831, on the recommendation of Schinkel, he was made a professor of the Berlin Academy of Arts. However, commissions were still scarce; King Friedrich Wilhelm III, who occasionally bought Blechen's works at exhibitions, commissioned the two famous views of the palm house on the Pfaueninsel (Peacock Island; Potsdam, Castle Sanssouci), which the artist executed with great attention to detail. Blechen also painted *A Ruined Chapel* for the Königsberger Kunstverein. The dealer Louis Friedrich Sachse, owner of the most respected art gallery in Berlin, looked after the sale of Blechen's pictures. Amongst early collectors of Blechen's works were the publisher and book-dealer Decker and the bankers Brose and Kuhtz.

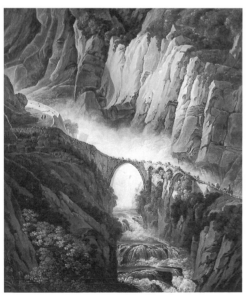

fig. 57
Peter Birmann
The Devil's Bridge, 1811
Oil on canvas, 62 × 51.5 cm
Signed bottom right: P.Birmañ. Pinxit.l.N 17 1811
Provenance: Kunsthaus Pro Arte, Basel; acquired 1942

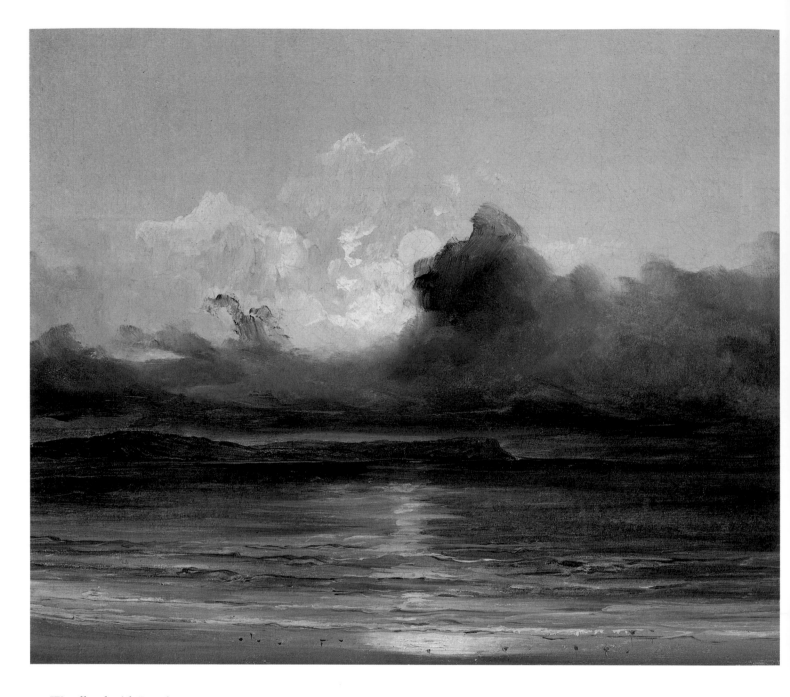

44 Woodland with Brook

Increasingly Blechen returned to the motifs which he had painted before his tour of Italy, namely German landscapes, forest interiors and ruins. These works benefited from the artist's experience in the south and his new firmly controlled brushstroke. However, the first signs of mental illness began to affect his artistic output, which soon became dominated by premonitions of death and decay. He created, so to speak, interior views of nature. The forest becomes a threat, leading a life of its own, overgrown with rampant vegetation, and trees twisting in agony resem-

ble suffering individuals.

Contemporary art critics observed these tragic changes. Count Athanasius Raczynski, in his *History of the New German Art* of 1841, wrote: "Under his brush nature assumes an alien character; he has an extraordinary fascination; his spirit is affected by a deep melancholy. His works move and attract us, and their monotonous colouring has the effect of enhancing them. He has the gift of discovering in nature effects which had not been experienced by anybody before him, and of which academic teaching is unaware; effects whose deeper meaning most of the

43
Carl Blechen
Sunset at Sea
Oil on canvas, 24 × 27.5 cm
Provenance: M. Grosell, Copenhagen (1927); Ludwigs Galerie, Munich; acquired 1932
(Rave 1338)

44
Carl Blechen
Woodland with Brook (1831/35)
Oil on canvas, 47.5 × 38 cm
Provenance: Coll. von Decker; Walter Unus, Berlin; Gertrud Heinrich, Berlin
(Rave 1916)

Johann Georg von Dillis
(1759-1841)

A man of many interests, Johann Georg von Dillis started his artistic career relatively late. His father was a forester employed by the Elector's court. With the help of his godfather, the Elector Maximilian II, Johann Georg attended the gymnasium at Munich and studied theology. He was consecrated as a priest in 1782 and was a member of the freemasons for a short period. In 1786 he applied for a dispensation from his clerical duties. He then gave drawing lessons in aristocratic Munich houses and accompanied his patron and friend, Count Rumford,[1] on study trips to the Bavarian Alps, as well as to Switzerland, Mannheim, Mainz, Frankfurt, Dresden, Prague and Vienna. In 1790 he was appointed inspector of the Elector's painting gallery at the Hofgarten, Munich. This position carried great responsibility at a time when Napoleon's invasions and a trend to secularisation caused the displacement of many works of art, particularly from churches.

From 1794/95 Dillis made a number of lengthy tours to Italy, staying in artistic circles in Rome (Koch, Kauffmann, Thorvaldsen) and purchasing works of art for the Bavarian Royal Court. He visited Italy at regular intervals, making eleven trips up to the time of his death.

In 1808 he was appointed professor of landscape painting at the Munich Academy of Visual Arts. However, he was sceptical about the value of academic study: "The most important question is – have academies helped or hindered painters? – have they furthered the acceptance of art and good taste? – has ever an academy produced a great genius?"[2] The standards of classicism imposed by the academies were incompatible with the concepts of *paysage intime*, the study of unadorned truth to nature. In 1814, when Joseph Anton Koch's (q. v.) *Noah's Sacrifice after the Flood* won the prize for landscape painting at the Academy, Dillis resigned his position: "I cannot exist amongst such beasts of art, I must tender my resignation," he wrote in a draft letter to the Crown Prince.[3] Wilhelm von Kobell (q. v.) succeeded Dillis as professor of landscape art.

After Dillis had come to see his famous collection of Old German pictures, Sulpiz Boiss_rée described his impression of the artist in a letter to Goethe: "Having heard much about this distinguished connoisseur, we found our expectations surpassed by his in-depth knowledge. He has acquired works of art in Italy for the Crown Prince of Bavaria and currently is in charge of most art purchases for Bavaria. Since his first vocation was as a priest he painted landscapes merely as a hobby which, apparently, he continues mainly for the sake of the experiments he has been conducting for almost thirty years regarding the properties of colours, oils etc."[4] Dillis painted a series of mostly small-scale portraits, but his greatest artistic achievement are his fluently painted landscapes which are free of all academic restraints. They fall into two major categories, the southern (Italian) views, and the more numerous northern views. In the late eighteenth century Dillis discovered the beauty of his homeland and started painting motifs from the Upper Bavarian mountains, the Alps and the surroundings of Munich. The sketchy view of the *Trivasschlösschen* (Trivas Castle), painted in 1797 (Munich, Neue Pinakothek), with its spontaneous effect, is an amazing early example.

As a master of small-scale painting Dillis continued the tradition of *plein-air* studies he discovered in Rome, then the focus of modern art. His three views of the city from the tower of the Villa Malta, painted in 1818 (Munich, Schack Galerie), are his best known and internationally acclaimed works. Conceived as a triptych, these relatively large-scale paintings anticipate the character of the Italian views painted by Corot some ten years later.

Dillis was impressed with the work of French painters in Rome; in 1805 he visited Simon Denis, whose oil sketches he admired.[5] Shortly after its appearance in 1805 he probably read Valenciennes' treatise, *Eléments de perspective pratique à l'usage des artistes*, which offers practical hints on *plein-air* sketching in oil and draws attention to the form-dissolving effect of atmospheric light. He also had contacts with Corot's teacher, Jean-Victor Bertin. In 1806 he was in Paris, continuing his visits to artists' studios, amongst them that of Jean-Joseph-Xavier Bidauld.

In 1794 he travelled in the Salzburg region in the company of his patron, Count Rumford, and the 2nd Viscount Palmerston, who seem to have acquainted him with the latest artistic developments in England, perhaps showing him some of the prints then in circulation after works by Richard Wilson, Joseph Wright of Derby, William Pars, Thomas Jones, John Robert Cozens and "Warwick" Smith.[6] Dillis also read works by the English aestheticias, such as William Gilpin's *Three Essays* (1792); of these the essay "On Picturesque Beauty" had a special fascination for him. In Rome Dillis was introduced to Turner's new light-dominated painting technique.

Dillis was too mature an artist to imitate literally such English and French models in his own works. However, he derived inspiration from the great variety of their new discoveries, to the benefit of his own artistic development.

46 The Prater Island near Munich

To encourage the study of nature Dillis, when teaching at the Academy, took his students on rambles around Munich. The marshes along the Isar, the English Garden, and the Prater Island offered many picturesque motifs. Inspired by Ruisdael, Everdingen and Hobbema, Dillis made studies of old gnarled trees and other aspects of unspoiled nature. The present study offers a relatively restricted view dominated by a massive group of trees that fill, and reach beyond, the picture space. The tiny figure of a farmer seems lost in the thicket. The emphasis on trees takes precedence over topography or landscape, anticipating one of the characteristics of the Barbizon School.

Dillis' peaceful scenes still echo Rococo idylls in the manner of Salomon Gessner, but the latter's nymphs have been transformed into mothers with children, and flute-playing fauns into peasants on their way to work. Romantic mythology has given way to painterly representations of everyday scenery. Böcklin (fig. 87) and Corot, in his late work, were to reverse this trend, restoring the nymphs to the leafy thickets, full of mystery.

46
Johann Georg von Dillis
The Prater Island near Munich
Oil on paper, mounted on cardboard, 25.5 × 19 cm
(Messerer 24)

Christian Morgenstern
(1805-1867)

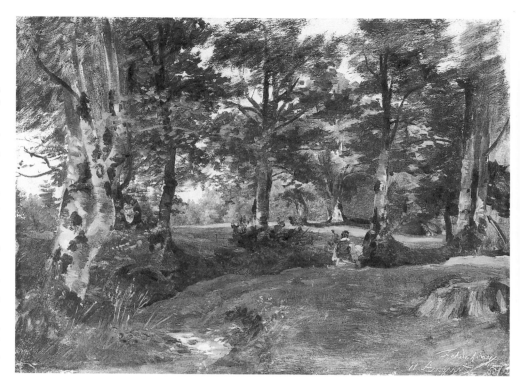

Morgenstern's talent, like Wasmann's (q. v.), who was also born in Hamburg in 1805, developed fully only in the south, in the region of the Alps. Originally he trained in the studio of the panorama painter Cornelius Suhr. With Suhr he travelled to Russia in 1820-23 to display panoramas. After returning to Hamburg he entered the painting school of Siegfried Bendixen and moved in the circle of the Hamburg Romantics. He completed his artistic education at the Copenhagen Academy in 1827-28, and then undertook study trips to Sweden, Norway and the Harz mountains of Germany, settling in Munich in 1829. Taking the achievements of Dillis (q.v.) and Kobell (q. v.) as examples, he discovered during his early Munich years the attractions of the city's surroundings and the fascination of the Upper Bavarian alpine foothills under changing atmospheric conditions. From 1835 he maintained a close friendship with Carl Rottmann (q.v.).

51 View across Lake Starnberg to the Benediktenwand

The surroundings of Lake Starnberg inspired the artist to produce several enchanting paintings, such as this south-easterly view from Starnberg across the lake. On the opposite shore the Castle Berg can be seen, where King Ludwig II drowned in 1866. Above it, on the left, lies the village of Aufkirchen, and in the background rises the Benediktenwand. Although the alpine chain is veiled in a thin mist and thick clouds have gathered on the left threatening rain, the painting is bright and clear. In particular, the snow on the mountain peaks shines blindingly white in the sunlight. The painting is structured in horizontal strips dividing it into brighter and darker zones which, notwithstanding the vertical composition, suggest the expansiveness of the landscape. The scene appears like a random cut-out from a greater vista which could be infinitely extended. Morgenstern reduced the distinct horizontality by the diagonal movement of the clouds on the upper left, balanced by the clump of trees in the right foreground. According to the artist's son, the Winterthur picture originated in 1844, the year of Morgenstern's marriage.[1]

fig. 66
Christian Morgenstern
Forest Stream in the Rennetal (Harz) (1829)
Oil on paper, mounted on panel, 28 × 33 cm
Provenance: Kunsthalle Hamburg (1905-50); acquired 1950
(Mauss 41)

fig. 65
Christian Morgenstern
Near Feldafing, 1857
Oil on paper, mounted on Pavatex, 25.5 × 35.5 cm
Inscribed bottom right: Feldafing / 11 August 857
Provenance: Fritz Nathan, St. Gallen; acquired 1946
(Mauss 247)

A comparison with the painting *Lake Starnberg* (Munich, Städtische Galerie im Lenbachhaus),[2] with its overall bright tonality, reveals an increased dissolution of the landscape in light. This painting is variously dated around 1830, or in the 1840s,[3] which makes it difficult to establish the chronological sequence of the two versions and the stylistic development involved. Interestingly, both views can be joined almost seamlessly to form a continuous panorama of Lake Starnberg with the wreath of the Alps above. In such works Morgenstern approaches the high standard of *plein-air* painting attained by Wasmann in his fluidly sketched Tyrolese landscapes.

51
Christian Morgenstern
View across Lake Starnberg to the Benediktenwand
(1844)
Oil on paper, mounted on panel, 31.5 × 33 cm
Provenance: Kunsthalle Hamburg (1905-50); ac-
quired 1950
(Mauss 157)

In his later career Morgenstern increasingly turned to the subtle charms of more modest scenes of nature. Dreamy visions of wooded thickets, moorlands and heather landscapes mark him as a painter of the *paysage intime*, close to the aims of the Barbizon School artists. Thus the landscape *Near Feldafing* (fig. 65), a region on the western shore of Lake Starnberg, painted in muted greens, shows a narrow sector, arranged in a rhythmic pattern of parallel layers with tree trunks placed at regular intervals. The picture differs from the earlier *Forest Stream in the Rennetal* (fig. 66) by its broader brushwork; the artist is no longer attempting a depiction of nature in minute detail, but seeking to capture the instant atmospheric impression.

fig. 70
Friedrich Wasmann
Girl looking up (c. 1844)
Crayon on blue paper, 25.5 × 17 cm
(Nathan 528)

fig. 71
Friedrich Wasmann
The Painter Eduard Freudenberg (c. 1828)
Crayon, 18.5 × 15 cm
(Nathan 388)

fig. 72
Friedrich Wasmann
The Artist's Sister, 1828
Pencil, 18 × 13 cm
Inscribed bottom right: 1828
(Nathan 382)

As a native of Hamburg he also would have known the works of his early eighteenth-century compatriot Balthasar Denner, whose depictions of old people reveal even the finest wrinkles. This approach, rather than the classical approach taken by idealising portraitists from Ingres to Hayez, is characteristic of numerous portraits by Wasmann, marking him in some way as a Douanier Rousseau *avant la lettre*.

The impressive, near life-size portrait of the woman from the Tyrol appears naive in its concept, absorbing in its psychological penetration, and disquieting in its aura. The figure is made up of compact, round volumes, monumentally filling the picture plane in the form of a solidly based triangle, on top of which, separated by the shining white collar, sits the face: a bizarre landscape of soft mounds, furrows, reddish nose and rosy cheeks. The pinched lines around the mouth and, above all, the eyes with the uneven lids express sadness and mistrust. The woman's character seems a riddle, giving rise to the fascinating conclusion that sorrow and malice are closely allied in her nature. Is she sinned against or sinner? The observant

viewer will find it difficult to avoid this question, to which there is no unequivocal answer. The woman's pose suggests wounded pride. Her arms, resting on her ample hips, are folded across her stomach, with one hand hiding the other.

Wasmann's merciless realism penetrates every detail. Thus the cords of her coral chain dig into the soft flesh of the neck, the bright red of the coral adding a shrill contrast to the rosy, pulsating flesh tones; even the wart under her right eye is included.[2]

The bonnet, the blue dress and the grey-patterned apron recall the colour scheme of

Leibl's (q. v.) masterpiece *Three Women in Church*. These two paintings also share the unity of an intentionally "unclassical" style and the rural milieu of the women portrayed. Retreating from the civilisation of large cities, both painters were searching for the memory of an unspoilt existence close to nature.

As with most Nazarenes, drawing plays an important part in Wasmann's work, particularly in his portraits. The drawings *Girl looking up* (fig. 70), *The Painter Eduard Freudenberg* (fig. 71) and *The Artist's Sister* (fig. 72) are telling examples of the artist's sharp psychological penetration into the sitter's character.

53
Friedrich Wasmann
Portrait of Maria Eisenstecken-Oberrauch, 1841
Oil on canvas, 82.5 × 59 cm
Signed bottom left: Wasmann f l 1841
Provenance: Bernt Grönvold; Minka Grönvold; Ludwigs Galerie, Munich; acquired 1931
(Nathan 31)

54 View near the Village of Ahorn with the Loser and Sandling Peaks

Between 1830 and 1843 Waldmüller regularly spent his summers in the Salzburg region, mostly at Bad Ischl. The purpose of his travels, however, was not solely the "use of the baths for the sake of my health", as specified in his request for leave.[10] He was fascinated by the untouched nature of this landscape, but he was not the only artist to discover it. In around 1815, the Olivier brothers (fig. 49) and Julius Schnorr von Carolsfeld (fig. 48) had painted Salzburg landscapes, starting a trend that became the fashion in the 1830s, with Stifter, Gauermann and others.[11] In those years Ischl was the most popular resort in Austria. When the Archdukes Rudolph and Franz Carl and the Archduchess Sophie successfully tried the healing powers of the baths, Ischl became a favourite place for the Imperial Court, in whose wake the nobility came to summer in their country houses. The theatre (built 1827), the pump room (1829-32) and the casino (1840) were the centres of society gatherings, but the surroundings of Ischl were also explored and viewing points, such as Sophienplatz, Elisenruhe, Karolinensitz and Dachsteinblick, were established around the town. At the same time the Rettenbach area (fig. 75) was opened up, where Waldmüller often painted.[12] Attracted by the gushing stream deep down in the abyss, he approached his motif so closely that only a small segment of sky is visible.

In the years 1833 and 1834 Waldmüller worked in the village of Ahorn, situated west of Ischl, adopting various vantage points for his paintings.[13] He enjoyed climbing the slopes of the valley up to where the eye could roam unhindered into the distance. In the present work the view extends from a brightly lit patch of meadow in the foreground, past a group of maple trees and across the village that has sunk so far into the depths of the valley that only the roof of a house remains visible. Behind the wooded hills at the other side of the valley the silhouettes of the Loser and Sandling mountains appear.

"Waldmüller was captivated by the pristine green wilderness in its summery growth, the narrowly limited segment of nature with its cool shadows and the grasses and stones, branches and leaves, glowing in warm, sunlit

colours... The lack of aerial perspective in the high mountains favoured Waldmüller's artistic intentions, making the faraway mountain chains and forest slopes appear as clear and as tangible as the foreground motifs, with no loss of definition in the distance, which for Waldmüller was an essential requirement. There was no veiling, or unifying or dissolving atmosphere. The depth of space revealed itself almost exclusively by overlapping and layering of forms."[14] This observation applies particularly to the 1832 painting *The Dachstein with Lake Gosau* (fig. 76).[15] Compared with Rudolf von Alt's *View of the Altaussee Valley* (fig. 78), painted in the same year and also showing the Dachstein, but with a conventional foreground, this picture strikes one as very modern.

Waldmüller's landscapes of those years, offering sweeping views from an elevated position into wide spaces which open up in depth by means of receding motifs, suggest an arbitrary field of vision. "The essential compositional achievement does not depend on the invention of certain space constructions but on the choice of a vantage point corresponding to the painter's ideal concept of space. The pictures of this phase present themselves without any noticeable intrusion into the visible landscape formation. The view is determined entirely by the painter's position. The viewer, in a way, assumes the place occupied by the artist while painting and thus gains a coherent, homogeneous picture of expanding space. When contemplating the landscape one crosses the aesthetic threshold towards the picture."[16]

By limiting the view to a radically confined section he increases the value of objects hitherto found unworthy of painting. This process has its parallel in photography, which was gradually becoming known at the time. Indeed, Waldmüller was very interested in using such technical aids to achieve his aim "of reproducing nature with utmost fidelity." Athanasius Count Raczynski reported as early as 1840 that Waldmüller "consulted the black mirror when drawing his nature studies."[17] It is also assumed that Waldmüller in his later work made use of photography. His landscapes of the Prater (Vienna) and the Salzburg region, exhibited in the 1830s with the note "studies from nature", served as experiments for exploring the effect of light.[18] He liked to work in full sunlight which elimi-

fig. 76
Ferdinand Georg Waldmüller
The Dachstein with Lake Gosau, 1832
Oil on panel, 31.5 × 25.5 cm
Signed bottom left: Waldmüller/1832.
Provenance: Coll. Palmer, Vienna (until 1915); auction Dorotheum, Vienna (1915); A. Huber-Traffelet, Fribourg; acquired 1942
(Grimschitz 314)

55
Ferdinand Georg Waldmüller
The Sandling Mountain near Altaussee, 1834
Oil on panel, 31.5 × 25.5 cm
Signed on the riverbank, left: Waldmüller 1834.
Provenance: Paul Rauers, Hamburg; Ludwigs Galerie, Munich; acquired 1928
(Grimschitz 377)

nated the intermediary tones and made objects appear in their unchanged "objective" form. Clearly the artist did not share the Romantics' predilection for obfuscating transitional states, such as dusk, and for night and winter scenes pregnant with mood.

55 The Sandling Mountain near Altaussee

This accomplished small-scale panel is based on an oil sketch on canvas, presumably made on the spot.[19] Water, meadow, forest and mountain ridge are arranged in superimposed layers parallel to the picture plane. Clouds cling like cotton wool to the peak of the Sandling, monumentally extending its height into the foreground. Their contours correspond to the rounded hilltops of the mountain massif that rises behind the forest like a slumbering prehistoric colossus. A tiny hut, above which lies a dense strip of mist, seems in danger of being crushed by nature's forces creeping in from all directions.

Astonishingly, at the same time as Waldmüller, Friedrich Gauermann found his way to a similarly unconventional, naturalistic representation of landscape. Even before 1830 he produced a small number of nature studies from the Salzburg Alps (fig. 77), which easily rival those of his more famous compatriot.

Waldmüller's understanding of nature, which embraces every incidental detail, finds a parallel in the theories of the Austrian author Adalbert Stifter who, under Waldmüller's influence, also painted views around Salzburg. In his preface to *Bunte Steine* (Coloured Stones), of 1852, Stifter describes the working of the "gentle law", which he had postulated: "The drifting of air, the running of water, the growing of grain, the heaving of the sea, the greening of the earth, the glowing of the sky, and the gleaming of the stars I con-

fig. 77
Friedrich Gauermann
Mountain Landscape
Oil on paper, mounted on panel, 28.5 × 39.5 cm
Provenance: Ludwigs Galerie, Munich; acquired 1935

sider as great: the approaching storm, the lightning splitting houses, the gale driving the surf, the mountain spitting fire, the earthquake burying lands, I do not consider greater phenomena than the above, indeed I consider them lesser because they are only the effect of much higher laws." Stifter applies this "gentle law" also to people: "A whole life full of justice, simplicity, self-control, reasonableness, effectiveness in one's own sphere, admiration of beauty, coupled with a serene and calm endeavour, I consider as great: powerful emotions, terrifying wrath, lust for revenge, the fanatical spirit seeking action, change, destruction, while often in its fury throwing away its own life, I do not consider greater, but lesser, as these things are only manifestations of isolated and one-sided powers, comparable to storms, fire-spitting mountains and earthquakes. We will endeavour to discern the gentle law which governs the human race."[20] Stifter's definitive rejection of the aesthetic of the sublime carried with it the re-evaluation of the commonplace with its quiet contemplation. Heroic themes

in landscape paintings, such as storms, gales, volcanoes and earthquakes, and in history painting, as in the work of Füssli (q.v.), which prevailed around 1800, were no longer congenial to Waldmüller. His genre paintings, with depictions of the simple life, also found their theoretical mouthpiece in Stifter. The detailed study from nature, established since the time of classicism as a preparatory stage in painting, had now become the accepted motif of the finished painting itself. In this way Waldmüller reached the same phase of realism as the painters of the Barbizon School in France, for instance Corot, and also of Courbet and Daumier.

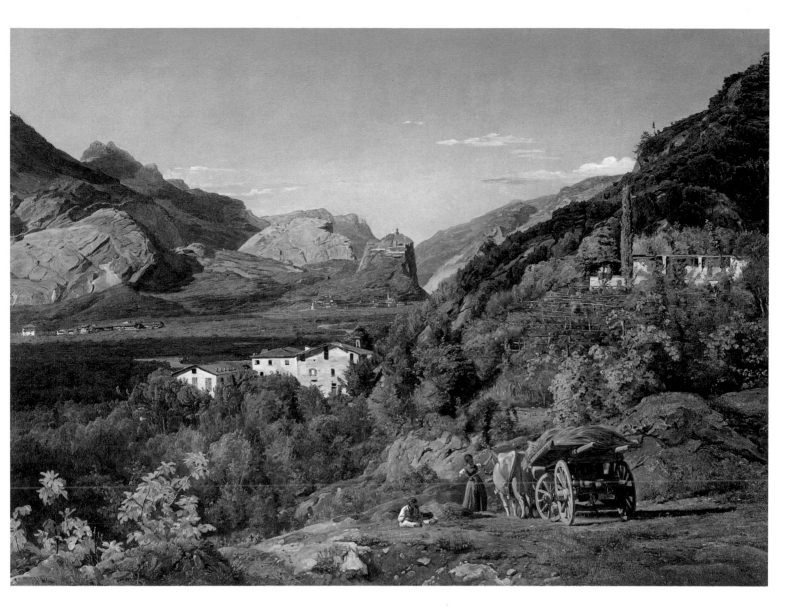

56 View of Arco

From 1825 Waldmüller travelled to Italy almost every year. On his 1841 journey, which took him as far as Sicily, he painted landscapes near Lake Garda, in which he renewed his experiments with luminosity. This development culminated in views of Sicily, painted from 1844, in which he tried to suggest the glaring light of the sun by a glowing ochre-brown palette. These southern landscpes, mostly painted in a square format, are again more spacious.

In the *View of Arco*, featuring a village north of Lake Garda, the foreground, rising diagonally from the lower left to the upper right margin, takes up almost half the picture space. Behind it the wide valley expands towards a mountain panorama which closes the composition. There, in a central position,

rises the Schlossberg, topped by the four-teenth-century castle which Dürer, on his return from Italy, had made the subject of his famous watercolour (Paris, Louvre). The eye follows a northerly direction along the route across the Alps, dominated by the Schloss-berg. The light falling from the left foreground suggests that Waldmüller captured the intense mood of a late afternoon when long shadows were beginning to spread in the valley. The light makes the landscape glow with rich colours. In contrast to the mostly unpeopled Salzburg landscapes, figures are reintroduced, heralding Waldmüller's increasing trend towards genre painting.

Light and colour have become the determinant means of expression. In pursuit of this aim Waldmüller practised painting in pure sunlight, for which his contemporaries

56

Ferdinand Georg Waldmüller
View of Arco, 1841
Oil on canvas, 44.5 × 57.5 cm
Signed centre bottom: Waldmüller 1841
Provenance: Siegfried Count Wimpffen, Vienna
(1907); Ludwigs Galerie, Munich; acquired 1930
(Grimschitz 593)

showed little appreciation: "According to hearsay, in his old age he hit on the idea that to obtain a shining colour one must paint by sunlight."[21]

The artist sought to explain his theories regarding his artistic work. He declared himself opposed to drawing in preparation of a painting, although he had followed this practice himself in some of his early work, and asserted the primacy of painting above drawing. He felt "certain that whoever could paint could also master all methods of drawing ... By study and experience I have gained the conviction that a full knowledge of the effects of light and shadow can only be obtained by painting in oil, because by this method alone can one achieve a representation as close as possible to nature." At the same time the brushstroke "must always follow the form, that is, observe the principle that vertical forms cannot be realised by horizontal brushstrokes and vice versa." Indeed, his paintings show how the brushstrokes, by their varying intensity, structure the surface of the picture. "Only by observing and applying the correct intensity of light and shade can the correct colour be realised." For this purpose the student should view "the motif as a whole, in order to find the highest light and the deepest shadow; an excellent aid for this is to close one eye completely and observe the objects with the other eye half-open. He [the student] should then discern: a) the place where a light or a shadow falls; b) the form of this light or shadow; c) their intensity. If he fails to observe one or other of these, the effect will be inaccurate."[22] Waldmüller's technique can be examined in his unfinished paintings; he always painted a little bit at a time, unfinished portions remaining as white underpainting.[23]

57 Portrait of Countess Anna Maria Kinsky

Anna Maria Kinsky, daughter of Count Stephan Zichy and Countess Franzisca Anna Starhemberg, was the wife of Prince Anton Kinsky (1817-46). Waldmüller's paternal grandfather had been employed by the family in the eighteenth century as coachman and wagonmaster to Prince Franz Ulrich Kinsky in Vienna.[24] The young twenty-three-year-old countess, somewhat unwillingly sitting for her portrait, had been widowed the year before and is therefore dressed in mourning. The picture is accordingly subdued in colour, with black, white and grey tones dominating. Only the posy of flowers with its warm red and green hues, an enchanting example of Waldmüller's still-life painting, together with the gold bracelets, supply accents of colour. The armchair covered in red damask seems to be a studio prop; it is also used in the *Portrait of the Artist's Wife* of 1850 (Vienna, Österreichische Galerie) and in other portraits of that period.[25]

57
Ferdinand Georg Waldmüller
Portrait of Countess Anna Maria Kinsky, 1847
Oil on canvas, 79 × 63.5 cm
Signed right: Waldmüller/ 1847.
Provenance: Galerie St. Lucas, Vienna (1921); Oskar Beil, Vienna; auction Dorotheum, Vienna (1934); M. Lindemann, Vienna; acquired 1934
(Grimschitz 703)

Waldmüller generally preferred portraits on a small scale, but here he has filled the canvas with the imposing nearly life-size figure of the sitter in a composition of classical severity. He devoted much time to the accessories and the precisely rendered variations of the fabrics, as if intending to distract from the slightly sullen expression of the countess. Her features seem to be a little lost in the elongated plump face, with only the nose, of a less than Grecian shape, sitting squarely in its place. Waldmüller did not attempt to ennoble nature. As a naturalist he faithfully reproduces the visible. It remains for the viewer to detect any inner beauty in the facial features, as in Stifter's *Brigitta*.

The artist usually commenced his portraits without any preparatory drawing. He remarked to his pupil Emmerich von Zichy: "I envy the painters who can work from memory or from a drawing, a sketch; theirs is a gift I do not possess." Working exclusively from the model was an unavoidable necessity to him, which was sometimes criticised. A reviewer of the 1845 Vienna Art Exhibition wrote in the *Leipziger Illustrierte Zeitung* that Waldmüller was "no more than an admirable copy-machine".[26]

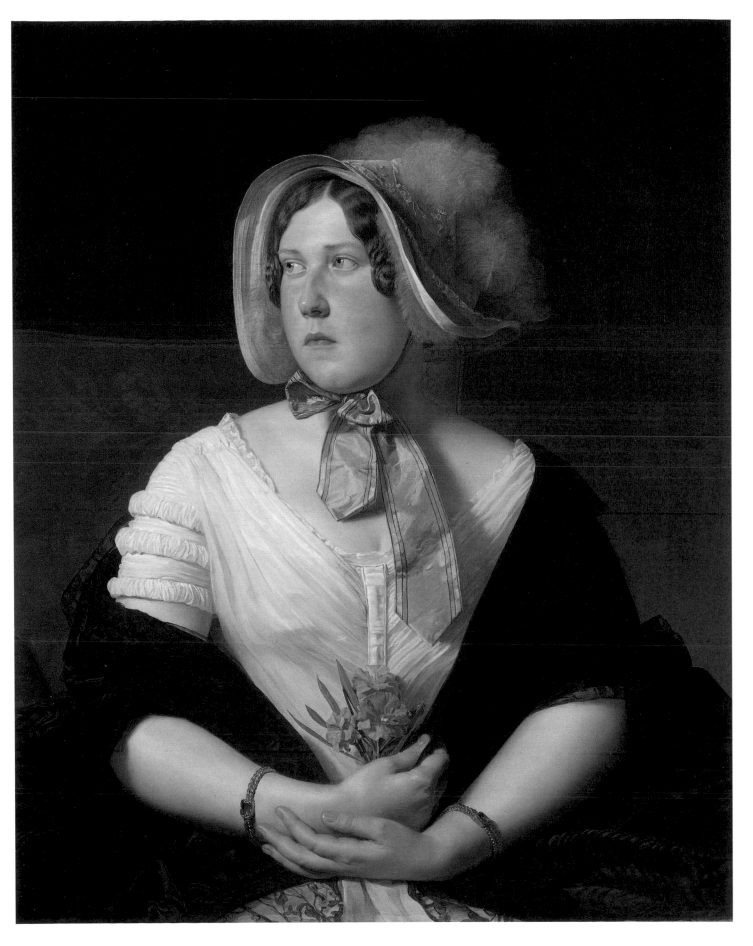

fig. 81
Jakob Alt
Wooded Valley with Factory, 1865
Oil on canvas, 29 × 36 cm
Signed bottom left: Jac. Alt/1865
Provenance: Walter Boesch, Zurich; acquired 1950

58 The Monastery of Melk on the Danube

The monastery at Melk often inspired Jakob Alt and his son Rudolf. Built by the architect Jakob Prandtauer between 1702 and 1731, it is one of the most important Baroque buildings in Austria, and its picturesque position on a rocky pinnacle above the Danube makes it especially popular.

The cycle of 71 engravings of *The Danube from its Source to Belgrade*, published in 1826, includes a view of Melk from a similar vantage point, but with a different foreground. The caption to the print expresses the fascination felt by contemporary viewers: "The imposing apearance of this Benedictine monastery equipped with royal splendour, situated on a modest hill close to the bank of the river and above the neat market town, far outshines all other castles, monasteries and buildings on the Danube."[4]

The Winterthur painting has a direct connection with the day- and night-views of Melk painted for the Emperor Ferdinand I's peep-show box, on which father and son worked between 1833 and 1848.[5] The 1834 day-view is seen from a virtually identical vantage point. The 1846 night-view, which is preceded by the 1845 Winterthur painting, features the same steamboat, not included in the day-view. Presumably this was the *Maria Anna* operating between Vienna and Linz.[6] Nothing else in the picture refers to the new industrial age. The people strolling leisurely along by the river under the protective bulk of the monastery are not overawed by the technological progress represented in the Biedermeier shipping idyll on the Danube. Nothing as yet indicates the accelerated rhythm of life to which Menzel reacted with his unfailing power of observation.

In his later years, however, Jakob Alt was more aware of the impact of industrialisation on the landscape, which prompted him to adopt a realistic approach in his work, as in the 1865 picture *Wooded Valley with Factory* (fig. 81), one of the earliest representations of a modern industrial plant in Austrian painting. Perhaps under the influence of Waldmüller, Alt paid increasing attention to the effect of atmospheric light which envelops both nature and technology. However, it was left to his son Rudolf, in the watercolour *The Kitschelt Iron Foundry in the Skodagasse, Vienna* (1903), to follow the modern approach to the representation of industry as demonstrated in Menzel's *Iron Mill* (1875; Berlin, Nationalgalerie).[7]

58
Jakob Alt
The Monastery of Melk on the Danube, 1845
Oil on canvas, 34.5 × 30 cm
Signed bottom right: J. Alt 1845
Provenance: Carl Lugner, Vienna (1912); Fritz Nathan, St. Gallen; acquired 1950

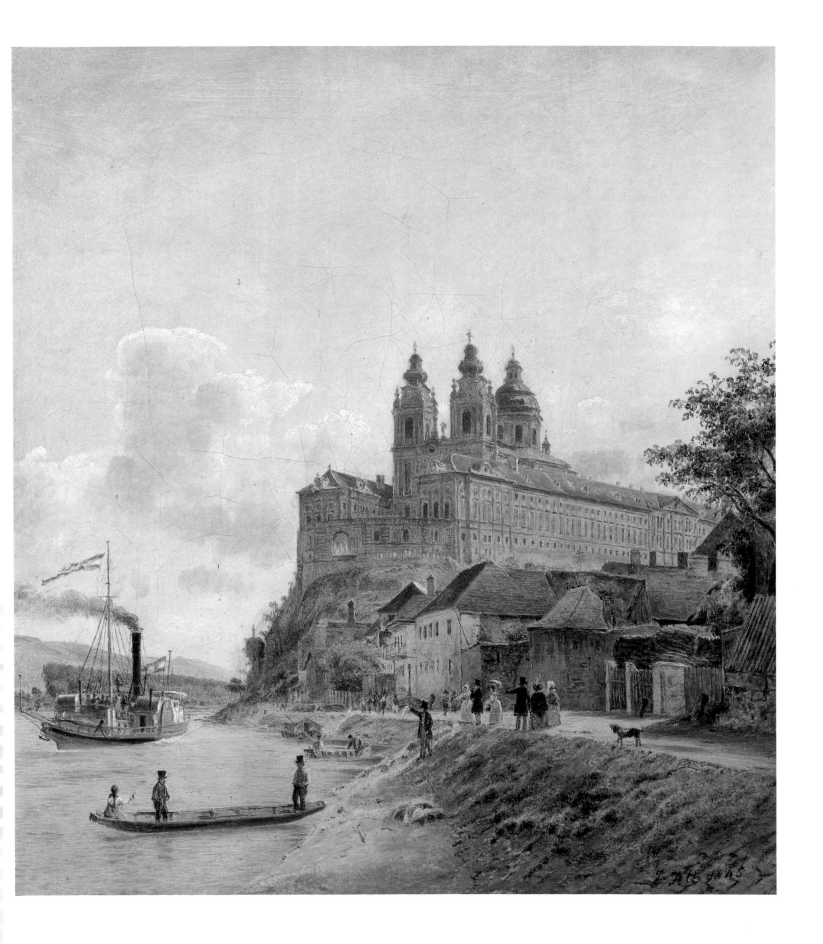

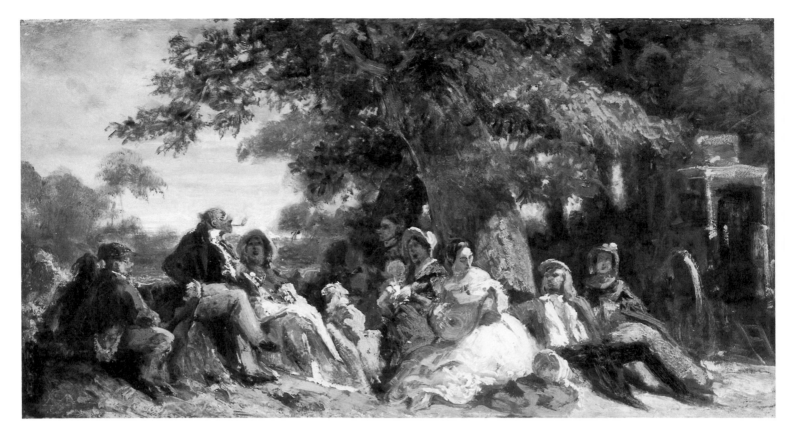

freedom aspirations of the Sansculottes are still in the far future. They refer to a time when nightwatches belonged to the everyday life of a city. The picture, dating from *c.* 1860 to 1870, is a memento of a sheltered small town as yet untouched by modern life and the technical innovations of the industrial age. Spitzweg pays homage to the idyll of a vanished epoch, remote from historical reality, which from appearing merely picturesque had, with the lapse of time, become transfigured. Mysteries lurk in the dark nooks of the little town. The fountain figure, however, holds no terror for the two revellers who are guided home by the lonely light from a window. Although no moon is visible, the picture suggests a night made bright by a full moon. Its light, illuminating the scene like a stage set, falls almost vertically into the depth of the abyss-like street, casting short shadows, particularly near the chimney on the roof. The cold moonlight falls on the early Baroque façades to the left and right of the bay window, for which the artist used drawings he had made in 1858 in Rothenburg, Dinkels-bühl and other places.[10]

There is an artificial, brittle element in this picture which tries to capture a fleeting moment of the past.[11] No real life seems to be possible behind the houses, standing abandoned like coulisses in the theatre waiting to be removed after the end of the play. Spitzweg employs stage-like effects, emphasised by the costumes from the world of the theatre. He extracts at random quotations from the props of Romanticism. His work is thus in harmony with the epoch of historicism, which authorised such use as part of its artistic programme. The use of light, with the tension between bright moonshine and the lonely lighted window, recalls the *Nightwatches by Bonaventura*: "It was one of those eerie nights with light and dark alternating rapidly and strangely. In the sky the clouds, driven by the wind, flew by like whimsical pictures from a journey, and the moon appeared and disappeared in rapid succession... and I was glad to see, high above the city, a dim lamp shining from a small mansard room... I knew well who reigned so high above in the air, it was an unfortunate poet, awake only at night when his creditors were asleep and only the muses were not amongst their numbers."[12]

Adolph von Menzel
(1815-1905)

Menzel, one of the most outstanding figures of German nineteenth-century painting, did not choose to become an artist. In 1832, when only seventeen, the death of his father forced him to carry on the family lithographic enterprise in which he had been trained. As the eldest son, responsible for the family who had moved from Breslau to Berlin just two years earlier, he threw himself with enormous energy and industry into the production of lithographic commissions. The 398 woodcut illustrations he carried out between 1839 and 1842 for Kugler's *Life of Frederick the Great*, published by the art dealer Louis Sachse, who played such an important part in Blechen's (q.v.) career, brought him early success, and further commissions. In the 1840s he produced illustrations of Prussian history, such as the two hundred vignettes for the works of Frederick the Great, for which he undertook extensive historical research. During his lifetime he was famed for his history paintings, produced from the 1850s onwards. Initially he concentrated on themes based on the life of Frederick, but later he dealt with contemporary subjects and events from more recent Prussian history, to which he added motifs from everyday life. Known as "Little Excellency" (because of his short stature), he moved freely round the court, and in 1898 the Emperor Wilhelm II awarded him the "Black Eagle", the highest Prussian order.

Apart from these official activities, Menzel's search for reality in his art from the 1840s onwards found its outlet mostly in small-scale oil paintings. Discovered only after the artist's death, because he considered them mere experiments, they established him in Germany as the celebrated forerunner of Impressionism.[1] Since then, the "unofficial" Menzel, much more than the Emperor's court painter, has been the object of admiration. His artistic virtuosity, manifested in thousands of drawings, pastels and gouaches, but only in a few oil paintings, made him an artists' artist. Max Liebermann (q.v.), for instance, reports "that Degas talked to me about Menzel in terms of the highest admiration [and] ... considered him the greatest living master, whose *Dinner Dance* he had tried to copy from memory."[2]

64 The Anhalter Railway Station by Moonlight

Menzel, the observer, began his explorations of the visible world with nearby motifs. These include the view from his window, which offered him ever new revelations, not least because he frequently changed his domicile. On 1 March 1845 Menzel announced in a letter: "I am about to move, near the end of this month, beyond the Anhaltsche Tor (Anhalt Gate) to Schöneberger Strasse, No. 18, two storeys up, where I shall have more room and a more convenient place for painting."[3] Until March 1847 Menzel lived with his invalid mother – who died in 1846 – his sister Emilie and his brother Richard, in the four-storey apartment house. The new buildings along the Schöneberger Strasse, begun only in 1843, were situated in the immediate vicinity of the Anhalter station on the Berlin-Potsdam line. The bustling building activities in his new surroundings inspired several small-scale oil paintings of the developing metropolis, depicted from unusual vantage points and with a spontaneity hitherto rarely seen in his work.[4] These include the view from his apartment looking towards the Anhalter railway station, erected at the end of the 1830s and replaced by new buildings in 1847.[5]

Seen from the third storey a panorama of verticals unfolds. At the top of the painting, above a wall of clouds, the moon is set against the deep blue of the nocturnal sky; below, in the faint glow of two lanterns the hardly recognisable buildings of the railway station lie deserted. A solitary railway carriage stands on a rail, while in the foreground a building site opens up like a bottomless abyss. The moon in the upper median is placed on the same vertical as the door and windows of the central building, precipitating the rapid downwards movement of the composition. The view is restricted at the sides by the verticals of the apartment building façades. The right façade is in the darkness, while the left is lit by the pale light of the moon; curtains flutter from the upper windows, moved by the night breezes as if by an invisible hand. Pot plants on the window-sill below resemble human heads. An eerie feeling pervades the scene. The deserted building site enclosed by wooden fences is in a state of disarray. A ladder and planks are scattered around like pieces tossed aside after a game. By night the debris man has extracted from the earth is revealed. The cool silvery light of the moon reflected from the roofs adds an ominous note. This is no longer the idyllic moon of the Biedermeier, to which lovers look up in enchantment, but a sinister, tormenting moon, inducing sickness and sleepwalking. Perhaps the artist, who seemed to like working in the dark, painted the picture during a sleepless night by a full moon.

Menzel not only had a sure grasp of the scene before him but also a prophetic presentiment of its future development, which apparently led him to anticipate that the station building could not survive in such a neighbourhood. Indeed, in 1875-80 it was replaced by the monumental glass and iron construction of the new station hall, a symbol of Berlin's faith in progress during a period of rapid industrial expansion, known as the *Gründerzeit*.

As Werner Hofmann remarked about the painting *The Wall of the Studio* (Hamburg, Kunsthalle), Menzel was not concerned with a complete view of reality: "He confronts details, fragments. The fragments, legitimised by being placed in the artificial framework of the studio, made him recognise the disorder and chaos he encountered at every step in reality. Beenken said of the *Garden of Prince Albrecht's Palace* that chaos had invaded nature. This significant observation does not apply only to Menzel's landscapes – such as the *Berlin-Potsdam Railway*, whose track cuts through nature – and the many house demolitions, building sites, untidy rooms etc.; Menzel's eye always penetrates the mask, he sees reality as a process of destruction, as a permanent disharmony, as the place where conflicts are fought out."[6] His home, however, though not always free of interruptions, remained an oasis of calm and contemplation. The family, a source of happiness and harmony, where music was played, is juxtaposed with the chaos of the world, where all is fragmentation, segmentation and devastation. This contrast runs through

64
Adolph von Menzel
The Anhalter Railway Station by Moonlight (1846)
Oil on paper, mounted on panel, 46 × 35 cm
Provenance: Ludwigs Galerie, Munich; acquired 1932

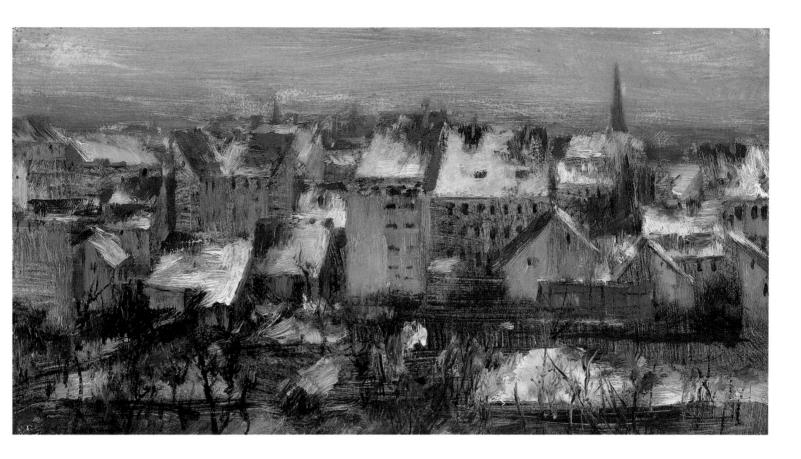

Menzel's work like a *leitmotif*. The window-views occupy an intermediary position: looking from the familiar and secure interior into the unknown outside, they are the zones of friction where disturbance threatens to penetrate the place of order.

Menzel attempted to capture the chaos of the world, whose harmony he saw as broken into a thousand splinters. He observed and recorded accurately: unrest, work, need, ruin, death, decay—nothing could deter him. He sought to restore meaning to the world through history painting, that is to say through the one dominating figure of Frederick the Great, who restored order to the most restless and turbulent situations (*Petition, Bonsoir Messieurs*), or at least attempted to do so (*Frederick the Great at the Battle of Hochkirch*), and who valued domesticity (*Round Table Company*) and music (*Flute Concert*).

65
Adolph von Menzel
Portrait of Frau Maercker (1846/47)
Oil on canvas, 37.5 × 28 cm
Signed bottom right: A. M.
Provenance: Frau Flesch, Frankfurt am Main; Fritz Nathan, St. Gallen; acquired 1948
(Tschudi 54)

65 Portrait of Frau Maercker

Menzel made many drawings of people, but was never a portrait painter as such, although in the *Königsberg Coronation* (1865) he created the quintessential panorama of prominent Prussian society. The single-person oil portrait, going beyond the character of a coloured study, occurs almost only in the 1840s and is confined to sitters from the circle of his family and friends; predominant amongst the latter are members of the Arnold, Puhlmann and Maercker families.[7]

Meier-Graefe made an apt analysis of the full-figure *Portrait of Frau Maercker*, who is sitting on a sofa with an open book beside her: "Menzel at the time was not attracted by the psychological [aspects] but by the space. The interior in these intimate portraits is not a backdrop but becomes part of the image... The wall, previously decorated with large grey-green ornamental motifs on a reddish-brown ground, has turned almost black. This ground leaves traces in the dress which are repeated in the lighter tonality of the blue-speckled mantilla and the even brighter and lighter hues of the face. The brown of the carpet is heightened almost to red. Even the padded footstool, with its minutely observed

66
Adolph von Menzel
Berlin Tenements in the Snow (1847/48)
Oil on paper, mounted on cardboard, 13 × 24 cm
Provenance: A. von Menzel estate, Berlin; Johanna Krigar-Menzel, Berlin (1905); Coll. Neumann, Berlin (1906); Fritz Nathan, St. Gallen; acquired 1938
(Tschudi 31)

mesh cover painted in an old master manner, is organically absorbed into the picture. The meticulous attention to detail does not suggest pedantry. As with certain pictures by Krüger [q. v.], once the eye has adapted to the small scale the objects seem the right size."[8]

From 1845 to 1847 the Menzels, at 18 Schöneberger Strasse, were neighbours of the Maercker family, with whom they remained friends even after moving to the Ritterstrasse. In *Evening Company* of 1847 (Berlin, Nationalgalerie), made as a quasi-token of friendship, Menzel portrayed the Maerckers (Frau Maercker was suffering from toothache at the time), together with a guest, his sister and himself. He also made portraits of the children in gouache. Frau Maercker's husband, whom Menzel painted sitting in his room at night with a cigar,[9] was appointed Minister of Justice in the moderately liberal

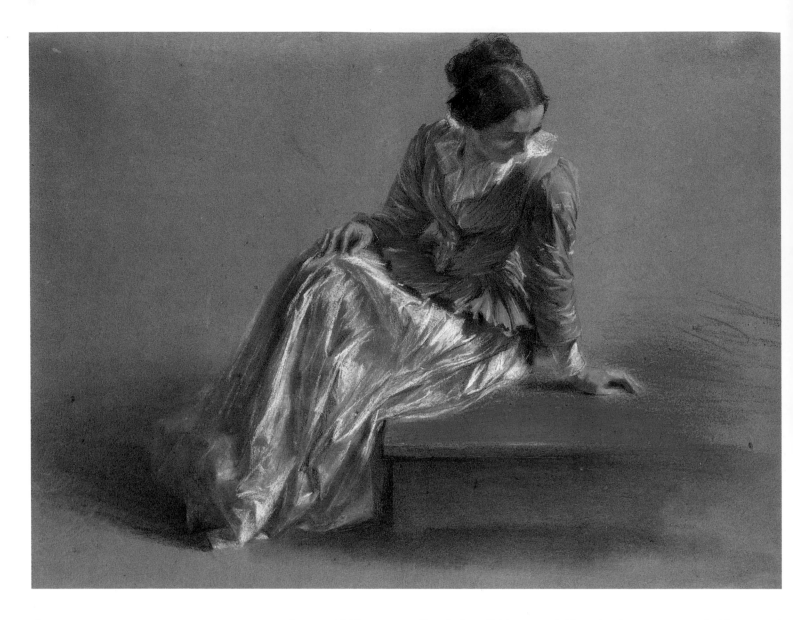

67
Adolph von Menzel
Costume Study of a Seated Woman, Menzel's Sister
Emilie
Pastel on brown paper, 22 × 28.5 cm
Provenance: Count Pourtalès, Munich
(Tschudi 252)

Auerswald-Hansemann Revolution Cabinet, which was in office only up to September 1848; he was later made President of the Court of Appeal in Halberstadt.

The portrait of Frau Maercker, because of its similarity to that of Clara Schmidt von Knobelsdorff (Berlin, Nationalgalerie), has hitherto been dated 1848, but may have been painted earlier, in 1846/47, judging from the study head of Frau Maercker in Hamburg (Kunsthalle), dated 1846.[10] In the finished painting Menzel introduced a change in accordance with a note he had made on the study: "the hand closer to the mouth."

66 Berlin Tenements in the Snow

From mid-March 1847 until 1860 Menzel lived at No. 43 Ritterstrasse, Berlin. This view from his window onto the backyards of

neighbouring houses was probably painted soon after his move. With sober precision Menzel observed how the multi-storey apartment blocks at the periphery of the rapidly growing metropolis squeezed out the irregularly spaced houses and gardens of the suburb. A little later the German author Theodor Fontane documented this process in his narrative *Irrungen, Wirrungen* (Errors, Confusions) of 1882-87, creating a literary monument to this lost world.

A comparison with the very similar oil sketch *Houses viewed from the Rear* (Berlin, Nationalgalerie) makes it clear that Menzel was

69
Adolph von Menzel
Krigar at the Piano
Pencil and chalk, 37 × 26.5 cm
Signed bottom right: A. Menzel

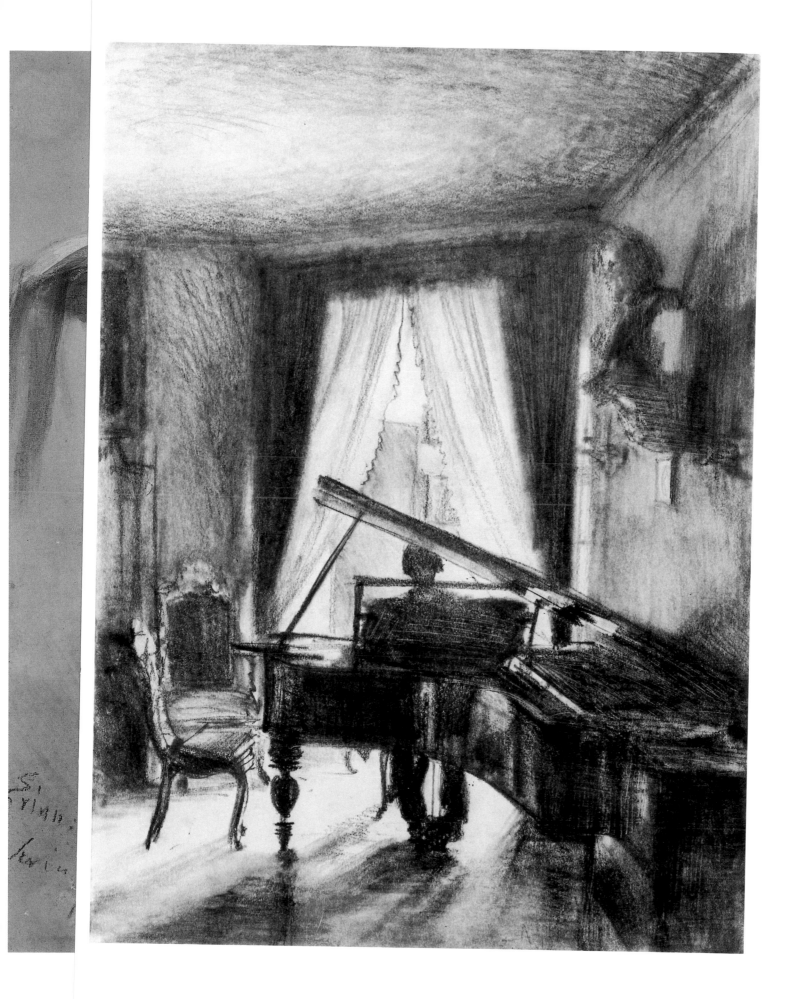

not a
racy
The s
plast
respo
A de
Berli
of th
(Berl
In sp
capt
The
crea
Und
char
pink
rang
pain
defy
virtu
not
ing
sess
pair
brai
In c
top:
Ten
hap
dep
spe
con
dep
he
rect

67
Me
Mu
don
sup
ing
Me
acc
lik
tiv
up
lov
zel
fro
dr
nis
ter
wi
fa

16

68
Adolph von Menzel
Head of a Dead White Horse, 1848
Oil on paper, on cardboard, 37.5 × 52.5 cm
Signed top left: A.M.I48
Provenance: Adolph von Menzel estate, Berlin; Ernst Seeger, Berlin (1905); National-Galerie, Berlin (1912); Julius W. Böhler, Kriens; acquired 1950 (Tschudi 43)

partly bared teeth, without however showing the bloodstained area of the cut, as Géricault did with the heads of guillotine victims. A virtuoso painting in whites unfolds, oscillating between transparency and opacity, with the yellow ground and the whites and mixed brown-and-black tones combined in a musical triad. Full of admiration, Karl Scheffler commented: "In this horse's head the self-obliterating work of study dominates. One should observe the *imprimatura*, infinitely true and rich in tone-by-tone nuances, particularly around the mouth, and the manner in which the bright tones are developed from the yellowish ground." [24]

69 Krigar at the Piano

Travel, and the company of scholars and authors in the literary society "Tunnel über der Spree", as well as music, became important in Menzel's life in the 1850s. However, while others, disappointed in the events of 1848, saw music as the most sublime form of retreat from everyday life and suffering, even from the world at large, especially after reading Schopenhauer's *Die Welt als Wille und Vorstellung* (The World as Will and Idea), Menzel again refused to be carried away by fashion. Lack of money and time had prevented him from learning to play an instrument in his youth, and music for Menzel meant the classics up to Schumann and Brahms. However, as a good citizen, he arranged for Emilie and Richard to receive the obligatory piano lessons, for which they thanked him by frequent recitals. There was even more music heard in Menzel's home when Emilie met Hermann Krigar and married him in 1859. Krigar, a musician also active as a composer, was from 1854 to 1857 director of the Neue Berliner Liedertafel (choral society), and finally Royal Director of Music. Through him Menzel met the violinist Joseph Joachim, later director of the Berlin College of Music, who at that time often performed with Clara Schumann. At the beginning of the 1860s Joachim, together with Krigar, founded in the Krigar-Menzel apartment the string quartet which developed into the world-famous Joachim Quartet.[25]

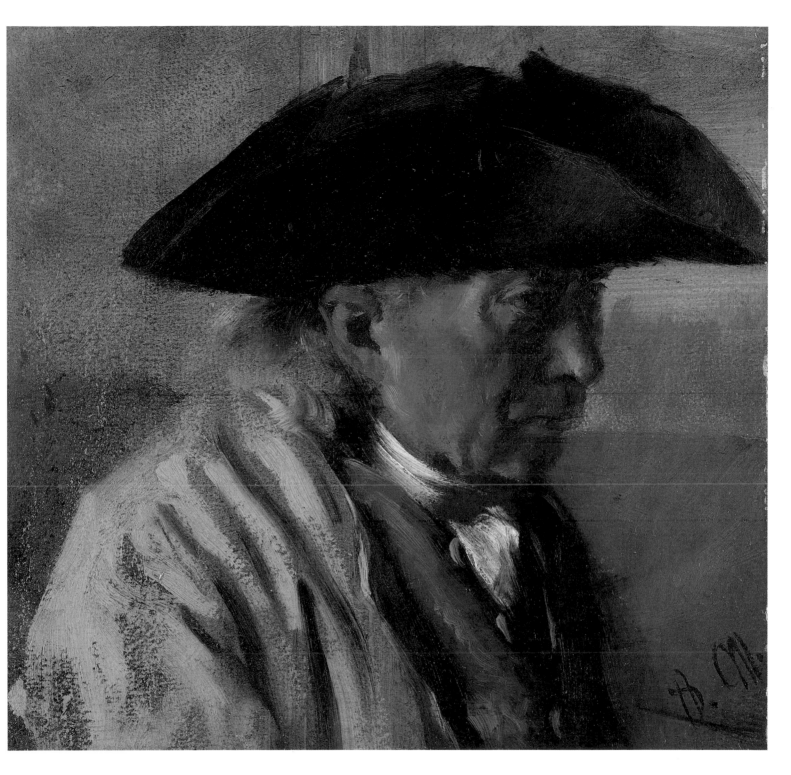

Menzel depicted his brother-in-law at the piano in the music room at No. 7 Potsdamer Strasse in a masterly drawing, executed with forceful strokes.[26] Absorbed in his music, the pianist melts into one black shape with the grand piano. Surrounded by restless rhythmic diagonals, he is the one calm vertical axis in the centre. He does not notice the sunlight flooding in, seemingly making the furniture dance to the music, recalling the *Balcony Room* of 1845 (Berlin, Nationalgalerie). Even the curtains, fluttering in a gentle breeze, seem to respond to the sounds in the room.

71

Adolph von Menzel

Head of a Peasant with Three-Cornered Hat (1850/ 60)

Oil on paper, mounted on cardboard, 22 x 22.5 cm
Signed bottom right: A. M.

Provenance: Coll. Mairowsky, Cologne; Fritz Nathan, St. Gallen; acquired 1950

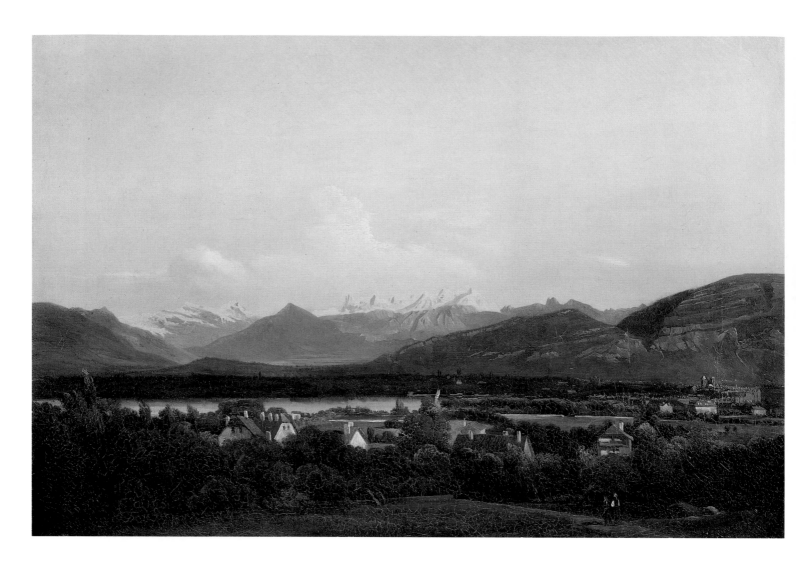

Alexandre Calame

(1810-1864)

In the 1840s and 1850s Calame's wild and fantastic mountain views, the epitome of romantic alpine scenery, brought him triumphant success all over Europe. Royalty, aristocrats and patricians from Germany, England, Russia and France were amongst his wealthy clientele. In Paris, where Durand-Ruel sold his works on commission,[1] Calame regularly exhibited at the Salon – in spite of his poor opinion of it. Discussing the Salon of 1842 he concluded: "I am more than ever convinced that nature, pure and simple, is the best of all teachers and that the lessons taught by the French artists of the Salon are useless, if not harmful."[2] He showed a similar contempt for the Salon of 1855, where Corot's works were "closest to his heart": "in brief, this Salon seems to me of a great vacuity."[3] In

his studio in Geneva Calame assembled a large number of students from all countries, whose collaboration was necessary to satisfy the huge demand for his paintings and to produce several versions of often large-scale studio works.[4]

His style relied on a few key compositions from which he produced masterly variations.[5] His characteristic compositional scheme involves a carefully modelled foreground, which serves as a repoussoir to offset the light-enveloped mountain peaks in the background, under a lightly clouded blue sky

73
Alexandre Calame
View of Geneva from Petit-Saconnex, 1834
Oil on canvas, 30.5 × 44 cm
Signed bottom right: A. Calame f/ Genève 1834
Provenance: Lady Osborne, Ireland; Dr. Fritz Nathan, St. Gallen; acquired 1938
(Anker 39)

(see fig. 92). Böcklin (q. v.), one of Calame's many students, described the way his master confined himself to "two basic principles of composition: one is determined by the distribution of light, i.e. light radiating from above the far mountain peaks is set off against, but partly penetrates, a solid dark mass, such as a wood...The second principle concerns the colour scheme, relying for effect on the contrast of the cool light blue of distant mountains and sky with the warm orange hues of pine or fir trees, and usually a muddy grey in the foreground: he was never able to find the third colour."[6]

His inescapable success forced Calame into a routine of mass production. Only on his study tours, away from the strict regime of the studio, did he further develop his gifts as a sensitive draughtsman and unconventional observer of nature. The many oil sketches painted out of doors reveal his direct and spontaneous feeling for nature.

Twentieth-century critics, noting the difference between the artist and the entrepreneur, much prefer the study sketches, which they consider part of the development of *plein-air* painting. Most recent critical opinion, however, has rehabilitated the large-scale paintings, and their artistic merit is now recognised.

73 View of Geneva from Petit-Saconnex

Alexandre Calame grew up in Geneva in great poverty and deprivation. He broke off his early training as a bank clerk to become a student of François Diday, a painter of alpine scenes. Diday awakened in the young artist a love of nature in the mountains, which was then associated with wild romantic beauty.

In 1830, aged twenty, Calame sold his first oil painting to the Belgian musician and art lover Jean-Baptiste Müntz-Berger, who had settled in Geneva as professor of music and was taking painting lessons in Diday's studio. Müntz-Berger subsequently developed a fatherly affection for the young orphaned painter and the two became friends. From 1832 Calame frequently stayed in the professor's country house in Petit-Saconnex, a village north of Geneva, near the lake. In 1834 he married Amélie, Müntz-Berger's only daughter. The couple initially lived in her parents' house, where Calame painted this view.

A label attached to the back of the picture suggests that he sold it on 16 October 1834 to Lady Isabella Osborne.[7] Lady Osborne was apparently staying at Geneva and took the painting with her to Ireland. She expressed her admiration by ordering two more pictures, in 1835 and 1839.[8] The 1834 painting was probably Calame's first work to be sold abroad, and helped to establish the artist's international reputation.

The painting, continuing the tradition of Geneva views by artists such as Ferrière (q. v.) and Töpffer (see fig. 22), lacks the virtuosity of later works, and to some extent shows the young artist's inexperience. Much later, in

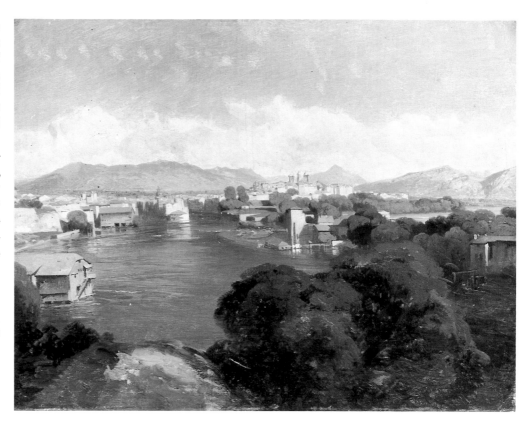

1855, Calame painted the second of only two views of his native city, the *View of Geneva from St-Jean* (fig. 90), which reveals the influence of Corot. The 1834 painting anticipates Calame's interest in the Alps, with the carefully executed mountain panorama rising majestically in the distance behind the horizontal layers of the landscape, and featuring the well-known peaks of Voirons, Môle, Mont Blanc, and the Little and Large Salève.

fig. 90
Alexandre Calame
View of Geneva from St-Jean (c. 1855)
Oil on cardboard, 32 × 40 cm
Provenance: Calame sale, Hôtel Drouot, Paris, 12-21 March 1865; H. Darier, Geneva; Rodolphe Dunki, Geneva; acquired 1933
(Anker 646)

74 The Lütschen Valley with the Wetterhorn

The year 1835 brought the first opportunity of seeing the mountains close at hand, when Calame began his series of tours to the Bernese Oberland, which provided countless motifs for paintings. The lonely mountain of the Wetterhorn, viewed from various vantage points, proved a fascinating subject. In the present painting the high plateau of a precipitous rock opens up a view of the valley beneath, leading along the Schwarze Lütschine towards Grindelwald. Inaccessible in the airy distance, the peak of the Wetterhorn seems suspended above the valley, as if guarding the scene below.

This study only came to public notice after the artist's death, as part of his legacy. Although painted on the spot, it has the appearance of a finished painting, and in spite of its small size, conveys a feeling of monumental-

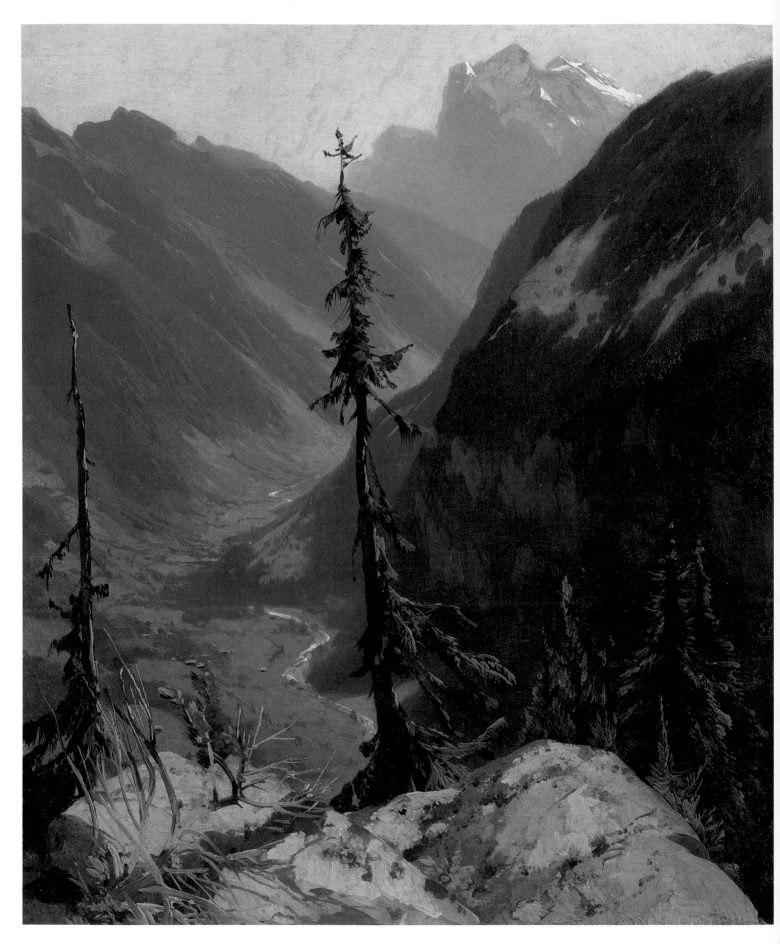

74

Alexandre Calame
The Lütschen Valley with the Wetterhorn (1850/55)
Oil on canvas, mounted on cardboard, 31 × 26 cm
Provenance: Arthur Calame, Geneva; Louis Buscar-
let-Calame, Geneva; Rodolphe Dunki, Geneva; ac-
quired 1935
(Anker 460)

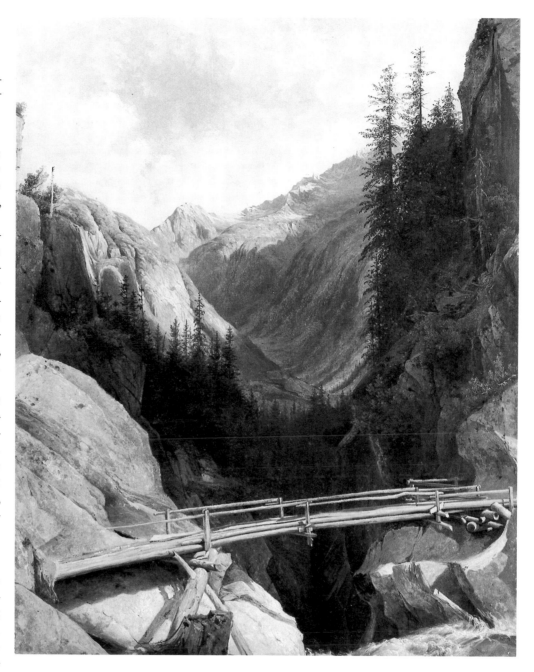

ity. Abrupt contrasts of sunlight and shade animate the view which unfolds dramatically from the brightly lit rock, topped with the rugged shapes of weather-beaten fir trees, into the depths of the valley.

In comparison with the view of the Wetterhorn from the east, painted some thirty years earlier by Joseph Anton Koch (Cat. 36), Calame's composition achieves greater unity through its atmospheric treatment. The rigidly linear monumental form of Koch's mountain, in its timeless solidity, is transformed by Calame into an ephemeral vision, affected by the constant changes of light and atmosphere.

Calame was a late romantic, painfully aware of the transience of the moment. In his paintings he attempted to capture the gentle melancholy of the fleeting instant. Deep chasms and dead trees, symbols of nature's tragic vulnerability, recur in many paintings, most noticeably in *At the Handeckfall* (fig. 91), and are juxtaposed with the peace and harmony of the eternal peaks above.

Calame's sensibility is akin to that of his friend Alphonse de Lamartine, who wrote a poem on one of Calame's paintings. The painter's wife used to read excerpts from Lamartine's *Meditations* to her husband during evenings in the studio. The two men shared the feeling of loneliness experienced by the romantic soul.[9] Calame poignantly expressed this mood in a letter to his wife: "Nothing elevates the soul as much as the contemplation of these snowy peaks ... when, lost in their immense solitude, alone with God, one reflects on man's insignificance and folly."[10]

75 Rocks near Seelisberg

Calame's weak constitution and an increasingly troublesome chest condition necessitated repeated visits to spas, some at the Riviera (fig. 93), and forced him to give up his trips to the high mountains; instead, he sought relaxation in the lower region of Lake Lucerne. The Urnersee, and the villages of Brunnen and Seelisberg, became a favourite sojourn. Calame may have visited Lucerne in 1841, and on a later extended tour in 1848 he discovered the Urnersee region. In the same year he painted the view of *The Urirotstock seen from Seelisberg* (fig. 92). This picture

fig. 91
Alexandre Calame
At the Handeck Fall (1842/43)
Oil on paper, mounted on canvas, 55 × 42 cm
Provenance: Dr. Robert Pfister, Zurich; acquired
1940
(Anker 208)

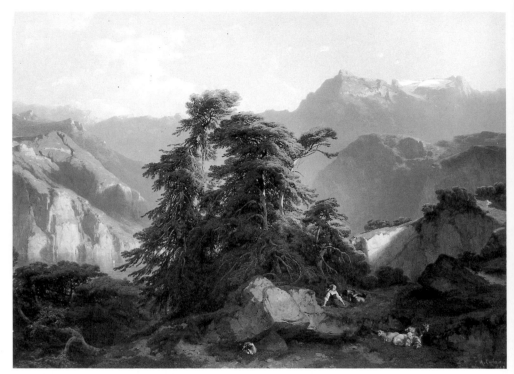

had been commissioned in 1846 by M. Knowles-Smith of Rotterdam for the agreed price of 1000 francs, but was delivered only in 1849. The dark fir trees in the foreground are based on a study from the opposite side of the lake and form a striking contrast with the view of the alpine panorama in the distance.[11]

The study, *Rocks near Seelisberg*, painted in 1861, belongs to the 496 paintings and sketches ("tableaux et études") left in Calame's estate and auctioned in Paris in 1865.[12] The artist had kept these oil studies and sketches during his lifetime, using them as models for larger paintings. They were never for sale, but occasionally one of them was given as a present to friends.

Although not intended for the public, *Rocks near Seelisberg*, with its large format and near-perfect execution, must be seen as a finished painting rather than as a study. Calame delights here in a play of contrasts between foreground and background, height and depth, light and dark. Glaring sunlight falling on the forground rock sets off the deep shadows in the ravines. The daring composition defies all conventions of classical landscape art. The eye of the onlooker is forced precipitously into the bottomless depth. A tiny fragment of blue sky appears incongruously at the upper edge of the painting. The only living thing in this arid scene is a wind-beaten tree, clinging precariously to the exposed ridge of the rock. The same motif appears in Caspar David Friedrich's *Chalk Cliffs on Rügen* (Cat. 30) as a symbol of life constantly threatened by death, while Calame's painting emphasises the heroic struggle for survival of the lonely tree against the hostile elements.

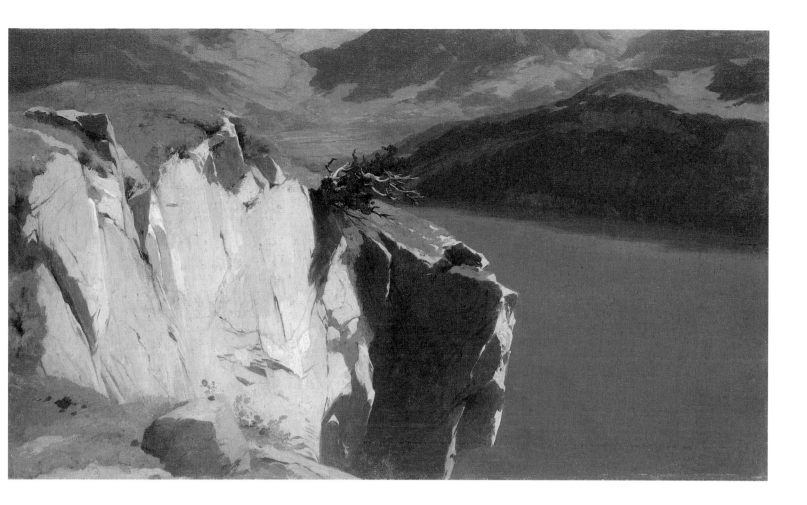

Calame's first biographer, Rambert, mentions the artist's fascination with this dramatic motif: "The shores of the lake did not suffice. At two steps' distance from the Rütli there is a splendid wall of perpendicular rocks tumbling into the lake from a vertiginous height. One would search in vain for another equally bold rock formation in Switzerland ... Calame does not hesitate to climb to the peak of the wall, and to place his stool on the very edge of the precipice. Through a ridge in this airy shoreline he could see, a few feet away, the plunging profile of this terrifying wall of rocks. Anybody else would have retreated, gripped by vertigo. But to him this was exactly what he wanted: the impression of the precipice, the vertigo."[13]

Calame frequently painted from this vantage point. A drawing, dated 8 August 1858 (Winterthur, Kunstverein) shows the same view through a less restricted field of vision.[14] Trees are added on the left and the mountain range of the Mythen fills the background, distracting the gaze from the gorge with the tree clinging to its edge, which is the uncompromising main motif of the 1861 painting.

75
Alexandre Calame
Rocks near Seelisberg, 1861
Oil on canvas, mounted on cardboard, 32 × 52 cm
Dated bottom right: 1861
Provenance: Vente Calame, Hôtel Drouot, Paris, 12-21 March 1865; Arthur Calame, Geneva; Louis Buscarlet-Calame, Geneva; Rodolphe Dunki, Geneva; acquired 1935
(Anker 761)

fig. 98
Robert Zünd
Chestnut Trees near Horw (1857)
Oil on canvas, 76 × 93 cm
Signed bottom left: R. Zünd
Provenance: Galerie Neupert, Zurich; acquired
1929

78 Sunny Meadow

Zünd regarded the large-scale paintings which he finished in the studio as his most representative works. They were produced according to a slow and elaborate procedure and hence their number is small. The composition was first carefully prepared in drawings and small oil studies before being transferred to canvas. Further drawings and oil sketches served as preparatory studies for details. For instance a pencil sketch dated 22 July 1857 shows in exact detail the group of trees in the painting *Chestnut Trees near Horw* (fig. 98).[5] After completing the underpainting in several colours, Zünd let the picture dry for several weeks before finishing it gradually with carefully applied glazes.[6] Occasionally the artist experimented with new technical procedures, such as applying a white ground before adding local colours, in order to heighten the intensity of light. Koller was enthusiastic about this new technique.[7]

In spite of his painstaking working method Zünd succeeded in creating a fresh and spontaneous image of nature. The *Sunny Meadow* is a particularly striking example, recalling the interpretation of nature in Waldmüller's paintings and Adalbert Stifter's "gentle law" (see p. 140). The landscape represents the western area of the Riedebene (Reed Plain) in the environs of Lucerne, in front of the Horwerbucht (Horw Bay) at the foot of the Schattenberg mountain, where a road leads to Kriens.[8]

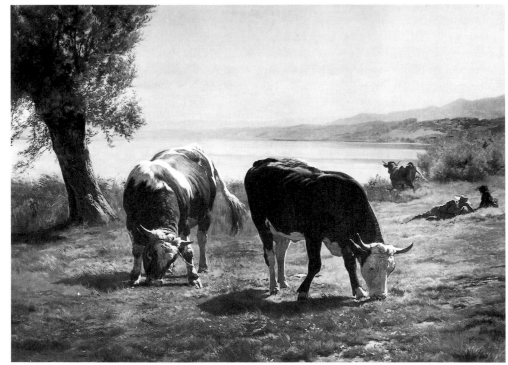

fig. 99
Rudolf Koller
Cattle grazing on the Zürichhorn, 1864
Oil on canvas, 98.5 × 138.5 cm
Signed bottom right: RKoller. 1864.
Provenance: Kunst und Spiegel AG, Zurich; acquired
1927

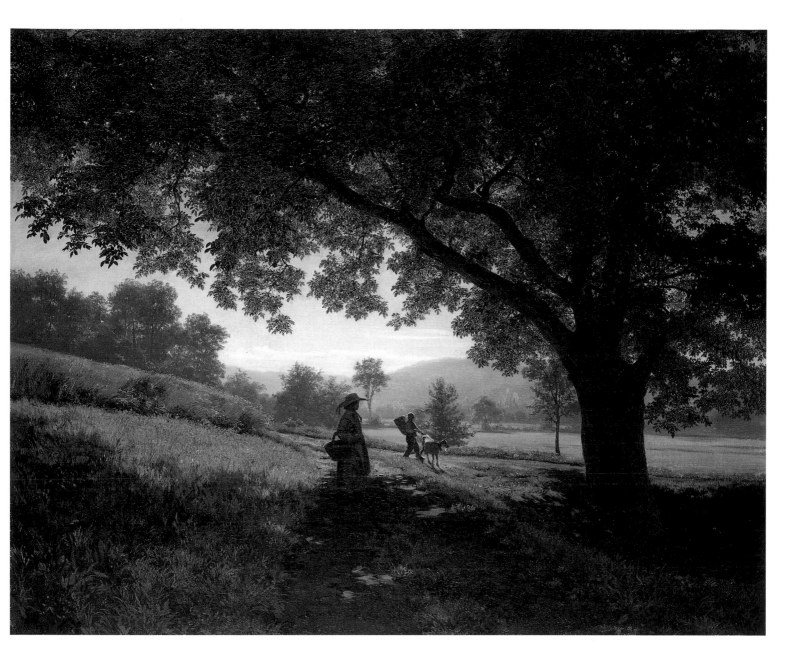

78
Robert Zünd
Sunny Meadow (1856)
Oil on canvas, 76 × 92.5 cm
Signed bottom left: R. Zünd
Provenance: Private collection, Zurich; Galerie Fischer, Lucerne; Dr. Fritz Nathan, St. Gallen; acquired 1941

This major work by Zünd shows a heightened contrast of light and shade, suggesting the glowing heat of a bright summer's day spreading over the fertile ground, punctuated with fields, woods and trees. A gigantic walnut tree dominates the entire foreground, where a peasant woman, carrying a basket, seeks rest in its shade before continuing her way towards the fields. The eye of the observer is led from this shadowed zone towards the blinding light of the white midday haze. In the field on the left the stalks of ripening wheat are bent under their load, their saturated gold suggesting the concentrated energy of the sun. The field gently sweeps towards the picture's depth, but the painting is dominated by the pattern of leaves, the blades of grass, the pebbles on the path, all of which are rendered with the utmost attention to every smallest detail.[9]

Rudolf Koller

(1828-1905)

The son of a butcher and innkeeper, Koller developed a passion for animals in his childhood, and at the age of twelve declared his wish to become a painter of horses. During his years at Düsseldorf Academy he met Feuerbach (q. v.) and Böcklin (q. v.), who became his lifelong friend. Together with Böcklin, Koller set out via Brussels and Antwerp to Paris, where the Dutch animal paintings in the Louvre, as well as the productions of Raymond Brascassat's studio, made a great impression on him. He moved to Munich to see the Bavarian painters of animals, and there his own animal studies soon attracted attention.[1] He became friends with Robert Zünd (q. v.), with whom he frequently shared study tours and exchanged ideas.

Koller acquired a growing reputation as the Swiss animal painter *par excellence*, a Helvetian counterpart of Rosa Bonheur, whose works were equally successful in Paris. In 1860 Jakob Burckhardt wrote from Paris to the painter Stückelberg: "Tell Koller that one of his paintings would be desirable in the Luxembourg, that is to say for the art-loving public, not for Rosa Bonheur and Troyon, for she is becoming mannered and he careless."[2]

Koller often complained that the many commissions for animal paintings particularly of cows, which he never tired of depicting in all possible variations, prevented him from developing his other talents, such as portraiture or landscape: "My animal paintings seemed to me very prosaic, compared with your spirited pictures of Faust and the Gleyres," he told Stückelberg. "Well, being condemned to struggle with the dumb animals of the world, I must bear my fate with equanimity."[3]

Koller continued to aim at fidelity to nature and precise representation of the animal, which he liked to show in motion, as in the extremely popular and dramatic *Gotthardpost* (Zurich, Kunsthaus), or in more tranquil scenes, such as *Autumn Pasture* (fig. 100). Such paintings were produced on his country estate Zur Hornau at the Zürichhorn, acquired in 1862, where he kept a number of animals. "I made it my rule to purchase every animal intended as protagonist in one of my paintings... so that I could study it ... Animals cannot be painted in the studio but have to be [suitably] placed outdoors ... "[4] In this way he sometimes achieved a happy synthesis of animal and landscape, as in the painting *Cattle grazing at the Zürichhorn* (fig. 99).

Koller saw himself primarily as a painter, and only secondarily as an animal specialist: "It does not matter which subject one paints, people or animals. I have grown up amongst animals, but I am not too concerned with cows and their breed, I want to paint large forms and coloured patches."[5]

79 The Richisau

Koller frequently stayed in the region of the Richisau where he often painted in the company of friends.[6] This picture painted in 1858, probably on the spot, shows the view from the Klöntal towards Glarus, with the steep mountains of Vorderglärnisch, Vrenelisgärtli, Ruchen, Fürberg and Nebelchäppeler on the right.[7] The view into depth is, however, blocked out by a group of trees in the middle distance. Koller's attention is mainly concentrated on the foreground area which he depicts in an unconventional manner. Renouncing the traditional repoussoir, such as the carefully arranged foliage used by Claude Lorrain to offset the emptiness of the foreground, he paints in extreme close-up a stagnant sunken pond, surrounded by a thick

fig. 100
Rudolf Koller
Autumn Pasture, 1867
Oil on canvas, 256 × 206 cm
Signed bottom left: RKoller. 1867.
Provenance: (Johann Heinrich)? Moser, Schaffhausen; Karl Fierz-Landis, Zurich; Galerie Neupert, Zurich; acquired 1940

spread of weeds. The smooth dark blue surface of the pond is broken up by the mirror image of marsh plants, and by strong light reflections.[8] Nature here does not reflect orderly cultivation but the exuberant power of growth. Koller's obsession with large-leaved foreground vegetation makes him an apt follower of Adam Pynacker or of Carl Wilhelm Kolbe the Elder. His choice of a "cut-out" from nature, observed with extreme realism, recalls Zünd's unqualified naturalism.

Koller's contemporaries marvelled at the coloristic intensity of his paintings. The startling contrast of the deep blue pond with the shrill yellow-green of the leaves creates a motif of its own, independent of the descriptive content of the picture. In 1861 the art theorist Friedrich Theodor Vischer reported that Koller's colouring was not universally admired: "I do not want to enter the debate about his green; the opponents call it poisonous, to which he replies: 'The trees are not red as painted by you, but green.' It seems to me that art requires more restraint than he would admit."[9] Koller's painting *Cows in a Cabbage Patch* (Zurich, Kunsthaus) is equally intense in colour and shows the same

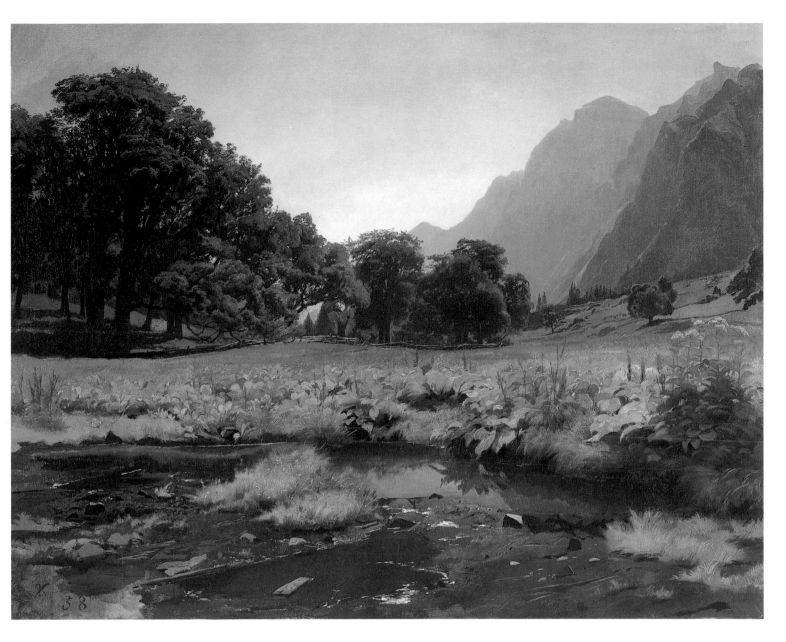

predilection for fleshy foliage. When it was shown in 1858 at the German Historical Exhibition in Munich, Friedrich Voltz, a well-known Munich painter of landscapes and animals, remarked that Koller's use of green and blue was somewhat too energetic: "In Munich we have only recently emerged from the brown sauce stage and are still far removed from such advances."[10] In 1869, after Koller's palette had been reduced to a subdued, pale tonality, Gottfried Keller observed: "Those who had previously been enchanted with his splendid cows, their rose-red nostrils rendered transparent by the sun, with the juicy green of alps and trees, the colorful flowers in the grass, the azure-blue mountain slopes, were now dismayed."[11]

It is instructive to compare Koller's painting with Caspar David Friedrich's *Large Enclosure near Dresden* of sixteen years earlier (Dresden, Gemäldegalerie Neue Meister), which has an almost identical composition. However, instead of Friedrich's transcendental spirituality we find Koller's powerful, earthbound radiance, as expressed in Gottfried Keller's poetry:
"Let the eyes drink to the full
from the golden abundance of the world."[12]

79
Rudolf Koller
The Richisau, 1858
Oil on canvas, 82 × 101 cm
Signed bottom left: RK 58
Provenance: Galerie Fischer, Lucerne; acquired 1941

Albert Anker

(1831-1910)

Albert Anker's popularity has survived undiminished to our day. His paintings express a close attachment to the native soil and cater to the needs and yearnings of people for a vision of a sane world. His numerous depictions of rural daily life, occasionally verging on the sentimental, feature happy children and contented old people in their home surroundings, evoking a sense of national identity.

Living at Ins, a large farming village in the Bernese Lakeland, where he was born, Anker was able to study his motifs at close hand. His artistic horizon, however, reached beyond his native village. His theology studies at Berne and Halle came to an end when his father, a veterinary surgeon, consented to an artistic career. From 1854 to 1856 he studied with Charles Gleyre in Paris and attended the Ecole des Beaux-Arts where, from 1856 to 1858, he was annually honoured with a medal. In the following years he spent his summers at Ins and his winters mostly in Paris, where he kept a home until 1890. From 1859 until 1890 he regularly exhibited at the Salon, obtaining a gold medal in 1866 for his painting *In the Wood* (Lille, Musée des Beaux-Arts), which had been inspired by Courbet's *Demoiselles au Bord de la Seine* and was acquired by the French Government.[1] He was a great admirer of Courbet's work, with the exception, however, of his social themes. The two painters shared the experience of growing up in rural surroundings at the foot of the Jura mountains. In 1863, when the Salon jury rejected one of Courbet's works, Anker wrote: "This jury consists of decrepit old fools living in a bygone age, having nothing in common with ours except the moans they utter ... "[2] Courbet's *Funeral at Ornans* (Paris, Louvre) must have inspired Anker's *Children's Funeral* (Aarau, Kunsthaus). Chardin's work, as well as contemporary genre painting, such as that of Charles Chaplin and François Bonvin, exerted a certain influence on his first Paris period.[3]

Anker's early success, which enabled him to lead a carefree artist's life, is documented in his carefully kept book of sales. Some works were even sold directly to the United States.[4] His rapidly rising prestige caused him to ac-

fig. 101
Albert Anker
First Attempts at Walking, 1875
Oil on canvas, 27 × 21 cm
Dated bottom left: 24 Août/75; signed bottom right: Anker
Provenance: Fritz Zbinden, Erlach (until 1932); Galerie Fischer, Lucerne; Otto Buel, Lucerne; acquired 1941(?)
(Huggler 190)

fig. 102
Albert Anker
Girl with Doll in a Child's Chair, 1878
Oil on canvas, 25 × 18.5 cm
Dated top left: 10 Sept/1878
Provenance: Cécile Du Bois-Anker, Geneva; Rodolphe Dunki, Geneva; acquired 1946
(Huggler 188)

cept official posts; thus he was nominated to the Grossrat (Grand Council) of the Canton of Berne, and became a member of the Federal Swiss Art Commission.[5] On his seventieth birthday the entire Bundesrat (Swiss Government) offered its congratulations to the artist, now holder of an honorary doctorate: "The products of your art can be understood by everyone, they are powerful true-to-life depictions whose sound realism will be admired by posterity."[6]

80 The Artist's Daughter Louise

The portrait of Anna Louise Anker (1865-1954), the artist's eldest daughter, was painted in Paris in February 1874, prior to the opening of the First Impressionist Exhibition.[7] With almost provocative self-confidence the nine-year-old girl, dressed in elegant Sunday clothes, poses for her father, her face fully turned towards the spectator. In contrast with the rural clothes usually worn by the other children he painted, she is wearing Paris fashions. A well-modulated scale of colour tones builds up the cool refinement of the picture. Anker has composed a symphony of grey tonalities with a hint of greenish, yellowish and reddish tints. These contrast with the pronounced blue accents,

80
Albert Anker
The Artist's Daughter Louise, 1874
Oil on canvas, 80.5 × 65 cm
Dated top left: Février. 74.
Provenance: Louise Oser-Anker, Basel; Kunsthaus Pro Arte, Basel; acquired 1929
(Huggler 192)

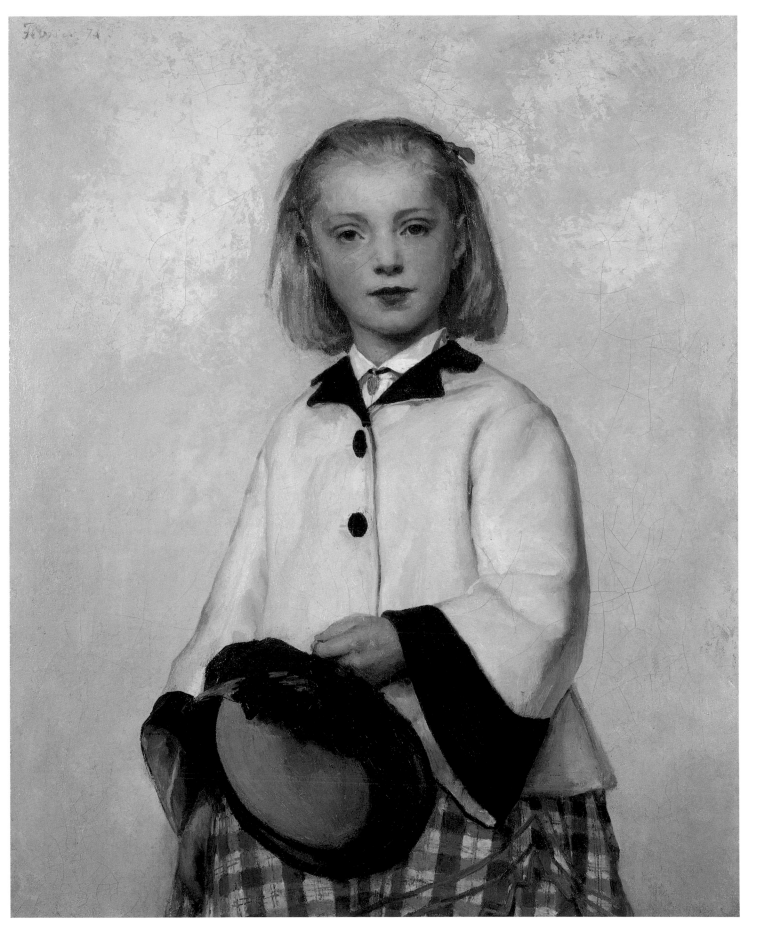

fig. 103
Albert Anker
Boy with School-Book and Slate, 1881
Oil on canvas, 56 × 42.5 cm
Signed bottom right: Anker./1881
Provenance: Lang, Basel (1881); Wackernagel, Basel;
Dr. Fritz Nathan, St. Gallen; acquired 1940
(Huggler 182)

determined by the colour of the eyes, in the checked skirt, the hatband, the medal at the neck and the ribbon in the hair. The sharply outlined black areas of paint add clarity and tranquillity to the structure and increase the luminosity of the bright tones. The method is comparable to the refined use of white by Manet, Anker's junior by one year, and other painters close to Impressionism.

Anker repeatedly used his own children as models, but never dressed in peasants' costumes. *First Attempts at Walking* shows the one-year-old Paul-Maurice Anker (fig. 101), and Fanny Cécile Anker at the same age is in *Girl with Doll in a Child's Chair* (fig. 102).[8]

81 The Little Knitters

Anker's pedagogic interests led him to study Pestalozzi's writings and to be actively involved in the school system of his native village.[9] This enabled him to represent the various stages of childhood in numerous paintings. The alert and serious gaze of the *Boy with School-Book and Slate* (fig. 103) seems to indicate the child's awareness of the importance of his studies. Far from resenting school, the boy willingly accepts his tasks, clutching under his arm a slate with his first attempts at writing, a school-book and a crayon case in the form of a fish.

The painting *The Little Knitters* features another childhood learning experience. The elder of the two sisters, with an expression of concentration and chin pressed against her chest, is fully absorbed in her knitting. Her little sister, too young to master the art, watches with fascination as the wool is transformed by her sister's skilful hands into an intricate garment. Trying to contribute to this amazing process, she is helping to unravel the wool from its ball. Anker's models were Berta and Marta Reubi, two children of close friends in the immediate neighbourhood.[10] The painter observed the scene with loving psychological insight, translating its reality into a harmonious composition. The children, in their innocence, are being playfully

introduced to the working conditions of the grown-up world, suggesting Anker's commitment to the work ethos as life's ultimate aim. Anker treated the motif of girls knitting in numerous pictures, amongst them the *Girl knitting by a Stove* (fig. 104).

Anker's images of people focus on youth and old age – the phases before and after the toils of life – which mirror soul and mind with undimmed clarity.[11] In one of these two poles of human existence the artist represented the preparation for grown-up activity, in the other the retreat from active life. Old age assumes the important function of protecting and advising. The intermediate years held little artistic interest for Anker.

"Anker consciously refrained from showing peasants at work in the field, in the stable, or engaged in other tasks. His imagery cannot be explained in terms of the realism that in-

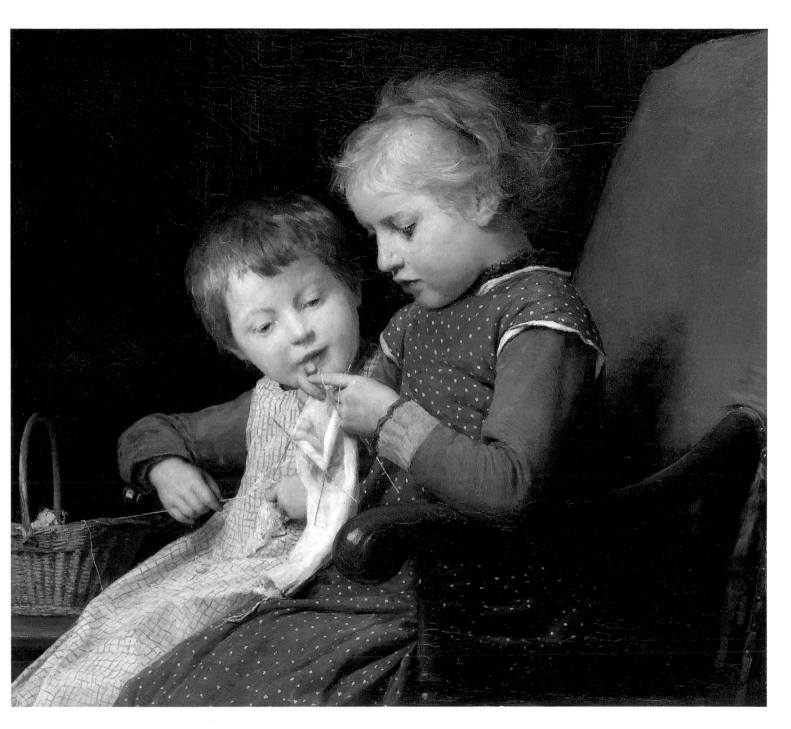

spires the representations of Millet's working peasants, Daumier's tormented urban dwellers, or Courbet's exhausted stonecutter."[12] The theme of work appears only marginally in his oeuvre, for instance in the *Potato Harvest near Ins* (fig. 105), a lively sketch, presumably inspired by Millet's *The Gleaners* (Paris, Louvre) and by his own observation in the fields.

Anker's selective vision of the world is shown at its best in works representing youth and old age in unison, for instance *At the Grandparents* (fig. 106). Seated in a roomy dark peasant kitchen near the hearth, over which a huge copper kettle is suspended, the grandfather hugs his grandson on his knee, while the boy's sister gazes into the flames. The warmth of the fire and the human warmth enjoyed by the young child combine to create a picture of perfect security. In the background the grandmother is preparing the ev-

81
Albert Anker
The Little Knitters (1892)
Oil on canvas, 62 × 68.5 cm
Signed centre left: Anker
Provenance: Creux, Ins/Lausanne (1892); W. Suchard-Young, Serrières; W. Russ, Neuchâtel (1910); H. Willenegger-Anker, Clarens; Dr. Paul Fink, Winterhur; acquired 1930
(Huggler 123)

fig. 104
Albert Anker
Girl knitting by a Stove
Oil on canvas, 32 × 46 cm
Provenance: Marie Quinche-Anker, Neuchâtel; acquired 1948
(Huggler 379)

fig. 105
Albert Anker
Potato Harvest near Ins (1885)
Oil on canvas, 20 × 31 cm
Provenance: Cécile Du Bois-Anker, Geneva; Willenegger, Vevey; Dr. Fritz Nathan, St. Gallen; acquired 1943
(Huggler 496)

ening meal. Anker makes effective use of two sources of light: the open fire casts a flickering, reddish light on the seated figures, while the flame of a candle is hidden behind the grandmother's figure, silhouetted against the softly lit still life of crockery on the table. The picture has given rise to many diverse interpretations, some far removed from its visual reality, such as the one offered by the well-known twentieth-century German author Ernst Jünger: "The stone plays an important part in the picture. The old man is looking to the past, which is neither personal nor historic, but a mythical present. The fire represents time. The group appears remote: old age and youth are caught in the spell of the timeless power of fate. The girl seems to be listening to a fairy-tale – and the boy? is he contemplating the future with a shudder? The mother, a personification of worry, is turning away. I recognised a statement in the work which, although unknown to the artist, leads him far beyond his subject. Behind the veil of peace lies a deeper peace evoking fear and reverence. An extraordinary feature of the painting is its apparent harmlessness which, like a curtain, hides its depth. This is a sacerdotal, an Elysian trait..."[13]

fig. 106
Albert Anker
At the Grandparents (1892)
Oil on canvas, 64.5 × 99.5 cm
Signed bottom right: Anker
Provenance: Creux-Wodey; W. Russ, Neuchâtel (1910); Dr. Fritz Nathan, St. Gallen; acquired 1944
(Huggler 88)

82 The Crèche

In the summer of 1890 the artist wrote to his friend François Ehrmann: "I am working on my crèche picture, whose little models keep me amused and cheered. I wish I would need no other models in my life, except some old man telling me stories of past times."[14]
Apparently this picture features the "Gerberngraben Crèche" in the Matten quarter of Berne,[15] which housed the poorer population of the city. Here, during the day, children whose parents had to work were looked after by a deaconess. Anker pictures the young flock at their midday meal, presided over by

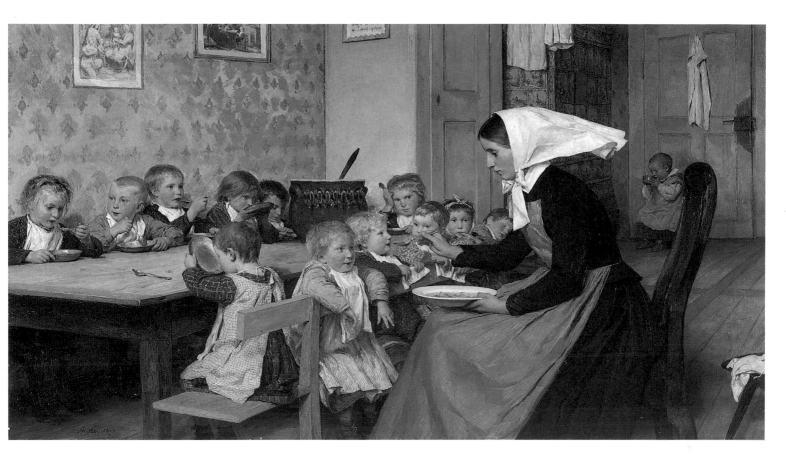

82
Albert Anker
The Crèche, 1890
Oil on canvas, 79.5 × 142 cm
Signed bottom left: Anker 1890
Provenance: La Roche-Ringwald, Basel (1890); auction La Roche-Ringwald, Galerie Steinenring 23, Basel (1910); P. Sprecher-Wirth, Zurich; F. Leuthold-Sprecher, Zurich; acquired 1950
(Huggler 65)

the disproportionately large figure of the deaconess. The long horizontal format of the picture makes the room appear low. The bare floor planks, rough wooden table and plain furnishings echo the children's simple clothes. The meal, too, appears to be of the simplest kind, consisting exclusively of soup served from a huge faience pot on the table. All the children are eating from tin bowls, the bigger ones using spoons while the little ones slurp the soup from the bowl. Only the nurse holds a white porcelain plate apparently containing a nourishing mixture of bread and milk. Notwithstanding the plain surroundings, the round children's faces looking out from the picture are healthy and contented. The little ones feel safe in the motherly care of the deaconess who has their complete trust.

One of the engravings on the wall depicts mothers bringing their children to Jesus to receive his blessing. The children in the crèche may expect the same divine protection. The individual portrayals of the children, combined in a harmonious ensemble, lend an authentic character to the scene. Thus, one child has fallen asleep, another suffers from toothache, and another clearly disobedient youngster has to eat his soup in shameful isolation on the seat reserved for offenders.

An anecdote typical of the artist is connected with the painting: when Anker proposed to paint the deaconess she bashfully hesitated because she thought her bonnet was not clean. He therefore made a bonnet of snow-white paper and put it on her head. However, he could not resist including the discarded dirty bonnet on the chair behind her back, as a white accent in the picture.

The painting is one of Anker's most successful group compositions, which he carefully prepared in single studies and an overall compositional design. He made several studies of the children, occasionally using the same model for different heads.[16] The bright colouring is determined by the motif. Throughout his career the artist used bright and dark colours to distinguish respectively between city and country motifs. This is particularly apparent in the dualism of Anker's bright "urban" and dark "rural" still lifes.[17]

191

Frank Buchser

(1828 - 1890)

Frank Buchser, an inveterate traveller and adventurer, was an exceptional figure in Swiss art. An heir to the tradition of Swiss mercenaries, he proved to be an artistic swashbuckler, conquering the world not with the sword but with the brush. His colourful life could offer subject matter for many a novel or film. He was the son of a peasant horsedealer and innkeeper in the Solothurn district, and a relative of Jean-Victor Schnetz, Ingres's successor as Director of the French Academy in Rome. While training with an organ-builder and a piano manufacturer he took drawing lessons, and then spent a short period in Paris, before moving to Rome in 1848. After serving in the Swiss Guard for a few months to finance his studies, he joined the forces of Garibaldi in 1849 to fight the French. He returned to Paris for further studies and then moved on to Gustaaf Wappers at the Antwerp Academy. In the following years he travelled to Spain and England, and lived in Switzerland, Holland and Paris, where in 1855 he was impressed with Courbet. In 1860 he took part in the Spanish war in Morocco. Later travels took him to Greece and again to Italy.

Buchser, the opponent of civilisation,[1] not given to excessive modesty, knew how to cut a figure. His colleagues, amongst them Koller (q.v.) and Zünd (q.v.), saw in him the incorrigible poseur,[2] the dandy with cigarette shown in his self-portrait with friends, *Los tres amigos* (St. Gallen, Kunstmuseum). Buchser tried his hand at all categories of painting, portraiture, history, genre and landscape, with the exception of still life, which was presumably too quiet for his temperament.[3] His landscapes show an astonishing variety of motif and style; unlike Menn (q.v.) he did not concentrate on a few favourite motifs and moods. His most powerful creations are his sketches, which capture the visible world with daring impetuosity, compensating for a lack of subtlety with their energy of gesture and a rare sensibility for phenomena of light and colour.

Buchser spent probably his most formative years in America. The victory of the Northern States in the American civil war was greeted in Switzerland with great enthusiasm. The

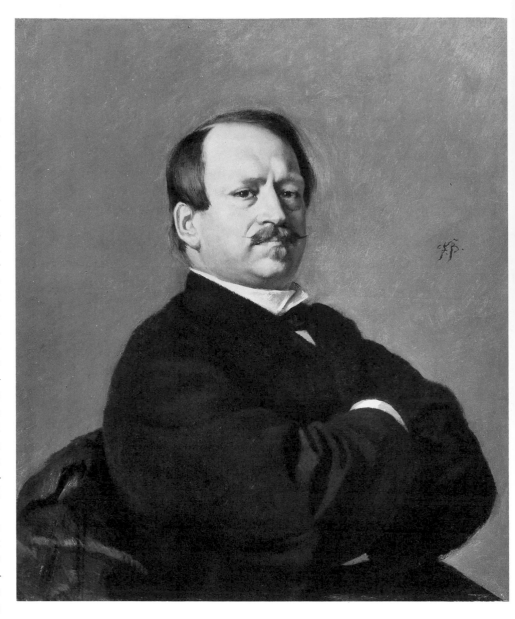

fig. 107
Frank Buchser
Portrait of Constant Fornerod (c. 1865)
Oil on canvas, 75.5 × 63 cm
Signed centre right: F. B.
Provenance: E. G. Castres, Geneva; Rodolphe Dunki, Geneva; acquired 1941

United States were considered as "allies in the spirit of republican freedom and equality". Hence, radical circles conceived the idea of "creating a lasting monument to the great historical achievement of the American War, by commissioning pictures of significant scenes featuring the deceased president A. Lincoln, the president A. Johnson, the Secretary of State Seward and the generals Grant and Sherman, either together or singly; the paintings to be presented to the Swiss High Federal Council (Hoher Bundesrath), that is to the Swiss people, as the nation's property."[4] Buchser's painting, designed to reinforce the ties between the great country overseas and the small European republic, was intended to hang in the still bare building of

the Bundeshaus, for which a grandiose decorative scheme was being prepared in the summer of 1865.[5] A subscription for covering the costs produced a sum sufficient to give Buchser the commission. Well supplied with letters of recommendation by the Ministers Dubs and Fornerod, whose portrait Buchser probably painted on that occasion (fig. 107), the artist set out on his mission.[6]

He arrived in New York on 21 May 1866 and, a few days later, proceeded to Washington to commence his work. He was cordially received in the highest circles. Secretary of State Seward recommended him to the Minister Stanton and the generals Grant and Sherman.[7] General Banks, whose portrait Buchser painted, also "seemed to be pleased with the idea that Switzerland should have a painting of the great men of the Union; everybody seemed flattered and full of praise for the old sister-republic Switzerland."[8]

83 Landscape near Virginia Dale

Buchser, after finishing the portrait of his compatriot Johann August Sutter, one of the founders of California, and the *Blacklegs of Washington*, his first great composition of black people,[9] started on the portrait of the American President. However, his longing to see the aborigines of America and the untouched landscape of the West prompted an abrupt departure from Washington and its society. Senator Sprague, former governor of Rhode Island, had invited Buchser to accompany him, General William Tecumseh Sherman and his brother Senator John Sherman on an inspection tour of the Great Plains, to supervise the construction of the transcontinental railway. Buchser travelled via Omaha to Fort Kearney, the railway terminus. Thence he continued via Julesburg to Fort Laramie, with its Indian camp, where the group arrived on 31 August 1866. On 6 September, they finally reached Virginia Dale in North Colorado on the Wyoming border.[10] Buchser spent ten days on the ranch of a Mr. Redways. While exploring the region, he also accompanied a group of emigrés on the move.[11] As well as a series of drawings and oil sketches he completed the painting *Landscape near Virginia Dale*, whose extreme horizontality seems the ideal format to reproduce the limitless expanse of this region. The scene is dominated by massive granite blocks which give the Laramie Mountains their distinctive character. A path with wheel marks leads past cattle shelters into the depth. Several covered wagons make their slow burdensome trek towards the West. A drawing in Buchser's diary, dated 14 September, accurately outlines the middle portion of the pic-

83
Frank Buchser
Landscape near Virginia Dale, 1866
Oil on canvas, 45 × 137.5 cm
Signed on the back: Virginia Dale [...]/Sept 1866/
Frank Buchser [...]
Provenance: Victor D. Spark, New York; acquired 1953

ture, which is repeated on other pages.[12] Detailed studies of covered wagons and the log cabin are dated 9 and 10 September.[13] On returning to the River Platte, the painter travelled upstream on the Missouri to North Dakota, and reached Washington on 10 October 1866.

Reminiscing about his adventure, Buchser concluded: "I have more or less succeeded in illustrating with my palette my travels to the West. Some paintings appealed even to these prosaic people, the newspapers were full of praise, but so far I have sold none."[14]

84
Frank Buchser
Village Street in Woodstock, Virginia (1867)
Oil on canvas, 24 × 33 cm
Signed bottom right: Woodstock 21 Aug F. B.
Provenance: Galerie Bollag, Zurich; acquired 1927

84 Village Street in Woodstock, Virginia

Late in 1866 and early 1867 Buchser's paintings of black people, particularly *The Volunteer's Return* (Basel, Kunstmuseum), attracted some attention in Washington and New York, which encouraged him to continue along these lines.[15] In the spring of 1867 he planned a large composition intended as a monument to the yoke of slavery. He travelled to West Virginia to study the living conditions of the black population. With him was his mistress, a Creole girl, whom he called Phryne, a reference to Praxiteles' beautiful model for the Aphrodite of Cnidos. In July he painted a few sun-flooded studies of wooded scenes along a stream near Piedmont on the Upper Potomac, in which he included the figure of Phryne bathing.[16]

Mindful of his intention to make studies of black people, on 6 August he moved on to Woodstock, Virginia, where he stayed until 10 September. His diary records the lively days he spent there: "I stayed nearly two months in Grant County, West Virginia, making studies which resulted in three nice paintings. Phryne was with me the last three weeks, then we both moved to Woodstock, Shenandoah, Virginia. *En este momento recibo carta blanca de amor*, Phryne, Phryne!... But here the people, the ignoramus[sic]-rebels, turned against me, throwing caricatures and newspaper articles at me as hard as they could..."[17]

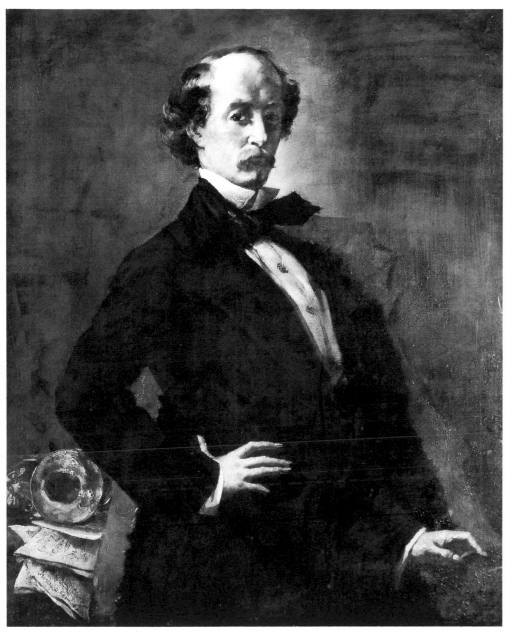

fig. 108
Frank Buchser
Portrait of Buchser's Friend Mollberg, 1854
Oil on canvas, 115 × 91.5 cm
Signed bottom left: F. Buchser 1854./ ...
Provenance: P. Schnyder von Wartensee, Lucerne;
acquired 1929

chief de'vour [sic] is the secret, which panders to the Radical ruin-policy,"[20] and Buchser was forced to abandon his plans.

Buchser joined in the heated controversies with a cynical letter to the editor of the newspaper,[21] and on 21 August he sat down in the middle of the village, to paint a study of its main street after a storm, with houses and trees still dripping wet: a few people are standing under the white sailcloth awnings in front of the houses, and horses are tied up on the side of the street along which a black horseman comes galloping, scattering the chickens and a goose in the foreground. Buchser convincingly captures the sleepy atmosphere of the place: "peaceful, yet somewhat strange and wild. The colouring is surprisingly bright and restless, the ground a strong vermilion, demanding the equally intense dark green of the trees in the middle distance which, in turn, is countered by a crimson poster on one of the houses on the left. The wood in the background is pea-green, and a sharp white occasionally pierces the foreground and middle ground. This was clearly a piece of bravado, for Buchser rarely showed himself so provocative, so surprisingly 'American' and 'modern'."[22]

In another study Buchser painted a circus which had pitched its tent in the village around this time.[23]

Buchser seems to have ventured into a nest of hornets. The fertile Shenandoah Valley, renowned for the beauty of its landscape, had only recently emerged from the devastations of the civil war. The old-established white population was impoverished, and suffering from the revenge politics of Congress. They hated the alien authorities and suspected that their protégé, the "negro-painter", was an agent of the Radicals intent on stirring up feelings against the conquered state of Virginia with his paintings of ragged blacks. A ruined harvest and the demoralisation of the freed slaves contributed to the distrustful and xenophobic mood. The painter's letters of recommendation from Secretary of State Seward and General Howard opened doors only to the officials from the North.[18] Buchser apparently commenced his painting in the centre of the village; preparatory drawings of black men squatting on the floor are preserved.[19] Suspicion was immediately aroused, and on 15 August the *Shenandoah Herald* published a caricature showing Buchser at work amidst a sprawling crowd of tattered blacks, and alarmingly the figure of a black man is nailed to the top of his easel. The County Court withdrew official printing orders, but this provoked renewed attacks on the corruption of the Court which "takes under its especial patronage every wandering Jew, and fourthclass German dauber, whose

85

Frank Buchser
Landscape near Scarborough, 1874
Oil on canvas, 50 × 73 cm
Signed bottom left: Stony hags (?) Scarbro / Octr.
10th 1874 F. Buchser
Provenance: Richard Kisling, Zurich; auction Ga-
lerie Bollag, Zurich, 18 Nov. 1929; Dr. Fritz Nathan,
St. Gallen; acquired 1948 (?)

85 Landscape near Scarborough

In May 1853 Buchser made his first trip to England, where he painted a series of full-figure portraits with dramatic chiaroscuro effects,[24] such as the *Portrait of Buchser's Friend Mollberg* (fig. 108). His second sojourn in England, of 1855-57, was also mainly devoted to the lucrative art of portraiture, and his *Portrait of an Englishman* (fig. 109) belongs to this period. The identity of the sitter is unknown. He also painted a few *plein-air* studies.

Buchser often visited the fashionable English spa town of Scarborough on the coast of Yorkshire, where he established a studio. He courted the affluent clientele, modifying his virtuoso depictions of fishing girls on the beach to suit the taste of the general public.[25] At the same time he painted some more ambitious works, foremost amongst them the *Landscape near Scarborough*.

The date of the picture, 10 October 1874, scratched into the wet paint, indicates that it was not painted on the spot, since Buchser was in Switzerland between August and December 1874. It has therefore been assumed that the artist re-worked a composition begun during an earlier stay, adding the green field in the foreground, together with the actual date and an indistinct name of the location.[26] Buchser, indeed, made a series of studies with the foreground left unfinished.[27]

fig. 109
Frank Buchser
Portrait of an Englishman, 1856
Oil on canvas, 55.5 × 45.5
Signed bottom right: F. Buchser/56
Provenance: Private collection, London; Dr. Fritz
Nathan, St. Gallen; acquired 1937

A hedge crossing the picture diagonally and almost completely engulfing the fence, becomes the major motif of the composition. With its vehement brushwork, colour applied in dots and partly in long thick strokes, and web-like pattern of lines scratched into the paint, the painting mirrors the forces of life. The unassuming subject of the hedge seen in close-up becomes a metaphor of the all-embracing power of nature, implied by the unrestrained impetuosity of Buchser's brushwork. The field in the foreground and the view into the gentle valley with its subtle harmonies of brick-red and green provide a contrasting area of calm.

This picture with its choice of motif, its complementary contrast of blue-green with the subdued orange-red tones of the fields, and its striated formation of clouds, bears a surprising resemblance to contemporary paintings by Pissarro, although Buchser could hardly have been familiar with the French artist's work and shows no knowledge of the systematic brushwork of the Impressionists.[28]

Arnold Böcklin

(1827-1901)

Even in his own lifetime Arnold Böcklin was a legend. Soon after his death, however, the champions of Impressionism in Germany, led by Julius Meier-Graefe with his book *The Case of Böcklin and the Theory of the Units*, tried to deal a fatal blow to his reputation.[1] But the painter's friend Hans Thoma (q. v.) expressed the general feeling of his contemporaries when he said: "We live in Böcklin's era;"[2] hence it would be a mistake to see the artist merely as the painter of the world-weary cultured bourgeoisie.

Böcklin's progress towards the status of a cult figure was not always smooth. He neither sought nor rejected success, which arrived only after years of privation in Italy. The son of a Basel merchant, he took drawing lessons in his native city, and then studied with Wilhelm Schirmer at the Düsseldorf Academy and with Alexandre Calame (q. v.) in Geneva. Through Calame's expressive alpine landscapes,[3] he experienced nature in its late Romantic mood, as a stage for the display of heightened sensibilities. However, he soon moved away from Calame, and the Alps did not prove a lasting source of inspiration. After a stay in Paris during the turmoil of the 1848 Revolution, he decided to satisfy his longing for the south and on the advice of his friend Jacob Burckhardt moved to Italy in 1850. Italy became his spiritual home where he tried to realise the eternal truths of humanity by recreating the myths of antiquity in realistic sensuous landscape settings. Böcklin frequently returned for extended periods to Switzerland and Germany, where he maintained a lively intellectual contact with his friends, amongst them Gottfried Keller (fig. 110) and Jakob Burckhardt. Another important influence was Johann Jakob Bachofen, who explored the earliest epochs of civilisation in search of "the dark depths of human nature", and discovered in the matriarchal order of the world "the subjection to physical laws of the spiritual, the dependence of human development on cosmic forces."[4]

In Italy, Böcklin adapted his staffage to the atmosphere of the southern landscape. In his early work the figures are more or less subordinated to and closely absorbed in nature (fig. 111), but gradually they begin to dominate and to establish the mood.[5] For his mythological themes he relied less on the exalted world of Olympian gods and goddesses, and resorted to personifications of natural forces in the shape of satyrs, nymphs, Pan, centaurs, tritons and nereids. Böcklin's world of antiquity gains conviction from his dialogue with Bachofen and Nietzsche, who were also engaged in a search for the origins of man, before the separation of myth from history. Böcklin was not a history painter but an artist illustrating general human impulses and eternally recurring primal conditions. His paintings are about feelings such as loneliness, longing, separation, erotic desire, struggle, intoxication, happiness and bliss, which, in the guise of mythical creatures, have a timeless validity.

Oskar Reinhart did not collect Böcklin's melancholy, elegiac works, full of an unsatisfied longing. Neither the beauty of wilderness and decay, as shown in the *Villa at the Sea*, nor the morbidity of the *Isle of the Dead* were of interest to him, but, following Meier-Graefe's polarisation of Böcklin's oeuvre, he was attracted to the early painterly works, animated by lyrical sounds of the flute. With the exception of the major late painting *Paolo and Francesca* (fig. 116), he collected only sketches from the late work.

86 Pan amongst the Reeds

Pan, together with his retinue of fauns, satyrs and nymphs, seems to be Böcklin's favourite, most frequently represented, mythological figure, which he "took close to his heart."[6] His early work, in particular that between 1854 and 1860, singles out these sensual creatures in a variety of situations. He starts with simple scenes of nature far removed from civilisation, as can be seen in *Goatherd in the Campagna* (fig. 111), where the enchanted growth of vegetation dispels any doubts about the existence of satyrs and nymphs.

These beings seem to behave quite naturally in works such as *Bacchanalia* (fig. 112), where a procession of intoxicated music-making couples advances towards the place of sacrifice. This is one of the most freely

fig. 110
Arnold Böcklin
Portrait of Gottfried Keller (1889)
Chalk and gouache, 41 × 28 cm
Signed bottom right: AB

painted of Böcklin's early forest scenes, based on his experience of the light-filled Roman woods. "All objects – bark, leaf, rock and ground – have been reduced by the radiant light to mere gradations of brightness. The three pairs of revelling bacchantes, beating their drums, are dissolved into broad bands of light: Dionysian drunkenness as intoxication with light! ... The human form ecstatically surrenders to the great life-force of light."[7] In such paintings Böcklin explored the animalistic-Dionysian characteristics, which had been adapted as a motif by some of the Romantics.[8] As explained in his trea-

86
Arnold Böcklin
Pan amongst the Reeds (1856/57)
Oil on canvas, 138 × 99.5 cm
Signed bottom right: A. Böcklin fec.
Provenance: Emma von Obermayer, Vienna/Rome/ Paris; Carl Steinbart, Berlin (1885); art dealer Amsler & Ruthardt, Berlin; A. Schwabe, Berlin (1901); Marion von Weber, Dresden (1901); Ludwigs Galerie, Munich; acquired 1928
(Andree 114)

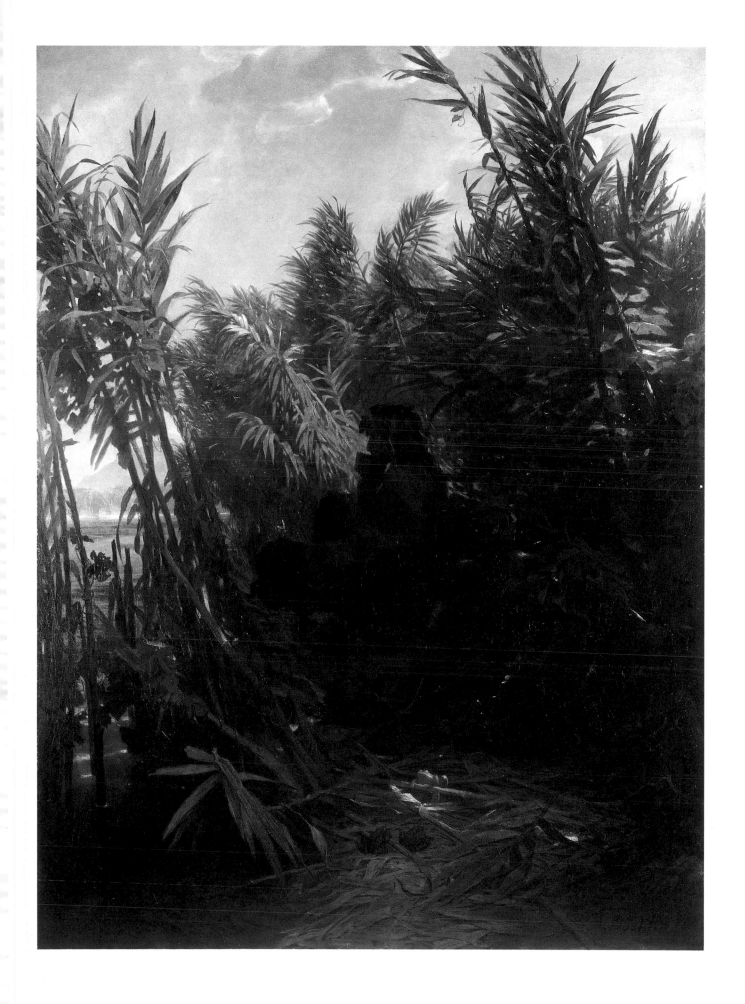

Anselm Feuerbach

(1829-1880)

The artist grew up in Speyer in a good middle-class family with wide humanistic interests. His father was a professor of archaeology. After studying at the academies of Düsseldorf, Munich and Antwerp, he entered Couture's studio in Paris, where he was influenced by Delacroix and Courbet. The character of his early work was formed by history painting, and focused on subjects from the Renaissance. He arrived in Italy for the first time in 1855 and after a stay in Venice settled in Rome in 1856, where he remained, apart from brief trips to Germany, until 1873. His painting *The Temptation of St. Anthony*, intended for the 1855 World Exhibition in Paris, had been rejected and subsequently destroyed by the disappointed artist, but he reverted to the composition in a second version (fig. 118) inspired by the motif of *Tannhäuser*; the strong influence of Tintoretto suggests that it was probably painted in Venice.[1] Choosing his themes from "high" mythology, in contrast with Böcklin's (q.v.) "everyday" myths and Marées' (q.v.) ideal of pure objectivity, Feuerbach was the most literary of the "Deutsch-Römer" (a group of German artists working in Rome *c.* 1860-80) whose work was based on a constant study of earlier art, particularly the art of the Italian Renaissance.[2] His relationship with Anna ("Nanna") Risi, whom he met in 1860 and who left him in 1865, and with Lucia Brunacci, who took her place in 1866, provided him with the models for some of his best-known paintings on the theme of Iphigenia and Medea.

91 Iphigenia

One of the central themes in Feuerbach's work, which he pursued from about 1858,[3] is the subject of Iphigenia which, as Richard Muther remarked, contains strong autobiographical elements: "Agamemnon's daughter... is the lonely Feuerbach himself who, like Hölderlin, the Greek Werther, flees to a dream-like Hellas on a happy shore to find peace for the sick soul."[4] For Muther the painter was a man who "deeply felt all the intellectual and spiritual contradictions bred by the nineteenth century, even cultivating them with a certain tenderness as a kind of

superior, refined condition ..., practising, in the manner of Bourget and Verlaine, psychopathology under the microscope, and searching with a weary soul for the refinement of simplicity."[5] Feuerbach himself expressed such a state of mind in one of his letters: "Just when I think I can no longer endure the waiting, exalted subjects come to me from above, giving me strength and consolation... I know that I am now receptive to the overwhelming power of antiquity ... my restless mind is ever ready to create; why does the mere thought of Iphigenia affect me so much, why does this age-old story move me so deeply that I can find neither peace nor rest to recreate it?"[6]

Re-introduced by Goethe, the legend of Iphigenia was one of the best known Greek myths in the nineteenth century and seemed to express the current yearning for Greece.[7] According to Euripides, Iphigenia, daughter of King Agamemnon, was to be sacrificed to the goddess Artemis to enable the Greek fleet to sail against Troy. Artemis, however, substituted a stag for the sacrifice and banished Iphigenia to Tauris, where she became a priestess. There she was found by her brother Orestes, who helped her to escape and return home. Characteristically Feuerbach was not interested in the drama of sacrifice and rescue but in the elegiac, melancholy state of longing as expressed by Goethe in his *Iphigenia on Tauris*: "Alas, the sea keeps me from my loved ones / and during long days standing on the shore / my soul searches for the land of the Greeks / and my sighs are answered / only by the dull roar of the waves."

Feuerbach's long preoccupation with the subject resulted in two full-figure paintings. The first version (1862; Darmstadt, Hessisches Landesmuseum)[8] had been planned according to Goethe's text with Iphigenia standing, but in its finished state shows her seated. Her self-absorbed, contemplative

gaze gives way in the second version (Stuttgart, Staatsgalerie), on which Feuerbach worked from 1867 to 1871, to a more purposeful, alert expression of expectant yearning. The Winterthur head was painted in preparation for this second version and cannot be separated from the complicated history of its creation.[9] Executed as an independent painting, it differs in the pose of the right arm, which is hanging down, as well as in the hair-style, clothes and jewels.[10] The neutral background, omitting a landscape, makes the profile head stand out in clear and clean outlines, comparable to the portrait busts of "Nanna" of about 1861.[11] The cool grey harmony of both paintings, enlivened only by the colours of the jewellery, struck Feuerbach's stepmother (and others) as peculiar.[12] The model for this Iphigenia was Lucia Brunacci, while Nanna Risi posed for the first version.

Feuerbach originally considered the *Iphigenia* a purely private work: "I have destined the Iphigenia for our house, and I believe anybody wanting a personification of longing will find it in this picture," he told his stepmother.[13] He had discussed the central motif in connection with the first version: "Now I have solved the problem of Iphigenia. The state of mind which we call longing needs physical calm. It requires introspection, self-abandonment. In a moment of contemplation the picture was born, not following Euripides, or Goethe, but simply representing Iphigenia sitting at the sea shore while her soul is 'searching for the land of the Greeks.' What else could she do?"[14] This "late nineteenth-century picture of longing, pure and simple"[15] does not suggest a "longing directed away from this world (as in Romanticism) but a longing confined to the world, which was aimless because, lacking concrete objectives, it remained a search for the currently unattainable: faraway lands, the fatherland, the past, truth, greatness, the ancient gods – gods walking on this earth."[16]

91
Anselm Feuerbach
Iphigenia, 1870
Oil on canvas, 62.5 × 49.5 cm
Signed bottom right: A. Feuerbach./R.70.
Provenance: Dr. Lobstein, Heidelberg (1891-1929); private collection, Heidelberg (1942); Fritz Nathan, Zurich; acquired 1953

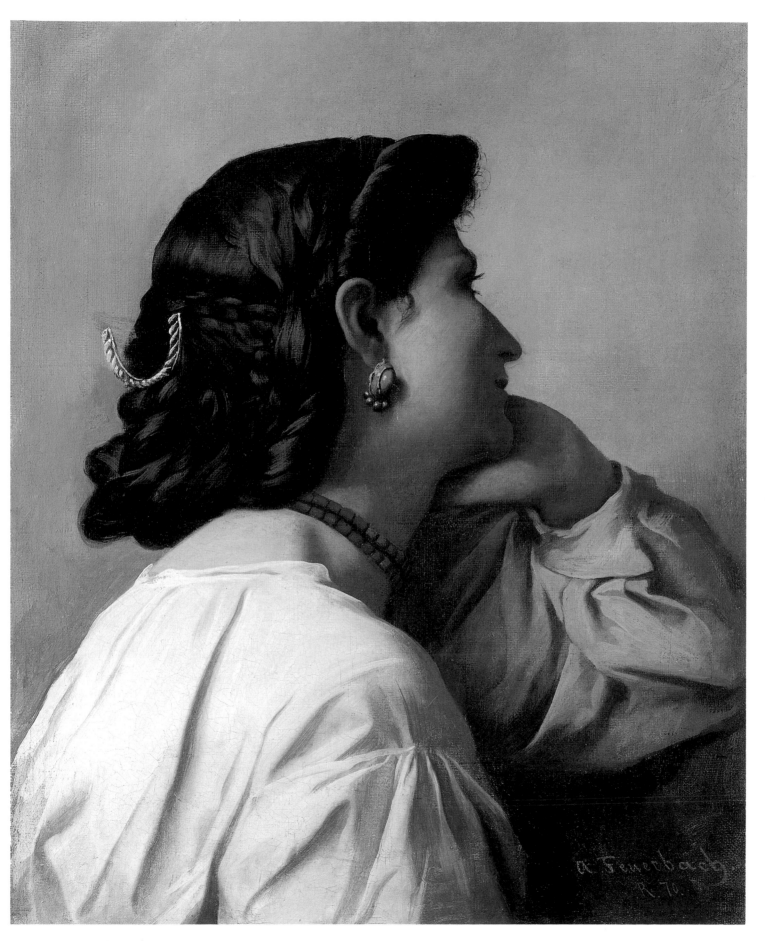

209

Hans von Marées
(1837-1887)

Marées, the third and youngest of the great "Deutsch-Römer" artists, travelled with Franz von Lenbach in 1864 to Rome, the city for which he yearned,[1] where, like Böcklin (q. v.) and Feuerbach (q. v.), he was to copy works by the old masters for Count Schack. Italy remained his chosen home which, apart from a few trips and a stay in Germany in 1870-73, he never left. He got to know Böcklin and Feuerbach and assembled a circle of young students. He maintained a lively intellectual exchange with his patron, the art theorist Conrad Fiedler, who provided for his financial needs.[2] With him, in 1869, he visited Spain, France, Belgium, and Holland, where he was most impressed with the works of the seventeenth century. On his first visit to Holland in 1860, he had been stimulated by Rembrandt's chiaroscuro, which influenced his early work, such as the 1862 *Self-Portrait with Hat* (fig. 117).[3]
Marées' life, though uneventful, found fulfilment in work, a ceaseless struggle in which the artistic process was almost more important than its result. His objective, the unadorned and monumental portrayal of the classical ideal of man, was both simple and limitless, requiring a constant striving for perfection, which was impossible to attain. His work remained locked in his studio during his lifetime and first became known after his death, when it met with mixed reactions.

Some critics, including his friend Conrad Fiedler, with whom he had corresponded about theories of art,[4] found a discrepancy between intention and execution, which led to the painter's ultimate failure,[5] while Julius Meier-Graefe in his magnificent monograph raised him to the position of a leading star of the new art, making comparisons with Cézanne which have been repeated ever since.[6] Marées' evident commitment to formal artistic values[7] and his "failure" aroused the admiration of many serious art historians around the turn of the century, who were aware of his tragic conflict. Richard Muther, for instance, praised Marées' simplicity: "Didactic formulae were replaced by poetry, historical anecdotes by the joy of visual beauty, theatrical pathos by the static purity of line."[8] Karl Scheffler observed: "No other artist's painting is as difficult to describe in words as Marées'. For in this art of tonal monumentality, in this visual expression of philosophy, there is hardly any subject content, no drama, no narrative and no stimulating objects. To convey an impression of this kind of painting one would have to find precise verbal descriptions of forms and movements, light and colour. This, however, is just as impossible as describing music in words. Swinging rhythm is everything... To the question what did Marées paint? there is only the inadequate answer: portraits and nudes, horses and hounds in ideal landscapes."[9] As early as 1897 Heinrich Wölfflin commented: "Purest beauty was coupled with risible distortion ..., but the paintings' power to touch the soul was so great as to make one forget their faults ... in the realisation that they aimed at the highest pinnacle of artistic achievement."[10]

92 St. Martin and the Beggar

Several times Marées, as well as Feuerbach (fig. 118), turned to themes from Christian iconography, particularly the lives of the saints. According to popular legend St. Martin, an officer of the Roman legion in Gaul who later became Bishop of Tours, during a severe winter in Amiens cut his cloak in two with his sword and gave one half to a beggar. Marées returned to the motif in his triptych *The Three Riders* (Munich, Neue Pinakothek), where the saint appears in a winter landscape. Marées is thought to have painted a first version of this subject, which no longer exists.

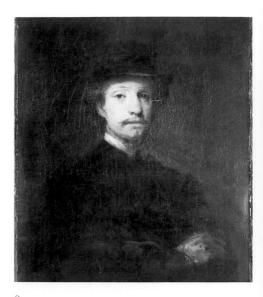

fig. 117
Hans von Marées
Self-Portrait with Hat (c. 1862)
Oil on canvas, 70 × 60 cm
Provenance: Gift of Marées to the painter Ernst Kunde, Munich; Karl Sachs, Breslau (1912-24); Fritz Nathan, St. Gallen; acquired 1940
(Meier-Graefe 80, Gerlach-Laxner 51)

fig. 118
Anselm Feuerbach
The Temptation of St. Anthony, 1855
Oil on canvas, 81.5 × 100 cm
Signed bottom left: A. Feuerbach. 1855.
Provenance: Galerie Hugo Helbing, Munich (1895); August Riedinger, Augsburg (1904-22); art dealer Schulte, Berlin (1929); Galerie Hugo Helbing, Munich; Ludwigs Galerie, Munich; acquired 1934 (Ecker 193)

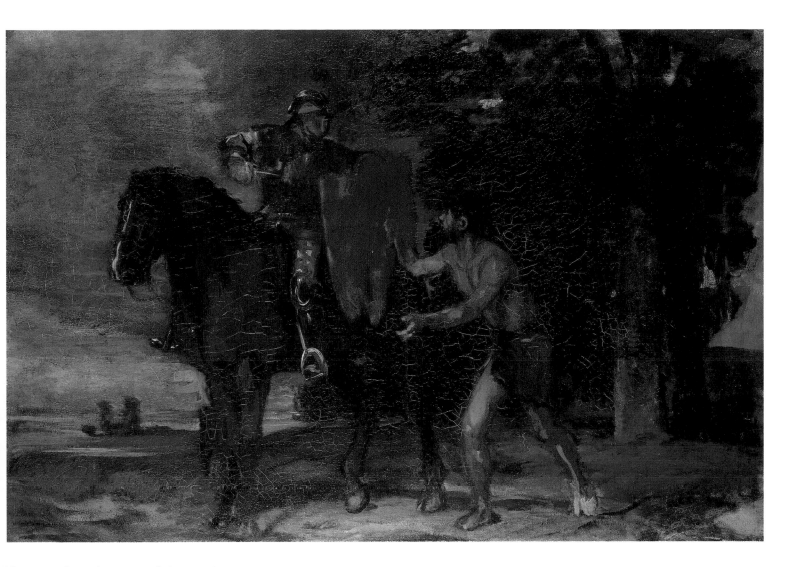

The un-Italian character of this work suggested to Meier-Graefe that it was painted on the artist's return from Spain, at the same time as *Philip and the Chamberlain* (Berlin, Nationalgalerie), when he was staying on Fiedler's country estate Crostewitz near Leipzig, in the winter of 1869/70.[11]

The painting still suggests the artist's struggle with the composition, which is firmly contained within the picture plane, but it is above all a coloristic *tour-de-force*. Instead of merely defining objects, the jewel-like colours shine in their own right. The entire picture appears to be painted solely to set off a plane of pure carmine red against a deep azure blue; everything else, including the narrative itself, seems at first glance to be a concession to artistic convention. The purity and luminosity in the centre are gradually absorbed in the dusky shades towards the edges. The mood created by the fading sunset befits the motif. "Marées generally favours the late evening dusk that envelops the scene with soft shadows, making a few forms stand out in brighter light. There are clear references to Rembrandt and the Venetians, but at the same time this treatment expresses something of the artist's innermost self, conjuring up apparitions out of solemn, colourful darkness."[12]

Action and content, however, are not unimportant for they are expressed in sublimated form: "the ... red of the cloak provides a link between the figures of the mighty knight above and the miserable beggar below, who receives not only the garment to cover himself, but participates in the splendour it symbolises. The knight, by abandoning a part of his own status with the cloak, elevates the beggar, thus achieving a brotherly Christian union more effectively than by offering him alms."[13] Colour and landscape have been seen as influenced by Rubens and Delacroix.[14]

92
Hans von Marées
St. Martin and the Beggar (c. 1869/70)
Oil on canvas, 73.5 × 105 cm
Provenance: Konrad Fiedler; Adolf von Hildebrand, Munich (until 1906); Mary Levi, Partenkirchen (1906); National-Galerie Berlin (1906-08); Mary Balling, Partenkirchen (1908); Mary Balling estate (1924); Ludwigs Galerie, Munich; acquired 1934 (Meier-Graefe 147, Gerlach-Laxner 92)

fig. 119
Hans von Marées
*Two Female Studies, from the Front and from the
Back*
Red chalk, 57 × 43 cm
Provenance: Baron Karl von Pidoll, Munich
(Meier-Graefe 686)

Marées was a highly gifted painter of riders
and horses. The latter became a *leitmotif* of
his work, inspired by his studies with the
horse painter Carl Steffeck. Meier-Graefe
saw the horse as a major component of this
composition: "In the 'Martin' the saint's
horse is pivotal to colour and composition,
an anchor for all the loose [colour-] fields,
with the deepest glow of colour emerging
from its firm flesh. The broad shoulders and
stocky neck stand out monumentally against
the horizon. As a breed this horse seems to be
close to the heavy stallions painted by Veláz-
quez."[15]

Marées' work is more accessible in the spon-
taneous drawings than in the constantly ela-
borated oil paintings. The drawings help de-
velop and clarify the concept of a painting,
providing a quick assessment of a motif in the
studio, or an aide-mémoire for ideas. These
sketches, sometimes produced in a single
hour, became superfluous after being incor-
porated in a painting and Marées used to give
them away, or use them as paper covers.[16]
Some drawings of nudes (fig. 119) show a
certain penchant for geometric form. Heads
are represented as spheres and legs as co-

lumns on which the body rests. The joints do
not suggest movement, but the capacity for
movement.

In keeping with his lengthy working proce-
dure for the paintings, Marées produced a
large number of studies for each motif. The
composition emerged during the process of
drawing. His painstaking method of realising
a picture, involving constant correction and
tightening, occasionally resulted in the inde-
pendent development of a pictorial idea,
sometimes successful, at other times abor-

fig. 120
Hans von Marées
Chiron and Achilles (1883)
Red chalk, 58.5 × 43 cm
Provenance: Baron Karl von Pidoll, Munich
(Meier-Graefe 799)

fig. 122
Hans von Marées
Nudes, Horses, Riders and Lions (c. 1884)
Red chalk, 57 × 43 cm
Provenance: Mary Balling, Partenkirchen
(Meier-Graefe 849)

fig. 121
Hans von Marées
St. George
Red chalk, 44 × 34 cm
Provenance: Baron Karl von Pidoll, Munich
(Meier-Graefe 590a)

tive. In this way the seated figure in the background of *Chiron and Achilles* (fig. 120) emerged from the preliminary sketches as an independent motif, the figure of *Innocence*.[17] Many drawings show a high degree of artistic autonomy, an outstanding example being the rhythmically structured study of *St. George* (fig. 121), one of the preparatory sketches for the *Riders* triptych in Munich.[18] The drawing *Nudes, Horses, Riders and Lions* (fig. 122) fascinates by the distribution of the figures, which are loosely scattered over the picture plane.

angle of the lens is adapted to the position of the book. In this holy hour, which she has saved from her housework, she is transfigured by the sunlight streaming in through the attic window, its glow surrounding her head with an aureole and casting bright streaks on her body and arms. The light evokes an aura of domestic peace. Patches of sunlight fall on the chest with its keys and on the floor, and reflections of the fully lit white curtain gleam on the upper drawer; in the window the mirror effects make their own patterns. The vase of white flowers on the sill reflects the cleanliness and purity of this bright and sober room. The view through the open window reveals the roof of the house opposite, with a cat sitting in a rooftop window. This idealising picture, one of the most ambitious works of the 32-year-old artist, expresses his affection for his mother in a universally valid form, but at the time the public showed little understanding for such simple and unsentimental character studies. A critic of the *Frankfurter Zeitung* called him the "not untalented founder of social-democratic painting".[5]

In the same year Thoma painted the *Portrait of Agathe Thoma in a City Dress* (fig. 124), as well as the *Self-Portrait* in the Hamburg Kunsthalle, which, together with his mother's portrait, form a kind of family trilogy. They are the inventory of the Thoma household in Säckingen.

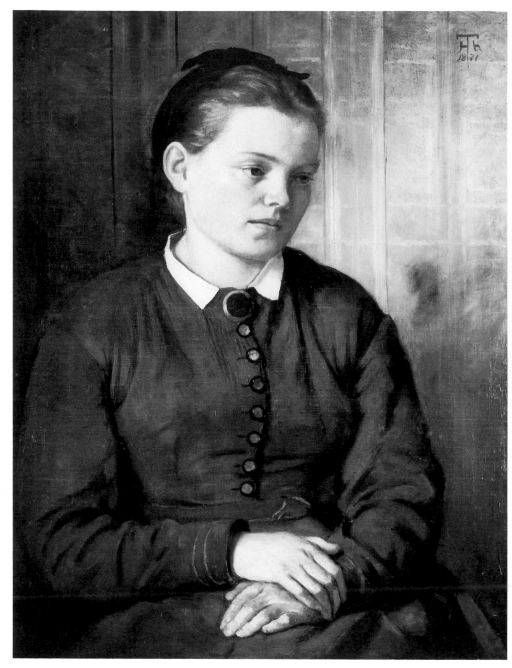

fig. 124
Hans Thoma
Portrait of Agathe Thoma in a City Dress, 1871
Oil on canvas, 75.5 × 58.5 cm
Signed top right: HTh/1871
Provenance: Ludwigs Galerie, Munich; acquired before 1936

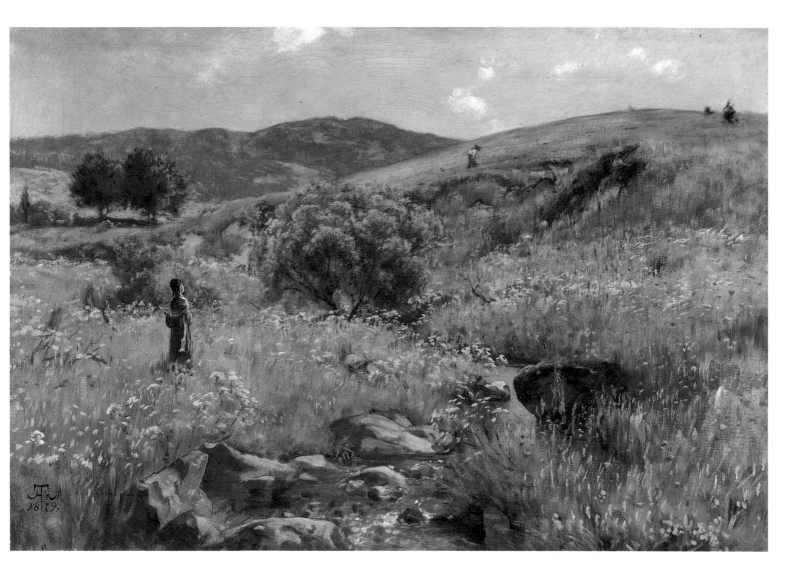

94 Flowering Meadows near Bernau

In spite of the broad subject matter of his oeuvre, Thoma gave his best in his landscapes. "They express his character most clearly. Defining the whole of his creative work, they are the red thread running through all his art."[6] He became in later life the German landscape painter *par excellence*. The popularity of his paintings introduced many to the beauties of nature, which was henceforth seen through his eyes. The Black Forest, his home and lifelong favourite motif, remained the inexhaustible reservoir and elixir of his art, to which he kept returning. In his youth he experienced the peace and calm of his native valley, where he marvelled at the miracles of the microcosm when observing the animals and plants, whose language he seemed to understand.[7] His dew-filled, close-ups of nature captured the movement of grasses and the murmuring of the trout streams.

Thoma's experience of nature was supported by a deep religious feeling: "I knew the Bible intimately, and nature often spoke to me like a psalm."[8] Nature's beauty revealed to him the Creator, and in his paintings he sought to "reveal the universal law of life... in the smallest blade of grass."[9] Ultimately it did not matter to him which region he was painting: "Since as a painter I include in landscape the clouds and the blue of heaven – the atmo-

94
Hans Thoma
Flowering Meadows near Bernau, 1879
Oil on canvas, 52 × 74 cm
Signed bottom left: HThl 1879.
Provenance: August Weismann, Freiburg im Breisgau (1909); private collection, Zurich (1924); Fritz Nathan, St. Gallen; acquired 1942

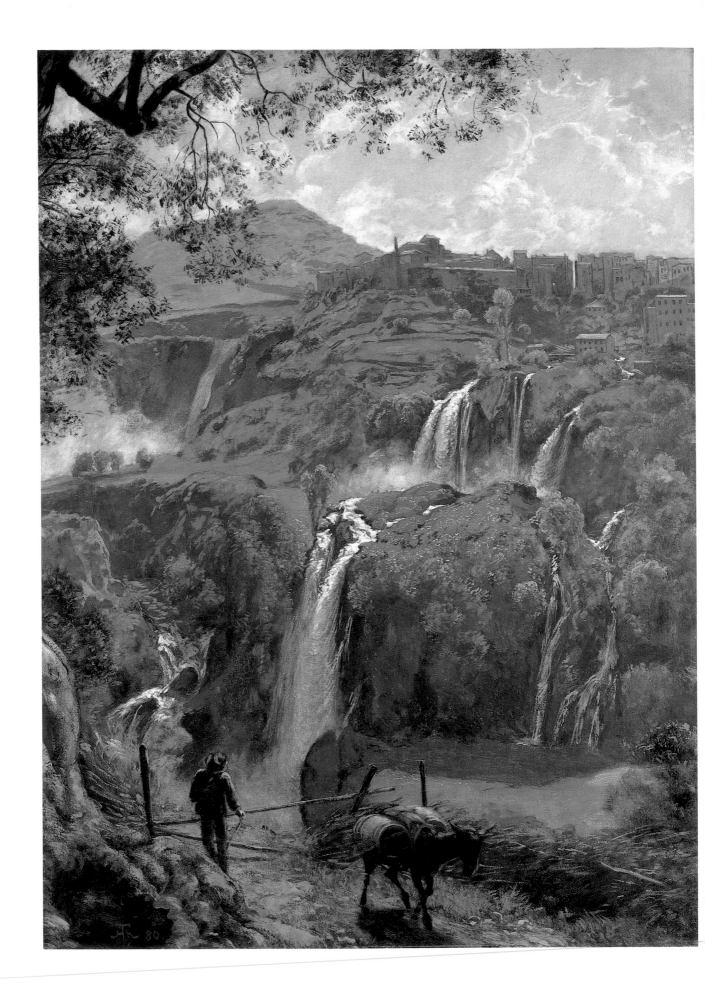

fig. 127
Hans Thoma
Study for The Waterfalls of Tivoli, 1880
Tempera on paper, mounted on cardboard,
62.5 × 54 cm
Signed bottom right: HTh.; inscribed centre bottom:
Tivoli 28. 4. 80
Provenance: Fritz Nathan, St. Gallen; acquired
1938

At that time Thoma lived in Frankfurt, a city
that offered him few interesting motifs. In
contrast with the Impressionists, all the cities
where he lived or travelled – including Paris,
Florence, Venice, London, with their *vie mo-
derne* – left him cold. He did not become a
bohemian but, on the contrary, brought his
home background into the city. The four
views he painted from the window of his
Frankfurt house focus not on the lively street
but on the château Holzhausen in the park
called the Öd.[15] Nothing suggests an urban
view. For Thoma these pictures represent "a
valid testimony to the serenity of our life,
with flowers expressing more profoundly
than words the happiness and peace that was
ours."[16] The young couple lived in Frankfurt
from 1877 until 1899, sharing their house-

95
Hans Thoma
The Waterfalls of Tivoli, 1880
Oil on canvas, 106 × 77 cm
Signed bottom left: HTh 80.
Provenance: Charles Minoprio, Liverpool (1880) (?);
Ludwigs Galerie, Munich; acquired 1934

hold with Thoma's mother and his sister
Agathe. The painting *View of the Öd*
(fig. 126) was the only one of the four views
to remain in the artist's possession, which
makes it a personal memento of that time. As
in the painting *The Artist's Mother in an At-
tic Room*, light floods into the room, which
also contains a vase of flowers on the window
sill. The Bible lies open on the table, inviting
the expectation that the mother will enter at
any moment.

95 The Waterfalls of Tivoli

Like so many German artists of his century,
Thoma was drawn to Italy, although he was
not inspired by a longing for classical antiqu-
ity. Unlike Feuerbach (q. v.) he did not search
for the ideal of classical art, neither did he
share his friend Böcklin's interest in a revival
of classical myths, even though he painted
mythological subjects inspired by Böcklin
(q. v.); he was more driven by curiosity and a
thirst for adventure.[17]
He first travelled south in February 1874,
without any great preparations or expecta-
tions: "Eyes, eyes are all one should take
along on a journey to Italy – and only as
many books as will not ruin the eyes."[18]
Characteristically, he wanted to observe the
land and people with an open mind; how-
ever, he sometimes found his compatriots
frustrating: "I found them often full of in-
flated ideas of their own knowledge, but
blind to everything they see. The powerful
impressions of art, nature and human life
present here are wasted on their stereo-
typed minds."[19] Nevertheless, he sometimes
participated in the lively discussions of the
German artists in Rome, where in 1874 he

met Hans von Marées (q. v.), Adolf von Hil-
debrand and Frank Buchser (q. v.). On one
such occasion it was suggested that all an-
cient art should be removed and the Vatican
and its collections burnt.[20] Thoma, however,
attributed such ideas, which anticipated
Marinetti's Futuristic manifesto, solely to the
excessive intake of alcohol. He was not over-
whelmed by the grandeur of classical art, but
revelled in the southern atmosphere of the
Campagna, exploring its magnificent land-
scape under azure-blue skies. Inebriated by
the scent of olive groves in bloom he listened
to the lively songs of the goatherds.
The second of his five Italian tours, under-
taken in 1880 as a belated quasi-honeymoon
with his wife Cella, proved the most fruitful.
The Liverpool art dealer Charles Minoprio
had commissioned about ten Italian views
from him. "He gave me a list indicating ap-
proximately the motifs he desired, without
however making this a binding obligation.
Thus I painted the first picture while still in
Frankfurt... which made me feel somewhat
relieved."[21] Thoma could charge all travel
expenses, which he meticulously recorded, to
his client, who was one of his earliest patrons.
Thoma had visited him in England in 1879:
"At Easter 1879, Charles Minoprio from Liv-
erpool, a native of Frankfurt, bought one of
my landscapes in the Kunstverein. This was
the beginning of an important relationship
which happily gave me security over the next
few years, when my pictures were rejected by
almost all German exhibitions... Eventually
this English collection owned more than
sixty of my pictures, which were shown in an
exhibition of the Liverpool Art Society [in
1884], so that my first exhibition took place
in England."[22]
In Italy Thoma filled his sketchbooks, and on
his return to Germany he painted the com-
missioned pictures, among them *The Water-
falls of Tivoli*, which are in the same tradi-
tion as countless other views of Tivoli. The
cascading waterfalls sparkle like strings of
pearls of almost fluorescent whiteness amidst
the green vegetation of the slopes, topped by
the familiar silhouette of the little town
whose roofs glitter in the midday light.
Thoma's working procedure, and his under-
standing of reality, become apparent when
comparing the large-scale preparatory
sketch (fig. 127), made on the spot, with the
painting. The sketch, a pencil drawing with

again proves his mastery of the *alla prima* technique, that is painting wet on wet in order to preserve the freshness and purity of colour and the sensibility of a personal handwriting.[14] This had to be done without any overpainting or subsequent adding of glazes, which Trübner once criticised as a mechanical, unartistic way of achieving harmony.[15] Trübner himself used this technique of modelling in coloured patches even more consistently than Leibl.

Leibl, in his experiments with the application of colour in those years, sometimes used a rough, stabbing brushstroke, as in the *Man with a Black Beard* (fig. 131). By contrast he also produced paintings in an almost old master technique, with a sensitive application of colour, such as the *Portrait of Alwine Belli* (fig. 132). The skin of the sitter, who died soon afterwards, has a sickly colour and a porcelain-like smoothness resembling vellum.

99 Village Politicians (Peasants in Conversation)

Becoming disillusioned with the Munich artistic milieu and its frequently adverse criticism, Leibl decided to retreat to the country. In the spring of 1873 he moved to Grasslfing on the edge of the Dachau moor. Hitherto he had been painting middle-class people from an urban milieu, but now he felt in a new element: "Here, in the freedom of nature and amongst nature's people one can paint naturally."[16] From spring 1875 to late 1877 he lived in Unterschondorf on Lake Ammersee. It was an immensely productive period during which he created not only the *Village Politicians*, but also *The Hunter* and the *Unequal Couple*. The choice of such rural motifs brought about a change of technique leading to a smoother application of paint, which prompted an often repeated comparison with Holbein in an 1878 review in the Paris *Figaro*.[17]

Leibl seems to have started the *Village Politicians*, together with the *Three Women in Church* (Hamburg, Kunsthalle) his most famous work, in 1875, but finished it only at the beginning of 1877.[18] In a letter to his mother he wrote: "My picture shows five peasants in a small farmhouse room putting their heads together, presumably to discuss a municipal matter, since one of them is holding a piece of paper like a land register. They

are real peasants painted as faithfully as possible from nature; the room is equally real, since I painted the picture in it; the view from the window shows a part of the Ammersee."[19] Leibl pretends to be a neutral witness to the scene, speculating about the subject discussed by the peasants, although he undoubtedly made them pose for the picture, putting a piece of paper in their hands. They all had to be present for the sittings, which took place over one year.

Leibl was concerned solely with objectively observing a specific piece of reality, as he explained: "My principle does not concern the *what*, but the *how*, to the chagrin of the critics and reviewers, and the crowd at large, who are mainly interested in the *what*."[20] Leibl thus left the subject of his painting to our imagination. Although the painterly execution has precedence over the motif, the human content emerges spontaneously from the painter's precise observation, as summarised in Leibl's often quoted sentence: "I paint people as they are, their soul is present anyway."[21] Leibl thus created a masterly characterisation of peasantry, not anecdotal or novelistic like Franz von Defregger's peasant scenes, but as a subject with its own validity. Eberhard Hanfstaengl's interpretation of the peasant character and the reaction to the land register, which occupies the focal point of the composition, is particularly apt: "Though he usually likes to assert his personal independence, when faced with an official document he joins forces with others on the principle of opposing authority, from which rarely anything good can be expected. These men of marked individuality are presented in a quietly restrained group almost resembling a still life. Such a depiction can only be achieved through great familiarity with the peasant character: suspicious to the point of stubbornness, slow in the uptake but at times very aware, reluctant to be jolted out of his lethargy and dullness, and demonstrating his rejection through silence rather than speech. There has never been a more perceptive representation of a peasant than the old man with his hands resting on a stick – he is the epitome of centuries-old defiant self-assurance, not to be shaken by fate, however hard, unwavering, durable and firmly rooted in his own milieu like an ancient tree. This is the central figure around which Leibl grouped the rest, giving each a different part

to play and thus registering a scale of various reactions."[22]

Anton Freiherr von Perfall gave a vivid account of the circumstances in which the work was created: "In the winter of 1877 I visited [Leibl]. He was painting the *Village Politicians*, the picture that finally opened the eyes of the critics to Leibl's art, albeit only in France, not in Germany. Hitherto there were no painters of real peasants, only pedlars of anecdotes and village dramas, and painters of pretty girls in folk costume and of handsome country lads, associates of Auerbach and Hermann Schmidt, some good, some better, some worse, – but none of them painted the peasant as he grows and stands on his own soil, without any novelistic implications. Even the great Dutch painters could not do it, their work is also dominated by anecdote, drollery or brutality. The *Village Politicians* was thus an epoch-making subject. – I can still see it: The narrow room, the massive Leibl next to his models, the searing heat and the small window slits opening onto the lake. The mayor, resting his hands on his stick, was snoring noisily, the reader of a newspaper was currently being painted. Leibl literally painted by the sweat of his brow – but the finished picture shows no trace of this, no signs of torment or strain; it looks as unselfconscious as a work of nature. The most ingenious piece of painting I ever saw was the white wall. It projected a vivid light that enabled the artist to place his figures wherever he wanted. It separates and reunites two groups. The artist's intentions are projected in absolute clarity which penetrates all objects, be it a glittering button, a red cloth, a knitted cap, an ear or a stocking – an amazing artistic achievement."[23]

Perfall published further details in the periodical *Jugend* in 1901: "It was winter, the light from the snow outside was falling on the group from two directions, through windows not much larger than gunports. I kept wondering how he managed to distinguish anything on his panel. Never before have I seen him work so hard. He did not say a word, his manly features were full of strain, his brawny blacksmith's fist guided the brush with admirable delicacy. He did not compose by painting one figure after the other: everyone in the whole group, from beginning to end, had to stay where they were. I remember how delighted he was to observe the delicate

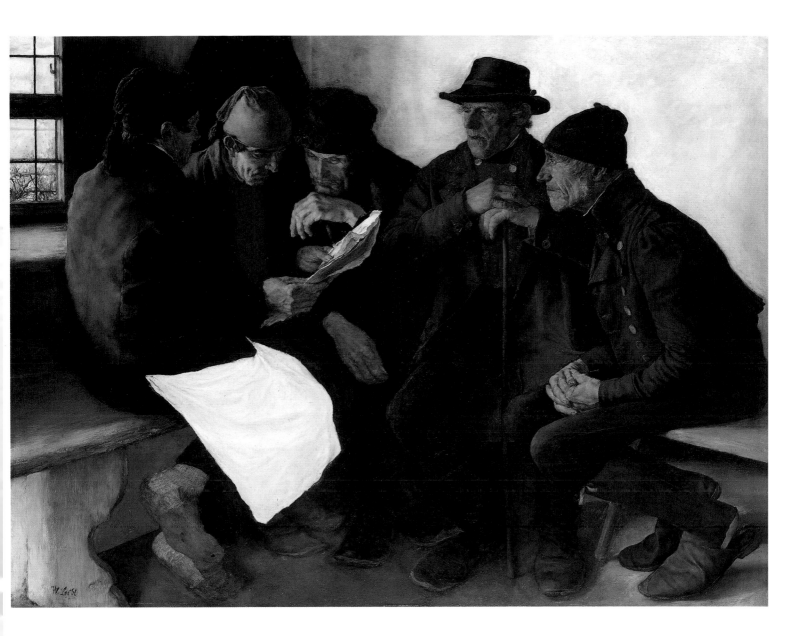

99
Wilhelm Leibl
Village Politicians (Peasants in Conversation) (1877)
Oil on panel, 76 × 97 cm
Signed bottom left: W. Leibl
Provenance: William Stewart, Paris, later New York (1878); Eduard Arnhold (1899 - 1929); Eduard Arnhold estate, Berlin (1930); Dr. Kuhnheim, Munich; Fritz Nathan, Zurich; acquired 1953
(Waldmann 131)

rim of light around the contour of the black tasselled cap worn by the peasant half-turning his back towards the onlooker."[24]

Afflicted by extreme nearsightedness, which caused distortions of perspective, Leibl struggled to achieve the subtle modelling and contours of the figures – the key to the success of his painting. He carefully recorded the phenomena of colour and light in their strong chiaroscuro contrasts and conceived the idea of placing in the darkest zone a near-snowy white plane which seems to float detached on the picture surface. This white apron, mystery and seal of Leibl's genius, shatters the perfect illusion, raising the representation of nature to a work of art.

Leibl himself had called the painting simply *The Peasants*, but as early as 1878 critics in-

troduced the title familiar today; Edmond Duranty, in the *Gazette des Beaux-Arts*, entitled it *Paysans politiquant*.[25] When first exhibited in 1877 in the Munich Kunstverein, and again in 1878 in the Vienna Künstlerhaus, the painting had little success, causing the painter deep disappointment. However, at the 1878 World Exhibition in Paris it met with an enthusiastic reception. The reviews by Charles Tardieu, Edmond Duranty and Roger Ballu were full of praise for the work. The picture was acquired directly from the exhibition by William Stewart, a wealthy art collector from Philadelphia.[26]

Carl Schuch

(1846 - 1903)

Carl Schuch was another artist of the inner Leibl (q.v.) circle. He was born in Vienna, where he studied at the Academy from 1868 to 1870. After a stay in Italy with the painter Albert Lang, he moved to Munich. In 1871, in the company of Lang and Trübner (q.v.), he painted pictures on Lake Starnberg, where the three artists encountered Leibl.[1] Subsequently they shared a studio. Schuch and Trübner spent the winter of 1872/73 in Rome, followed by numerous joint study trips which later prompted Trübner to set himself up as "Schuch's impresario".[2] From autumn 1876 to spring 1882 Schuch stayed mostly in Venice, often in the company of Karl Hagemeister, his painter-friend and later biographer. The two spent the summer months of 1878, 1880 and 1881 in the villages of Ferch and Kahnsdorf on the Havel, in the Brandenburg Marches. Schuch was greatly attracted by the wide wooded landscape and the thatched farmhouses, as well as by the lakes and ponds with their unusual light effects. In *Landscape at Ferch* (fig. 135) he captured the peace and loneliness of this region in an emphatically static composition. Hagemeister, who specially praised this picture, rightly characterised such works as "landscape still lifes".[3]

From 1882 to 1894 Schuch lived in Paris, where he was in direct contact with contemporary French painting; he developed his purely painterly late style, detached from the object, and pointing to developments in the future. He also occupied himself with theoretical problems of art. From 1891 his mental faculties began to fade, bringing his work to an end. He returned to Vienna in 1894, where he died in a sanatorium in 1903.

fig. 135
Carl Schuch
Landscape at Ferch (c. 1878)
Oil on canvas, 68 × 86 cm
Signed bottom right: CSchuch
Provenance: Fritz Nathan, St. Gallen; acquired 1946

101 Still Life with Wild Duck

In his Paris years Schuch painted almost exclusively still lifes. This is the more surprising as the painter, according to his biographer Hagemeister, repeatedly mentioned "his constant determination to proceed from still life to architecture and landscape."[4]

Like Cézanne, Schuch confined himself to a limited number of motifs. He used a few objects, in ever-changing juxtapositions, to examine purely artistic problems, which he also discussed theoretically. Struggling for the autonomy of the picture, he experimented with composition, contour, visual effect and colour harmony, in a series of paintings differing little from one another.[5]

The *Still Life with Wild Duck*, probably painted around 1885, again shows objects frequently used in other paintings. A wild duck, four kohlrabi and a wooden box, placed on a table-top made from two planks joined in the middle, are the entire inventory.

The objects emerge indistinctly from a neutral dark ground, following their own rules. Most of the Paris still lifes without a table cloth show the same wooden table-top, which Schuch once described as a "grey-green plank".[6]

Schuch used carefully to record the compositions of his palette in his Paris notebook, as if listing the ingredients in a recipe.[7] He often spoke about "coloristic actions" that determined his still lifes. The present picture may serve as an example. There is action in the way the objects emerge from the intense chiaroscuro, and this is intensified by the complementary contrast of pure emerald green in the leaves and the traces of red lacquer in the colour scale of the kohlrabi, moving from broken white towards violet. The loudest chords within the muted, broken-up palette, whose delicate nuances combine with the differentiating layers of paint, express the most delicate variations of surface effects. The softness of the plumage, the compact surface of the vegetables, the brittleness of the wooden box are subtly transformed into painting. The spaces between the objects are painted with equal intensity, suggesting not emptiness but atmospheric density.

Schuch regarded his subject in terms of possible tonal scales or "palettes", as pointed out in Gottfried Boehm's astute analysis: "The research into appearances in Schuch's sense is the re-creation of things seen from the logic of tonal sequence, from the structure of the picture. This logic is ambiguous. On the one hand it is concerned with 'pure painterly' conditions; on the other hand it delineates the picture of things seen, aiming to develop it in its essence from the roots upwards."[8]

Schuch, however, certainly did not think of colour in impressionistic bright and pure tone values. His still lifes are rather "saturated with the power of dark", which is never an autonomous black pigment, but is modulated in each case according to the colour values dominating a picture. "Unbroken light exists as little as darkness entirely free of light."[9] Schuch was not concerned with simply representing the surface of objects, which only records the visible aspect of the motif, but sought to express "reality in its developing visibility, in its ethereal essence."[10] In this he proved to be the most intellectual of the painters emerging from the Leibl circle, whose artistic aims have often given rise to comparisons with Cézanne.

101
Carl Schuch
Still Life with Wild Duck (c. 1885/87)
Oil on canvas, 62.5 × 79.5 cm
Signed top right: CSchuch
Provenance: Coll. Doering, Stettin (1913); Max von Bleichert, Leipzig (until 1931); Rudolph Lepke auction house, Berlin; acquired 1931

Wilhelm Trübner
(1851-1917)

Some of Trübner's early work, painted in the short span between 1871 and 1878, is among the best produced by the Leibl circle, so that, after Schuch (q. v.) and Leibl (q. v.), Trübner is considered a major exponent of the group.[1] Confining himself to a purely painterly manner, he offers in such works "nothing but good painting, whose tonality, like still life, expresses absolute objectivity."[2] At the same time, however, he also showed a tendency towards anecdote and mythology, which is at loggerheads with his progressive theoretical ideas. He had a close relationship with Leibl, who painted his portrait (Cat. 98), and also with Thoma (q. v.) and Schuch. With the latter, in 1872, he travelled to Venice and Rome, where he painted in a brothel the astonishing *Nude behind a Curtain* (fig. 137), which, as the bouquet suggests, is inspired by Manet's *Olympia*.

102 Seeon Monastery with Haystacks

After 1878 Trübner experienced an artistic crisis, from which he emerged only a decade later. In a second great burst of creativity, he produced above all the landscapes of the Chiemsee region. In a tribute on the artist's sixtieth birthday Karl Scheffler remarked that his desire for painting had been re-awakened.[3] In the summer of 1891 Trübner stayed on the island of Fraueninsel in the lake of Chiemsee. There, amongst other pictures, he painted *The Flagpole* (fig. 139), with its pole patterned in the Bavarian colours blue and white, described by Justi as "a symbol of unquestioning acceptance of actuality".[4] In the following summer Trübner again stayed in the Chiemsee region, this time in Bad Seeon, where he painted the venerable old monastery, a Benedictine foundation with predominantly Romanesque architectural features, in at least eight versions.[5] A comparison of *Seeon Monastery with Haystacks* with *Seeon Monastery with Wooden Bridge* (fig. 136), probably painted earlier, before the hay-harvest, clearly shows the artist's striving for clarification and compositional unity. Elliptical forms in the sky and in the foreground, which are mirrored along the horizontal line of the bank, give the painting a dynamism which is reinforced by the monastery complex, seen at

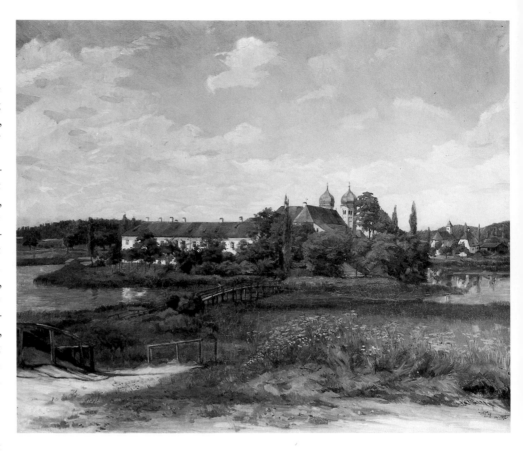

fig. 136
Wilhelm Trübner
Seeon Monastery with Wooden Bridge, 1892
Oil on canvas, 77.5 × 92.5 cm
Signed bottom right: W. Trübner. 1892.
Provenance: Städelsches Kunstinstitut, Frankfurt am Main (on loan?); Galerie Karl Haberstock, Berlin (1925/26); Siegfried Buchenau, Niendorf/Lübeck (1927); Fritz Nathan, St. Gallen; acquired 1940 (Rohrandt 602)

an angle. This disciplined, concentrated arrangement prevents the foreground from becoming an incidental motif. Trübner must have observed with satisfaction the haymakers whose work contributes greatly to the clarity of his composition.

Such paintings manifested a new commitment to colour which Scheffler, discussing "Impressionism translated into Old German", described with great insight: "Contrasting with the Velázquez-like manner and the delicate blacks of his youthful works, his painting after 1890 assumes a colourful brightness. Every shadow is now transformed into colour ... The pleasure in splendid colour harmonies threatens to become inebriation with colour."[6]

Trübner's colour is neither spontaneous, nor

fig. 137
Wilhelm Trübner
Nude behind a Curtain, 1872
Oil on canvas, 67 × 92 cm
Signed bottom left: W. Trübner. 12. 1872./Roma.
Provenance: G. Schwarz, Frankfurt am Main (1916); bought back by Wilhelm Trübner; auction Rudolph Lepke, Berlin (1918); Julius Böhler, Lucerne (1927); acquired 1939 (Rohrandt 150)

imitative of materials or objects. As in Cézanne's works, the surface of the painting is structured by parallel layers of brushstrokes. "Trübner: that means the broad brush! This painter can think only in terms of oil colour."[7] This "structured", clearly ordered

manner of painting avoids dissolving objects in light but emphasises their solidity; it is well suited to the type of *Kulturlandschaft* (cultural landscape) preferred by the painter, which harmoniously embraces buildings pregnant with history. Trübner continued to be attracted to landscape and architecture, such as the monasteries in Herrenchiemsee (1874), Frauenchiemsee (1891), Seeon (1892), Amorbach (1899) and finally Schloss Cronberg (1896).[8]

His *alla-prima* painting technique, translating everything into colour chords, differs decisively from Liebermann's vivacious, seemingly uncontrolled brushstroke, which the artist developed under the influence of French Impressionism. Trübner himself, in 1911, divided his past work into three periods. The third period, from around 1889 to 1899, with the Frauenchiemsee and Seeon motifs, led to the climax of his landscape art, which he saw characterised by the "liberal, securely controlled simplification of the brushstroke, the dismantling of forms into broadly structured, space-defining areas, the intense brightening of colour in full outdoor light, the idiosyncratic concept of colour and the elevation of gradually developed problems of painting to a monumental painterly expression. In landscape the magnificent representation of air and space leads to the greatest simplification and brightness of colour."[9]

102
Wilhelm Trübner
Seeon Monastery with Haystacks, 1892
Oil on canvas, 62 × 76 cm
Signed bottom left: W. Trübner. 1892
Provenance: Bernhard Lippert, Magdeburg (1911); Galerie Karl Haberstock, Berlin (1924); Ludwigs Galerie, Munich; acquired 1924
(Rohrandt 604)

Fritz von Uhde
(1848-1911)

Uhde's painting blends a naturalistic concept with impressionistic elements. Though partly influenced by Liebermann (q.v.), one year his senior, Uhde did not pursue the transition to Impressionism dogmatically. The roots of his artistic career, which was periodically interrupted by his military ambitions, are manifold. After a short stay at the Dresden Academy he studied with the painter of battle scenes, Ludwig Albrecht Schuster, a pupil of Horace Vernet; he was also influenced by Makart, who sent him to Karl von Piloty in Munich. He frequented the Munich studio of Liebermann, with whom he struck up a friendship and on whose advice he made a journey to Holland in 1882. There he studied the phenomena of light and colour and began to make sketches of children. For his religious paintings, executed from 1884, Uhde adopted a naturalistic style to make them more topical and more emotionally appealing. Some of these works represent Christ as intercessor for the poor, and show him in a contemporary setting and in stylish clothing, resulting in some ambiguity. Nevertheless, he may have given an impetus to some of the Expressionists.

Uhde's ambitious religious paintings seem strange today and can hardly be viewed without reservations. His compositions based on the simple, "natural" life and his own surroundings are more highly regarded, since they express a modern, unbiased approach. These pictures include the *Landing Pier on Lake Starnberg* (fig. 138), which shows surprising parallels with Trübner's *Landscape with Flagpole* (fig. 139). Uhde's landscape, however, includes references to a family scene. The table in the foreground holds an abandoned empty beer glass and a place setting with dessert bowl and cup, which must be connected with the two figures on the pier. A woman with a dog stares forlornly into the

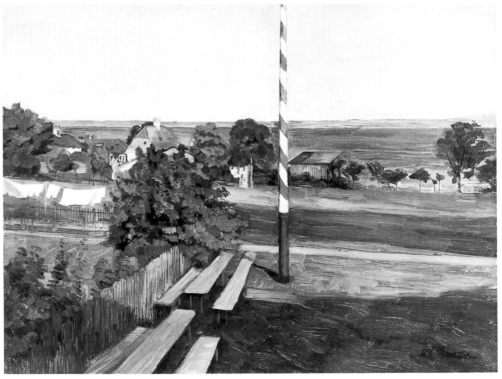

fig. 138
Fritz von Uhde
Landing Pier on Lake Starnberg (c. 1890)
Oil on panel, 36.5 × 47 cm
Provenance: Fritz von Uhde estate, Munich (1911); Galerie Hugo Helbing, Munich; Gustav Henneberg, Zurich (1919); Frau Lehmann-Streiff, Zurich; acquired 1936

fig. 139
Wilhelm Trübner
Landscape with Flagpole (1891)
Oil on canvas, 47 × 64 cm
Signed bottom right: W. Trübner
Provenance: Hermann Nabel, Berlin (1908-17); Hans Reinhart, Winterthur; acquired 1965 (Rohrandt 597)

103
Fritz von Uhde
The Big Sister (c. 1884/85)
Oil on canvas, 60 × 48.5 cm
Signed top right: Uhde
Provenance: Ludwigs Galerie, Munich; acquired 1934

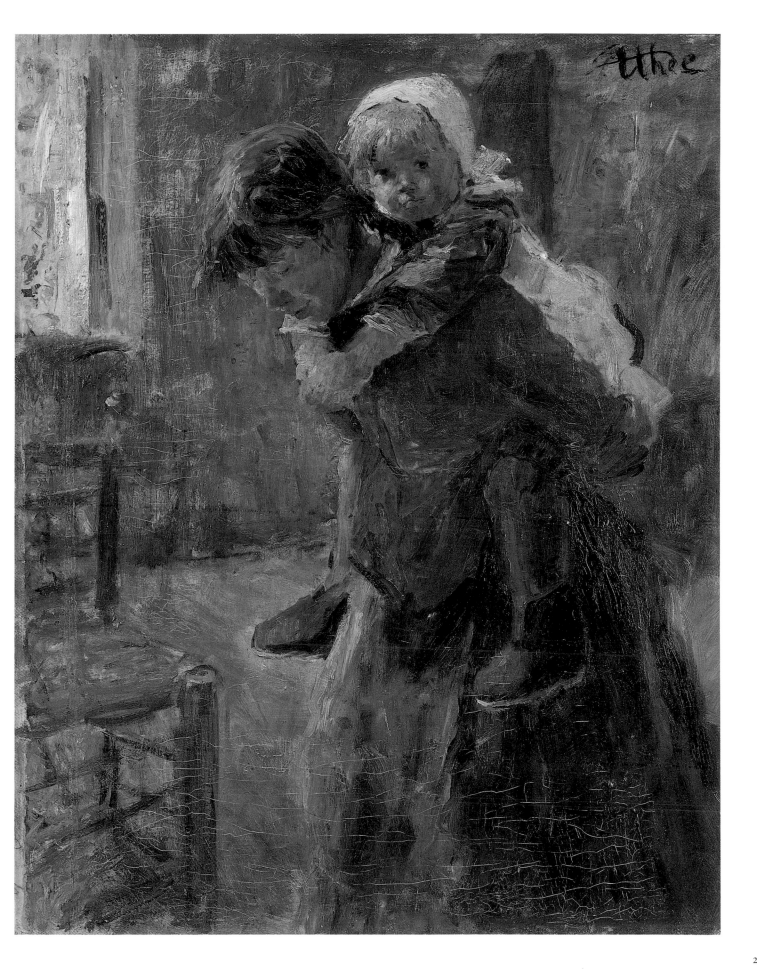

237

water, and further along a man is seen from behind, looking into the distance. The two figures express isolation, they do not communicate. Significantly, this work became known only from the artist's legacy. Usually Uhde preferred to paint family scenes expressing domestic harmony. His three daughters, portrayed by the father in every phase of growing up, are always depicted as well brought-up girls from a good middle-class family. As well as his daughters, born in 1881, 1882 and 1886, Uhde often painted other children, and also young girls on the verge of adulthood, with great psychological insight, and depicted without sentimentality. Not surprisingly these studies of children found their place in Uhde's religious paintings, particularly in *Come Lord Jesus, be our Guest* and *Suffer Little Children to come unto Me*, making such scenes appear strangely close to life.[1]

103 The Big Sister

In spite of its comfortable format and painterly execution on canvas, with the artist's signature confirming its finished status, this work is in fact a study for the much larger painting *The Big Sister* in Nuremberg.[2] A comparison of the two versions provides a revealing insight into Uhde's working method. The Nuremberg picture shows a wider space, enriched by several objects which give it a narrative character. There is a table on the left, a picture hangs on the wall and a flower pot stands on the window seat. These details, however, do not add to the credibility of the milieu and unnecessarily distract from the figures. In the Winterthur picture Uhde sympathetically analyses the face of the older girl and the childishly curious and somewhat suspicious expression of her little sister. The latter looks at the viewer, whose closeness is suggested by the fact that the older sister is visible only to the knee. By contrast the finished version shows both children full-size, each with a half-smile, clearly an attempt at idealising and introducing a touch of prettiness. The nervous restlessness of the Winterthur sketch, with its flickering contours of light around the figures, shows that it was painted spontaneously, directly in front of the model. The sketchy character, suggesting impressionist influences, has been suppressed in the large version, without being entirely removed; its traces produce a mannered effect. Thus the vivid portrait revealed in the study has been turned into a pleasant picture, which, incidentally, is very similar to Liebermann's 1876 painting *Brother and Sister* (Dresden, Staatliche Kunstsammlungen).

104 Girl Reading

In preparation for this painting Uhde closely observed the Munich art scene, picking up various trends which he allowed to mature in this happy composition. In contrast with the previous work this painting has nothing sketchy about it, but reveals an awareness of Leibl's careful technique and motifs. The painting also shows a certain affinity with Thoma's *The Artist's Mother in an Attic Room* (Cat.93), in for instance the motif of

reading, the view from the window over a roof and the cosy domesticity. In Uhde's work, however, the sunlight streaming in produces more intense colours. Since his meeting with Liebermann in Munich in 1880, his palette brightened and work and social themes attracted his interest. This painting, as indicated by the apron and the household utensils such as bucket, jug and plate, is set in the milieu of domestic servants. But work as such is not the central theme, unlike the similarly conceived contemporary painting *Girl peeling Potatoes* (Cologne, Wallraf-Richartz-Museum), with its romantic Cinderella figure, for which the same model posed. Uhde does not succumb to the anecdotal, which revels in picturesque incidents, but chooses a moment of repose and relaxation.

A source for Uhde's art, which cannot be underestimated, was Holland, where Liebermann also found inspiration. During a lengthy stay at Zandvoort in 1882, the rural population in their colourful costumes and the bright, diffused light inspired his first naturalistic pictures. These include the *Dutch Seamstresses*,[3] which may be considered the first step towards the *Girl Reading*.

104
Fritz von Uhde
Girl Reading (1885)
Oil on panel, 60 x 45 cm
Signed bottom right: F. v. Uhde
Provenance: A. Piper, Berlin-Grunewald; Galerie Eduard Schulte, Berlin (1908); Max von Bleichert, Leipzig (1931); auction Rudolph Lepke, Berlin (1931); Siegfried Buchenau, Niendorf/Lübeck; Walther Bernt, Munich; acquired 1950

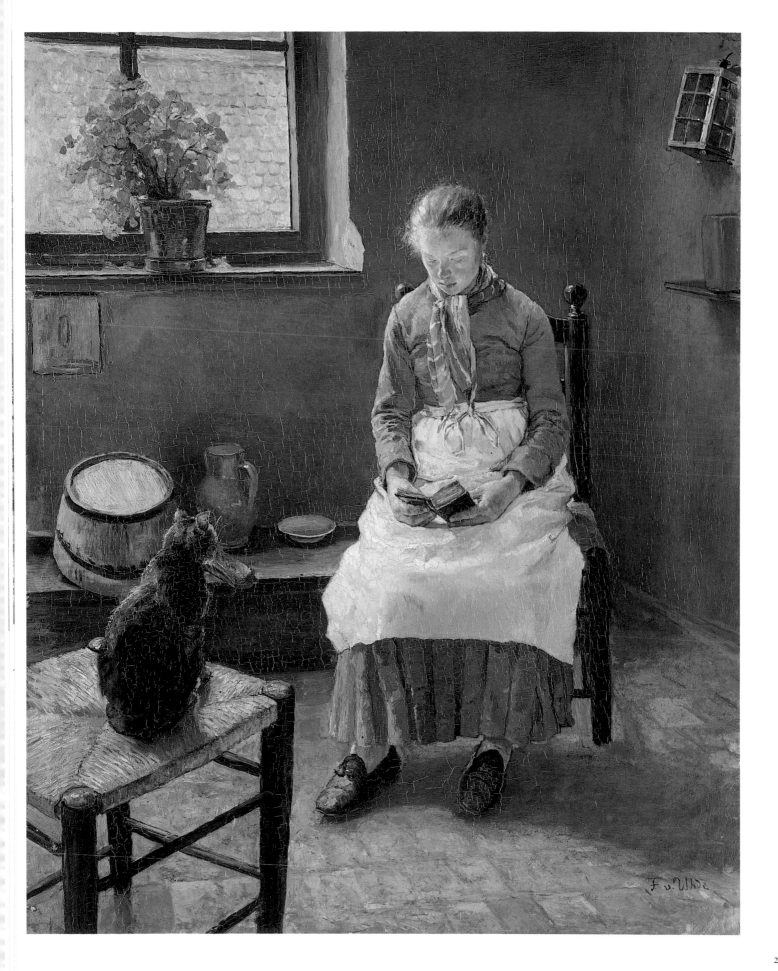

shall walk until the Day of Judgement." Since then Ahasverus has wandered restlessly all over the world.[6] He had to accept his inevitable fate in the same way as Duchosal had to accept his illness, and Hodler the death of the members of his family. *Ahasver* is derived from a series of realistically painted lonely old men, such as the *Old Man in Contemplation* (fig. 148), which is also related to the group of paintings called *The Tired of Life*. These works demonstrate Hodler's endeavour to raise tragic personal experiences to the level of literature.

At the same time as the portrait of his slumbering poet friend (Hanover, Niedersächsische Landesgalerie) Hodler painted his thirteen-year-old sister Louise-Delphine. Seen in three-quarter-profile to the right, she is sitting upright on a high-backed chair, her head slightly turned towards the spectator, her dark eyes looking into the distance with an expression of awakening inner yearning. Her crossed-over hands relax on her lap, and in her left hand she holds a narcissus, symbol of spring, youth and purity.

There are two variants of the picture which, at first glance, look very similar, but on closer inspection reveal their differences. Their chronological sequence has been variously assessed in the literature but the most recent investigations suggest that the Winterthur picture is a slightly idealised version of the portrait in Zurich (Kunsthaus), which seems to have been painted directly from the model.[7] In the Winterthur painting the harmoniously flowing contours seem to be more consciously emphasised. Their soft modulations differ from the spontaneous placing of the richly differentiated colour fields in the Zurich painting, which is partly unfinished and whose sketchy technique has caused some authors to assume the direct influence of Manet.[8] The girl in the Winterthur version, which shows the faint outlines of a bed in the background, appears more graceful and fragile. Her features are smoother, the eyebrows and lips thinner, less suggestive of sensuality and revealing a spiritual, vulnerable type of beauty.

Hodler expressed his penchant for simplification and clarity of form, coupled with a tendency to geometric structure, in his theoretical writings on art, where one can find an explanation for the schematic regularity of the narcissus petals in his portrait of Louise-Delphine: "Thus many flowers have their petals of equal form, colour and size evenly arranged around a common centre... as an expression of a certain unchangeable order in nature." Such observations led Hodler to "recognise the important and decisive role played by parallelism, or the repetition of equivalencies, in nature, particularly in phenomena which give us most pleasure, such as flowers."[9]

109 Surprised by the Storm

Hodler's predilection for ambitious multi-figured compositions on a large scale, combined with a heightened sense of reality, pregnant with new meaning, developed early in his career. He probably thought of history painting as a "royal discipline", not immediately accessible to him from his training. Yet this was one of the genres in which he became an innovator with his symbolic figure paintings.

The painting *Surprised by the Storm*, submitted by Hodler to the 1886 Geneva Concours Diday, a biennial figure painting competition, belongs to this development. He frequently participated in such competitions, including the Concours Calame, hoping to make a living from the prize money. The subject for 1886 was "A figure painting representing a group of at least five persons in a barque, being surprised by a heavy storm on the open sea, fighting for their lives against the raging waves."[10] Hodler approached the set task with enormous vigour which, however, proved in vain as the jury did not award a prize to his painting, judging it "not quite conforming to the programme".

With almost unsurpassed dramatic effect the painter squeezed six figures into a nutshell of a boat. Exposed to the forces of nature four women cling to one another in the centre of the vessel, with contorted bodies and terror-stricken faces. The two men have taken on the active role in this catastrophe. The man in the bow fearfully clutches the stump of the broken mast while making a meaningless attempt to recover the now useless sail floating in the water. The helmsman, as yet unaffected by hysteria, is hunched over the helm, trying to prevent the boat from capsizing. The group is seen in extreme close-up, with the raging elements relegated to the background, where the grey sky combines with the banded crests of waves to form a framing motif. The shore is nowhere visible. The water does not splash across the side of the vessel, but rather has the

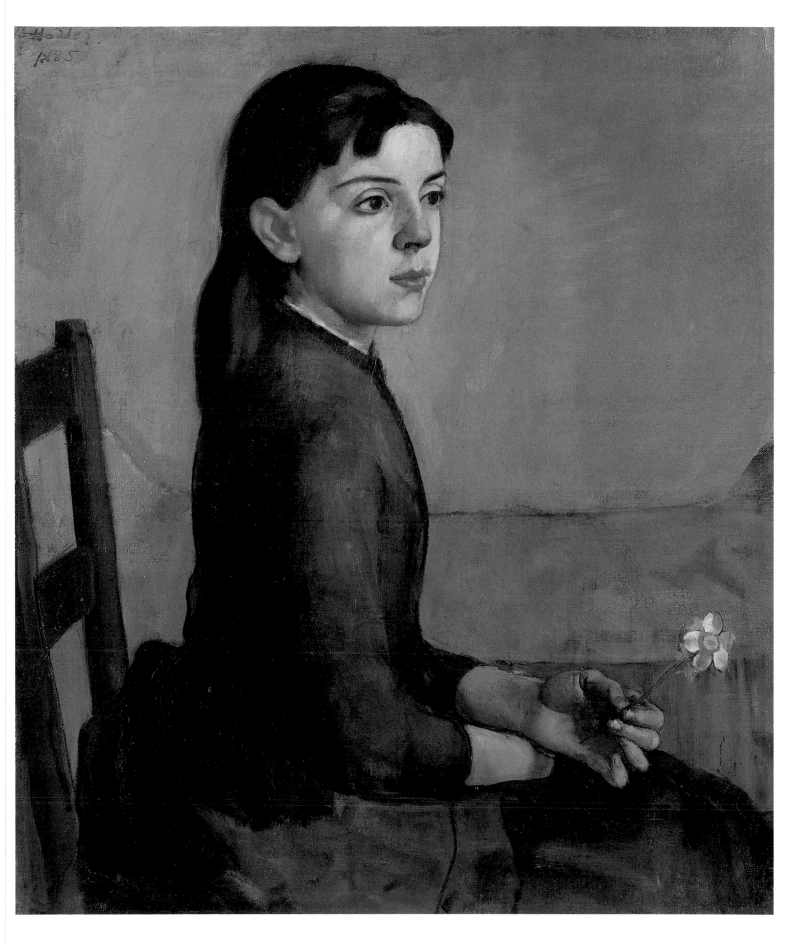

fig. 150
Ferdinand Hodler
Landscape near Langenthal (c. 1882)
Oil on canvas, 72 × 55 cm
Signed bottom right: F. Hodler
Provenance: Bernhard Koehler, Berlin

as well as in figure painting: "emphasising and isolating the essential, and only the essential, determines the artist's creative task, determines art itself."[16] Outlines play a major part in this: "The drawing must always be clear and assured, making the basic structure of the landscape visible and impressive. Equally, the composition must be so striking as to create its impact on first glance. The essential feeling, the dominating accent, must be emphasised beyond any doubt."[17]

Hodler first consistently applied the compositional principle of parallelism to landscape in his painting *The Beech Wood* (1885; Solothurn, Kunstmuseum). "With parallelism I mean any kind of repetition. Whenever I feel most strongly the charm of nature's objects I am impressed with their unity. When walking through a wood with fir trees, one next to the other, striving towards heaven, I see trunks rising in front, beside, and behind me like innumerable columns. I am surrounded by endlessly repeated equivalent lines."[18] Hodler quotes many more examples from all spheres of nature and of human life to reinforce the universal validity of his theory.

fig. 151
Ferdinand Hodler
At the Foot of the Small Salève (c. 1890)
Oil on canvas, 71 × 52 cm
Signed bottom right: F. Hodler.
Provenance: Coll. Schmeil, Dresden; auction Coll. Schmeil, Paul Cassirer, Berlin/Dresden (1916); acquired 1950
(Loosli 2119)

110
Ferdinand Hodler
The Road to Evordes (c. 1890)
Oil on canvas, 62.5 × 44.5 cm
Signed bottom right: F. Hodler
Provenance: Swiss private collection, South of France (until 1930); Galerie Moos, Geneva; acquired 1931 (Loosli 2455)

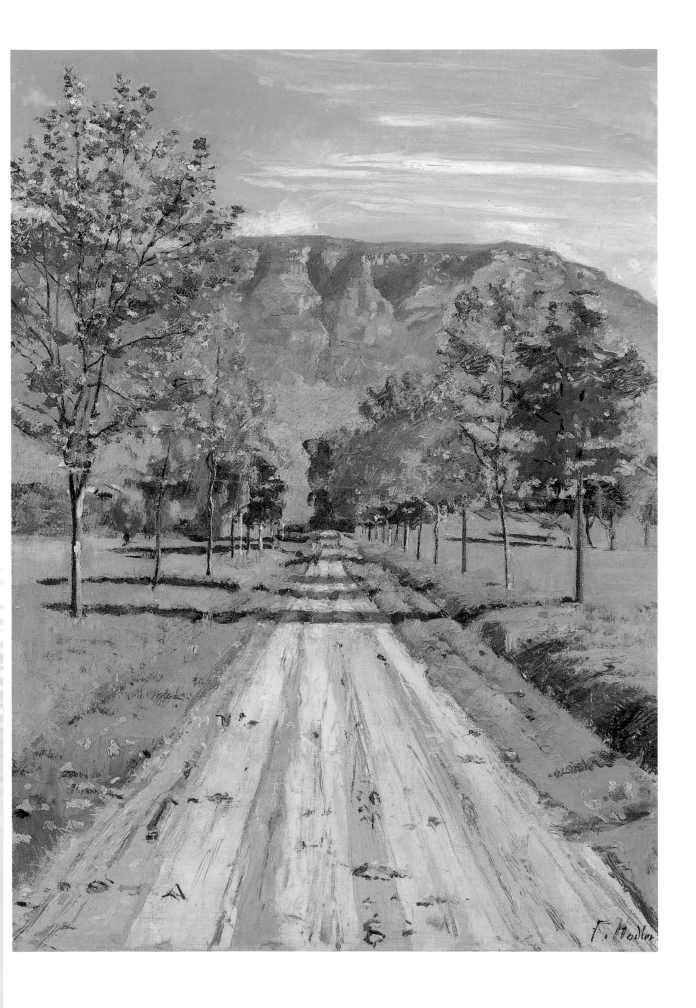

Meandering upwards, the mountain massif reaches the blinding white of the eternal ice crowning the peaks, which even the intense heat of the sun in mid-summer cannot melt. The richly structured wall of rocks, where bright yellow-green bands of grass alternate with brownish and deep blue shadows in the crevasses, is vertically articulated like an abstract pattern. The individual components are arranged in an upward moving rhythm, conforming to expectations of parallelistic repetitions and symmetries. Deep furrows of erosion mark the rock surface, resembling the wrinkles carved by fate and old age in Hodler's face, as depicted in his late self-portraits. The conspicuous off-centre position of the peak seems to heighten the dramatic and expressive content of the painting, leaving panoramic or merely picturesque anecdotal views far behind.[22]

Many of Hodler's portraits of mountain peaks show an increased emphasis on the sky, which gains in space and importance: "When looking up to the sky you have a feeling of unity, both exhilarating and bewildering. The vastness of space is overwhelming."[23]

112 The Dents Blanches near Champéry

Hodler's wife Berthe spent the summer months from June to August 1916 in Champéry (Valais), together with three-year-old Paulette whose mother, Valentine Godé-Darel, had died the previous year. The artist probably painted this mountain landscape on one of his frequent visits to her. Hodler's letter of 23 August 1916 to the Solothurn collector Gertrud Müller confirms his preoccupation with mountains: "I am immersed in landscape from morning to evening. My painting gives me greater satisfaction. I am beginning to understand mountain landscape better."[24]

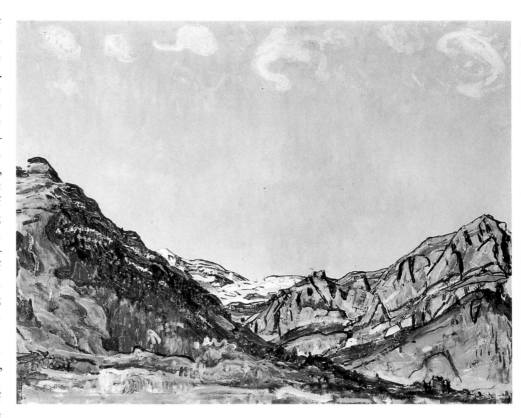

fig. 153
Ferdinand Hodler
Lansdscape near Champéry (1912/16)
Oil on canvas, 60.5 × 79 cm

The broadly layered, rocky massif of the Dents Blanches, rising in the form of a flattened pyramid towards the blue sky, appears like a vision revealed in heightened clarity and plasticity in an elliptical wreath of clouds which, in Hodler's terminology, "eurhythmically" encircle the mountain. The clouds form a frame within the picture plane, floating in front of the mountain at the bottom, while above they form a vault reaching into the depths of space. The mountains seem both infinitely remote and close by. The picture is characterised by symmetries and repetitions of form which contribute to its structural unity. The contours of the flattened, symmetrical mountain ridge are repeated in the parallel outline of the foreground peak, covered with green vegetation.

During the 1910s Hodler added cosmic dimensions to his sublime landscapes, which he called *paysages planétaires*, by projecting the sky as an expression of the all-embracing, unifying universe. His sketchbooks contain numerous schematic drawings of the vault of the sky. The semi-circle above a horizontal line, being the geometric schema of the arc of the sky above the horizon, was for him the epitome of cosmic order and a symbol of nature's unity.[25] "When observing the vault of the sky its great uniformity fills me with admiration."[26] Mühlestein and Schmidt remarked that Hodler "made clouds dance like ecstatic women and planted mountains like *landsknechts*."[27]

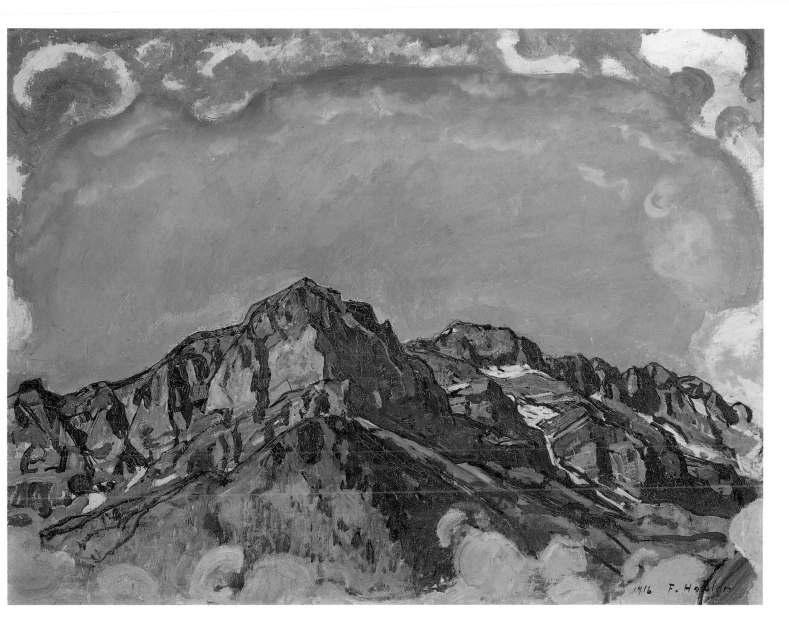

112
Ferdinand Hodler
The Dents Blanches near Champéry, 1916
Oil on canvas, 65 × 83 cm
Signed bottom right: 1916 F. Hodler
Acquired 1917 (?)
(Loosli 18)

Hodler made two further versions of the *Dents Blanches near Champéry*, but without a wreath of clouds and seen from a lower vantage point.[28] Another painting, *Landscape near Champéry* (fig. 153), features a cut-out portion from this picture but extends further to the left. A number of landscapes with a stream made in Champéry at the same time illustrate the "thousand-years' death of the mountains".[29] Hodler often reflected on the significance of the mountain as a symbol of decay: "All objects have a tendency towards the horizontal, aiming to spread over the earth like water, which constantly expands. Even the mountains diminish in height over the centuries until eventually they will be flat like the surface of water."[30]

Hodler's late mountain portraits are not only exalted depictions of nature, but sometimes have a particular meaning. The single, erect and immovable peak personifies the steadfastness and vitality of the individual, subject to the cycle of nature; at the same time it is a metaphor for the loneliness of the artist in his aesthetic isolation.[31]

Giovanni Segantini

(1858-1899)

Giovanni Segantini was accorded an almost religious reverence during his lifetime. His death from peritonitis in the loneliness of the mountains resulted in his transfiguration into a nature-bound prophet of a loss of faith in civilisation. Famous and amply represented in Europe's museums, he was seen as the equal of Nietzsche, and as sharing the confessional tendencies of Munch, Van Gogh and Ensor. Kandinsky awarded him a place amongst the pioneers of the "spiritual in art".[1] He was the heroic model for the Italian modern movement, particularly the later Futurists. Today Segantini is considered an important turn-of-the-century artist and a major exponent of Divisionism, the Italian version of Neo-Impressionism.

Born in 1858 in Arco (see Cat. 56) on Lake Garda, Segantini's childhood and youth were full of privation and sorrow. After the early death of his mother, which preoccupied him throughout his life and influenced the subject matter of his work, and following the death of his father, he stayed at different times with relatives, in orphanages and in institutions in Milan. In 1875 he began to attend evening courses at the Brera Academy in Milan, while working during the day for a decorative painter. In 1878 he was finally able to study full time. His picture *Choir of Sant' Antonio* (private collection) was awarded first prize in the 1879 National Exhibition at the Brera, marking the completion of his studies. First commissions for portraits and still lifes, and the patronage of the Grubicy Gallery, which later gave him an exclusive contract, enabled him to move to the Brianza region of Lake Como. In this as yet unspoilt landscape, Segantini, together with his painter colleague Emilio Longoni, discovered the culture of the peasants and their animals. In darkly toned scenes the peasants' everyday life is transformed into a dreamlike, bucolic experience – suggesting a knowledge of Millet, probably imparted by the Grubicy brothers. The painting *Ave Maria at the Crossing*,[2] one of his most impressive pictorial inventions, was awarded a gold medal at the 1883 World Exhibition in Amsterdam. At the beginning of 1886 Segantini left the hills of Brianza, after painting his monumental vision of rural har-mony, *At the Pole* (Rome, Galleria Nazionale d'Arte Moderna). After a stay in Milan and a trip through various alpine valleys, in August of the same year he moved to Switzerland. With his lifelong companion Bice Bugatti, a sister of the well-known furniture designer, and their four children, the artist settled in the Grisons village of Savognin at the foot of the Julier Pass. From then on the mountains and their inhabitants were the main motif of Segantini's work. Experiments with the division of colour, inspired by Vittore Grubicy, a much travelled critic and a painter himself, led to the development of the thread-like brushstroke characteristic of Divisionism.

113 Alpine Landscape with Woman at the Well

This early summer landscape in the mountains dates from the years in Savognin which, after Milan and Brianza, represent the artist's third creative period. The composition is marked by a pronounced horizontality, enhanced by the strongly rectangular format. The intensely light blue sky, the sunlit mountains and meadows, as well as the shadowed foreground divide the picture into three parallel zones. The horizontal orientation is further emphasised by the well, carved from a hollowed tree-trunk, the mountain range covered in snow, and the elongated shapes of the clouds. The absence of perspective lines, and the avoidance of any dynamic movement into depth, give the picture a static calm and a feeling of immeasurable spaciousness.

Although exhibited during the artist's lifetime,[3] the unsigned painting does not seem to be fully finished, as the still visible underpainting of the flesh tone and the crude structure of some of the clouds suggest. Explaining his painting technique, Segantini reported that he first covered the canvas with the brightest possible shade of *terra rossa* and, after fixing the essential lines, continued with the "colouring": "Using fine, very long brushes, I begin to work up the canvas with delicate, thin strokes of impasto, leaving a space between each stroke which I fill with complementary colour... Mixing colours on the palette makes them darker; the purer the colours... the better can we realise light, air and reality in our painting."[4] In order to increase luminosity, the painter sometimes applied gold or silver dust, a method used for the shoulder of the mountain lying in front of the peaks on the right. Segantini's divisionist application of colour suggests not only the transparent clarity of the mountain atmosphere, but also expresses the artist's pantheistic view of the world. The linear structure pervading sky, earth and man like a live nerve becomes the expression of the inner cohesion of externally different appearances: "There is only one difference between a man and a tree: the man moves around on the earth, while the tree is rooted in mother earth where it remains captive in expectation of its fate and its end. This, and nothing else, is our own experience ..."[5] The figure of the woman drinking from the well must be seen in the context of these ideas. Water, symbol of the eternal cycle, collects in the well which, in its turn, represents the life-giving power of nature. The motif of drinking, or of fetching water – a *leitmotif* in Segantini's work since the Brianza period – symbolises the inclusion of every creature in the cyclical pattern of creation. An entry in the artist's diary of 1 January 1890 reads like a commentary on this picture: "I love most the sun, and after the sun the spring, then the streams bubbling crystal-clear from the rocks in the Alps, trickling and running in the veins of the earth, like blood in our own veins ..."[6]

The Winterthur painting is iconographically and compositionally close to the 1888 picture *At the Drinking Trough* (Basel, Kunstmuseum), where in the background, above the cart drawn by cows, the houses and church of Savognin become visible. The same segment of landscape – in vertical format with correspondingly compressed proportions – is seen in *Noon over the Alps* of 1891 (St. Gallen, Kunstmuseum). Finally, a painterly drawing, *Ave Maria in the Mountains*,[7] apart from differences in the figure, is almost identical in motif and composition to the present work.

The title given to the painting by Segantini's son Gottardo, *Landscape from Savognino*,[8] can be confirmed by a comparison with other works showing the same mountain formations and in addition the buildings of the village.[9] The motif can be identified as the Piz Curver, situated north-west of Savognin, and – in the right half of the picture – Piz Tossa. Essentially two multi-peaked mountains with longer ridges, they here appear as an elongated chain, with their relative heights not

113
Giovanni Segantini
Alpine Landscape with Woman at the Well (c. 1893)
Oil on canvas, 71.5 × 121.5 cm
Provenance: Galleria Alberto Grubicy, Milan (until 1902); Paul Cassirer, Berlin; Max Wydler, Zurich; acquired 1949
(Quinsac 475)

conforming to the real topography. Moreover, the sharply rising slopes have been transformed into a level, rambling sheep pasture.[10] The modification of the motif, aiming at an emphasis on horizontals – coupled with the broad format – results in a panoramic effect.[11] However, the intention is not to present an unrestricted view, but to express the idea of cosmic unity. In the same sense the motif of motherhood – hitherto treated by Segantini as a genre-like mother-and-child relationship of men and animals – has been elevated to an all-embracing principle of existence: life in all its manifestations, here represented by the woman at the well, has been absorbed in the order of "mother earth".[12]

In 1894, after moving to Maloja in the Engadine, "where at the time the town-weary and nerve-racked, craving for pure mountain air

and pure nature",[13] gathered in cosmopolitan hotels, forming literary circles, playing golf and climbing mountains, Segantini entered the artistic and intellectual world of the *fin de siècle*. He corresponded with poets and painters, established contacts with critics and merchants and maintained close connections with the European Secession movements. His pictures triumphantly progressed through the museums, and Segantini received guests from all over the world, for instance Max Liebermann and Count Robert de Montesquiou, the Paris aesthete and "Prince of Decadence".[14] But in spite of honours, sales and an enormous demand for his work, the financial situation remained precarious, for Segantini, the most expensive landscape painter of his age, indulged in a *grand-bourgeois* life style and often took months over one picture.

In his last work, which remained unfinished, the *Triptych of Nature: Growth, Existence, Death* (St. Moritz, Segantini Museum),[15] the longing for the cyclical unity of life, which embraces all living things – nature, animals and man – and all temporal conditions – blossoming, maturing, dying – finally

achieved the programmatic realisation of ideal harmony. The artist died in September 1899, while working on the centre painting on the Schafberg mountain near Pontresina. Segantini's method of freely combining motifs taken from his own surroundings liberated alpine painting from its dependence on topographical relevance. In contrast with his contemporary Hodler (q. v.), who always respected this relevance and immortalised the mountains in their lonely sublimity, Segantini, though also an outdoor painter, created his landscapes according to his inner vision.

Matthias Wohlgemuth

Cuno Amiet

(1868-1961)

Cuno Amiet was one of the artists who revived Swiss painting around 1900. Under the impact of contemporary French painting he freed himself from nineteenth-century tradition, shaking off the dominant influence of Hodler's (q.v.) style. With his friend Giovanni Giacometti (q.v.) he developed a joyful colourism – Fauvism with a Swiss imprint. In his exceptionally long career his work underwent several phases of development, but in spite of all the changes in the degree of abstraction and facture, colour remained the determining constant.

After an early attempt at painting, making copies in the museum of his native city of Solothurn, he received drawing lessons at the Gymnasium and, from 1884, sporadic painting instruction from Frank Buchser (q.v.). In 1886 he entered the Academy in Munich, where he met Giacometti. The two pursued their studies in a close working relationship and in 1888 moved together to Paris, where they studied at the Académie Julian with Bouguereau and Robert-Fleury, sharing an apartment and studio. Giacometti had to return to Switzerland in 1891, but Amiet remained in France and from May 1892 to June 1893 worked in Pont-Aven in Brittany.

114 Still Life with Apples and Tomatoes

His one-year stay in Pont-Aven was decisive in Amiet's artistic development: the study of Bernard's and Gauguin's Cloisonnism prompted the transition from tonal painting to glowing colour and an emphasis on the picture's surface. Although he did not meet Gauguin, then living in Tahiti, nor Van Gogh, who had died in 1890, their works, discovered in Pont-Aven, had a decisive influence on him.[1]

The new impressions are absorbed in this still life, painted in 1892, showing a basket with apples on the left and a plate with tomatoes on the right. The narrow focus, with no horizon, and high viewpoint, cutting off parts of objects, reflect the typical composition of Japanese coloured woodcuts, which had influenced the examples studied by Amiet. The manner in which the strawberry-red and apple-green brushstrokes are applied in rhythmic parallels, as well as the use of impasto, is stylistically closer to Van Gogh than to Gau-

114
Cuno Amiet
Still Life with Apples and Tomatoes, 1892
Oil on panel, 34 × 60 cm
Signed bottom left: Amiet 92
Provenance: A.-M. Poncet, Yverdon; acquired 1953

guin's Cloisonnism. The structure in stripes in parts of the painting recalls the work of the Irish artist Roderick O'Connor, who had close contacts with Amiet in Pont-Aven.

An undated variant (Aarau, Kunsthaus) of the same height is much narrower, thus reducing the view and making the arrangement appear more crowded. In its motif and style the Winterthur painting is directly related to the *Still Life with Tomatoes* (private collection),[2] which shows the same ceramic plate with blue decorations; however, painted the year following, in 1893, it is bolder in composition and colour.

Throughout his life, Amiet relied on the insights gained in the circle of Gauguin's followers, in the same way as his compatriot Hans Brühlmann, who died at the early age of 33, was constantly guided by Cézanne's "construction" and "modulation" (fig. 154). Amiet's coloristic talent can be seen in his rich output during the first two

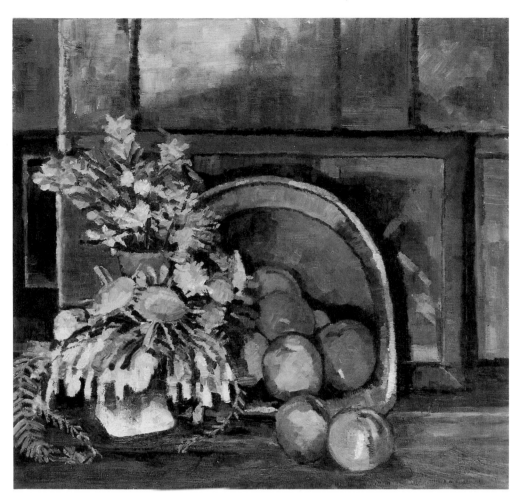

fig. 155
Cuno Amiet
Winter at Oschwand, 1941
Oil on jute, 50 × 61 cm
Signed bottom right: CA/41
Provenance: Galerie Neupert, Zurich; acquired 1942

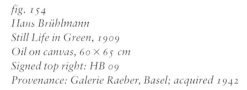

fig. 154
Hans Brühlmann
Still Life in Green, 1909
Oil on canvas, 60 × 65 cm
Signed top right: HB 09
Provenance: Galerie Raeber, Basel; acquired 1942

decades of the twentieth century. He absorbed a great variety of influences – Gauguin, Van Gogh, O'Connor, Neo-Impressionism, the Nabis, Hodler and finally Expressionism – so skilfully that he was often criticised for a lack of originality and a confusing multiplicity of styles.[3] Nevertheless, until 1910 he was a respected personality of the international avant-garde. Except for the period in Brittany, he only occasionally had direct contact with contemporary movements. However, though living in a secluded country house near Berne (on the Oschwand near Herzogenbuchsee), he kept in close touch with the artistic developments in the major centres. In 1904 he was represented at the nineteenth exhibition of the Vienna Secession, by thirty paintings, which were hung near to Hodler's, the guest of honour. On that occasion he met Gustav Klimt, Kolo Moser and the composer Gustav Mahler. In the year following his 1905 one-man show at the Richter Gallery in Dresden, he became a member of the artists' group Die Brücke, on the invitation of Erich Heckel. It was Amiet who transmitted to Germany the effects of French Post-Impressionism, before the young artists there had an opportunity to see the originals. Subsequently Amiet was present at numerous shows of modern painting and at the international art exhibitions of the European capitals, meeting in the 1910s such influential figures as Kandinsky, Macke, Jawlensky, Klee and the art historian Worringer, with whom he discussed theoretical questions. But he did not achieve the great breakthrough and at the end of the First World War he faded from the international scene. In Switzerland, however, where he had so long remained in Hodler's shadow, he received wider recognition. In the pioneering years the advocates of the "new" Swiss art, Oscar Miller in Biberist, Josef and Gertrud Müller in Solothurn and Richard Kisling in Zurich, had gathered around them, and supported, first Hodler and then Amiet and his younger, often penniless colleagues; but now Amiet's increasing adoption of a smooth *peinture* aroused the general interest of buyers. He continued painting his preferred motifs, mostly derived from his immediate surroundings, the rural buildings in the environs of the Oschwand, the floral splendour of the large farmhouse gardens, fruit harvests, winter scenes (fig. 155), his wife Anna, self-portraits and portraits of friends (and increasingly those commissioned by strangers), flower and fruit still lifes. However, the urge for innovation and delight in experimenting, which had distinguished his earlier work, gave way, particularly in the 1930s and 1940s, to a certain ingratiating quality and a more conventional concept of painting. Only in his extreme old age, did Amiet, now an octogenarian, recapture "pure" painting and its abstract qualities, thus closing the circle by returning to his beginnings as a colourist in Pont-Aven.[4] *Matthias Wohlgemuth*

Giovanni Giacometti
(1868-1933)

Giovanni Giacometti, with Cuno Amiet (q. v.), belongs to the group of "Swiss colourists", who, by turning to French examples, escaped from the powerful influence of Hodler (q.v.). A cousin of the painter Augusto Giacometti and father of the famous painter and sculptor Alberto Giacometti, he was born in 1868 in the mountain village of Stampa in the Bregaglia valley (Grisons), where he spent his early years. From 1886 to 1887 he lived in Munich, where he studied painting at the private school of Heinrich Knirr. Among the circle of Swiss painters in Munich was Cuno Amiet, who became a life-long friend.

Deeply impressed with the French *plein-air* painters at the International Art Exhibition in the Munich Glaspalast, in 1888 the two friends moved to Paris. They studied at the Académie Julian with Bouguereau and Robert-Fleury, and shared an apartment and a studio. The summer months were spent either with the Giacomettis in Stampa or at the Amiet house at Solothurn. In 1889 they visited Frank Buchser (q.v.), Amiet's first teacher. Shortly afterwards Amiet went to Pont-Aven, where he developed his coloristic talent in the circle of Gauguin's followers, while Giacometti, for financial reasons, returned to Switzerland in 1891. A portrait commission in January 1893 enabled him to undertake a journey of several months to Italy.

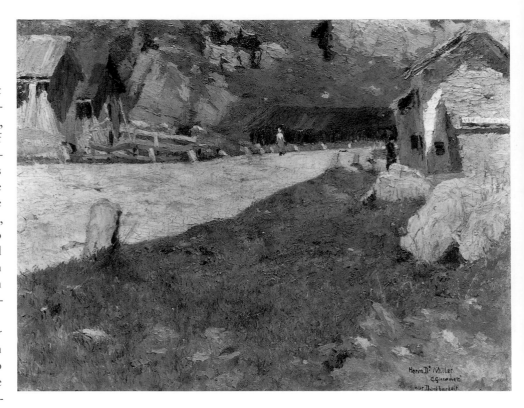

115 Stonebreakers at Lungotevere

"I felt the need to explore new horizons. Hence I decided in 1893, although I had hardly any money, to go to Rome. There I found my motifs in the ruins, the narrow streets, the gardens and the Campagna. I was working from early morning to late evening."[1] The origin of the present painting dates from that time.

The artist set up his easel at the Lungotevere Augusta, near the Ara Pacis, with a view along the Tiber towards the Gianicolo. The iron bridge on the right of the picture is the temporary bridge of Ripetta, built between 1877 and 1879 and replaced in 1901 by the Ponte Cavour. The city's topography is captured in a wealth of details. We see from right to left the cupola of San Salvatore in Lauro, the Orologio (clock) of the Oratorio dei Filippini and the cupola of the Chiesa Nuova; towards the centre of the picture is the pointed spire of Santa Maria dell'Anima and the Palazzo Altemps, with the cupola of Sant' Agnese in Agone and San Apollinare on its left.

In the middle foreground stonebreakers are busy working on the fortifications of the bank. In contrast to Courbet's famous *Stonebreakers*, they are not the main motif of the picture, but through the low vantage point the viewer experiences the scene from their perspective, with the massive blocks of stone almost tangibly near. The building site occupies nearly half of the picture space, with the city panorama, stretching from the left across the whole width of the elongated format, relegated to the background. The sunlight impregnates the façades and roofs with a golden-red glow, softly complementing the misty pale blue of the sky, while the richly detailed architecture looks down on the coarse shapes of the building blocks, its raw material.

fig. 156
Giovanni Giacometti
Village Scene (c.1894)
Oil on canvas, 30.5 × 40 cm
Inscribed bottom right: Herrn D^r. Miller / G. Giacometti / aus Dankbarkeit.
Provenance: Oscar Miller, Biberist; Kurt Blass-Miller, Zurich; acquired 1946
(Köhler 443)

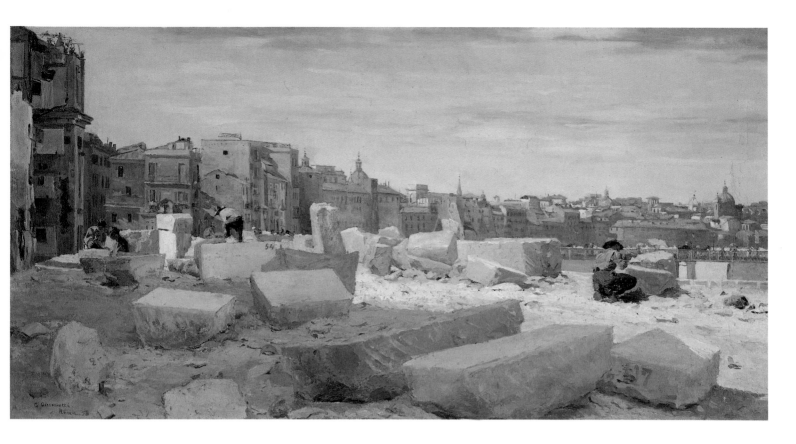

Under the impact of the southern light Giacometti's tonal palette brightened considerably, recalling the tradition of Roman *plein-air* painting, such as Corot's early Italian landscapes. The decisive impetus towards pure colour, however, came a year after the Italian trip through an encounter in his native country. In August 1894 Giovanni Segantini (q.v.), who was by then already famous, moved to Maloja, where Giacometti met him. "A mutual sympathy arose immediately and, from our first meeting, we had a warm understanding of each other, which grew more pronounced over the course of years."[2] The small painting *Village Scene* (fig. 156) seems to be one of the first examples of Segantini's influence, seen in the skilful distribution of light and dark, and in the finely hatched, densely layered strokes of colour,

which make a date of around 1894 conceivable.[3] Only after the turn of the century – and after Segantini's death – did Giacometti succeed in emancipating himself from the older artist's influence and from his symbolically charged subject matter and divisionist technique. Amiet had introduced him to French Post-Impressionism, above all to Van Gogh and Gauguin, and from these stimuli he developed a personal mode of expression, to which the light and colour of Fauvism were central. In the years before the First World War Giacometti created his most accomplished and original works on which his reputation as one of the foremost Swiss painters after Hodler rests.

116 Portrait of Ottilia Giacometti

A letter from 1910 confirms the important role the artist allotted portrait painting: "The human face remains the highest challenge in art."[4] With this in mind Giacometti painted portraits of friends and villagers, but he rarely accepted portrait commissions. However, he depicted his family – his parents, wife and children – again and again. "I enjoyed the happiness of domestic family life, surrounded by my children, who are today my companions. My children live in my paint-

115
Giovanni Giacometti
Stonebreakers at Lungotevere, 1893
Oil on canvas, 40 × 75 cm
Signed bottom left: G Giacometti./Roma 93
Provenance: Galerie Moos, Geneva; Coll. Natural, Geneva; Coll. Bondanini, Geneva; acquired 1955
(Köhler 22)

fig. 157
Giovanni Giacometti
Self-Portait in the Studio, 1930
Oil on canvas, 60.5 × 50.5 cm
Signed bottom left: G/G
Provenance: Galerie Aktuaryus, Zurich (1943); AG
Möbelfabrik Wald; acquired 1948
(Köhler 413)

ings, and in my paintings my biography is written ..."[5] This half-length portrait shows Ottilia, the eight-year-old daughter of the artist. She was the third child of the family, born in Stampa in 1904. The figure, in a white and Prussian-blue plaid dress, is intricately entwined in the brilliantly coloured background. Only the face, framed by long brown hair, with big green-blue eyes, remains an integral shape. The rest of the composition largely denies physicality, with the drawing giving way to colour. This applies particularly to the background, which one can judge best by a comparison with another, coloristically very similar painting of 1912, entitled *Sunspecks* (Chur, Kunstmuseum). In that painting two girls are seated on the ground in a forest, and they reappear here on either side of Ottilia, who is standing in the central axis: on the left, cut by the edge of the picture, a red-haired child in a blue dress, and on the right, mostly hidden by the main figure, a fair-haired child in white pinafore with red sleeves. Together with the blue tree trunks they form a surface pattern which transforms visual reality into coloured reflections evoked by the sunlight.

The late *Self-Portrait in the Studio* (fig. 157), painted in 1930, three years before Giacometti's death, reverts to a more conventional perspective and a more descriptive use of colour, while still expressing the artist's continuing interest in light and colour effects. His dark blue figure, silhouetted against the window in a *contre-jour* effect, stands before the easel, while the studio becomes a glowing space of complementary orange hues.

Like Hodler and Amiet, Giacometti painted a great number of self-portraits.[6] He was, so to speak, at the centre of the circles of motifs embracing his immediate world: the house with its rooms and inhabitants, the garden, the village and its population, and above all the landscape, including the narrow valley of Bregaglia and the wide open plain and lakes of the Engadine. *Matthias Wohlgemuth*

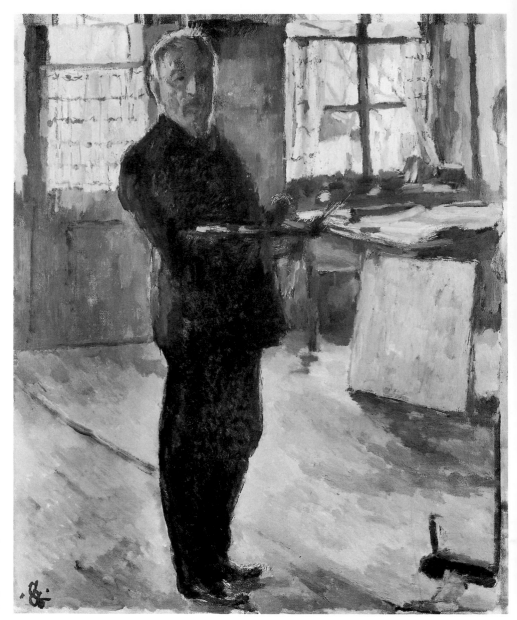

116
Giovanni Giacometti
Portrait of Ottilia Giacometti, 1912
Oil on canvas, 61 × 50 cm
Signed bottom left: G/G/1912
Provenance: Galerie Aktuaryus, Zurich; acquired 1936
(Köhler 196)

Biographies

Jacques-Laurent Agasse

Born 24 March 1767 in Geneva. Studies at the Ecole de Dessin in Geneva. Friendship with Firmin Massot and Adam-Wolfgang Töpffer. From 1786 to 1789 in Paris, artistic training in the studio of Jacques-Louis David. 1790 journey to England with the art patron and lover of horses Lord Rivers, who persuades him to settle in London permanently in 1800. Henceforth he keeps a *catalogue autographe* of his works. Exhibits regularly at the Royal Academy. Receives commissions from King George IV among others. Dies 27 December 1849 in London.
Literature: Cat. Geneva/London 1988/89.

Jacob Alt

Born 27 September 1789 in Frankfurt am Main. There receives first artistic instruction. 1811 enters the history class of the Vienna Academy. Marries in the same year and ends his studies. Frequent travels to the Austrian Alps and the Danube region, in preparation for the series of lithographs appearing from 1818. In 1828 and 1833 journeys to Upper Italy, and 1835 to Rome. Dies 30 September 1872 in Vienna.
Literature: Koschatzky 1975.

Rudolf von Alt

Born 28 August 1812 in Vienna. Works in the studio of his father Jakob Alt. 1826 enrols in the history class of the Vienna Academy. Frequent study trips within Austria and to Upper Italy, sometimes with his father. Many commissions for landscape watercolours and city views. 1833-44 watercolour vedute for Archduke Ferdinand. 1863 journeys to the Crimea on commission for Czar Alexander II. 1867 participates in the Paris World Exhibition. 1872-73 stay in Rome. 1878 collaborates in the series of scenes from the Russian-Turkish war. In the last twenty years of his life awarded many honours. Dies 12 March 1905 in Vienna.
Literature: Hevesi 1911, Koschatzky 1975.

Cuno Amiet

Born 28 March 1868 in Solothurn, son of a Solothurn state secretary amd historian. 1884 painting lessons with Frank Buchser in Feldbrunnen. From 1886 studies at the Mu-nich Academy, where he meets his exact contemporary Giovanni Giacometti; 1888 both move to Paris. 1892-93 in Pont-Aven, formative encounter with Gauguin's and Van Gogh's art. On return to Solothurn he meets Ferdinand Hodler. 1896 spends the summer with Giacometti in Stampa; meets Giovanni Segantini. 1896 moves to the Oschwand near Herzogenbuchsee. 1901 participates in the 12th Exhibition of the Vienna Secession. 1906 joins the artists' group Die Brücke in Dresden. 1919 honorary doctorate from the University of Berne. Dies 6 July 1961 in Oschwand, Berne.
Literature: Mauner 1984.

Albert Anker

Born 1 April 1831 in Ins, Berne, son of a veterinary surgeon. 1851-54 studies theology in Berne and Halle. 1854 beginning of painting career. Until 1856 in Paris as pupil of Charles Gleyre. 1861-62 first journey to Italy. Lives in Paris, regularly participating in the Salon, and in Ins. 1870-74 member of the Bernese Council (Grosser Rat). Between 1889 and 1901 member of the Federal Art Commission (Eidgenössische Kunstkommission) and of the Federal Commission of the Gottfried-Keller Foundation. 1900 honorary doctorate from Berne University. 1901 suffers a stroke which leaves his right hand paralysed, making painting difficult. Dies 16 July 1910 at Ins.
Literature: Huggler 1962, Kuthy/Lüthy 1980.

Hans Beckmann

Born 21 March 1809 in Hamburg. Five years study at the drawing school of the Hamburg official painter (*Amtsmaler*) Christian Friedrich Belitz. Further studies in Hanover and at the Brunswick Polytechnic. From 1832 studies at the Munich Academy. Active in Munich and in the region of the Bavarian alpine foothills, later again in Hamburg. Dies 4 December 1882 in Hamburg.

Peter Birmann

Born 14 December 1758 in Basel. 1771 studies with Rudolf Huber the Younger. 1775 moves to Berne; colours the engraved alpine views by Caspar Wolf, then works in the studio of Johann Ludwig Aberli, producing Swiss vedute. 1781-90 active as painter of vedute in Rome, popular with the English and Russian aristocracy. On return begins an art publishing business, engaging many artists, including his sons Samuel and Wilhelm, and Franz Hegi, Jakob Christoph Miville and Hieronymus Hess. Dies 18 July 1844 in Basel.

Carl Blechen

Born 29 July 1798 in Cottbus. From 1815 training and employment in a Berlin bank. 1822-24 at the Berlin Academy. 1823 journey to Dresden; meets Caspar David Friedrich and Johan Christian Dahl. 1824-27 painter of decorations at the Königstädtisches Theatre in Berlin. Makes designs for theatre sets and a few studies from nature. 1827-28 free-lance artist. 1828 journey to Italy, stay in Rome and environs, then in Naples. Intensive studies from nature; 1819 returns via Switzerland and southern Germany to Berlin. 1831 succeeds his teacher Lütke as professor of landscape painting at the Berlin Academy. 1833 journey to the Harz region of Germany. 1835 journey to Paris. From the mid-1830s signs of mental illness. 1836 resigns from teaching. Dies 23 July 1840 in Berlin.
Literature: Kern 1911, Rave 1940, Cat. Berlin 1990.

Arnold Böcklin

Born 19 October 1827 in Basel. 1845 at the Düsseldorf Academy, pupil of Wilhelm Schirmer. 1847 and 1848 visits Aachen, Brussels, Antwerp and Paris with his friend Rudolf Koller. From 1850 lives in Rome. 1855 marries Angela Pascucci. 1857 moves to Munich; meets the art collector and patron Adolf Friedrich von Schack. 1860 appointed professor at the Weimar School of Art. Between 1862 and 1874 stays in Rome, Basel, Paris and Munich, then moves to Florence. 1885 returns to Switzerland. 1889 honorary doctorate from the University of Zurich. 1893 finally settles in Florence. Dies 16 January 1901 in San Domenico near Fiesole.
Literature: Schmid 1903, Cat. Basel 1977, Andree 1977.

Hans Brühlmann

Born 25 February 1878 in Amriswil, Thurgau. 1898 drawing class at the Arts and Crafts School (Kunstgewerbeschule) in Zurich. 1899 studies landscape drawing with Hermann Gattiker in Rüschlikon and at the

Royal School of Art (Königliche Kunst-schule) in Stuttgart. 1902 enters the Stuttgart Academy, pupil of Adolf Hölzel. Member of the Hölzel circle, together with Hermann Haller, Carl Hofer, Johannes Itten and others. 1906 journey to Italy. Various commissions for frescoes. End of 1909 beginning of an incurable nervous disease, which makes work difficult. Commits suicide on 29 September 1911 in Stuttgart.
Literature: Kempter/Diggelmann/Simmen 1985.

Frank Buchser
Born 15 August 1828 in Feldbrunnen, Solothurn. Apprenticed to an organ maker. First drawing lessons in 1847, followed by trip to Paris and Italy. From 1850 two years instruction at the Antwerp Academy. Frequent and extensive journeys to England, Spain, Morocco, North America, as well as the Balkans and Greece. From the 1860s occupied with art-political problems; co-founder of the Association of Swiss Artists. Settles in Switzerland 1885; campaigns for Swiss art reform; co-initiator of the National Art Exhibition. Dies 22 November 1890 in Feldbrunnen.
Literature: Wälchli 1941, Cat. Solothurn 1990.

Heinrich Bürkel
Born 29 May 1802 in Pirmasens. 1822 moves to Munich and studies at the Academy. 1829 first tour of Italy with Friedrich Nerly. Further stays in Italy 1830-32, 1837 and 1853-54. Friendship in Munich with Carl Spitzweg. 1843 honorary member of the Dresden and Vienna Academies, and in 1858 of the Munich Academy. Dies 10 July 1869 in Munich.

Alexandre Calame
Born 28 May 1810 in Vevey, son of a stonemason. After breaking off his training with a bank, from 1826 studies with the Geneva painter of alpine views François Diday. 1835 tour of the Bernese Oberland. 1837 and 1838 journeys to Paris, Holland and Germany. 1844-45 journey to Italy. A lung condition makes further painting activity in the high mountains impossible. Moves to Lake of Lucerne. From 1853 repeated stays on the Riviera. Dies 17 March 1864 in Menton, France.
Literature: Anker 1987.

Franz Ludwig Catel
Born 22 February 1778 in Berlin. First works as a draughtsman and book illustrator. From 1806 attends the Berlin Academy. 1807-11 in Paris, takes up oil painting. 1811 moves to Rome where he paints landscape vedute and folk scenes. Numerous commissions for the German, English and Russian aristocracy. About 1824 moves in the artists' circle around Crown Prince Ludwig of Bavaria. 1824 travels with Karl Friedrich Schinkel and Karl Begas to the Gulf of Naples. 1841 titular professor of the Berlin Academy. Dies 19 December 1856 in Rome.

Johan Christian Clausen Dahl
Born 24 February 1788 in Bergen, Norway, son of a fisherman. 1811-18 studies at the Copenhagen Academy. Patronised by the Danish Crown Prince Christian Frederik. 1818 plans an extensive journey, but remains in Dresden where he marries the daughter of the former director of the *Grünes Gewölbe*. Friendship with Caspar David Friedrich and with Carl Gustav Carus. 1820-21 journey to Italy. 1824 associate professor for landscape painting at the Dresden Academy. Frequent trips to Norway. Dies 13 October 1857 in Dresden.
Literature: Bang 1987, Cat. Munich 1988.

Johann Georg von Dillis
Born 26 December 1759 in Grüngiebing, Upper Bavaria, son of Wolfgang Dillis, district forester in the Elector's employ. 1771-81 studies philosophy and theology at the Collegium Albertinum in Munich and at the University of Ingolstadt. 1782 ordained as a priest. Studies at the Drawing Academy in Munich. From 1786 drawing master for aristocratic Munich families. 1790 inspector of the Electoral Hofgarten Gallery. 1794-95 and 1805-06 first and second journeys to Italy. In Rome friendship with Johann Martin von Rohden and Joseph Anton Koch. Journey to Paris and southern France. 1818 receives a title of nobility. Until 1814 professor of landscape painting at the Munich Academy and curator of the royal collection of drawings. Several times in Italy and Paris as artistic agent of the Crown Prince. 1822 director of all Munich collections. 1830 and 1832 travels with Ludwig I to Italy. Dies 28 September 1841 in Munich.
Literature: Lessing 1951, Messerer 1961, Cat. Munich/Dresden 1991/92.

François Ferrière
Born 11 July 1752 in Geneva, son of a clockmaker. 1792/93 moves to England. As a successful miniature portraitist he works for the royal court and exhibits at the Royal Academy. 1804-13 in St. Petersburg and Moscow, active as respected portrait painter. Returns to England. 1821 finally settles in Geneva. Dies 25 December 1839 in Morges.
Literature: Crosnier 1903.

Anselm Feuerbach
Born 12 September 1829 in Speyer. His father Joseph Anselm Feuerbach was professor of archaeology at the University of Freiburg im Breisgau, his uncle was the philosopher Ludwig Feuerbach. 1845-48 studies with Johann Wilhelm Schirmer at the Düsseldorf Academy. After two years in Munich and a brief period at the Antwerp Academy with Gustaaf Wappers he enters the studio of Thomas Couture in Paris. A stipend from Grand Duke Friedrich of Baden enables him to stay in Italy from 1855. After one year in Venice he settles in Rome in 1856. Friendship with Böcklin. 1860 meets Anna ("Nanna") Risi who becomes his most important model until 1865. 1862-66 commissions for the Munich art collector Adolf Friedrich Count von Schack. 1866 Lucia Brunacci becomes his favoured model. 1873 appointed professor of history painting at the Vienna Academy. 1876 resigns. 1877 moves to Venice. Dies there 4 January 1880.
Literature: Cat. Karlsruhe 1976, Ecker 1991.

Carl Philip Fohr
Born 26 November 1795 in Heidelberg. First instruction in drawing and watercolour from Friedrich Rottmann, after 1810 from Georg Wilhelm Issel in Darmstadt. 1815 studies at the Munich Academy. 1816 settles in Rome, working in the studio of Joseph Anton Koch. Drowns in Rome while bathing in the Tiber on 29 June 1818.
Literature: Hardenberg/Schilling 1925.

Caspar David Friedrich
Born 5 September 1774 in Greifswald, son of a soap and candle maker. First studies with Johann Gottfried Quistorp, drawing master at the University of Greifswald. 1794 enters the Copenhagen Academy as student of Christian August Lorentzen, Jens Juel and

Nicolai Abraham Abildgaard. 1798 moves to Dresden. Close contacts with the Romantic philosophers, authors and scholars. Repeated journeys to Greifswald and Rügen. 1807 takes up oil painting. 1810 walking tours in the Harz region and 1811 in the Riesengebirge mountains; further walking tours in the Elbsandstein mountains and elsewhere. From 1816 member and from 1824 associate professor at the Dresden Academy. 1818 marries Caroline Bommer. From 1817 friendship with Carl Gustav Carus. From 1823 shares a home with Johan Christian Dahl. A stroke suffered in 1835 ends his production of paintings almost completely. Dies 7 May 1840 in Dresden.
Literature: Sumowski 1970, Börsch-Supan 1973, Cat. Hamburg 1974, Märker 1974, Rautmann 1979, Koerner 1990, Cat. London 1990, Cat. New York/Chicago 1990/91, Cat. Copenhagen 1991, Cat. Madrid 1992.

Ernst Fries

Born 22 June 1801 in Heidelberg. First training, together with Carl Philipp Fohr, with Friedrich Rottmann, later in Karlsruhe with Carl Kuntz, and at the Munich Academy. Learns oil painting from the English landscape painter George Wallis. 1822 study tour through Germany, Austria and Switzerland. 1823-27 in Italy; meets Ludwig Richter and the circle around Joseph Anton Koch and Johann Martin von Rohden. On return home he marries. 1831 appointed Baden court painter in Karlsruhe. Dies there 12 October 1833.
Literature: Gravenkamp 1921.

Johann Heinrich Füssli (Henry Fuseli)

Born 6 February 1741 in Zurich, son of the portraitist and art historian Johann Caspar Füssli. Studies theology, ordained in 1761. Through Johann Jacob Bodmer contact with Zurich intellectual circles. Together with Johann Caspar Lavater he criticises the Landvogt Grebel and encounters difficulties with the Zurich authorities. 1763 leaves Switzerland, travels to Berlin and in 1764 finally settles in England. 1768 meets Sir Joshua Reynolds, on whose suggestion he spends eight years in Italy. After a short stay in Zurich in 1779 returns to England for good, where he is also active as art theorist, poet and literary critic. From 1799 professor at

the Royal Academy. Dies 16 April 1825 in London.
Literature: Schiff 1973, Cat. Hamburg 1974/75, Cat. London 1975.

Eduard Gaertner

Born 2 June 1801 in Berlin. Childhood in Cassel. 1813 returns to Berlin. From 1814 apprenticed at the Royal Berlin porcelain manufactury. 1821 studies with the Hoftheater painter Carl Wilhelm Gropius, then for a short period at the Academy. 1825-27 in Paris, financed by a royal travel stipend. 1833 member of the Berlin Academy. 1834 paints a large panorama of Berlin. 1837-39 in St. Petersburg and Moscow, to carry out commissions for the Czar. After 1840 several trips to Belgium, Austria, Bohemia, Saxony, Thuringia and the Prussian provinces. Dies 22 February 1877 in Zechlin, Mark.
Literature: Wirth 1979, Trost 1991.

Friedrich Gauermann

Born 20 September 1807 in Miesenbach, Lower Austria, son of the painter Jakob Gauermann. 1824-27 studies at the Vienna Academy. Study trips to Dresden, Munich and the Salzkammergut. 1839 and 1840 extended stays in Munich, friendship with Heinrich Bürkel and Christian Morgenstern. 1836 member of the Vienna Academy. Dies 7 July 1862 in Vienna.
Literature: Feuchtmüller 1987.

Giovanni Giacometti

Born 7 March 1868 in Stampa, Grisons. Son of a farmer, confectioner and hotelier, and cousin once removed of Augusto Giacometti, father of the sculptor and painter Alberto, as well as of the craftsman Diego and the architect Bruno Giacometti. 1886 meets Cuno Amiet, his exact contemporary, at the private school of Heinrich Knirr in Munich. From 1888 to 1891 the two share a studio and an apartment in Paris. 1893 lengthy stay in Italy. 1894 meets Giovanni Segantini, and later Ferdinand Hodler. Stimulated by Amiet, makes critical assessment of Cézanne, Van Gogh, Gauguin and his circle in Pont-Aven. 1908 participates in Die Brücke exhibition in Dresden. Dies 25 June 1933 in Glion, Vaud.
Literature: Kohler 1968.

Anton Graff

Born 18 November 1736 in Winterthur. First artistic instruction there 1753-56. 1756 works for an engraver in Augsburg. Various journeys in Germany and Switzerland. 1766 appointed painter to the court of the Elector of Saxony in Dresden. 1769 commissioned by the Leipzig bookseller and publisher Philipp Erasmus Reich to paint a series of portraits for a gallery of contemporary poets and philosophers. 1771 marries the second daughter of the Winterthur aesthetician Johann Georg Sulzer. 1783 honorary member of the Berlin Academy. 1789 professor of portraiture at the Dresden Academy of Art. 1812 honorary member of the Imperial Academy of Painting in Vienna and of the Munich Academy of Art. Dies 22 June 1813 in Dresden.
Literature: Berckenhagen 1967.

Ferdinand Hodler

Born 14 March 1853 in Berne. 1872-77 student of Barthélemy Menn. 1877 first journey to Paris; 1878-79 in Spain, mostly Madrid. 1881 collaborates with Eduard Castres in the Bourbakipanorama in Lucerne. 1883 journey to Munich. Participates in numerous competitions in Geneva. From 1884 association with Augustine Dupin and participation in the Symbolist circle around the poet Louis Duchosal. 1891 associate member of the Société Nationale des Artistes Français; from 1892 exhibits regularly in Paris. 1897 honoured with the gold medal first class at the Seventh International Art Exhibition in the Munich Glaspalast; his design for the armory hall of the Swiss Landesmuseum in Zurich triggers the "fresco-battle" throughout the country. Meets Cuno Amiet and Giovani Giacometti. 1900 awarded honorary gold medal at the Paris World Exhibition. Member of the Secession in Munich, Berlin and Vienna, where he participates as a guest of honour in the nineteenth Secession Exhibition. Between 1908 and 1913 receives commissions for frescoes in Jena and Hanover. From 1908 associated with Valentine Godé-Darel, who dies in 1915. 1910 honorary doctorate from Basel University. His signing of the protest against the bombardment of Reims Cathedral 1914 results in his expulsion from all German art associations and the end of his international career. 1917 grand retrospective in the Zurich Kunsthaus. Dies 19 May 1918 in Geneva.

Literature: Loosli 1921/24, Mühlestein/Schmidt 1942, Hirsh 1981, Zelger/Gloor 1981, Cat. Berlin/Paris/Zurich 1983.

Georg Friedrich Kersting

Born 31 October 1785 in Güstrow, son of a glazier. From 1805 studies at the Copenhagen Academy with Christian August Lorentzen, Jens Juel and Nicolai Abraham Abildgaard. 1808 moves to Dresden, meets Caspar David Friedrich and becomes one of his circle of friends, which includes Gerhard von Kügelgen, Louise Seidler and Heinrich von Kleist. 1811 first great success with his paintings of "interior portraits". 1813 joins the wars of liberation as a volunteer and is honoured for outstanding bravery. 1816 drawing master for a princess in Warsaw. From 1818 artistic director of the painting department of the royal porcelain manufactury in Meissen. Dies there 1 July 1847.
Literature: Gärtner 1988.

Wilhelm von Kobell

Born 6 April 1766 in Mannheim, son of the Mannheim court painter Ferdinand Kobell. Studies at the local academy of drawing with Franz Anton Leitensdorfer and Egid Verhelst. Extended study periods in Trier and Munich. 1791 associate member of the Berlin Academy. 1792 called to Munich as court painter to the Elector Karl Theodor; moves there the following year. Associates with Johann Georg von Dillis and his circle of friends. Between 1809 and 1817 produces a series of large-scale battle scenes depicting the victories of the Bavarians fighting for the cause of the Rheinbund against Prussia and Russia. 1809-10 studies in Paris. 1814 professor of landscape painting at the Munich Academy. 1817 receives a title. Dies 15 July 1853 in Munich.
Literature: Wichmann 1970.

Christen Købke

Born 26 May 1810 in Copenhagen. 1822 enters the Copenhagen Academy and visits the studios of Christian August Lorentzen and Christoffer Wilhelm Eckersberg. 1814 journey to Dresden to see Johan Christian Dahl. 1838-40 stay in Rome, Naples and Capri. 1844 participates in the decorations of the Thorvaldsen Museum in Copenhagen. Works on further interior decorations of villas and country houses. Dies 7 February 1848 in Copenhagen.
Literature: Krohn 1915, Cat. Copenhagen 1981, Schwartz 1992.

Joseph Anton Koch

Born 27 July 1768 in Obergiblen in the Lech Valley, Tyrol. Studies at the Hohe Karlsschule in Stuttgart under Philipp Friedrich Hetsch. A supporter of the ideas of the French Revolution she flees to Strasbourg in 1791. 1792-94 stays in Switzerland; works in the Bernese Oberland. With a stipend from the English art patron George Frederick Nott travels to Italy and in 1795 settles in Rome. There moves in the circle of Johann Christian Reinhart, Asmus Jakob Carstens and Bertel Thorvaldsen. 1803 transition to oil painting. 1812-15 in Vienna, then again in Rome. 1825-28 execution of the wall frescoes (Dante Room) in the Casino Massimo in Rome, in collaboration with Friedrich Overbeck, Julius Schnorr von Carolsfeld and Peter von Cornelius. Dies 12 January 1839 in Rome.
Literature: Lutterotti 1985, Cat. Stuttgart 1989.

Rudolf Koller

Born 21 May 1828 in Zurich. 1843-45 pupil of the landscape painter Johann Jakob Ulrich. Travels with Böcklin to Brussels, Antwerp and Paris. Moves to Munich in 1849, where he meets Robert Zünd and Ernst Stückelberg. Returns to Zurich in 1851; acquires a house at the Zürichhorn in 1862. 1868-69 journey to Florence, Rome and Naples. 1870 beginning of an eye complaint. 1898 jubilee exhibition in Zurich on his 70th birthday; receives honorary doctorate from the university. Dies 5 January 1905 in Zurich.
Literature: Frey 1928, Fischer 1951.

Franz Krüger

Born 10 September 1797 in Grossbadegast near Dessau. First instruction from Carl Wilhelm Kolbe the Elder in Dessau. From 1812 studies at the Berlin Academy, first exhibition in 1818. 1824 appointed court painter; 1825 Friedrich Wilhelm III awards him the title of Royal Professor. 1824 Czar Nicolas of Russia commissions a large-scale parade picture, which Krüger finishes in 1830. Similar works follow, also portraits, military scenes and pictures of riders. Frequent visits to St. Petersburg and Moscow as guest of the Czar. 1846 journey to Paris, where he meets Horace Vernet and Delacroix. Dies 21 January 1857 in Berlin.
Literature: Weidmann 1927, Franke 1984.

Gerhard von Kügelgen

Born 6 February 1772 in Bacharach on the Rhine. First studies with Januarius Zick in Koblenz. 1791-95 in Rome. 1795 travels to Riga; 1798 to Tallinn. 1798-1803 in St. Petersburg, where he is a sought-after portraitist. 1805 moves to Dresden, transition to history painting. 1814 professor at the Academy. Close friend of Caspar David Friedrich. Murdered on 27 March 1820 near Loschwitz, near Dresden.

Wilhelm Leibl

Born 23 October 1844 in Cologne, son of the cathedral director of music Karl Leibl. First painting lessons from the history painter Hermann Becker. From 1864 studies at the Munich Academy and attends the painting school of Hermann Anschütz. 1869 short period of study with Karl von Piloty. In the same year friendship with Gustave Courbet in Paris. 1870 returns to Munich, becomes centre of a group of painters, the so-called Leibl circle, to which Wilhelm Trübner, Fritz Schider, Carl Schuch and Hans Thoma also belong. Leibl retreats from the city to live in Upper Bavaria: Grasslfing near Dachau (1873-74), Unterschondorf on Lake Ammersee (1875-77), Berbling (1877-81), Aibling (1881-92, in the company of the painter Johann Sperl), and from 1892 in Kutterling. 1886 honorary member of the Munich Academy; 1892 appointed professor. Dies 4 December 1900 in Würzburg.
Literature: Waldmann 1914, Ruhmer 1984.

Carl Julius von Leypold

Born 24 July 1806 in Dresden. Studies at the Dresden Academy, with Friedrich Matthäi among others, then in the studio of Johan Christian Dahl. 1826-28 influenced by Caspar David Friedrich, but reverts to the realistic tendencies of Dahl. 1857 honorary member of the Academy. Dies 31 December 1874 in Niederlössnitz near Dresden.

Max Liebermann

Born 20 July 1847 in Berlin. Drawing instruction from the horse painter Carl Steffeck. 1868-73 studies at the art school in Weimar. 1871 first journey to Holland, where he returns many times. 1872 journey to Paris, staying until 1878. Friendship with the Hungarian painter Mihály Munkácsy. 1878-84 lives in Munich, where he meets Wilhelm Leibl and Fritz von Uhde, then moves to Paris. After 1890 preoccupied with French Impressionism. 1897 special show within the framework of the Great Berlin Art Exhibition. 1898 member of the Prussian Academy of Arts; 1920-32 president. 1899-1911 president of the Berlin Secession. 1933 forbidden to paint and to exhibit. Dies 8 February 1935 in Berlin.
Literature: Hancke 1914, Meissner 1974, Cat. Berlin/Munich 1979/80.

Jean-Etienne Liotard

Born 22 December 1702 in Geneva, son of a jeweller. First training with the Geneva miniaturist Daniel Gardelle. 1723 moves to Paris. 1736 accompanies the French envoy to Italy. 1738 journey to Constantinople, where he is successful as a portraitist. 1743 arrives in Vienna, paints portraits of the Empress Maria Theresa and the court aristocracy. Numerous portrait commissions in Venice, Frankfurt am Main, Darmstadt, Lyons, Paris, London and Amsterdam. 1758 returns to Geneva. Continues his travels. 1781 publishes the *Traité des principes et des règles de la peinture*. Dies 12 June 1789 in Geneva.
Literature: Fosca 1956, Loche/Roethlisberger 1978, Cat. Geneva/Paris (de Herdt) 1992.

Hans von Marées

Born 24 December 1837 in Elberfeld, son of a jurist and president of the Chamber. The family moves to Koblenz. 1853-55 studies at the Berlin Academy. From 1854 takes lessons with Carl Steffeck. 1857 moves to Munich where he meets Franz Lenbach. 1864 first sale of pictures to Count Schack, which enables him to travel to Italy. 1865 settles in Rome; friendship with the sculptor Adolf von Hildebrand and the art theorist and patron Conrad Fiedler. 1869 journey with Fiedler to Spain, France, Belgium and Holland. 1870-73 in Berlin with Hildebrand; the two artists decorate the library hall of the

Zoological Station in Naples. In Florence meets Arnold Böcklin. Dies 5 June 1887 in Rome.
Literature: Meier-Graefe 1910, Gerlach-Laxner 1980, Cat. Munich 1987/88.

Firmin Massot

Born 5 May 1766 in Geneva. First instruction from his sister, the miniature painter Pernette Massot. Friendship with Jacques-Laurent Agasse and Adam-Wolfgang Töpffer. 1787-88 journey to Italy. In Coppet, during the French Revolution, meets Madame de Staël. Subsequently moves to Lausanne. 1798 returns to Geneva; portrays high society, including Madame Récamier, Madame de Staël and Empress Josephine. Dies 16 May 1849 in Geneva.

Barthélemy Menn

Born 20 May 1815 in Geneva, son of a pastrycook. First studies in his home town with the history painter Jean-Léonard Lugardon. 1833 in Paris with Jean-Auguste-Dominique Ingres, whom he follows in 1835 to the French Academy in Rome. Friendship with Louis-Léopold Robert. Travels via Florence to Rome. 1837 to Naples, Capri and Salerno. 1838 again in Paris where he meets Delacroix and the painters of the Barbizon School. From 1840 friendship with Corot. 1843 returns to Geneva. Having unsuccessfully applied for a teaching position at the Ecole des Beaux-Arts, opens a private teaching studio. 1850-92 teacher at the Ecole de Figure of the Geneva Art Society, where he instructs, among others, Edouard Castres, Auguste Baud-Bovy and Ferdinand Hodler. Travels to France, Italy and Germany. Dies 11 October 1893 in Geneva.
Literature: Brüschweiler 1960.

Adolph von Menzel

Born 8 December 1815 in Breslau. 1830 the family moves to Berlin. 1832 takes over his father's lithography workshop. 1833 brief study at the Academy. From 1834 publishes several series of printed illustrations, amongst them 358 woodcuts for Franz Kugler's *Life of Frederick the Great*, 436 pen lithographs for the *Armeewerk* and 200 woodcut-vignettes for the Works of Frederick the Great. From the 1840s produces oil paintings, partly small-scale landscapes, interiors and portraits, partly large-scale history paint-

ings. 1853 member of the Berlin Academy; 1856 professor. Several journeys to Paris, Vienna, Upper Italy and the Salzburg Alps. 1866 travels to Königgrätz as war reporter. 1885 honorary doctor of Berlin University and honorary citizen of Breslau. 1895 made privy councillor and awarded title of excellency; becomes honorary citizen of Berlin. 1898 raised to the rank of hereditary nobility. Dies 9 February 1905 in Berlin.
Literature: Tschudi 1906, Hütt 1981, Jensen 1982, Cat. Hamburg 1982, Cat. New York et al. 1990/91.

Christian Ernst Bernhard Morgenstern

Born 29 September 1805 in Hamburg, son of the portrait painter and drawing teacher Carl Heinrich Morgenstern. 1818-20 journey through Germany, and 1820-23 to Russia, with the panorama painter Cornelius Suhr. 1824 enters the Hamburg painting school of Siegfried Bendixen. Moves in the circle of Hamburg Romantics. 1827 study trip to Norway and Sweden. 1828 attends the Copenhagen Academy. 1830 moves to Munich, on advice of the art historian Rumohr. Numerous travels. Friendship with Carl Rottmann. 1842 honorary member of the Munich Academy. Meets the art collector Count Schack. Dies 26 February 1867 in Munich.
Literature: Mauss 1969.

Victor Müller

Born 29 March 1830 in Frankfurt am Main. First studies at the Städelsche Kunstinstitut; 1849-51 at the Antwerp Academy. 1851-58 further studies in Paris; 1852 joins the studio of Thomas Couture. 1855 participates in the World Exhibition. Beginning of preoccupation with Gustave Courbet. 1858 returns to Frankfurt. 1865 moves to Munich, propagator of French art in the Leibl circle. Dies 21 December 1871 in Munich.
Literature: Lehmann 1976.

Ferdinand Olivier

Born 1 April 1785 in Dessau, son of the pedagogue Ferdinand Olivier. First drawing lessons with Carl Wilhelm Kolbe the Elder and Christian Haldenwang. 1804-07 stays with his brother Friedrich in Dresden. 1807 studies with Carl Ludwig Kaatz. Acquaintance with Caspar David Friedrich and Philipp Otto Runge. 1807-10 with his brother Fried-

rich in Paris as secretary at the Saxon embassy. 1811 the brothers move to Vienna, where Ferdinand Olivier, next to Joseph Anton Koch, is at the centre of the circle of Romantic artists. 1815 and 1817 stays in Salzburg. 1817 admission to the Nazarene Brotherhood of St. Luke, although he has not been to Italy. 1830 moves to Munich. Friendship with Julius Schnorr von Carolsfeld and Carl Rottmann. From 1833 professor of art history at the Munich Academy. Dies 11 February 1841 in Munich.
Literature: Grote 1938.

Ludwig Richter
Born 28 September 1803 in Dresden, son of the painter and graphic artist Carl August Richter. 1820-21 travel reporter with Prince Narischkin in southern France. 1823-26 in Italy; active in Joseph Anton Koch's studio; moves in the circle of German artists, recording his experiences in his *Lebenserinnerungen* (memoirs). 1828 drawing instructor at the Meissen porcelain manufactury. Subsequently makes many popular woodcuts. 1841-76 professor at the Dresden Academy of Art. Dies 19 June 1884 in Dresden.
Literature: Neidhardt 1969.

Louis-Léopold Robert
Born 13 May 1794 in Les Eplatures, Neuchâtel. First training with a copper engraver in Paris. 1811 accepted into the Academy. From 1812 pupil of Jacques-Louis David. 1816 returns to Switzerland. Stay in Italy financed by the banker and art patron Roulet de Mézerac. 1818 settles in Rome; 1822 his brother Aurèle follows him there and becomes his assistant. 1821 and 1825 travels to Naples. 1828 to La Chaux-de-Fonds, Verona, Venice and Ferrara. 1831 awarded the Cross of the Legion of Honour in Paris. 1832 moves to Venice; commits suicide on 20 March 1835.
Literature: Ségal 1973, Gassier 1983.

Johann Martin von Rohden
Born 30 July 1778 in Cassel. Studies at the Cassel Academy. 1795 journey to Rome where he participates in classes for painting the nude, arranged by Christian Reinhart. 1798 Republican disturbances in Rome prompt his return to Germany. 1802-11 second stay in Rome; moves in the circle around Joseph Anton Koch. Returns to Cassel. Acquaintance with Goethe. 1812-27 third stay

in Rome. Converted to Catholicism. Marries the daughter of the landlord of the inn at Tivoli. 1819 member of the Berlin Academy; 1821 co-founder of the German Library in Rome. 1827 appointed court painter to Wilhelm II of Hessen, and returns to Germany. 1829 finally settles in Rome. Dies there on 9 September 1868.
Literature: Pinnau 1965.

Carl Rottmann
Born 11 January 1797 in Handschuhsheim near Heidelberg, son of the university drawing teacher Christian Friedrich Rottmann. 1821 moves to Munich where he attends the Academy. From 1822 extensive study tour of the Salzburg and Werdenfels regions and the Inn Valley. 1824 marries the daughter of the Hofgarten superintendent Sckell. 1826-27 first journey to Italy and Sicily. 1829 second journey to Italy and 1834-35 journey to Greece, on commission from Ludwig I of Bavaria to make studies for the frescoes for the Hofgarten arcades, carried out between 1830-34 (Italian scenes) and 1838-50 (Greek scenes). 1841 appointed Royal Court painter. Dies 7 July 1850 in Munich.
Literature: Bierhaus-Rödiger 1978.

Philipp Otto Runge
Born 23 July 1777 in Wolgast, Pomerania, son of a ship owner and merchant. 1795 joins the merchant firm of his brother Daniel. From 1797 first drawing lessons. 1799-1801 studies at the Copenhagen Academy. 1801-03 at the Dresden Academy. Meets Anton Graff, Caspar David Friedrich and Ludwig Tieck. 1804 marries Caroline Bassenge and moves to Hamburg. Friendship with the Hamburg bookseller and publisher Friedrich Perthes. Corresponds with Clemens Brentano, Goethe, Achim von Arnim, Henrik Steffens and Friedrich Wilhelm Schelling; visited by Arthur Schopenhauer. 1810 publication of his theoretical treatise on the colour sphere. Until his death on 2 December 1810 in Hamburg works on his cycle the *Times of Day*, for which he makes numerous drawings, preparatory oil paintings and a series of engravings. 1840/41 his brother Daniel publishes the art-philosophical legacy of the painter, which proves him to be one the greatest theorists of the Romantic movement.
Literature: Traeger 1975, Cat. Hamburg 1977/78.

Jacques Sablet
Born 28 January 1749 in Morges. First taught by his father, a decorative painter and art dealer, in Lausanne. Then active in Lyons as a decorative painter. Journeys to Paris and studies with the history painter Joseph-Marie Vien, who is also teacher of his brother François. The two brothers stay in Rome with Vien. 1793 returns to Switzerland, then settles in Paris. Dies there 4 April 1803.
Literature: Cat. Nantes/Lausanne/Rome 1985.

Jean-Pierre Saint-Ours
Born 4 April 1752 in Geneva. First instruction at the drawing school of his father, the enamel painter Jacques Saint-Ours. 1768 studies with Joseph-Marie Vien in Paris, fellow pupil of Jacques-Louis David. From 1780 in Rome, student at the French Academy. Renewed encounter with David; friendship with the sculptor Antonio Canova. 1792 settles permanently in Geneva. Political activity as member of the National Assembly and the Legislative Committee. Works on the manuscript "Recherches historiques sur l'utilité politique de quelques-uns des beaux-arts chez différents peuples", which was later destroyed. Dies in Geneva 6 April 1809.

Fritz Schider
Born 13 February 1846 in Salzburg. First artistic training in Vienna. 1868 goes to Munich. Friendship with Wilhelm Leibl, whose niece Lina Kirchdorffer he marries in 1877. 1876 employed at the Basel school of drawing and modelling. Contributor to Julius Kollmann's *Plastisch-anatomische Studien für Künstler*. 1884 is granted Basel citizenship. 1893 publishes *Plastisch-anatomische Studien für Akademien, Kunstgewerbeschulen und zum Selbstunterricht*, for which the University of Basel gives him an honorary doctorate of medicine. Dies 15 March 1907 in Basel.
Literature: Ruhmer 1984.

Julius Schnorr von Carolsfeld
Born 26 March 1794 in Leipzig, son of the painter Hans Veit Schnorr von Carolsfeld. 1811 studies at the Vienna Academy. Meets Joseph Anton Koch and Ferdinand Olivier. 1817 travels to Italy and settles in Rome, where he joins the Nazarenes. 1827 moves to Munich. Until 1867 paints five halls of the

residence of Ludwig I with frescoes of the Nibelungen saga. His illustrations for the saga appear in 1843 and those for the Bible in 1860. 1846 called to Dresden as professor at the Academy and director of the Gallery of Paintings. Dies 24 May 1872 in Dresden.
Literature: Singer 1911.

Carl Schuch
Born 30 September 1846 in Vienna. 1864-67 studies at the Vienna Academy. 1868-70 study trip to Italy, at times with Albert Lang. 1869 moves to Munich; establishes links with Wilhelm Leibl and Wilhelm Trübner. 1872-73 study trip with Trübner to Italy. Again in Munich; meets the painter Karl Hagemeister, with whom he undertakes several journeys. 1876-82 lives in Venice, then until 1894 in Paris. From 1891 mental illness prevents him from painting. 1894 moves to Vienna. 1898 admitted to a sanatorium. Dies 13 September 1903 in Vienna.
Literature: Hagemeister 1913, Cat. Mannheim/Munich 1986.

Moritz von Schwind
Born 21 January 1804 in Vienna. Son of the Court Secretary Johann Franz von Schwind. 1818-23 studies at the Vienna Academy under Ludwig Schnorr von Carolsfeld and Peter Krafft. Friendship with the brothers Ferdinand and Friedrich Olivier, Franz Schubert and Franz Grillparzer. 1828 moves to Munich. Meets Peter von Cornelius. 1832-34 paints the walls of the Tieck Room in the Residence. 1835 journey to Italy. 1840-44 frescoes in the Kunsthalle Karlsruhe and in the Ständehaus. 1844-47 lives in Frankfurt am Main. 1847 returns to Munich; professor at the Academy. Contributes to *Fliegende Blätter* and to *Münchner Bilderbogen*. 1853-55 working on the Wartburg frescoes. 1857 journey to London. 1863-67 frescoes in the Vienna Opera. Dies 8 February 1871 in Niederpöcking on Lake Starnberg.
Literature: Weigmann 1906.

Giovanni Segantini
Born 15 January 1858 in Arco, Trentino. 1874 apprenticed to a decorative painter in Milan. Attends evening classes at the Academy Brera. From 1879 friendship and business relations with the painter, critic and art dealer Vittore Grubicy. 1881 moves to the Brianza,

where he works until 1886. 1883 honoured with a gold medal at the Amsterdam World Exhibition. 1886 moves with his family to Savognin, where he lives in seclusion until 1894. 1892 and 1893 honoured with gold medals in Munich and Turin. 1894 moves to Maloja in the Engadine. Friendship with Giovanni Giacometti. Meets Cuno Amiet and Ferdinand Hodler. Corresponds with the painters Pelizza da Volpedo, Max Liebermann and Gustav Klimt. 1896-97 commission for an Engadine panorama for the 1900 World Exhibition in Paris, which was not carried out. Dies 28 September 1899 on the Schafberg mountain near Pontresina.
Literature: Servaes 1902, Quinsac 1982, Cat. Zurich 1990/91.

Max Slevogt
Born 8 October 1868 in Landshut. 1885-89 studies at the Munich Academy, with Wilhelm von Diez among others. 1889 further studies at the Académie Julian in Paris. 1889-90 journey to Italy with Wilhelm Trübner and the art historian Karl Voll. 1892 first exhibition in the Munich Kunstverein. Contributes to the journals *Jugend* and *Simplicissimus*. 1898 journey to Holland. 1899 and 1900 stays in Paris. 1901 moves to Berlin. 1908-12 in Munich and the Palatinate. 1914 journey to Egypt. War painter at the western front. 1914 member of the Berlin Academy and in 1915 of the Dresden Academy. 1917 director of a master studio at the Berlin Academy. Dies 20 September 1932 in Neukastel, Palatinate.
Literature: Imiela 1968.

Carl Spitzweg
Born 5 February 1808 in Munich. Pharmaceutical training at the Royal Court Pharmacy in Munich and studies pharmacy, botany and chemistry at Munich University. 1832 journey to Italy. 1833 finally decides to take up painting. 1834 study trip to the Bavarian mountains; 1836 journey to southern Bavaria and Austria. 1837 first sale of pictures. From 1844 contributions to *Fliegende Blätter*. 1847 acquaintance with Moritz von Schwind. 1851 journeys to Paris with Eduard Schleich the Elder and his brother Eduard, continuing to London, Brussels and Antwerp. Further extensive travels. 1862 stay in Vienna. 1868 honorary member of the Munich Academy. 1875 member of the Central

Painting Commission in Munich. Dies there 23 September 1885.
Literature: Roennefahrt 1960, Jensen 1980, Ebertshäuser 1981, Wichmann 1986 and 1990.

Hans Thoma
Born 2 October 1839 in Bernau, Black Forest. Trains with a lithographer and a decorative painter in Basel, then with a painter of clock cases in Furtwangen. 1859-66 attends the Karlsruhe School of Art, studies with Ludwig des Coudres and Johann Wilhelm Schirmer. 1867 studies at the Düsseldorf Academy, where he meets Otto Scholderer, with whom he travels to Paris in 1868. Meets Gustave Courbet. 1868-70 lives in Bernau and Karlsruhe, then in Munich, where he frequents the Leibl circle. Friendship with Arnold Böcklin. 1874 journey to Italy. 1877 marries and moves to Frankfurt am Main. 1880 second journey to Italy. 1890 exhibition in the Munich Kunstverein. 1899 professor at the Karlsruhe School of Art and director of the Gallery. 1903 honorary doctorate from Heidelberg University. 1905 called to the Baden Upper Chamber and receives the title excellency. 1909 the Thoma Museum is set up in the Kunsthalle Karlsruhe. Dies 7 November 1924 in Karlsruhe.
Literature: Thode 1909, Cat. Freiburg 1989.

Adam-Wolfgang Töpffer
Born 20 May 1766 in Geneva. First active as copper engraver and illustrator. Friendship with Firmin Massot and Jacques-Laurent Agasse. 1789 and 1791 journeys to Paris. On return to Geneva study trips to the Savoy and Vaud regions. 1804 again in Paris, frequents art dealers and artists. 1807 drawing teacher to Empress Josephine in Paris. 1816 journey to England, visiting Agasse and participating in an exhibition at the Royal Academy. 1817 publication of the *Album de caricatures*. 1824 journey to Italy. Back in Geneva active as drawing teacher, miniaturist and painter. Dies there 10 April 1847.
Literature: Baud-Bovy 1903/04.

Wilhelm Trübner
Born 3 February 1851 in Heidelberg. 1867 enters goldsmith school in Hanau. Acquaintance with Anselm Feuerbach. 1867-68 attends the Karlsruhe School of Art. 1869 studies at the Munich Academy; continues

studies with Hans Canon in Stuttgart. 1870 back in Munich, with Wilhelm von Diez. Acquaintance with Albert Lang, Carl Schuch and Wilhelm Leibl. 1872 shares studio with Lang and Hans Thoma in Munich. Meets Lovis Corinth, Max Slevogt and Max Liebermann at the Städelsche Kunstinstitut in Frankfurt. 1901 member of the Berlin Secession. 1907 member of the Munich Secession. 1903-17 professor at the Karlsruhe Academy, also director. 1912 honorary member of the Milan Academy. Dies 21 December 1917 in Karlsruhe.
Literature: Rohrandt 1972.

Fritz von Uhde

Born 22 May 1848 in Wolkenburg, Saxony. 1866-67 studies at the Dresden Academy, then begins a military career. Until 1877 active as an officer as well as a painter. 1876 visits Hans Makart in Vienna. 1877 moves to Munich. 1878 joins the Reserve. 1879 works in the Paris studio of Mihály Munkácsy. 1880 marries and returns to Munich. Friendship with Max Liebermann. 1882 stay in Zandvoort. 1884 turns to religious subjects and depictions of children. 1892 co-founder of the Munich Secession. Dies 25 February 1911 in Munich.
Literature: Rosenhagen 1908.

Ferdinand Georg Waldmüller

Born 15 January 1793 in Vienna. 1807-13 intermittent studies at the Vienna Academy. 1813 drawing teacher for the children of Ignaz Count Gyulai in Agram. There active as painter of decorations for the town theatre. Meets the singer Katharina Weidner and marries her. When she is called to the court theatre the couple move to Vienna. 1825 journey to Italy; 1826 and 1827 in Dresden. Portrait commissions for the Imperial family. 1829 curator of the paintings gallery of the Vienna Academy. 1830 journey to Paris. From 1841 several journeys to Italy. His published suggestions for reform and a polemic advocating the closing of the Academy force his retirement. 1864 rehabilitated by the Emperor. Dies 23 August 1865 in the Hinterbrühl near Mödling.
Literature: Roessler-Pisko 1907, Grimschitz 1957, Buchsbaum 1976, Cat. Vienna 1990.

Friedrich Wasmann

Born 8 August 1805 in Hamburg. 1824-28 studies at the Dresden Academy with Gustav Heinrich Naeke. 1828 returns to Hamburg. Helped by a stipend continues his studies at the Munich Academy. His asthma makes a warmer climate advisable, hence he moves in 1830 to Obermais near Merano, Tyrol. 1832-35 in Rome, frequenting Emil Janssen and the circle of the Nazarenes, above all Friedrich Overbeck. Converts to Catholicism. After a stay in Munich returns to southern Tyrol, where he executes numerous portrait commissions. 1843-46 in Hamburg. 1846 marries and settles permanently in Merano. Dies there 10 May 1886.
Literature: Nathan 1954.

Caspar Wolf

Born 3 May 1735 in Muri, Aargau. Trains as decorative and church painter in Constanz, then apprenticed to the view painter Jakob Christoph Weyermann in Augsburg. Travels to Munich and Passau. 1760-68 in Muri, works for the convent. After a short stay in Basel travels to Paris, where he works with Philippe-Jacques de Loutherbourg. From 1771 again in Switzerland first in Muri, from 1774 in Berne, 1777-79 in Solothurn. Between 1774 and 1779 paints more than 150 alpine landscapes for the Bernese publisher Abraham Wagner. 1780-83 again in Paris, later in the Rhineland. Dies 6 October 1783 in Heidelberg.
Literature: Raeber 1979, Cat. Basel 1980.

Robert Zünd

Born 3 May 1827 in Lucerne, son of a state councillor and director of finance. Moves to Geneva, and takes lessons first from François Diday, then from Alexandre Calame. 1851 stay in Munich. Lifelong friendship with Rudolf Koller, with whom he works in 1852 at Lake Walensee. From 1852 frequently in Paris. Acquaintance with Frank Buchser and Albert Anker. 1860 journey to Dresden. 1863 settles outside Lucerne. 1883 beginning of friendship with Theodor Reinhart, the father of Oskar Reinhart, who becomes his patron. 1906 honorary doctorate from Zurich University. Dies 15 January 1909 in Lucerne.
Literature: Cat. Lucerne 1978.

Paola Giacosa / Nico Renner

Notes

Oskar Reinhart and his Concept of Collecting
(pp. 14 - 19)

1 Marianne Zelger-Vogt, "Porträt einer Kunststadt", in *Zürich, Konturen eines Kantons*, Zurich, n. d. [1983], p. 155 f.

2 See Peter Wegmann, "Gottfried Semper und das Winterthurer Stadthaus", *Neujahrsblatt der Stadtbibliothek Winterthur*, Vol. 316 (1986), Winterthur 1985.

3 *Reden, gehalten bei Anlaß der Eröffnung der Ausstellung »Sammlung Oskar Reinhart« im Kunstmuseum Bern, den 16. Dezember 1939, von den Herren Bundespräsident Philipp Etter, Fürsprech F. v. Fischer, Dr. h. c. Oskar Reinhart, Stadtpräsident Ernst Bärtschi* [Berne 1939], pp. 16, 18.

4 *Der Briefwechsel zwischen Dr. Theodor Reinhart und Robert Zünd*, ed. Walter Hugelshofer, Jubiläumsausgabe des Kunstvereins Winterthur zum 25jährigen Bestehen des Kunstmuseums 1941, p. 48 (letter dated Winterthur, 17 September 1892).

5 Eduard Hüttinger, "Oskar Reinhart, Historische Prämissen seiner Sammlung", in Rudolf Koella, *Sammlung Oskar Reinhart, mit Beiträgen von Michael Stettler und Eduard Hüttinger*, Zurich 1975, p. 23; Max Huggler, "Die Privatsammlung Oskar Reinhart", in *Schweizer Monatshefte*, October 1955, p. 359.

6 Hüttinger 1975 (see note 5), p. 26 f.

7 Quoted from ibid., p. 27.

8 Correspondence in the archives of the Collection Oskar Reinhart *Am Römerholz*.

9 See Lukas Gloor, "Von Böcklin zu Cézanne, Die Rezeption des französischen Impressionismus in der deutschen Schweiz", in *Europäische Hochschulschriften*, Reihe XXVIII, vol. 58, Bern 1986, p. 248 f.

10 Letter to Walter Braunfels, 3 February 1922, Archives of the Collection Oskar Reinhart *Am Römerholz*.

11 Carl Georg Heise, "Dr. Oskar Reinhart zum 70. Geburtstag", in *Neues Winterthurer Tagblatt*, 11 June 1955.

12 Hugo von Tschudi, in *Ausstellung deutscher Kunst aus der Zeit von 1775 bis 1875 in der königlichen Nationalgalerie Berlin 1906*, ed. Vorstand der deutschen Jahrhundertausstellung, Munich 1906, p. IX.

13 [Georg Schmi]dt, "Die Sammlung Oskar Reinhart. Zur Ausstellung in der Kunsthalle [Basel]", in *National-Zeitung [Basel]*, 22 April 1932.

14 Letter to Galerie Alfred Flechtheim, Berlin, 24 October 1932, Archives of the Collection Oskar Reinhart *Am Römerholz*.

15 Carl Georg Heise, "Die Stiftung Oskar Reinhart in Winterthur", in *Werk 38*, July 1951, p. 219 f.

16 Ibid., p. 222.

17 Julius Meier-Graefe, "Die Sammlung Oskar Reinhart (1. Die Deutschen)", in *Frankfurter Zeitung*, 29 April 1932.

18 Schmidt 1932 (see note 13).

19 Petra Kipphoff, "Wie es ihm gefiel", in *Die Zeit*, No. 12, 1970.

20 Diary, entry 20 January 1941, p. 89, Archives of the Collection Oskar Reinhart *Am Römerholz*.

21 Hans Mühlestein, Georg Schmidt, *Ferdinand Hodler*, Erlenbach-Zurich 1942.

22 *Reden* 1939 (see note 3), p. 18.

23 Richard Bühler, *Notizen aus der Sitzung des Galerievereins vom 13. Dez. 1929 unter ausschließlicher Berücksichtigung der verschiedenen Voten Oskar Reinharts*, typescript, Archives Descendants Richard Bühler.

24 Letter to Galerie Abels, Cologne, 23 Nov. 1935; Archives of the Collection Oskar Reinhart *Am Römerholz*.

25 Letter to Will Grohmann, Dresden, 10 January 1934; Archives of the Collection Oskar Reinhart *Am Römerholz*.

26 Gloor 1986 (see note 9), p. 146.

27 Quoted from Bühler 1929 (see note 23).

28 See *Künstlerfreunde um Arthur und Hedy Hahnloser-Bühler*, Exhibition Catalogue Kunstmuseum Winterthur 1973. See also Gloor 1986 (note 9), p. 139 f.; *Das gloriose Jahrzehnt, Französische Kunst 1910 - 1920 aus Winterthurer Besitz*, Exhibition Catalogue Kunstmuseum Winterthur 1991.

29 Hedy Hahnloser-Bühler, in *Hauptwerke der Sammlung Hahnloser, Winterthur*, Exh. Cat. Kunstmuseum Lucerne 1940.

30 Richard Bühler, in a letter of 7 September 1922 to Hedy Hahnloser. Quoted from Matthias Frehner, "Richard Bühler – ›Das Urteil der Zukunft nicht fürchten‹", in *Geschichte des Kunstvereins Winterthur seit seiner Gründung 1848, Neujahrsblatt der Stadtbibliothek Winterthur*, vol. 321 (1991), Winterthur 1990, p. 220.

31 See Hugo Wagner, "Zur Enstehung der Sammlung und Stiftung Rupf", in *Hermann und Margrit Rupf-Stiftung*, Kunstmuseum Berne 1969.

32 *Ansprache von Dr. Oskar Reinhart* (at the opening of the Oskar Reinhart Foundation, 21 January 1951), p. IV, Archives of the City of Winterthur (IIB25/e/1).

33 Heise 1951 (see note 15), p. 224.

Jean-Etienne Liotard
(pp. 20 - 27)

1 Cat. Geneva/Paris 1992, p. 94.

2 Ibid., p. 70.

3 Ibid., p. 156.

4 Liotard frequently painted this admirer of his art: see Cat. Geneva/Paris 1992, p. 18, n. 31.

5 See Zelger 1977, p. 219; Later, Jacques Offenbach made the life of the actress the subject of his operetta *Madame Favart*.

6 The painting is lost; illustrated in Zelger 1977, p. 219.

7 Loche/Roethlisberger 1978, No. 213; Fosca 1956, p. 67.

8 See Fosca 1956, p. 169 f.

9 See Cat. Geneva/Paris 1992, p. 23; also Fosca 1956, pp. 91 f, 97 f; Liotard's letter to Rousseau, 25 August 1765.

10 See Zelger 1977, pp. 221, 224.

11 Humbert/Revillod/Tilanus 1897, p. 52 (the whole treatise on pp. 51 - 100).

12 Ibid., p. 56. Liotard summarised his artistic criteria under the following headings: "le dessin, le coloris, le jugement, l'invention, la composition, l'expression, le clairobscur, l'harmonie, l'effet, le contraste, le saillant et la grâce."

13 See Loche/Roethlisberger 1978, No. 91: *La belle liseuse, Mlle Lavergne* (Amsterdam/Rijksmuseum).

14 Humbert/Revillod/Tilanus 1897, p. 81.

15 Ibid., p. 83 f. See also pp. 70, 80, 84, 91.

16 Zelger 1977, p. 225 f.

17 Humbert/Revillod/Tilanus 1897, p. 74 (see also pp. 76, 80, 82, 83).

18 Ibid., p. 97.

19 See Zelger 1977, p. 226, quoting Michel Faré: "Il dépasse tous les peintres de son temps par des préoccupations plastiques auxquelles, un siècle plus tard, le nom de Cézanne est associé." See also Fosca 1956, p. 156.

Caspar Wolf (pp. 28 - 37)

1 *The Diary of John Evelyn*, ed. E. S. de Beer, Oxford 1955, p. 256.

2 Schaller 1990, p. 88.

3 Raeber 1979, p. 57.

4 Cat. Basel 1980, p. 30.

5 *Merkwürdige Prospekte aus den Schweizer-Gebürgen und derselben Beschreibung*, 1st ed. 1776 [recte 1777], "Bern bey Wagner"; and "Alpes Helveticae, in Bern bey Wagner" (1777).

6 Raeber 1979, p. 66.

7 Ibid., pp. 80 - 84.

8 Seitz 1987, p. 54.

9 Cat. Berne 1991, p. 393.

10 *Liberté!, liberté! ton trône est en ces lieux: / La Grèce où tu naquis t'a pour jamais perdue, / Avec ses sages et ses dieux. / Rome, depuis Brutus, ne t'a jamais revue, / Chez vingt peuples polis à peine es tu connue… / Chez tous les Leventins tu perdis ton chapeau. / Que celui du grand Tell orne en ces lieux ta tête! / Descends dans mes foyers en tes beaux jours de fête.* (Cat. Berne 1991, p. 394.)

11 Steiger 1983, vol. II, p. 228 (19 October 1779).

12 Raeber 1979, p. 67 and fig. 29.

13 Ibid., p. 360: *Description*, 1779, No. 21.

14 Cat. Berne 1991, p. 397.

15 Raeber 1979, p. 361: *Description*, 1779, No. 30.

16 Zumbühl 1980, p. 29.

17 Cat. Basel 1980, p. 46.

18 Sulzer 1771/74, vol. I, p. 653.

19 Zumbühl 1980, pull-out illustration in supplement.

20 Ibid., p. 31 f., notes 4, 57, 58.

21 Seitz 1987, p. 142.

22 Zumbühl 1980, p. 33 and note 57.

23 Ibid., p. 33.

24 Raeber 1979, p. 360: *Description*, 1779, No. 33.

25 Cat. Basel 1980, p. 96.

26 Ibid., p. 94, see also Rupke 1990, pp. 241-259.
27 Raeber 1979, p. 210, No. 181.

Anton Graff (pp. 38-41)

1 Sulzer 1771/74, vol. II, p. 920.
2 Ibid., p. 918.
3 Ibid., p. 919.
4 Ibid., p. 921.
5 See Traeger 1975, p. 18.
6 Quoted in Berckenhagen 1967, p. 168.
7 See Dobai 1978, p. 10 and notes 7-9.
8 For instance Friedrich Schlegel mentions him, together with Baumgarten, as the inventor of the rational system, and Kant as the inventor of the critical system, of philosophical aesthetics. (*Über das Studium der griechischen Poesie*, 1797).
9 Sulzer 1771/74, vol. II, p. 919.
10 For instance, *A few tentative Thoughts about the reasonable Upbringing and Education of Children* (1745); see Dobai 1978, p. 10 and n. 11.
11 Sulzer 1781, p. 10.
12 Ibid., p. 15.
13 Ibid., p. 66 f.
14 Ibid., p. 92 f.
15 Richter 1980, p. 67 f.

Johann Heinrich Füssli (Henry Fuseli) (pp. 42-45)

1 Schiff 1973, p. 461, No. 507: Study of an illustration in Johann Caspar Lavater's *Essays on Physiognomy*, London 1792; and p. 532, No. 972.
2 See Cat. Hamburg 1974/75, p. 24; Schiff 1973, p. 49.
3 Cat. Hamburg 1974/75, p. 27, letter dated 4 Nov. 1773.
4 Ibid., letter to Herder, dated 25 March 1775.
5 Brun 1905, vol. I, p. 521, on the painting *The Artist in Conversation with Johann Jakob Bodmer* (Zurich, Kunsthaus).
6 Cat. Hamburg 1974/75, p. 37 f.
7 Schiff 1973, p. 383.
8 See Füssli's drawing *The Artist despairing before the Greatness of Antiquity* (Zurich, Kunsthaus).
9 See ibid., p. 51, regarding Füssli's passion for the theatre.
10 Ibid., Nos. 1240, 1632, 1635.
11 Ibid., p. 382.

12 Ibid.
13 Ibid., Nos. 1584, 1585.
14 Cat. Hamburg 1974/75, p. 44.
15 Ibid., p. 42.
16 Ibid., p. 44.
17 Ibid., p. 68.
18 Schiff 1973, p. 600.
19 Ibid., p. 621 f., No. 1656.
20 Ibid., No. 1037; in an engraving of this motif (No. 1313) the bards executed by King Edward are floating in the background.

Jean-Pierre Saint-Ours (pp. 46-47)

1 See De Herdt 1989, p. 134 f.
2 Cat. Berne 1991, p. 472.
3 De Herdt 1989, p. 138.
4 Geneva, Musée d'Art et d'Histoire.
5 Geneva, Musée d'Art et d'Histoire.
6 Schnapper 1981, p. 101.
7 Munich, Neue Pinakothek.
8 Zelger 1977, p. 289: "Ce 5 juin 1788 j'ai terminé mon tableau des mariages Germains que le Public a trouvé infiniment Supérieur aux choix des Spartiates je l'ai présenté au Cardinal. Ce qui m'a mérité des compliments assez agréables, ce tableau moins monotone par le ton que le premier et mieux peint me fait espérer dans la Suite plus de progrès."
9 Ibid., p. 298: "J'avois appris par votre précédente le succès qu'a eu chez M. le Cardinal un tableau fait par le sr Saint-Ours, et qui représente les cérémonies des mariages des Germains. J'en suis charmé et je ne puis que voir avec plaisir tout ce qui annonce qu'il se forme des peintres qui promettent de faire un jour honneur à l'Ecole françoise; le sujet m'en paroît bien choisi et propre à faire de l'effet…"
10 Tacitus, *Germania*, chapter 18.
11 Ibid., chapter 17.
12 Ibid., chapter 16.
13 Quoted in De Herdt 1978, p. 7 f.
14 Ibid., p. 7.

Jacques Sablet (pp. 48-51)

1 See Cat. Paris/Detroit/New York 1974/75, p. 600 (regarding Sablet's portraits): "He was most successful in little, full-length portraits set against the background of an Italian landscape. His style, characterized by an extreme delicacy of tones, fine light, and

freshness of atmosphere, often puts Sablet on the level of Gauffier…"
2 Ibid, p. 601: *Thomas Hope playing Cricket* (London, Cricket Memorial Gallery). This type of portraiture, with increasing emphasis on the landscape, was also favoured by Louis Gauffier, who had been somewhat influenced by Sablet. See ibid., p. 429 f., ill. p. 147: Gauffier, *Portrait of Doctor Penrose* (1798).
3 Zelger 1977, p. 294.
4 About 1785 Joseph Wright of Derby began to paint the pioneers of the industrial age, with their factories.
5 See the similar pose of *Thomas Hope* (note 2).

François Ferrière (pp. 50-51)

1 See Boissonas 1990, pp. 147-152.
2 J. Sénebier, *Histoire Littéraire de Genève*, vol. 3, Geneva 1786, p. 334.
3 For the topography see Pianzola 1972, pp. 52, 58 (watercolour by Jean Dubois, showing the same tower on the Quai des Pâquis).
4 Cat. Lugano/Geneva 1991/92, p. 76.
5 Cat. Paris 1984/85, p. 193.

Adam-Wolfgang Töpffer (pp. 52-55)

1 Baud-Bovy 1903/04, p. 43.
2 Cat. Atlanta 1988, p. 86.
3 Cat. Berne 1991, p. 685 f. and p. 443 f.
4 The *Rustic Breakfast* of 1808 has a similar landscape. See Cat. Atlanta 1988, p. 84, quoting Rodolphe Töpffer's observations about his father's discovery of the picturesque Savoyard landscape.
5 David Teniers the Younger, well known for his *kermesse* scenes (a further source of inspiration for Töpffer), painted a huge picture after this etching (Munich, Alte Pinakothek).
6 Cat. Paris/Detroit/New York 1974/75, p. 393.
7 Letter to Mlle Counis, Töpffer's future wife, whom he married in 1793 (Baud-Bovy 1903/04, vol. II, p. 26).
8 Cat. Berne 1991, p. 687. The citizen being run through the mill

which extracts his money, presents the following message: "For the useless restoration of the fortifications."

Jacques-Laurent Agasse (pp. 56-65)

1 Zelger 1977, p. 23.
2 For portraits of giraffes and gnus see Cat. Geneva/London 1988/89, Nos. 59, 60.
3 Ibid., p. 122.
4 Ibid., No. 23 (Yale Center for British Art); see also Nos. 24-26.
5 The following entries are relevant: "1805, *A Celebrated Race-Horse*; 1809, *Grey Mare in Hampshire* and *Iron Grey Stallion in Devonshire*; 1815, 28 July, *A Grey Arabian Horse*, begun some years before, 1/2 length" (see Cat. Geneva/London 1988/89, p. 102). The *Catalogue autographe de son oeuvre 1800-1849* is in the Musée d'Art et de'Histoire in Geneva (Agasse-Archive, Inv. 1906-I).
6 Zelger 1977, p. 25: probably the stable interior, Cat. Geneva/London 1988/89, p. 72: "12 July 1810 Inside of a stable. Kitcat." (The term Kitcat describes a canvas format of c. 70 x 90 cm.)
7 Cat. Geneva/London 1988/89, p. 102, No. 31; painted in 1809.
8 Zelger 1977, p. 26; Cat. Geneva/London 1988/89, p. 108.
9 Zelger 1977, p. 26.
10 Ibid.
11 Schinkel 1862, vol. 2, p. 158.
12 Ibid., p. 156.
13 Zelger 1977, p. 26; "1815… November 10. Stage-coach, figure etc. 1/2 length" (a canvas format of 50 x 40 inches); another version: "ditto. alterations. Kitcat [canvas 36 x 28 inches]." See Cat. Geneva/London 1988/89, p. 108.
14 Cat. Geneva/London 1988/89, No. 38 (the Oskar Reinhart Foundation painting), No. 39: *A View of Lambeth from Westminster Bridge.* (Coll. Thyssen-Bornemisza).
15 See Fox 1987, p. 119; Zelger 1977, p. 28 f.
16 The *Catalogue autographe* mentions two versions of the *Landing at Westminster Bridge*, a larger one, exhibited at the Royal Academy in 1818 ("4 April 1818 Landing at Westminster Bridge S. 3 feet & half by 2 feet 4 inches"), now

lost, and a smaller ("May sketch of ditto small"), presumably the version in the Oskar Reinhart Foundation, since "small" refers to a canvas format of c. 40 x 50 cm. This version apparently was owned by Agasse's sister and was exhibited in 1820 in the Geneva Salon (Cat. Geneva/London 1988/89, p. 116).

17 Zelger 1977, p. 28.

18 Cat. Geneva/London 1988/89, No. 113: *St. Paul's Cathedral in London seen from Southwark Bridge* (Geneva, Musée d'Art et d'Histoire); No. 114: *View of Greenwich Hospital* (Oskar Reinhart Foundation).

19 Fox 1987, p. 164 f., ill.

20 Cat. Geneva/London 1988/89, p. 35 f.

21 Trost 1991, p. 26. In Berlin, for instance, gas lighting was introduced as late as 1826. The first gas lanterns were placed in the Unter den Linden. See Gaertner entry (Cat. 63).

22 "May 1822 The flowers cart of the spring 18 by 14", "september 1825 Copy of the picture of the flowers cart. small."

23 In the Cat. Geneva/London 1988/89 the version in vertical format is said to be the first, while Zelger (1977) considers the Winterthur version the original.

24 See Cat. Geneva/London 1988/89, p. 120.

25 Hardy 1905, quoted in Buyssens 1988, p. 4.

26 Cat. Atlanta 1988, p. 90; Cat. Geneva/London 1988/89, p. 162.

27 "1830 July: ditto [The pleasure ground]. Smaller."

Louis-Léopold Robert (pp. 66-71)

1 Cat. Nuremberg/Schleswig 1991/92, pp. 25, 29.

2 *Rest of the Reapers in the Pontine Marshes, Return from the Festival of the Madonna del Arco* (both Paris, Louvre), *Departure of the Adriatic Fishermen* (Neuchâtel, Musée d'Art et d'Histoire).

3 A study for Romeo and Juliet was shown in the memorial exhibition of 1835 in Neuchâtel (Gassier, p. 276, No. 31L). It is not clear whether this work contains an allusion to Robert's impossible love for Charlotte Bonaparte.

4 Billeter 1990, p. 74.

5 All quotes from Heine in: Heinrich Heine, *French Painters, Exhibition of Paintings in Paris 1831*, chapter on L. Robert.

6 Zelger 1977, p. 286.

7 Gassier 1983, p. 104 f.

8 Ibid., p. 135.

9 From 1815 the Canton of Neuchâtel belonged both to Switzerland and Prussia, hence Robert was half Prussian and half French-speaking Swiss.

10 Gassier 1983, p. 297.

11 Ibid.

12 Ibid., letter dated 24 Jan. 1823.

13 Ibid., No. 45 (private collection).

14 Ibid., p. 313, letter of 16 March 1825.

15 Ibid.

16 Ibid., p. 314.

17 Ibid. The letters do not mention the first copy, which may be identical with a work mentioned by Aurèle as a copy executed in 1825 by him for Roulet de Mézerac (ibid., p. 314, No. 69). It is possible that both artists worked on this. A version dated 1825 formerly in the art market (Archiv SIK, Zurich) is on a smaller scale, and for that reason Léopold may have emphasised that he had executed the copy for Count Hahn in the size of the original.

18 Ibid., letter of 1 Aug. 1825.

19 Ibid.

Philipp Otto Runge (pp. 72-75)

1 Cat. Berne 1985, p. 142.

2 Runge 1841, vol. II, p. 183 (letter to his mother, 18 December 1802).

3 Ibid., p. 182.

4 Ibid., p. 195 (letter to Daniel).

5 See Cat. Hamburg 1977/78, pp. 196-199.

6 No. 1666; in a letter to Ludwig Tieck, Runge discusses his relationship to mathematics. See Runge 1840, vol. I, p. 39 f.

7 See Runge 1841, vol. II, pp. 203, 219; Runge 1840, vol. I, p. 48 (letters to Daniel, 10 March 1803, 12 June 1803 and 26 June 1803).

8 Runge 1840, vol. I, p. 31.

9 See Cat. Hamburg 1977/78, p. 136 f.

10 Runge 1840, vol. I, p. 17 (letter to Daniel, 7 November 1802).

11 Ibid.

12 Ibid., p. 36 (letter to Daniel, 23 March 1803).

13 Ibid., p. 82.

14 Ibid., p. 237.

15 Traeger 1977, p. 131.

16 Runge 1840, vol. I, p. 33 (letter to Daniel, 30 January 1803).

17 Ibid., p. 227.

18 Runge 1841, vol. II, p. 186 (letter to Perthes, 19 December 1802).

19 Runge 1840, vol. I, p. 29 (letter to his father, 13 January 1803); see Cat. Hamburg 1977/78, p. 168.

20 Ibid., p. 15 (letter to Daniel, 9 March 1802).

21 Ibid., p. 26 (letter to Ludwig Tieck, 1 December 1802).

22 Novalis, *Hymns to the Night*, first hymn (Atheneum print).

Caspar David Friedrich (pp. 76-87)

1 Traeger 1979, pp. 96-114.

2 Sumowski 1970, pp. 7-44; Koerner 1990, p. 95.

3 A few remarks by Friedrich may clarify this: e. g. on the Nazarenes, "is it not detestable and often disgusting to see desiccated Virgin Marys, dressed in paper garments, with a starving Christ-child in their arms, often deliberately badly drawn. All the mistakes of those times are deceitfully aped, but the good in those works, which are inspired by a deep and childlike piety, cannot be mechanically imitated, and the hypocrites, even if they converted to Catholicism, will never succeed. With our better insight, we must not imitate what our forefathers created in childlike innocence." (Hinz 1974, p. 111). The "realistic" approach ("The art of our time is only concerned with faithfully reproducing what the eye can see") in Friedrich's opinion lacks "the artist's inner spiritual communication with nature." (Hinz 1974, p. 116).

4 Ibid., p. 86.

5 Quoted from Eimer 1974, p. 109.

6 Börsch-Supan 1973, p. 213 f.

7 *Journal des Luxus und der Moden*, 2 January 1812, quoted in Börsch-Supan 1973, p. 79 f: No. 3, the Dresden *Mountain Landscape*; No. 5, the Schwerin *Winter Landscape*; No. 8, the Winterthur painting; No. 9, the London *Winter Landscape*; Nos. 1 and 2, the Berlin *Morning in the Riesengebirge* and its lost pendant; Nos. 6 and 7, the Winterthur *Port by Moonlight* and its lost pendant.

8 See reviews in the *Journal des Luxus und der Moden*, quoted in Börsch-Supan 1973, p. 80.

9 Ibid., p. 82.

10 See the review "About the Leipzig Paintings Exhibition for the Benefit of impoverished Villagers, Easter Fair 1814." Ibid.

11 Cat. London 1990, pp. 35-37.

12 e. g. Börsch-Supan 1973, p. 201 f., repeated in Cat. Madrid 1992, p. 144.

13 Other works in this series are the *Cross in the Mountains* in Düsseldorf (an easily understood combination of rock and crucifix, spring, pines or fir trees, vision of a church, and moon); the *View of the Elbe Valley* in Dresden; and the *Mist in the Mountains* in Rudolstadt. Further, the sepia drawings in Weimar (Börsch-Supan No. 122) and Berlin (Börsch-Supan No. 146), as well as a design for the *Tetschen Altar piece* (Börsch-Supan, p. 229). Most of these works were done around 1810.

14 Hinz 1974, p. 133 f.

15 e. g. the *Vision of the Christian Church* (Schweinfurt, Collection Schäfer), or *The Cathedral* (ditto).

16 Hinz 1974, p. 102.

17 See Cat. London 1990, p. 48, referring to Goethe's text about Strasbourg Cathedral and to Ernst Moritz Arndt's visit to St. Sebald in Nuremberg, which made him feel as if standing in a forest of sacred pines.

18 See Börsch-Supan Nos. 162, 169, 261 (here the contrast of oak and fir trees in one picture), 289.

19 Private collection. Significantly the straggling French soldier stands in front of a snow-clad forest of fir trees, symbol of Germany's "hibernation".

20 Hinz 1974, p. 212.

21 Oslo, National Gallery (Hofstätter 1974, p. 427, Hinz 1966, No. 382). The same oak in *Oak in the Snow* (Cologne, Wallraf-Richartz Museum), *Convent Court in the Snow* (previously Berlin, Nationalgalerie), *Giant's Grave by the Sea* (Weimar, Staatliche Kunstsammlungen).

22 Bremen, Kunsthalle (Hofstätter 1974, p. 506, Hinz 1966, No. 519), and Oslo, National Gallery (Hofstätter 1974, p. 508, Hinz 1966, No. 520).

23 Hinz 1974, p. 83.

24 Ibid., p. 92 f. On p. 125 a similar

statement: "The painter should not paint only what he sees before him, but also what he sees within himself. Should he see nothing within himself, then he had better desist from painting what he sees before him."

25 Mentioned in the *Journal des Luxus und der Moden*, 1812; quoted in Börsch-Supan 1973, p. 79 and Nos. 197, 198. The *Port by Moonlight* is not painted on paper, as stated in all the literature, but on canvas.

26 The first picture was painted for a deceased person. Its background again features a port with ships at anchor, and a city with a full moon. The gate in the foreground points to the transition from this world to the next: an image of hope and resurrection. The second painting has similar motifs but includes a crucifix, which gives it a specific Christian symbolism. Compare also *On the Sailboat* (St. Petersburg, Hermitage), where the visionary city more generally points to a safe haven to come. See Rautmann 1974, pp. 86-91.

27 The moon in Friedrich's paintings often has a similar significance. In the *Landscape with Rainbow* (Essen, Museum Folkwang), for instance, the moon appears above a rainbow, as if having created it. However, sunlight is falling from outside the picture space on the wanderer at rest, a self-portrait of Friedrich. This figure turns away from the direct light of the sun, observing instead the broken colours of the rainbow and the reflected light of the moon, filtering through dark clouds. An explicit connection between moon, Christ and rainbow is established in *The Cathedral* (Schweinfurt, Collection Schäfer).

28 Hinz 1974, p. 90.

29 A comparable picture, previously in Gotha (Herzogliches Museum), was shown at the 1818 Exhibition of the Dresden Academy.

30 *Kunst und Künstler* XXVI, 1928, p. 109, and Hinz 1974, p. 39.

31 Humboldt, diary of his journey to northern Germany in the year 1796; quoted in Cat. Berne 1985, p. 120.

32 Jensen 1974, pp. 184-188.

33 Oslo, National Gallery, sketchbook of 1815, folios 13 and 14, both dated 11 August 1815 (Hof-

stätter 1974, p. 610, Hinz 1966, No. 647/648).

34 Oslo, National Gallery, sketchbook of 1818, folio 6 (Hofstätter 1974, p. 676; Hinz 1966, No. 686).

35 In Schelling's essay, "System des transzendentalen Idealismus", para. 2, 1800 (Schelling 1858, p. 620).

36 The precipice as symbol of death occurs for the first time in Friedrich's 1803 woodcut *Woman at the Abyss*.

37 This drawing, owned by the Hamburg Kunsthalle, is the penultimate scene, representing death, in a Four Seasons cycle. The last scene shows angels in adoration. The crystalline white of the chalk rocks also recalls ice (compare the *Arctic Shipwreck*, Hamburg, Kunsthalle).

38 Quoted in Börsch-Supan 1973, p. 146. It is quite likely that the picture mentioned is the *Chalk Cliffs on Rügen*.

39 Presumably Friedrich was influenced by Runge's symbolism of light and colour, as expressed in such statements as: "Light is the sun which we cannot look at, but when it inclines towards the earth or man, the sky turns red ... Red is the ordained intermediary between earth and sky." (Runge 1840, vol. I, p. 17).

40 Börsch-Supan (No. 257) interprets the colours red, blue and green, which he thinks he sees in the figures, as allegories of the Christian theological virtues, faith, hope and charity. However, the colours should be seen as an effect of the divine, bestowed on the woman and the man in the centre as a blessing. The man on the right is not green but, turning directly towards the light, appears a lightless brown.

41 Carus' third letter: "On the effect of some landscape phenomena on the soul."

42 Adam Müller, in his essay "Something about Landscape Painting", describes landscape painting as symbolising eternity in a sequence of moments in space (quoted in Cat. Berne 1985, p. 132).

43 Hinz 1974, p. 129.

44 Märker 1974, p. 168 f; Eschenburg 1978, p. 128.

45 In the Essen *Landscape with Rainbow* a top hat is shown in the same way, lying next to the wanderer, a self-portrait of Friedrich (see note 27).

46 Hinz 1974, p. 89.

47 Memoirs of L. Förster, 1846, quoted in Börsch-Supan 1973, p. 136.

48 In the talk "About the relationship of the creative arts to nature," 1807 (Schelling 1860, p. 293).

49 Compare also Friedrich's remark: "man is not meant to follow purely human models but to aspire to the divine and the infinite." (Hinz 1974, p. 83).

50 Börsch-Supan 1973, p. 422.

51 Hinz 1974, p. 81.

Georg Friedrich Kersting (pp. 88-89)

1 Both paintings are in Weimar, Kunstsammlungen. See Gärtner 1988, pp. 68, 73. Goethe sponsored the destitute Kersting at the beginning of 1813 and maintained an interest in him. On 18 August 1824 the artist wrote to his wife about his meeting with Goethe: "If only you could have seen the magnificent old man, looking at me so amiably with his powerful eyes and, with a warm farewell handshake, wishing me happiness and contentment, you would have wept tears of joy, as I did." (Weber 1971, p. 49).

2 Weimar, Kunstsammlungen. See the extensive interpretation in Gärtner 1988, pp. 65-74.

3 *Memoirs of the painter Louise Seidler*, ed. Hermann Uhde, Berlin 1922, p. 43.

4 In the *Elegant Reader* a map of the world hangs over the writing desk. This earlier, less severe composition suggests a creative untidiness.

5 Staiger 1983, p. 23.

6 Weber 1971, p. 49.

7 Compare, with gender-roles reversed, Peter Fendi's *The Poor Officer's Widow* (Vienna, Österreichische Galerie), who with her child is sitting abandoned in a small mansard room, in front of an almost identical miniature portrait of the deceased. In Kersting's *Embroideress* the ivy-wreathed portrait of Louise Seidler's dead fiancé hangs on the back wall.

8 Goethe, *Zur Farbenlehre*, didactic part, para. 802.

9 Here Kersting approaches Goya's etching *The Sleep of Reason produces Monsters*, from the 1799 series of *Los Caprichos*.

10 Staiger 1983, p. 32. See also p. 26: "The picture is not a harmless idyl; there are ghosts lurking behind this neat order of things." On p. 31, Staiger further emphasises the tendency towards the mysterious, the demonic.

Johan Christian Dahl (pp. 90-91)

1 Cat. Nuremberg/Schleswig 1991/92, p. 227.

2 Neidhardt 1976, p. 162 f.

3 Ibid., p. 171.

4 Cat. Munich 1988, p. 22.

5 Compare C. D. Friedrich, *Landscape with Oak Trees* (Cat. 26).

6 See Vignau-Wilberg 1979, p. 188.

7 See Jensen 1985, p. 78.

8 See Cat. Munich 1988, p. 25 f.

9 Neidhardt 1976, p. 168, quoting Aubert 1920, p. 408.

Franz Krüger (pp. 92-95)

1 Catalogue of the Berlin Academy Exhibition 1818, Nos. 138-142; see Franke 1984, p. 42.

2 Weidmann 1927, p. 38.

3 Inscribed *KR. 23*; Provenance: Collection Engelbrecht, auction Amsler & Ruthardt, Berlin 1924; Collection Heumann, Chemnitz.

4 G. Schadow 1849; see Franke 1948, p. 31.

5 Franke 1984, p. 31, ill. 2 and 3.

6 Ibid., p. 41: Krüger's purposeful retrospective of themes from the Freedom Wars is confirmed in A. von Helwig's comment on the 1820 painting *March of the Prussian Cavalry* (Kunstblatt No. 67, 21 August 1823): "This single action conjures up the whole of the disastrous winter of the year 1812/13 for our imagination."

7 Compare Runge's *Fall of the Fatherland*, planned as a cover illustration for *Fatherland Museum* (Vaterländisches Museum), featuring a soldier killed in action for the fatherland lying under the ground (see Cat. Hamburg 1977/78, p. 130).

8 Gallery Gisela Meier, Munich, Catalogue 1990.

9 The question of the monument remained acute long after the 1815 war. Schinkel and others made designs, but no concrete plans resulted, since the King showed no

particular interest. On the foundering of the monument projects see Franke 1984, pp. 34-39, 80-93.

10 Weidmann 1927, pp. 26, 36.
11 Auction Catalogue Boerner, Leipzig, 30 March – 1 Apr. 1943, No. 886.

Johann Martin von Rohden
(pp. 94-95)

1 Lammel 1986, p. 197 ff.
2 Richter 1980, p. 227 f., in the chapter "October to New Year's Eve 1824."
3 Oil on paper, mounted on canvas, 56 x 73.5 cm; see Cat. Hamburg 1976, No. 228, and Galassi 1991, p. 37.
4 Pinnau 1965, p. 80.
5 Neidhardt 1976, p. 192,
6 Ibid., p. 87.
7 Pinnau 1965, p. 116 and G 9.

Joseph Anton Koch (pp. 96-99)

1 Cat. Stuttgart 1989, p. 90.
2 See Hardenberg 1925, p. 40.
3 Grimmelshausen, Simplizius Simplizissimus, vol. 5, chapters 10-17.
4 Cat. Stuttgart 1989, p. 136 (No. 20) and p. 283 (No. 29).
5 Ibid., p. 16.
6 Schinkel 1862, vol. I, p. 265.
7 See Lutterotti 1985, p. 217, Nos. 59, 67.
8 Ibid., p. 298.
9 Ibid., see also No. 118.
10 Cat. Stuttgart 1989, pp. 83-86.
11 Richter 1980, p. 226 f.
12 See Cat. Stuttgart 1989, p. 286.
13 Ibid., p. 229.
14 Ibid., p. 32.

Ferdinand Olivier
(pp. 100-103)

1 See Cat. Vienna/Berlin 1990, p. 141; Grote 1938, pp. 111, 136 f, 148.
2 See Grote 1938, p. 139 f; Cat. Hamburg 1976, p. 269.
3 See Schwarz 1936.
4 Grote 1938, p. 188.
5 Ibid: "Dearest Julius, we have reached our most ardently desired destination. You alone are missing to complete the fulfilment of a long nourished hope."
6 Ibid., pp. 188, 190.

7 See Grote 1938, p. 228; Schwarz 1936, figs. 50, 51.
8 See Cat. Vienna 1990, pp. 133, 270.
9 See Grote 1938, pp. 185, 203 (1818), 205 (1820), 206 (1818); Cat. Berne 1985, pp. 166, 226 (1816).
10 See Grote 1938, pp. 195, 199; Cat. Berne 1985, p. 165.
11 Grote 1938, p. 235; Schwarz 1936, fig. 25.
12 Runge 1840, vol. I, p. 74.
13 Grote 1938, p. 354.
14 Ibid., pp. 330 f., 335.

Ernst Fries (pp. 104-105)

1 Galassi 1991, p. 136.
2 Richter 1980, p. 198.
3 Ibid., p. 296 f.
4 Vignau-Wilberg 1979, p. 102.
5 Richter 1980, p. 206.
6 1833, Munich, Neue Pinakothek; see Cat. Munich 1982, p. 102.
7 Galassi 1991, p. 49, and Cat. Munich/Dresden 1991/92, p. 290.

Carl Rottmann (pp. 106-107)

1 Bierhaus-Rödiger 1978, No. 537; Vignau-Wilberg 1979, p. 246 f.
2 Cat. Munich 1982, p. 285.
3 Cat. Munich 1979, pp. 132, 134, 141-145.
4 Vignau-Wilberg 1979, p. 247 f.; and Bierhaus-Rödiger 1978, Nos. 616-618, 640, 672, 679.
5 Entry of King Otto of Greece in Nauplia, 6 February 1833 (painted in 1835) and the pendant Reception of King Otto of Greece in Athens, 12 January 1835 (painted in 1839), both in the Neue Pinakothek, Munich.
6 Krauss 1930, p. 208.
7 Ibid., p. 212.
8 Eschenburg 1987, p. 145 f.
9 Cat. Munich 1987/88 (Deutsch-Römer), p. 316.
10 Cat. Munich 1982, p. 287.
11 Ibid., p. 288.
12 Eschenburg 1987, p. 146.

Carl Blechen (pp. 108-117)

1 The artist's character and life are discussed with great insight by Börsch-Supan, Cat. Berlin 1990, pp. 27-31.
2 Rave 1940, p. 23: Blechen's letter to Beuth, 22 November 1830.

3 P. K. Schuster in Cat. Berlin 1990, p. 21.
4 Rave 1940, p. 86. Blechen's biographer G. J. Kern writes in 1911: "Menzel continues only one aspect of Blechen's art, that is, the painterly; the other, romantic aspect lives on in Dreber and Böcklin. In 1856 Böcklin finished his Pan amongst the Reeds: it is Blechen's faun that is born again in this work." (Kern 1911, p. 137).
5 Cat. Berlin 1990, pp. 10-12; an exhibition reviewer in the Kunstblatt of 1827 noted: "a winter landscape at first glance appeared to me an invention of Friedrich" (Rave 1940, p. 8).
6 Rave 1940, p. 2.
7 Heinrich Heine, in the second of his Letters from Berlin, 16 March 1822, describes how the opera's music seemed to fill all the streets of Berlin: "When proceeding from the Hallischen to the Oranienburger Tor [Gate], and from the Brandenburger to the Könings-Tor, even when walking from the Unterbaum to the Köpnicker Tor, you will forever hear the same tune, the song of all songs, the Jungfernkranz."
8 The Kunstblatt, 21 May 1827, remarks how Blechen's pictures resembled the Wolf's Glen in Freischütz and seemed to have sprung from Hoffmann's Devil's Elixir (Rave 1940, p. 8).
9 Spenersche Zeitung, 28 November 1826 (Rave 1940, p. 6).
10 Amalie von Helvig, in Kunstblatt, 16 March 1829 (Rave 1940, p. 10).
11 Rave 1940, p. 16.
12 Cat. Berlin 1990, p. 40.
13 Rave 1940, p. 19.
14 See Galassi 1991, pp. 11-39, 83-129.
15 P. Krieger, in Cat. Berlin 1986, p. 118.
16 Contrary to previous records, the picture is not painted on paper.
17 Rave 1940, No. 1378, inscribed Spezia.
18 Ibid., p. 14.
19 Ibid., p. 68.
20 Ibid., p. 71.
21 Kunst und Künstler IX, 1911, pp. 6-9.
22 Rave 1940, p. 25.
23 See P. K. Schuster, in Cat. Berlin 1990, p. 23, where The Monk in a Rock Grotto is interpeted as an allegorical self-portrait by Blechen.

24 Staatliche Schlösser und Gärten, Charlottenburg; Cat. Berlin 1990, No. 72 (as by the artist's own hand).
25 On the making of copies see Rave 1940, p. 86, quoting from Fontane's report on the first paintings acquired by the collector Brose: "a small collection of Blechen paintings, but all copies made by the young painter G. W. Herbst. All were Italian sketches."
26 Gottfried Schadow in Kunstwerke und Kunstansichten 1834, p. 268 (Rave 1940, p. 34).

Johann Georg von Dillis
(pp. 118-121)

1 His real name was Benjamin Thompson. See Lessing 1951, p. 24.
2 Ibid., p. 63.
3 Ibid., p. 80 f. See also Cat. Munich/Dresden 1991/92, p. 13.
4 Letter dated 2 December 1815, quoted in Lessing 1951, p. 86.
5 On Dillis' relationship with French and English painting see Chr. Heilmann, in Cat. Munich/Dresden 1991/92, pp. 14-37.
6 Ibid., pp. 14-17.
7 Ibid., Nos. 16, 17, 19. Today this is the location of the Deutsches Museum.
8 Ibid., No. 144, p. 293 f.
9 Messerer 1961, No. 135, pp. 103, 173.
10 Cat. Munich 1988, p. 94, No. 29 (Bergen, Billedgalleri).

Wilhelm von Kobell
(pp. 122-127)

1 Lessing 1966, p. 70.
2 Ibid., letter of December 1825 to Ludwig I.
3 Karlsruhe, Kunsthalle; see Vignau-Wilberg 1979, p. 140.
4 Schlegel, Europa (chapter "Nachricht von den Gemälden in Paris" [Review of the paintings in Paris]), 1803, p. 114; see also Wichmann 1970, p. 72.
5 Wichmann 1970, p. 76.
6 Wichmann 1981, p. 34.

Christian Morgenstern
(pp. 128-129)

1 Vignau-Wilberg 1979, p. 222.
2 Oil on cardboard, 34.5 x 42.5 cm; see Ludwig 1978, p. 90 f., fig. 97.

3 Cat. Munich 1979, p. 396; Wichmann (1964) dates the picture in the 1830s, and Mauss (1969) in the 1840s.

Friedrich Wasmann (pp. 130-133)

1 Nathan 1954, p. 79 f.
2 The wart had been overpainted by another hand and reappeared only during a recent restoration.

Ferdinand Georg Waldmüller (pp. 134-143)

1 Roessler/Pisko 1907, vol. II, p. 111.
2 Grimschitz 1957, p. 12; Roessler/Pisko 1907, vol. II, p. 73 f: Waldmüller's plans for travel to Philadelphia.
3 Roessler/Pisko 1907, vol. II, p. 9.
4 Vienna, Österreichische Galerie; Cat. Vienna 1990 (Waldmüller), No. 19.
5 Roessler/Pisko 1907, vol. II, p. 53; Cat. Vienna 1990 (Waldmüller), p. 21.
6 Cat. Vienna 1990 (Waldmuller), p. 22.
7 Roessler/Pisko 1907, vol. II, p. 7 f.
8 Cat. Vienna 1990 (Waldmüller), p. 25, fig. 14 and No. 7.; see also Grimschitz 1957, Nos. 114-116
9 Grimschitz 1957, p. 45.
10 Buchsbaum 1976, pp. 80, 222-226.
11 Schwarz 1936; Grimschitz 1957, p. 46.
12 Grimschitz 1957, Nos. 286, 427, 430.
13 Ibid., Nos. 347, 348, 350 (painted 1833); Nos. 379, 384 (painted 1834).
14 Grimschitz 1957, p. 47.
15 There is another version, also dated 1832, in the Kunsthalle, Bremen (Grimschitz 1957, No. 315), and a third version, dated 1834, in the Leopold Collection, Vienna (Cat. Vienna 1990 (Waldmüller), No. 37).
16 Cat. Vienna 1990 (Waldmüller), p. 27 f.
17 Buchsbaum 1976, pp. 141, 144, n. 251; Schwarz 1936, p. 55, mentions Waldmüller's use of the *camera lucida* for the Salzburg landscapes.
18 Schwarz 1936, p. 50; Cat. Vienna 1990 (Waldmüller), p. 26.
19 Collection Schäfer, Schweinfurt;

see Grimschitz 1957, Nos. 284, 285 – this motif also exists in two versions, on panel and on canvas.
20 Adalbert Stifter, *Bunte Steine*. Preface.
21 *Zeitschrift für Bildende Kunst* 1866; quoted in Grimschitz 1957, p. 13.
22 "The need for a purposeful instruction in painting and the plastic arts. Outlined from his own experience by Ferdinand Georg Waldmüller, 1846"; quoted in Roessler/Pisko 1907, vol. II, p. 22 f.: III. The study of light and shadow.
23 See Roessler/Pisko 1907, vol. I, plates 200 and 209; see also Grimschitz 1957, No. 435 (after the removal of overpainting the unfinished portions reappeared).
24 Grimschitz 1957, p. 7.
25 Ibid., plate XX, and Nos. 699, 731, 732, et al.
26 Buchsbaum 1976, pp. 40, 42.

Jakob und Rudolf von Alt (pp. 144-147)

1 Koschatzky 1975, pp. 29-46.
2 Frimmel 1911, p. 74; Koschatzky 1975, p. 50.
3 Koschatzky 1991, No. 8.
4 Vignau-Wilberg 1979, p. 18.
5 Koschatzky 1975, p. 256 ff.
6 Vignau-Wilberg 1979, p. 18; Koschatzky 1975, pp. 54, 82.
7 Ibid., p. 20.

Moritz von Schwind (pp. 148-151)

1 Munich, Schack Galerie: see Cat. New York 1981, p. 178; Weigmann 1906, p. 75 (the first version in oil, 1831, corresponds to the drawing).
2 Weigmann 1906, p. 254.
3 Ibid., pp. 392, 553, mentions a sketch from the 1830s.
4 Ibid., p. 595 f.
5 Heinrich Heine, *Die romantische Schule*, vol. 2, chap. 2.
6 See Grote 1938, pp. 112, 113.
7 Weigmann 1906, pp. 354 f., 552.
8 Vignau-Wilberg 1979, p. 268.

Carl Spitzweg (pp. 152-155)

1 Cat. Munich 1982, p. 318.
2 Wichmann 1986, pp. 52-94, 510.
3 Wichmann 1990, pp. 107, 208.
4 Wichmann 1986, p. 510: mention-

ing the years 1844, 1845, 1849, 1851.
5 Vignau-Wilberg 1979, p. 282.
6 Ibid., p. 278.
7 Wichmann 1986, p. 498.
8 Munich, Neue Pinakothek, and Aachen, Suermondt Museum; see Wichmann 1986, No. 765.
9 Ibid., p. 498.
10 Betz 1981, p. 64.
11 Jensen 1980, p. 84.
12 Wichmann 1986, p. 499.

Christen Købke (pp. 156-157)

1 Cat. London 1984, p. 187: "Today Christen Købke is considered the most outstanding painter of the Golden Age. He is unsurpassed in his brushwork, his vision and his gift for composition. He was also a very talented colourist." See also Cat. Paris 1984/85, p. 203.
2 Cat. London 1984, No. 61; Krohn 1915, No. 102.
3 Cat. London 1984, No. 63; Krohn 1915, No. 134.
4 Cat. Copenhagen 1981, Nos. 38-44.
5 Krohn 1915, No. 124.
6 Cat. London 1984, p. 37; Cat. Paris 1984/85, p. 54 f.
7 Cat. Paris 1984/85, p. 51.

Eduard Gaertner (pp. 158-159)

1 Unter den Linden was the scene of many parades, as shown in Franz Krüger's *Parade on the Opera Square*, with two existing versions (the 1829 and 1839 versions are in Berlin and Potsdam respectively).
2 See Hermand 1986, p. 29 f.
3 A pentimento, reducing the original height of the street lamp on the left to the height of the one in the Berlin painting, may indicate that the Winterthur composition was the original version. However, the Berlin painting had been shown in the Exhibition of the Academy at the end of 1852. (Wirth 1979, No. 85).
4 "*Ja, Freund, hier unter den Linden kannst du dein Herz erbaun, Hier kannst du beisammen finden die allerschönsten Fraun…*" Heinrich Heine, *Briefe aus Berlin*, First letter (26 January 1822). (Here under the Linden, my friend / you can uplift your heart / for here you can find assembled / the most beautiful women …).

Adolph von Menzel (pp. 160-171)

1 Meier-Graefe 1906, pp. 139-176.
2 Liebermann 1922, p. 195.
3 Wirth 1965, p. 32.
4 e.g. *Building Site with Willows, Garden of Prince Albrecht's Palace, House with Backyard, The Berlin-Potsdam Railway* (all in the Berlin Nationalgalerie).
5 Vignau-Wilberg 1979, p. 210.
6 Cat. Hamburg 1982, p. 39.
7 Hütt 1981, p. 36.
8 Meier-Graefe 1906, p. 95 f.
9 Tschudi 1906, No. 44: *Interior with Minister of Justice von Maercker* (Schweinfurt, Coll. Schäfer). See also Tschudi Nos. 205-207.
10 Cat. Hamburg 1982, pp. 60-62, text to No. 16 (*Head Study of Frau Maercker*, ill.).
11 See *View of Roofs and Gardens* (Berlin, Nationalgalerie).
12 Cat. Hamburg 1982, p. 28.
13 Hermand 1986, pp. 35-37.
14 Cat. Hamburg 1982, p. 50.
15 The so-called Cassel Cartoon; Cat. Hamburg 1982, p. 66 f., ill. p. 67.
16 Cat. Berlin 1976, p. 267; Cat. New York et al. 1990/91, p. 65.
17 Wolff 1914, p. 126: letter to his brother and sister, 9 March 1848.
18 Ibid., p. 126 f.: letter to C. H. Arnold, 23 March 1848; see Cat. Hamburg 1982, pp. 82-85, and Hermand 1986, p. 45.
19 Wolff 1914, p. 136: letter to C. H. Arnold, 15 Sept. 1848; see Cat. Hamburg 1982, p. 20.
20 Ibid., p. 134: letter to C. H. Arnold, 3 May 1848.
21 See Cat. New York et al. 1990/91, p. 65.
22 Tschudi 1906, Nos. 42, 43, 47, 48, 50; dated studies are Tschudi No. 50 (10 April; Berlin, Nationalgalerie); Tschudi No. 47 (16 April; Berlin, Nationalgalerie) and Tschudi No. 43 (15 April; Oskar Reinhart Foundation); the whereabouts of the three horse studies, Tschudi Nos. 39-41, are unknown.
23 Hochhuth 1991, p. 188: recognisable on the left are the studies Tschudi Nos. 40, 41, 42, and on the upper right Tschudi Nos. 50, 47.
24 Scheffler 1912, p. 122.
25 The above paragraph is based on Hermand 1986, p. 55 f; see also Hochhuth 1991, p. 169.
26 Wirth 1965, p. 80.

27 Wolff 1914, p. 154: letter of 26 Dec. 1851 to C. H. Arnold.
28 Cat. New York et al. 1990/91, p. 76; Cat. Hamburg 1982, p. 15.
29 Another chalk drawing, inscribed *August 51 Swinemünde*, shows the same lady from behind, seated on a stool, in intimate conversation with her companion (Tschudi 1906, No. 299, whereabouts unknown).
30 Franz Krüger's portrait of Otto von Bismarck, in *Kunst und Künstler* VII, 1909, p. 158 f.
31 Cat. Hamburg 1982, p. 170.

Alexandre Calame (pp. 172-177)

1 Anker 1987, p. 252.
2 Ibid., p. 253. See also Calame's critique of French landscape painting on the same page.
3 Ibid., p. 254.
4 Ibid., p. 465 f. and p. 74.
5 Ibid., pp. 129-168.
6 Quoted in Zelger 1977, p. 126 f.
7 Calame's "Catalogue de mes ouvrages" notes: "1834. Vue du mont Blanc, de Saconnex f. 120 Lady Osborne 18pces sur 15 environ." Quoted in Anker 1987, p. 328. For Lady Osborne see ibid., p. 104 f.
8 Anker 1987, Nos. 51 and 112.
9 Ibid., p. 306 f.
10 Ibid., p. 308.
11 Ibid., Nos. 350, 351, and pp. 152, 154.
12 Rambert 1884, p. 560.
13 Ibid, p. 403 f.
14 Hugelshofer 1969, p. 220.

Barthélemy Menn (pp. 178-179)

1 Brüschweiler 1960, p. 30.
2 M. Fischer, in Brüschweiler 1960, p. 13.
3 Reinle 1962, p. 253.
4 Brüschweiler 1960, p. 39.
5 Reinle 1962, p. 250, after Brüschweiler 1960, p. 33.
6 Zelger 1977, p. 243.
7 Ibid.

Robert Zünd (pp. 180-183)

1 *Neue Zürcher Zeitung*, 23 March 1882, No. 82; Reinle 1962, p. 257; Cat. Lucerne 1978, pp. 28, 31.
2 Cat. Lucerne 1978, p. 30.

3 "Das beste ist halt doch nach der Natur zu malen." Ibid., p. 14: letter dated 2 May 1852.
4 Ibid., Cat. Nos. 22-25.
5 Ibid., p. 171.
6 Ibid., p. 28.
7 Ibid., pp. 17, 29, 54 f.
8 Zelger 1977, p. 383.
9 Cat. Lucerne 1978, p. 23.

Rudolf Koller (pp. 184-185)

1 Fischer 1951, pp. 20, 46 f.
2 Ibid., p. 30.
3 Koller's letter to Stückelberg, quoted in Frey 1928, p. 69.
4 Ibid., p. 75.
5 Fischer 1951, p. 36.
6 Koller made a caricature-like drawing of the group of *plein-air* painters, with their easels set up next to one another in a landscape. See Fischer 1951, p. 31, and Frey 1928, p. 56 f.
7 Zelger 1977, p. 198.
8 Ibid., see also Reinle 1962, p. 263.
9 *Kritische Gänge* (Critical Walks), Neue Folge, 1861, quoted in Frey 1928, p. 128.
10 Quoted in Frey 1928, p. 81.
11 Ibid., p. 81.
12 "Trinkt, o Augen, was die Wimper hält von dem goldnen Überfluss der Welt." Gottfried Keller, *Abendlied*.

Albert Anker (pp. 186-191)

1 Huggler 1962, p. 12.
2 Ibid, note 7.
3 Kuthy/Lüthy 1980, pp. 15-21.
4 Huggler 1962, Nos. 45, 143.
5 Kuthy/Lüthy 1980, p. 36.
6 Ibid., p. 7.
7 For the sitter's biography see Zelger 1977, p. 38.
8 Ibid., pp. 40, 43.
9 Cat. Schaffhausen 1989, p. 138.
10 Zelger 1977, p. 52.
11 Huggler 1962, p. 15.
12 Ibid., p. 14.
13 Letter to Heinz Keller, dated 14 Dec. 1957 (Archive of the Oskar Reinhart Foundation).
14 Zelger 1977, p. 48 f.
15 Ibid.
16 The studies are listed in Zelger 1977, p. 48 f.
17 Huggler 1962, p. 13.

Frank Buchser (pp. 192-197)

1 Wälchli 1942, p. 22.
2 Cat. Lucerne 1978, p. 56.
3 Überwasser 1940, p. 57.
4 Cat. Solothurn 1990, p. 14.
5 Wälchli 1942, p. 17; Lüdeke 1941, p. 14.
6 Wälchli 1942, p. 29.
7 Ibid., p. 33.
8 Ibid., p. 31 (quoted from Buchser's diary).
9 Cat. Solothurn 1990, p. 151 f.
10 Wälchli 1942, p. 38 f.; Wälchli 1941, pp. 127-130.
11 Lüdeke 1941, p. 32 f.
12 Reproductions in Wälchli 1942, p. 33; Cat. Solothurn 1990, p. 269 (*Evening Rest, Lovers' Gap*, 6 Sept. 1866); Wälchli 1941, fig. 50a.
13 Lüdeke 1941, figs. 20, 21.
14 Wälchli 1942, p. 42.
15 Cat. Solothurn 1990, pp. 149-156.
16 See *A Sacred Nook in Virginia*, Cat. Solothurn 1990, p. 180 f; Lüdeke 1941, p. 50 f.
17 Wälchli 1942, p. 49.
18 Lüdeke 1941, pp. 52-55; Wälchli 1941, p. 136.
19 Cat. Solothurn 1990, p. 170. These sketches, made in Woodstock, trace the first ideas for the 1870 painting *The Song of Mary Blane* (Solothurn, Kunstmuseum).
20 Wälchli 1942, p. 117.
21 Ibid., pp. 50, 116 f.
22 Lüdeke 1941, p. 54.
23 Cat. Solothurn 1990, p. 178 f.
24 Ibid., p. 93.
25 Ibid., pp. 193 f., 207 f.
26 Zelger 1977, p. 118: "Stony hags Scarbro", probably meaning stony hedges, Scarborough.
27 Cat. Basel 1990, pp. 34, 36, 38, 42.
28 Cat. Zurich/Cologne 1990, p. 151.

Arnold Böcklin (pp. 198-207)

1 Julius Meier-Graefe, *Der Fall Böcklin und die Lehre von den Einheiten*, 1905. The author distinguishes between the early and the late work of Böcklin, the latter being rejected as unartistic.
2 Hans Thoma, in a letter to Daniela Thode, quoted in Zelger, Cat. Freiburg 1989, p. 58.
3 See the entry on Calame, p. 172.
4 Johann Jakob Bachofen, *Das Mutterrecht* [The Law of Maternity],

1st ed., Stuttgart 1861, quoted in Hofmann 1974, p. 22.
5 Compare the two versions of *Pan amongst the Reeds*, Andree 1977, p. 240; Zelger 1977, p. 82.
6 Schmidt 1963, p. 3.
7 Ibid., p. 16 f.
8 See Friedrich Schlegel, *On the Study of Greek Poetry*. Also, Cat. Munich 1987/88 (Deutsch-Römer), p. 175, where Schelling is mentioned as the inventor of these terms.
9 Nietzsche, *Die Geburt der Tragödie aus dem Geiste der Musik*, Basel 1871, chapters 7, 8.
10 Zelger 1991, pp. 19-30.
11 Quoted in Cat. Munich 1987/88 (Deutsch-Römer), p. 175.
12 Ovid, *Metamorphoses* I, 689-713.
13 See Cat. Munich 1987/88 (Deutsch-Römer), p. 175, suggesting a shift from the Dionysian to the Apollonian in Böcklin's work.
14 Zelger 1977, p. 82; Schmidt 1963, p. 20; Andree 1977, p. 240.
15 Schmidt 1963, p. 19.
16 Zelger 1977, p. 88.
17 Schmidt 1951, p. 25; Zelger, in Cat. Basel 1977, p. 105.
18 Frey 1903, p. 51.
19 Böcklin 1910, p. 192.
20 *Kunst und Künstler* X, 1912, p. 71 f.
21 Draft letter to Max Jordan, 25 August 1877, in Böcklin 1910, p. 276.
22 Fleiner 1915, p. 21 f.
23 Schmidt 1963, p. 25.
24 Hofmann 1974, pp. 209-211.
25 Cat. Basel 1977, p. 115.
26 Zelger 1977, p. 94.
27 170 × 250 cm, lost since 1945. See Andree 1977, p. 400 f.
28 Hauck 1884.
29 Hauck 1902, p. 178 f.
30 Letter dated 11 September 1878, published in Tschudi 1901, p. 148.
31 Quoted in Reinle 1962, p. 211.

Anselm Feuerbach (pp. 208-209)

1 Ecker 1991, pp. 137 f., 143-145.
2 Cat. Munich 1987/88 (Marées), p. 20.
3 Letter to Viktor von Scheffel, 4 February 1858, in Ecker 1991, p. 225.
4 Muther 1893, vol. I, p. 408.
5 Ibid.
6 Letter by Feuerbach, 10 February 1858, in Ecker 1991, p. 225.
7 Böcklin's *Villa on the Sea* can be

interpreted as an Iphigenia subject – Cat. Munich 1987/88 (Deutsch-Römer), p. 190.

8 See Ecker 1991, p. 225 f.

9 Ibid., pp. 309, 312. Feuerbach's letter to his stepmother of 16 Oct. 1868 probably refers to the Winterthur head: "In November, if I do not travel, I will finish Orpheus and Iphigenia, the latter only as a head which we can keep."

10 The Winterthur version, like the Stuttgart one, shows many pentimenti, pointing to a long working process with repeated revisions. These are noticeable particularly in the hair clip, the earrings, the nose and the neckline of the Winterthur version.

11 Ecker 1991, Cat. 355 (Karlsruhe, Kunsthalle), 358 (Nuremberg, Germ. Nationalmus.), 360 (Cologne, Wallraf-Richartz-Museum).

12 A letter to the artist of 20 May 1869 describes her impressions: "The Iphigenia is a moving picture, with an almost frightening expression of painfully consuming inner torment … almost entirely in grey, it is the most colourless of all your pictures so far. This does not worry me; on the contrary, it is more effective than all the rest, quite wonderful and magnificent …" (Ecker 1991, p. 312). See also Muther 1893, vol. I, p. 407: "The critics objected to the grey tones, the art lovers complained about the unpatriotic subject or missed the narrative content."

13 Letter, autumn 1870, in Ecker 1991, p. 312. The Stuttgart Staatsgalerie had acquired its version from the artist by 1872; the artist may have kept the Winterthur study for himself.

14 Letter by Feuerbach, July 1861, in Ecker 1991, p. 226.

15 Cat. Munich 1987/88 (Deutsch-Römer), p. 267.

16 H. Theissing in Cat. Karlsruhe 1976, p. 83.

Hans von Marées (pp. 210-213)

1 Cat. Munich 1987/88 (Marées), p. 189.

2 Ibid., pp. 145-150.

3 Ibid., p. 98.

4 See Meier-Graefe 1910, vol. III, pp. 12-294.

5 Ibid., quotes from: Conrad Fiedler (p. 322), Richard Muther (p. 346), Max Nordau (p. 347), Heinrich Wölfflin (p. 389).

6 Regarding critical opinion on Marées see Cat. Bielefeld/Winterthur 1987/88, pp. 40-42, 66-76; Cat. Wuppertal 1987, pp. 23-27; Cat. Munich 1987/88 (Marées), pp. 21 f, 103.

7 For a contrary view see Lenz in Cat. Munich 1987/88 (Marées), p. 9 f.

8 Meier-Graefe 1910, vol. III, p. 346.

9 *Kunst und Künstler* VII, 1909, p. 286; see also Cat. Munich 1987/88 (Marées), p. 9.

10 Meier-Graefe 1910, vol. III, p. 388.

11 Ibid., vol. I, p. 162.

12 Cat. Munich 1987/88 (Marées), p. 10.

13 Ibid., p. 222.

14 Meier-Graefe 1910, vol. I, p. 172; Cat. Munich 1987/88 (Marées), p. 222; Cat. Munich 1987/88 (Deutsch-Römer), p. 123.

15 Meier-Graefe 1910, vol. I, p. 173.

16 Cat. Bielefeld/Winterthur 1987/88, p. 42 f.

17 Cat. Munich 1987/88 (Marées-Zeichnungen), pp. 194-197; Cat. Munich 1987/88 (Marées), p. 296 f.

18 Gerlach-Laxner 1980, p. 179; Cat. Munich 1987/88 (Marées), p. 280 f.; Cat. Munich 1987/88 (Marées-Zeichnungen), p. 61.

Hans Thoma (pp. 214-223)

1 Hamann/Hermand 1967, p. 364 f.

2 Gustav Pauli, *Hans Thoma, eine Festrede, die nicht gehalten wurde* [Hans Thoma, a celebration speech which was not delivered], in *Kunst und Künstler* VII, 1909, p. 527 f.

3 Thoma 1919, p. 43.

4 Ibid., p. 55.

5 Thode 1909, p. XXI.

6 Cat. Freiburg 1989, p. 78.

7 Thoma 1919, p. 32 (note 12).

8 Thoma 1909, p. 27.

9 Ibid., p. 241.

10 Ibid., p. 199.

11 Beringer 1938, p. 90.

12 Cat. Freiburg 1989, Nos. 23, 40, 41.

13 Thode 1909, fig. 116 (then in a Dresden private collection),

14 Cat. Freiburg 1989, p. 190.

15 See Thode 1909, figs. 132, 136, 144, 223.

16 Thoma 1919, p. 84.

17 Cat. Freiburg 1989, pp. 26-28.

18 Thoma 1909, p. 61.

19 Thoma 1919, p. 67.

20 Thoma 1909, p. 57 f.

21 Ibid., p. 65.

22 Thoma 1919, p. 75; see also Cat. Freiburg 1989, pp. 124, 228.

23 Thoma 1909, p. 71.

24 Ibid., p. 74.

25 Ibid., p. 66.

Wilhelm Leibl (pp. 224-229)

1 Ruhmer 1984, p. 78; Lehmann 1976, p. 130 f.

2 Ruhmer 1984, p. 15.

3 Waetzoldt 1981, p. 58.

4 Waldmann 1914, p. 43.

5 Ibid., p. 44; see also Langer 1961, p. 34; Mayr 1906, p. 34 f.; Ruhmer 1984, p. 15.

6 Ruhmer 1984, p. 16.

7 Ibid., p. 360.

8 Waldmann 1914, p. 51.

9 See Salzburger Museum Carolinum Augusteum, *Das Kunstwerk des Monats*, October 1990.

10 Ruhmer 1984, p. 41.

11 See the report on the auction of Trübner's legacy, Lepke, Berlin, 4 June 1918, in *Kunst und Künstler* XVI, 1918, p. 407.

12 Trübner 1907, p. 19; *Girl on the Sofa* (Berlin, Nationalgalerie).

13 Ibid., p. 15.

14 Ruhmer 1984, p. 58.

15 Ibid., p. 59.

16 Letter to the mother (Hanfstaengl 1958, p. 3); see also ibid. p. 5, and Ruhmer 1984, p. 17.

17 Hanfstaengl 1958, p. 22.

18 Leibl's letter to his mother, 30 Dec. 1876 (Mayr 1919, p. 64); see also Ruhmer 1984, p. 380.

19 Hanfstaengl 1958, p. 8.

20 Leibl's letter to his mother, 3 June 1876 (written while work on the *Village Politicians* was in progress). (Ruhmer 1984, p. 48.)

21 Hanfstaengl 1958, p. 16; Waetzoldt 1981, p. 42.

22 Hanfstaengl 1958, p. 9 f.

23 Perfall 1911, p. 439 f.

24 *Jugend*, 1901, p. 38 (Hanfstaengl 1958, p. 25 f.).

25 Ruhmer 1984, p. 380.

26 Vignau-Wilberg 1979, p. 177 f.; Charles Tardieu, in *L'Art* 1878, p. 108; Edmond Duranty, in *Gazette des Beaux-Arts* 1878, p. 60 ff., 153, 156.

Fritz Schider (pp. 230-231)

1 Ruhmer 1984, pp. 87, 89.

2 Ibid., p. 90.

3 Ibid., fig. 96, plates 72, 85; see Zelger 1977, p. 312.

4 Ruhmer 1984, pp. 83-88.

5 Zelger 1977, p. 312.

Carl Schuch (pp. 232-233)

1 Cat. Mannheim/Munich 1986, p. 114.

2 Ruhmer 1984, p. 35; see also p. 23.

3 Hagemeister 1913, pp. 112-114; see also Cat. Mannheim/Munich 1986, p. 230 f.

4 Cat. Mannheim/Munich 1986, p. 19.

5 Ruhmer 1984, p. 64-67.

6 Cat. Mannheim/Munich 1986, p. 278

7 Ibid., pp. 278, 294, 312.

8 Ibid., p. 47 f.

9 Ibid., p. 51.

10 Ibid.

Wilhelm Trübner (pp. 234-235)

1 Ruhmer 1984, p. 22.

2 Scheffler 1911, p. 269.

3 Ibid., p. 273.

4 Justi 1936, p. 163.

5 Rohrandt 1972, G 601-608.

6 Scheffler 1911, p. 274.

7 Ibid., p. 270.

8 Rohrandt 1972, p. 197.

9 Cat. Karlsruhe 1911 (Rohrandt 1972, p. 163 f.).

Fritz von Uhde (pp. 236-239)

1 Rosenhagen 1908, p. 50 (Leipzig, Städtisches Museum), p. 64 (Kiel, Kunsthalle), p. 65 (Paris, Louvre).

2 Germanisches Nationalmuseum; 164 × 177.5 cm. Another study on cardboard (Munich, Städtische Galerie im Lenbachhaus; 48.5 × 33 cm) may have served as the immediate preparation for the Nuremberg picture, to which it conforms precisely.

3 Rosenhagen 1908, pp. 35, 46, 55.

Max Liebermann
(pp. 240-241)

1 Liebermann 1916, p. 25 f.
2 *Kunst und Künstler* XXV, 1927, p. 372 (on the occasion of Liebermann's 80th birthday).
3 W. Martin, in *Kunst und Künstler* XXV, 1927, p. 387.
4 Waetzoldt 1981, p. 250.
5 Pauli 1911, p. 150.
6 Hancke 1914, p. 541.
7 Ibid., p. 417.

Max Slevogt (pp. 242-243)

1 Imiela 1968, p. 150; see also Sievers 1912, pp. 499-505.
2 Imiela 1968, p. 394 f., note 20, and p. 150 f.

Ferdinand Hodler
(pp. 244-257)

1 Hevesi, in Cat. Berlin/Paris/Zurich 1983, p. 134 (texts by Franz Servaes and Ludwig Hevesi).
2 For instance in the painting *Surprised by a Storm* (Cat. 109) – see Wohlgemuth/Zelger 1984, pp. 160, 178.
3 Ibid., p. 160.
4 Mühlestein/Schmidt 1942, p. 163 f.
5 Wohlgemuth/Zelger 1984, p. 170; see also Hirsh 1981, p. 64; Cat. Berlin/Paris/Zurich 1983, p. 72 f.
6 Wohlgemuth/Zelger 1984, p. 180.
7 Ibid., p. 172.
8 Ibid.; Hirsh 1981, p. 64.
9 Loosli 1921, vol. I, p. 77; for possible sources of Hodler's theories of parallelism see O. Bätschmann, in Cat. Los Angeles/Chicago/New York 1987, pp. 24-48, and in Cat. Ittingen 1989, pp. 16-23, with references to Gottfried Semper.
10 Quoted in Wohlgemuth/Zelger 1984, p. 177.
11 Ibid. 1984, p. 178, n. 6.
12 Ibid., p. 178.
13 Listed and discussed ibid., p. 198.
14 Mühlestein/Schmidt 1942, p. 255; see also Zelger/Gloor 1981, p. 109 f.
15 Loosli 1921, vol. I, p. 69.
16 Ibid., p. 71.
17 Cat. Los Angeles/Chicago/New York 1987, p. 17.
18 Loosli 1921, vol. I, p. 76.
19 Ibid., p. 10 f.
20 Cat. Los Angeles/Chicago/New York 1987, p. 84; Cat. Berlin/Paris/Zurich 1983, p. 339.
21 Quoted in Cat. Berlin/Paris/Zurich 1983, p. 313.
22 Wohlgemuth/Zelger 1984, p. 204.
23 Quoted in Cat. Berlin/Paris/Zurich 1983, p. 313.
24 Quoted in Wohlgemuth/Zelger 1984, p. 208.
25 Stückelberger 1990, p. 86.
26 Loosli 1924, vol. IV, p. 227.
27 Mühlestein/Schmidt 1942, p. 436.
28 Wohlgemuth/Zelger 1984, p. 208.
29 Cat. Berlin/Paris/Zurich 1983, p. 165.
30 Loosli 1924, vol. IV, p. 214 f.
31 Wohlgemuth/Zelger 1984, p. 204.

Giovanni Segantini
(pp. 258-259)

1 G. Metken, in Cat. Zurich 1990/91, p. 32.
2 1882, private collection. The picture, in its present condition, has been entirely overpainted (by Segantini's son Gottardo) in a divisionist technique. Its original appearance is illustrated in Cat. Zurich 1990/91, p. 114.
3 Esposizioni riunite al Castello Sforzesco. Omaggio a Segantini, Società Permanente di Belle Arti, Milan 1894, [or] Seconda Esposizione Triennale di Belle Arti di Brera, Milan 1894.
4 Segantini 1909, p. 147 f.
5 Ibid., p. 125.
6 Cat. Zurich 1990/91, p. 13.
7 About 1892, whereabouts unknown. Illustrated in Quinsac 1982, vol. 2, p. 405 (No. 497).
8 Segantini 1949, p. 80.
9 Next to the above named paintings, for instance *Ploughing* (Munich, Neue Pinakothek) and *Return from the Wood* (St. Gallen, Kunstmuseum).
10 The topographical area, or Segantini's free interpretation of the motif, can be seen in a photograph, which shows the artist outdoors, reworking the painting *Ploughing*. Cat. Zurich 1990/91, p. 231.
11 Wohlgemuth/Zelger 1984, p. 297, n. 9.
12 From 1888/89 Segantini interpreted the mother-theme in ambitious symbolic figural compositions, e.g. *The Bad Mothers*, 1894 (Vienna, Österreichische Galerie), or *The Punishment of the Wanton*, 1891 (Liverpool, Walker Art Gallery).
13 G. Metken, in Cat. Zurich 1990/91, p. 33.
14 Ibid.
15 Segantini began this work as a substitute for a project, initiated by hoteliers in 1896, for a pavilion with a painted panorama of Engadine, which was intended to promote tourism at the 1900 Paris World Exhibition; this project collapsed through lack of finance.

Cuno Amiet (pp. 260-261)

1 "My great experience was Gauguin and a few paintings by Van Gogh" (Amiet 1948, p. 55).
2 Illustrated in Mauner 1984, pl. 55.
3 Stylistic multiplicity, even occurring in works done at the same time, is characteristic of Amiet's œuvre. See Mauner 1984, passim.
4 About the late work see Cat. Solothurn 1986.

Giovanni Giacometti
(pp. 262-265)

1 Giacometti 1940, p. 200.
2 Köhler 1968, p. 13.
3 Giacometti dedicated the picture to the paper manufacturer Oscar Miller (1862-1934) in Biberist, whom he had met through Amiet in 1896. Miller was one of the first patrons promoting modern Swiss painting.
4 Köhler 1968, p. 39.
5 Giacometti 1940, p. 198. See his major work *The Lamp* (Zurich, Kunsthaus), 1912.
6 There are more than thirty self-portraits, the present one probably being the penultimate. See Köhler 1968, p. 31 ff.

Bibliography

AMIET 1948. Cuno Amiet: *Über Kunst und Künstler*, Berne 1948.

ANDREE 1977. Rolf Andree: *Arnold Böcklin, Die Gemälde*, Basel/Munich 1977.

ANKER 1987. Valentina Anker: *Calame, Vie et œuvre, Catalogue raisonné de l'œuvre peint*, Fribourg 1987.

AUBERT 1920. Andreas Aubert: *Maleren Johan Christian Dahl*, Kristiania 1920.

BANG 1987. Marie Lodrup Bang: *Johan Christian Dahl 1788-1857, Life and Works, I-III*, Oslo 1987.

BAUD-BOVY 1903/04. Daniel Baud-Bovy: *Peintres Genevois 1702-1817*, 2 vols., Geneva 1903/1904.

BERCKENHAGEN 1967. Ekhart Berckenhagen: *Anton Graff, Leben und Werk*, Berlin 1967.

BERINGER 1938. Joseph August Beringer (ed.): *Briefwechsel Hans Thoma und Georg Gerland*, Karlsruhe/Leipzig 1938.

BETZ 1981. Gerd Betz: *Carl Spitzweg, Der Künstler und seine Zeit*, Stuttgart/Zurich 1981.

BIERHAUS-RÖDIGER 1978. Erika Bierhaus-Rödiger: *Carl Rottmann 1797-1850, Monographie und kritischer Werkkatalog*, Munich 1978.

BILLETER 1990. Erika Billeter: *Schweizer Malerei, Hundert Meisterwerke aus Schweizer Museen vom 15. bis zum 20. Jahrhundert*, Berne 1990.

BÖCKLIN 1910. *Böcklin-Memoiren, Tagebuchblätter von Böcklins Gattin Angela mit dem gesamten brieflichen Nachlaß*, ed. Ferdinand Runkel, Berlin 1910.

BOISSONAS 1990. Lucien Boissonas: "François Ferrière (1752-1839) et quelques miniaturistes genevois de son temps: une vie d'artiste entre Genève, Londres et Saint-Pétersbourg", *Zeitschrift für Schweizerische Archäologie und Kunstgeschichte* 47, 1990, No. 2, pp. 147-152.

BÖRSCH-SUPAN 1973. Helmut Börsch-Supan, Karl Wilhelm Jähnig: *Caspar David Friedrich, Gemälde, Druckgraphik und bildmäßige Zeichnungen*, Munich 1973.

BRETELL/BRETELL 1983. Richard R. Bretell, Caroline B. Bretell: *Les peintres et le paysan au XIX siècle*, Geneva 1983.

BRUN 1905. Carl Brun: *Schweizerisches Künstler-Lexikon*, ed. Schweizerischer Kunstverein, 3 vols., Frauenfeld 1905-1913.

BRÜSCHWEILER 1960. Jura Brüschweiler: *Barthélemy Menn 1815-1893, Etude critique et biographique*, Zurich 1960.

BUCHSBAUM 1976. Maria Buchsbaum: *Ferdinand Georg Waldmüller 1793-1865*, Salzburg 1976.

BUYSSENS 1988. Danielle Buyssens: *Peintures et pastels de l'ancienne école genevoise XVIIᵉ - début XIXᵉ siècle, Catalogue des peintures et pastels*, Geneva 1988.

CAT. ATLANTA 1988. *From Liotard to Le Corbusier, 200 Years of Swiss Painting, 1730-1930*, exhibition catalogue, High Museum of Art Atlanta 1988, ed. Swiss Institute for Art Research, Zurich.

CAT. BASEL 1977. *Arnold Böcklin 1827-1901, Gemälde, Zeichnungen, Plastiken, Ausstellung zum 150. Geburtstag*, Kunstmuseum Basel 1977.

CAT. BASEL 1980. *Caspar Wolf (1735-1783), Landschaft im Vorfeld der Romantik*, exhibition catalogue, Kunstmuseum Basel 1980.

CAT. BASEL 1990. *Frank Buchser 1828-1890, Bilder*, exhibition catalogue, Kunstmuseum Basel 1990.

CAT. BERLIN 1976. *Moderne Cyklopen: 100 Jahre "Eisenwalzwerk" von Adolph Menzel*, exhibition catalogue, Staatliche Museen zu Berlin, Nationalgalerie, Kupferstichkabinett and Sammlung der Zeichnungen, Berlin 1976.

CAT. BERLIN 1986. *Galerie der Romantik*, catalogue, Schloß Charlottenburg Berlin 1986.

CAT. BERLIN 1990. *Carl Blechen, Zwischen Romantik und Realismus*, exhibition catalogue, Nationalgalerie Berlin 1990, ed. Peter-Klaus Schuster.

CAT. BERLIN/MUNICH 1979/80. *Max Liebermann in seiner Zeit*, exhibition catalogue, Nationalgalerie Berlin, Haus der Kunst Munich 1979/80.

CAT. BERLIN/PARIS/ZURICH 1983. *Ferdinand Hodler*, exhibition catalogue, Nationalgalerie Berlin, Musée du Petit Palais Paris, Kunsthaus Zurich 1983.

CAT. BERNE 1985. *Traum und Wahrheit, Deutsche Romantik aus Museen der Deutschen Demokratischen Republik*, exhibition catalogue, Kunstmuseum Berne 1985, ed. Jürgen Glaesemer.

CAT. BERNE 1991. *Zeichen der Freiheit, Das Bild der Republik in der Kunst des 16. bis 20. Jahrhunderts*, exhibition catalogue, Bernisches Historisches Museum and Kunstmuseum Berne 1991, ed. Dario Gamboni and Georg Germann.

CAT. BIELEFELD/WINTERTHUR 1987/88. *Hans von Marées und die Moderne in Deutschland*, exhibition catalogue, Kunsthalle Bielefeld, Kunstmuseum Winterthur 1987/88.

CAT. COPENHAGEN 1981. *Købke på Blegdammen og ved Sortedamssøen*, exhibition catalogue, Statens Museum for Kunst Copenhagen 1981.

CAT. COPENHAGEN 1991. *Caspar David Friedrich og Danmark*, exhibition catalogue, Statens Museum for Kunst Copenhagen 1991, ed. Kasper Monrad and Colin J. Bailey.

CAT. FREIBURG 1989. *Hans Thoma 1839-1924, Lebensbilder, Gemäldeausstellung zum 150. Geburtstag*, exhibition catalogue, Augustinermuseum Freiburg i. Br. 1989.

CAT. GENEVA/LONDON 1988/89. *Jacques-Laurent Agasse, 1767-1849, ou la séduction de l'Angleterre*, exhibition catalogue, Musée d'art et d'histoire Geneva, Tate Gallery London 1988/89.

CAT. GENEVA/PARIS 1992. *Dessins de Liotard, Suivi du catalogue de l'œuvre dessiné*, exhibition catalogue, Musée d'art et d'histoire Geneva, Musée du Louvre Paris 1992, ed. Anne de Herdt.

CAT. HAMBURG 1974. *Caspar David Friedrich*, exhibition catalogue, Hamburger Kunsthalle 1974, ed. Werner Hofmann.

CAT. HAMBURG 1974/75. *Johann Heinrich Füssli 1741-1825*, exhibition catalogue, Hamburger Kunsthalle 1974/75, ed. Werner Hofmann.

CAT. HAMBURG 1976. *William Turner und die Landschaft seiner Zeit*, exhibition catalogue, Hamburger Kunsthalle 1976, ed. Werner Hofmann.

CAT. HAMBURG 1977/78. *Runge in seiner Zeit*, exhibition catalogue, Hamburger Kunsthalle 1977/78, ed. Werner Hofmann.

CAT. HAMBURG 1982. *Menzel – Der Beobachter*, exhibition catalogue, Hamburger Kunsthalle 1982, ed. Werner Hofmann.

CAT. ITTINGEN 1989. *Ferdinand Hodler, Sammlung Max Schmidheiny*, exhibition catalogue, Kunstmuseum des Kantons Thurgau Kartause Ittingen 1989, ed. Swiss Institute for Art Research, Zurich.

CAT. KARLSRUHE 1976. *Anselm Feuerbach, Gemälde und Zeichnungen*, exhibition catalogue, Kunsthalle Karlsruhe 1976.

CAT. LONDON 1975. *Henry Fuseli, 1741-1825*, exhibition catalogue, Tate Gallery London 1975.

CAT. LONDON 1984. *Danish Painting, The Golden Age*, exhibition catalogue, National Gallery London 1984.

CAT. LONDON 1990. *Caspar David Friedrich, Winter Landscape*, exhibition catalogue, National Gallery London 1990, ed. John Leighton and Colin J. Bailey.

CAT. LOS ANGELES/CHICAGO/NEW YORK 1987. *Ferdinand Hodler, Landschaften*, exhibition catalogue, Wight Art Gallery University of California Los Angeles, The Art Institute of Chicago, National Gallery of Design New York 1987, ed. Swiss Institute for Art Research, Zurich.

CAT. LUGANO/GENEVA 1991/92. *La Suisse sublime vue par les peintres voyageurs 1770-1914*, exhibition catalogue, Fondation Thyssen-Bornemisza Villa Favorita Lugano, Musée d'art et d'histoire Geneva 1991/92.

CAT. LUCERNE 1978. *Robert Zünd in seiner Zeit*, exhibition catalogue, Kunstmuseum Lucerne 1978, ed. Franz Zelger.

CAT. MADRID 1992. *Caspar David Friedrich, Pinturas y dibujos*, exhibition catalogue, Prado Madrid 1992.

CAT. MANNHEIM/MUNICH 1986. *Carl Schuch 1846-1903*, exhibition catalogue, Städtische Kunsthalle Mannheim, Städtische Galerie im Lenbachhaus Munich 1986, ed. Gottfried Boehm, Roland Dorn and Franz A. Morat.

CAT. MUNICH 1979. *Münchner Landschaftsmalerei 1800-1850*, exhibition catalogue, Städtische Galerie im Lenbachhaus Munich 1979, ed. Armin Zweite.

CAT. MUNICH 1982. *Neue Pinakothek, Erläuterungen zu den ausgestellten Werken*, catalogue, Bayerische Staatsgemäldesammlungen, Munich 1982.

CAT. MUNICH 1985. *Deutsche Romantiker, Bildthemen der Zeit von 1800 bis 1850*, exhibition catalogue, Kunsthalle der Hypo-Kulturstiftung Munich 1985, ed. Christoph Heilmann.

CAT. MUNICH 1987/88 (DEUTSCHRÖMER). *"In uns selbst liegt Italien", Die Kunst der Deutschrömer*, exhibition catalogue, Haus der

Kunst Munich 1987/88, ed. Christoph Heilmann.

CAT. MUNICH 1987/88 (MARÉES). *Hans von Marées*, exhibition catalogue, Neue Pinakothek Munich 1987/88, ed. Christian Lenz.

CAT. MUNICH 1987/88 (MARÉES-ZEICHNUNGEN). Hans von Marées, Zeichnungen, Staatliche Graphische Sammlung Munich 1987/88.

CAT. MUNICH 1988. *Johan Christian Dahl, 1788-1857, Ein Malerfreund Caspar David Friedrichs*, exhibition catalogue, Neue Pinakothek Munich 1988.

CAT. MUNICH/DRESDEN 1991/92. *Johann Georg von Dillis 1759-1841, Landschaft und Menschenbild*, exhibition catalogue, Neue Pinakothek Munich, Albertinum Dresden 1991/92, ed. Christoph Heilmann.

CAT. NANTES/LAUSANNE/ROME 1985. *Les frères Sablet (1775-1815)*, exhibition catalogue, Musées départementaux de Loire-Atlantique Nantes, Musée cantonal des beaux-arts Lausanne, Palazzo Braschi Rom 1985, ed. Anne van de Sandt.

CAT. NEW YORK/CHICAGO 1990/91. *The Romantic Vision of Caspar David Friedrich*, exhibition catalogue, The Metropolitan Museum of Art New York, The Art Institute of Chicago 1990/91.

CAT. NEW YORK/ONTARIO 1981. *German Masters of the Nineteenth Century, Paintings and Drawings from the Federal Republic of Germany*, exhibition catalogue, The Metropolitan Museum of Art New York, The Art Gallery of Ontario 1981.

CAT. NEW YORK ET AL. 1990/91. *Adolph Menzel 1815-1905, Master Drawings from East Berlin*, exhibition catalogue, Frick Collection New York, Museum of Fine Arts Houston, Frick Art Museum Pittsburgh, Harvard University Art Museum Cambridge Mass. 1990/91.

CAT. NUREMBERG/SCHLESWIG 1991/92. *Künstlerleben in Rom, Berthel Thorvaldsen (1770-1844), Der dänische Bildhauer und seine deutschen Freunde*, exhibition catalogue, Germanisches Nationalmuseum Nuremberg, Schleswig-Holsteinisches Landesmuseum Schloß Gottorf Schleswig 1991/1992, ed. Gerhard Bott.

CAT. PARIS 1984/85. *L'âge d'or de la peinture danoise 1800-1850*, exhibition catalogue, Galeries Nationales du Grand Palais Paris 1984/85.

CAT. PARIS/DETROIT/NEW YORK 1974/75. *French Painting 1774-1830: The Age of Revolution*, exhibition catalogue, Grand Palais Paris, Institute of Arts Detroit, Metropolitan Museum of Art New York 1974/75.

CAT. SCHAFFHAUSEN 1989. *Museum zu Allerheiligen Schaffhausen, Katalog der Gemälde und Skulpturen*, Schaffhausen 1989.

CAT. SOLOTHURN 1986. *Der späte Amiet, Werke 1950-1960*, exhibition catalogue, Kunstmuseum Solothurn 1986.

CAT. SOLOTHURN 1990. *Frank Buchser 1828-1890*, exhibition catalogue, Kunstmuseum Solothurn 1990.

CAT. STUTTGART 1989. *Joseph Anton Koch 1768-1839, Ansichten der Natur*, exhibition catalogue, Staatsgalerie Stuttgart 1989, ed. Christian von Holst.

CAT. VIENNA 1990 (WALDMÜLLER). *Ferdinand Georg Waldmüller und die Entdeckung der Wirklichkeit*, exhibition catalogue, Kunstforum Länderbank Vienna 1990, ed. Klaus Albrecht Schröder.

CAT. VIENNA 1990. *Von Caspar David Friedrich bis Adolph Menzel, Aquarelle und Zeichnungen der Romantik aus der Nationalgalerie Berlin/DDR*, exhibition catalogue, Kunstforum Länderbank Vienna 1990, ed. Gottfried Riemann and Klaus Albrecht Schröder.

CAT. WUPPERTAL 1987. *Hans von Marées, Zeichnungen*, exhibition catalogue, Van der Heydt-Museum Wuppertal 1987.

CAT. ZURICH 1985. *Gemälde der Deutschen Romantik aus der Nationalgalerie Berlin Staatliche Museen Preußischer Kulturbesitz, Caspar David Friedrich, Karl Friedrich Schinkel, Carl Blechen*, exhibition catalogue, Kunsthaus Zurich 1985, ed. Peter Krieger.

CAT. ZURICH 1990/91. *Giovanni Segantini 1858-1899*, exhibition catalogue, Kunsthaus Zurich 1990/91.

CAT. ZURICH/COLOGNE 1990. *Landschaft im Licht, Impressionistische Malerei in Europa und Nordamerika 1860-1910*, exhibition catalogue, Kunsthaus Zurich, Wallraf-Richartz-Museum Cologne 1990.

CROSNIER 1903. J. Crosnier: "François Ferrière", *Nos Anciens et leurs œuvres*, Geneva 1903.

DOBAI 1978. Johannes Dobai: *Die bildenden Künste in Johann Georg Sulzers Ästhetik, Seine "Allgemeine*

Theorie der Schönen Künste", Winterthur 1978 (308. *Neujahrsblatt der Stadtbibliothek Winterthur*).

EBERTSHÄUSER 1981. Heidi C. Ebertshäuser: *Carl Spitzweg*, Munich 1981.

ECKER 1991. Jürgen Ecker: *Anselm Feuerbach, Leben und Werk, Kritischer Katalog der Gemälde, Ölskizzen und Ölstudien*, Munich 1991.

EIMER 1974. Gerhard Eimer: *Caspar David Friedrich, Auge und Landschaft*, Frankfurt am Main 1974.

ESCHENBURG 1987. Barbara Eschenburg: *Landschaft in der deutschen Malerei vom späten Mittelalter bis heute*, Munich 1987.

FEUCHTMÜLLER 1987. Rupert Feuchtmüller: *Friedrich Gauermann*, Rosenheim 1987.

FISCHER 1951. Marcel Fischer: *Rudolf Koller 1828-1905*, Zurich 1951.

FLEINER 1915. Albert Fleiner: *Mit Arnold Böcklin*, ed. Roland Fleiner, Frauenfeld 1915.

FOSCA 1956. François Fosca: *La vie, les voyages et les œuvres de Jean-Etienne Liotard, Citoyen de Genève dit le peintre turc*, Lausanne 1956.

FOX 1987. Celina Fox: *Londoners*, London 1987.

FRANKE 1984. Renate Franke: *Berlin vom König bis zum Schusterjungen, Franz Krügers "Paraden", Bilder preußischen Selbstverständnisses*, Frankfurt am Main 1984.

FREY 1903. Adolf Frey: "Arnold Böcklins Verhältnis zu Poesie und Musik", *Westermanns illustrierte deutsche Monatshefte*, 47, vol. 94, Brunswick 1903, pp. 51-57.

FREY 1928. Adolf Frey: *Der Tiermaler Rudolf Koller 1828-1905*, 2nd ed., Zurich/Leipzig 1928.

FRIMMEL 1911. Th. von Frimmel: "Ein übersehenes Ölgemälde von Rudolf von Alt", *Blätter für Gemäldekunde VII*, 1911, pp. 74 ff.

GALASSI 1991. Peter Galassi: *Corot in Italy, Open-Air Painting and the Classical-Landscape Tradition*, New Haven/London 1991.

GÄRTNER 1988. Hannelore Gärtner: *Georg Friedrich Kersting*, Leipzig 1988.

GASSIER 1983. Pierre Gassier: *Léopold Robert*, Neuchâtel 1983.

GERLACH-LAXNER 1980. Ute Gerlach-Laxner: *Hans von Marées, Katalog seiner Gemälde*, Munich 1980.

GIACOMETTI 1940. "Giovanni Giacometti berichtet über sein Leben und über seine Kunst", *Galerie und Sammler 8*, No. 9, November 1940.

GRAVENKAMP 1921. Curt Gravenkamp: *Ernst Fries, 1801-1833, Sein Leben und seine Kunst*, Diss. Frankfurt am Main 1921 (Ms).

GRIMSCHITZ 1957. Bruno Grimschitz: *Ferdinand Georg Waldmüller*, Salzburg 1957.

GROTE 1938. Ludwig Grote: *Die Brüder Olivier und die deutsche Romantik*, Berlin 1938.

HAGEMEISTER 1913. Karl Hagemeister: *Karl Schuch, Sein Leben und seine Werke*, Berlin 1913.

HAMANN/HERMAND 1967. Richard Hamann, Jost Hermand: *Stilkunst um 1900*, Berlin 1967.

HANCKE 1914. Erich Hancke: *Max Liebermann, Sein Leben und seine Werke*, Berlin 1914.

HANFSTAENGL 1958. Eberhard Hanfstaengl: *Wilhelm Leibl, Dorfpolitiker*, Stuttgart 1958.

HARDENBERG/SCHILLING 1925. Kuno Graf von Hardenberg, Edmund Schilling: *Karl Philipp Fohr, Leben und Werk eines deutschen Malers der Romantik*, Freiburg i. Br. 1925.

HARDY 1905. C. F. Hardy: *Agasse: his life, his work*, ms. [about 1905], Musée d'art et d'histoire Geneva, archives.

HAUCK 1884. Guido Hauck: *Arnold Böcklin's Gefilde der Seligen und Goethes Faust*, Berlin 1884.

HAUCK 1902. Guido Hauck: "Erinnerungen an Arnold Böcklin (Ein Besuch im Jahre 1886)", *Die Kunsthalle, Zeitschrift für Kunst und Kunstgewerbe*, Berlin 1902, pp. 177-180.

DE HERDT 1978. Anne de Herdt: "Rousseau illustré par Saint-Ours, Peintures et dessins pour le Lévite d'Ephraïm (1795-1809)", *Genava*, n.s. XXVI, 1978, pp. 229-271.

DE HERDT 1989. Anne de Herdt: "Saint-Ours et la Révolution", *Genava*, n. s. XXXVII, 1989, pp. 131-159.

HERMAND 1986. Jost Hermand: *Adolph Menzel*, Hamburg 1986.

HEVESI 1911. Ludwig Hevesi: *Rudolf Alt, Sein Leben und sein Werk*, Vienna 1911.

HINZ 1966. Sigrid Hinz: *Caspar David Friedrich als Zeichner, Ein Beitrag zur stilistischen Entwicklung der Zeichnungen und ihrer Bedeutung*

für die Datierung der Gemälde, Diss. Greifswald 1966.

HINZ 1974. Sigrid Hinz (ed.): *Caspar David Friedrich in Briefen und Bekenntnissen*, Berlin 1974.

HIRSH 1981. Sharon L. Hirsh: *Ferdinand Hodler*, Munich 1981.

HOCHHUTH 1991. Rolf Hochhuth: *Menzel, Maler des Lichts*, Frankfurt am Main/Leipzig 1991.

HOFMANN 1974. Werner Hofmann: *Das Irdische Paradies, Motive und Ideen des 19. Jahrhunderts*, 2nd ed., Munich 1974 (1960).

HOFSTÄTTER 1974. Hans H. Hofstätter: *Caspar David Friedrich, Das gesamte graphische Werk*, Munich 1974.

HUGELSHOFER 1969. Walter Hugelshofer: *Schweizer Zeichnungen von Niklaus Manuel bis Alberto Giacometti*, Berne 1969.

HUGGLER 1962. Max Huggler: *Albert Anker, Katalog der Gemälde und Ölstudien*, Berne 1962.

HUMBERT/REVILLIOD/TILANUS 1897. Ed. Humbert, M. Revilliod, J. W. R. Tilanus: *La Vie et les Œuvres de Jean Etienne Liotard (1702-1789), Etude biographique et iconographique*, Amsterdam 1897.

HÜTT 1981. Wolfgang Hütt: *Adolph Menzel*, Leipzig 1981.

IMIELA 1968. Hans-Jürgen Imiela: *Max Slevogt*, Karlsruhe 1968.

JENSEN 1974. Jens Christian Jensen: *Caspar David Friedrich, Leben und Werk*, Cologne 1974.

JENSEN 1980. Jens Christian Jensen: *Carl Spitzweg*, Cologne 1980.

JENSEN 1982. Jens Christian Jensen: *Adolph Menzel*, Cologne 1982.

JENSEN 1985. Jens Christian Jensen: *Malerei der Romantik in Deutschland*, Cologne 1985.

JUSTI 1936. Ludwig Justi: *Im Dienste der Kunst*, Breslau 1936.

KEMPTER/DIGGELMANN/SIMMEN 1985. Lothar Kempter, Hansjakob Diggelmann, Jeannot Simmen: *Hans Brühlmann*, 2 vols., Basel/Munich 1985.

KERN 1911. Guido J. Kern: *Karl Blechen, Sein Leben und seine Werke*, Berlin 1911.

KLESSMANN 1987. Eckart Klessmann: *Die deutsche Romantik*, 4th ed., Cologne 1987 (1979).

KOERNER 1990. Joseph Leo Koerner: *Caspar David Friedrich and the Subject of Landscape*, London 1990.

KÖHLER 1968. Elisabeth E. Köhler: *Giovanni Giacometti 1868-1933, Leben und Werk*, Zurich [1968].

KOSCHATZKY 1975. Walter Koschatzky: *Rudolf von Alt 1812-1905*, Salzburg 1975.

KOSCHATZKY 1991. Walter Koschatzky: *Rudolf von Alt, Aquarelle*, Vienna 1991.

KRAUSS 1930. Fritz Krauss: *Carl Rottmann*, Heidelberg 1930.

KROHN 1915. Mario Krohn: *Maleren Christen Købkes Arbejder*, Copenhagen 1915.

KUTHY/LÜTHY 1980. Sandor Kuthy, Hans A. Lüthy: *Albert Anker, Zwei Autoren über einen Maler*, Zurich 1980.

LAMMEL 1986. Gisold Lammel: *Deutsche Malerei des Klassizismus*, Leipzig 1986.

LANGER 1961. Alfred Langer: *Wilhelm Leibl*, Leipzig 1961.

LEHMANN 1976. Evelyn Lehmann: *Der Frankfurter Maler Viktor Müller 1830-1871*, Frankfurt am Main 1976.

LESSING 1951. Waldemar Lessing: *Johann Georg von Dillis als Künstler und Museumsmann 1759-1841*, Munich 1951.

LESSING 1966. Waldemar Lessing: *Wilhelm von Kobell*, Munich 1966.

LIEBERMANN 1916. Max Liebermann: *Die Phantasie der Malerei*, Berlin 1916.

LIEBERMANN 1922. Max Liebermann: *Gesammelte Schriften*, Berlin 1922.

LIEBERMANN 1927. "Max Liebermann im Urteil Europas, zum 80. Geburtstag des Künstlers", *Kunst und Künstler XXV*, 1927, pp. 365-402.

LOCHE/ROETHLISBERGER 1978. Renée Loche, Marcel Roethlisberger: *L'opera completa di Liotard*, Milan 1978.

LOOSLI 1921/24. Carl-Albert Loosli: *Ferdinand Hodler, Leben, Werk und Nachlaß*, 4 vols., Berne 1921-24.

LÜDEKE 1941. Henry Lüdeke: *Frank Buchsers amerikanische Sendung 1866-1871, Die Chronik seiner Reisen*, Basel 1941.

LUDWIG 1978. Horst Ludwig: *Münchner Malerei im 19. Jahrhundert*, Munich 1978.

LUTTEROTTI 1985. Otto R. von Lutterotti: *Joseph Anton Koch 1768-1839, mit Werkverzeichnis und Briefen des Künstlers*, Vienna/Munich 1985.

MÄRKER 1974. Peter Märker: *Geschichte als Natur, Untersuchungen zur Entwicklungsvorstellung bei Caspar David Friedrich*, Diss. Kiel 1974.

MAUNER 1984. George Mauner: *Cuno Amiet*, Zurich 1984.

MAUSS 1969. Martina Mauss: *Christian E. B. Morgenstern 1805-1867*, Diss. Marburg a. d. Lahn 1969.

MAYR 1906. Julius Mayr: *Wilhelm Leibl, Sein Leben und sein Schaffen*, Berlin 1906 (3rd edn. 1919).

MEIER-GRAEFE 1905. Julius Meier-Graefe: *Der Fall Böcklin und die Lehre von den Einheiten*, Stuttgart 1905.

MEIER-GRAEFE 1906. Julius Meier-Graefe: *Der junge Menzel, Ein Problem der Kunstökonomie Deutschlands*, Leipzig 1906.

MEIER-GRAEFE 1910. Julius Meier-Graefe: *Hans von Marées: Sein Leben und sein Werk*, 3 vols., Munich 1910 (vols. I and III), 1909 (vol. II).

MEISSNER 1974. Günter Meissner: *Max Liebermann*, Leipzig 1974.

MESSERER 1961. Richard Messerer: *Georg von Dillis, Leben und Werk*, Munich 1961.

MÜHLESTEIN/SCHMIDT 1942. Hans Mühlestein, Georg Schmidt: *Ferdinand Hodler 1853-1918, Sein Leben und sein Werk*, Erlenbach Zurich 1942.

MUTHER 1893. Richard Muther: *Geschichte der Malerei im 19. Jh.*, 3 vols., Munich 1893.

NATHAN 1954. Peter Nathan: *Friedrich Wasmann, Sein Leben und sein Werk*, Munich 1954.

NEIDHARDT 1969. Hans Joachim Neidhardt: *Ludwig Richter*, Leipzig/Vienna 1969.

NEIDHARDT 1976. Hans Joachim Neidhardt: *Die Malerei der Romantik in Dresden*, Leipzig 1976.

PAULI 1911. Gustav Pauli: *Max Liebermann, Des Meisters Gemälde*, Stuttgart/Leipzig 1911.

PERFALL 1911. Anton Freiherr von Perfall: "Wilhelm Leibl in Unterschondorf", *Kunst und Künstler IX*, 1911, pp. 432-441.

PIANZOLA 1972. Maurice Pianzola: *Genève et ses peintres*, Geneva 1972.

PINNAU 1965. Ruth Irmgard Pinnau: *Johann Martin von Rohden 1778-1868, Leben und Werk*, Bielefeld 1965.

QUINSAC 1982. Annie-Paule Quinsac: *Segantini, Catalogo generale*, 2 vols., Milan 1982.

RAEBER 1979. Willi Raeber: *Caspar Wolf 1735-1783, Sein Leben und sein Werk*, Aarau/Munich 1979.

RAMBERT 1884. Eugène Rambert: *Alexandre Calame, Sa vie es son œuvre d'après les sources originales*, Paris 1884.

RAUTMANN 1979. Peter Rautmann: *Caspar David Friedrich, Landschaft als Sinnbild entfalteter bürgerlicher Wirklichkeitsaneignung*, Frankfurt am Main/Berne/Las Vegas 1979.

RAVE 1940. Paul Ortwin Rave: *Karl Blechen, Leben, Würdigungen, Werk*, Berlin 1940.

REINLE 1962. Adolf Reinle: *Kunstgeschichte der Schweiz, vol. 4, Die Kunst des 19. Jahrhunderts, Architektur/Malerei/Plastik*, Frauenfeld 1962.

RICHTER 1980. Ludwig Richter: *Lebenserinnerungen eines deutschen Malers*, Frankfurt am Main 1980 (first edition 1909).

ROENNEFAHRT 1960. Günther Roennefahrt: *Carl Spitzweg, Beschreibendes Verzeichnis seiner Gemälde, Ölstudien und Aquarelle*, Munich 1960.

ROESSLER/PISKO 1907. Arthur Roessler, Gustav Pisko: *Ferdinand Georg Waldmüller, Sein Leben, sein Werk und seine Schriften*, 2 vols., Vienna 1907.

ROHRANDT 1972. Klaus Rohrandt: *Wilhelm Trübner 1851-1917, Kritischer und beschreibender Katalog sämtlicher Gemälde, Zeichnungen und Druckgraphik, Biographie und Studien*, Diss. Kiel 1972.

ROSENHAGEN 1908. Hans Rosenhagen: *Uhde*, Stuttgart/Leipzig 1908.

RUHMER 1984. Eberhard Ruhmer: *Der Leibl-Kreis und die Reine Malerei*, Rosenheim 1984.

RUNGE 1840. Philipp Otto Runge: *Hinterlassene Schriften*, ed. Daniel Runge, vol. I, Hamburg 1840.

RUNGE 1841. Philipp Otto Runge: *Hinterlassene Schriften*, ed. Daniel Runge, vol. II, Hamburg 1841.

RUPKE 1990. Nicholas A. Rupke: "Caves, Fossils and the History of the Earth", *Romanticism and the Sciences*, Cambridge 1990.

SCHALLER 1990. Marie-Louise Schaller: *Annäherung an die Natur: Schweizer Kleinmeister in Bern 1750-1800*, Berne 1990.

SCHEFFLER 1911. Karl Scheffler: "Wilhelm Trübner zu seinem sechzigsten Geburtstage", *Kunst und Künstler IX*, 1911, pp. 268-277.

SCHEFFLER 1912. Karl Scheffler: "Der Ausbau der Nationalgalerie", *Kunst und Künstler X*, 1912, pp. 67-77.

SCHEFFLER 1912. Karl Scheffler: *Die Nationalgalerie zu Berlin, Ein kritischer Führer*, Berlin 1912.

SCHELLING 1858. Friedrich Wilhelm Schelling: "System des transzendentalen Idealismus" (1800), *Sämtliche Werke*, ed. K. F. A. Schelling, vol. 3, Stuttgart / Augsburg 1858, pp. 607-629.

SCHELLING 1860. Friedrich Wilhelm Schelling: "Über das Verhältnis der bildenden Künste zu der Natur" (1807), *Sämtliche Werke*, ed. K. F. A. Schelling, vol. 7, Stuttgart / Augsburg 1860, pp. 289-329.

SCHIFF 1973. Gert Schiff: *Johann Heinrich Füssli 1741-1825, Text und Œuvrekatalog*, 2 vols., Zurich / Munich 1973.

SCHINKEL 1862. Karl Friedrich Schinkel: "Tagebuch der zweiten italienischen Reise" (in the year 1824), *Aus Schinkel's Nachlaß, Reisetagebücher, Briefe und Aphorismen*, ed. Alfred Freiherr von Wolzogen, 4 vols., vols. 1 and 2, Berlin 1862.

SCHMID 1903. Heinrich A. Schmid: *Verzeichnis der Werke Arnold Böcklins*, Munich 1903.

SCHMIDT 1951. Georg Schmidt: "Böcklin heute. Rede gehalten zum Gedenken des 50. Todestages im Kunsthaus Zürich am 3. März 1951", *Schriften aus 22 Jahren Museumstätigkeit*, Basel 1964, pp. 55-78.

SCHMIDT 1963. Georg Schmidt: *Arnold Böcklin, Pan*, Stuttgart 1963.

SCHNAPPER 1981. Antoine Schnapper: *J.-L. David und seine Zeit*, Fribourg 1981.

SCHWARTZ 1992. Sanford Schwartz: *Christen Købke*, New York 1992.

SCHWARZ 1936. Heinrich Schwarz: *Salzburg und das Salzkammergut, Die künstlerische Entdeckung der Stadt und der Landschaft im 19. Jahrhundert*, Vienna 1936.

SEGAL 1973. Georges B. Ségal: *Der Maler Louis-Léopold Robert*, Diss. Basel 1973.

SEGANTINI 1909. Bianca Segantini: *Giovanni Segantini, Schriften und Briefe*, Leipzig 1909.

SEGANTINI 1949. Gottardo Segantini: *Giovanni Segantini*, Zurich 1949.

SEITZ 1987. Gabriele Seitz: *Wo Europa den Himmel berührt, Die Entdeckung der Alpen*, Munich / Zurich 1987.

SERVAES 1902. Franz Servaes: *Giovanni Segantini*, Vienna 1902.

SIEVERS 1912. Johannes Sievers: "Neu-Cladow", *Kunst und Künstler X*, 1912, pp. 499-505.

SINGER 1911. Hans W. Singer: *Julius Schnorr von Carolsfeld*, Bielefeld / Leipzig 1911.

STAIGER 1983. Emil Staiger: *Vor drei Bildern: G. F. Kersting, C. D. Friedrich, J. L. Agasse*, Zurich 1983.

STEIGER 1983. Robert Steiger: *Goethes Leben von Tag zu Tag, vol. II. (1776-1788)*, Zurich / Munich 1983.

STÜCKELBERGER 1990. Johannes Stückelberger: "Hodler und die Arabeske, Eine Deutung der Wolkenrahmen auf seinen Landschaften", *Zeitschrift für Schweizerische Archäologie und Kunstgeschichte 47*, 1990, pp. 83-89.

SULZER 1771/74. Johann Georg Sulzer: *Allgemeine Theorie der Schönen Künste*, 2 vols., Leipzig 1771/74 (1st edn.).

SULZER 1781. Johann Georg Sulzer: *Anweisung zur Erziehung seiner Töchter*, Zurich 1781.

SUMOWSKI 1970. Werner Sumowski: *Caspar David Friedrich-Studien*, Wiesbaden 1970.

THODE 1909. Henry Thode: *Thoma, Des Meisters Gemälde*, Stuttgart / Leipzig 1909.

THOMA 1909. Hans Thoma: *Im Herbst des Lebens, Gesammelte Erinnerungsblätter von Hans Thoma*, Munich 1909.

THOMA 1919. Hans Thoma: *Im Winter des Lebens, Aus acht Jahrzehnten gesammelte Erinnerungen*, Jena 1919.

TRAEGER 1975. Jörg Traeger: *Philipp Otto Runge und sein Werk, Monographie und kritischer Katalog*, Munich 1975.

TRAEGER 1977. Jörg Traeger: *Philipp Otto Runge oder Die Geburt einer neuen Kunst*, Munich 1977.

TRAEGER 1979. Jörg Traeger: "Philipp Otto Runge und Caspar David Friedrich", *Runge: Fragen und Antworten, Ein Symposium der Hamburger Kunsthalle*, Munich 1979.

TROST 1991. Edit Trost: *Eduard Gaertner*, Berlin 1991.

TRÜBNER 1907. Wilhelm Trübner: *Personalien und Prinzipien*, Berlin 1907.

TSCHUDI 1901. Hugo von Tschudi: "Königliche Museen zu Berlin, Die Werke Arnold Böcklins in der Nationalgalerie", Munich 1901, *Gesammelte Schriften zur neueren Kunst*, ed. E. Schwedeler-Meyer, Munich 1912, pp. 134-162.

TSCHUDI 1906. Hugo von Tschudi: *Adolph von Menzel, Abbildungen seiner Gemälde und Studien*, Munich 1906.

UEBERWASSER 1940. Walter Ueberwasser: *Frank Buchser, mit einem Vorwort von Cuno Amiet*, Basel / Olten 1940.

VAUGHAN 1980. William Vaughan: *German Romantic Painting*, London and New Haven 1980.

VIGNAU-WILBERG 1979. Peter Vignau-Wilberg: *Stiftung Oskar Reinhart, Sammlungskatalog, vol. 2, Deutsche und österreichische Maler des 19. Jahrhunderts*, Zurich 1979.

WAETZOLDT 1981. Stephan Waetzoldt (ed.): *Meisterwerke deutscher Malerei des 19. Jahrhunderts*, Stuttgart 1981.

WÄLCHLI 1941. Gottfried Wälchli: *Frank Buchser 1828-1890, Leben und Werk*, Zurich / Leipzig 1941.

WÄLCHLI 1942. Gottfried Wälchli (ed.): *Frank Buchser, Mein Leben und Streben in Amerika, Begegnungen und Bekenntnisse eines Schweizer Malers 1866-1871*, Zurich / Leipzig 1942.

WALDMANN 1914. Emil Waldmann: *Wilhelm Leibl, Eine Darstellung seiner Kunst, Gesamtverzeichnis seiner Gemälde*, Berlin 1914.

WEBER 1971. Werner Weber: "Lesender bei Lampenlicht. Betrachtungen vor einem Bilde Georg Friedrich Kerstings", *Neue Zürcher Zeitung*, 6 June 1971.

WEIDMANN 1927. Walter Weidmann: *Franz Krüger, Der Mann und das Werk*, Berlin 1927.

WEIGMANN 1906. Otto Weigmann: *Schwind, Des Meisters Werke*, Stuttgart / Leipzig 1906.

WICHMANN 1964. Siegfried Wichmann: *Realismus und Impressionismus in Deutschland, Bemerkungen zur Freilichtmalerei des 19. und beginnenden 20. Jahrhunderts*, Stuttgart 1964.

WICHMANN 1970. Siegfried Wichmann: *Wilhelm von Kobell, Monographie und kritisches Verzeichnis der Werke*, Munich 1970.

WICHMANN 1981. Siegfried Wichmann: *Meister – Schüler – Themen, Münchner Landschaftsmaler im 19. Jahrhundert*, Munich 1981.

WICHMANN 1986. Siegfried Wichmann: *Carl Spitzweg und die französischen Zeichner Daumier, Grandville, Gavarni, Doré*, Munich 1986.

WICHMANN 1990. Siegfried Wichmann: *Carl Spitzweg*, Munich 1990.

WIRTH 1965. Irmgard Wirth: *Mit Adolph Menzel in Berlin*, Munich 1965.

WIRTH 1979. Irmgard Wirth: *Eduard Gaertner, Der Berliner Architekturmaler*, Frankfurt am Main 1979.

WIRTH 1990. Irmgard Wirth: *Berliner Malerei im 19. Jahrhundert, Von der Zeit Friedrichs des Großen bis zum Ersten Weltkrieg*, Berlin 1990.

WOHLGEMUTH / ZELGER 1984. Matthias Wohlgemuth, Franz Zelger: *Stiftung Oskar Reinhart, Sammlungskatalog, vol. 3, Schweizer Maler und Bildhauer seit Hodler*, Zurich 1984.

WOLFF 1914. Hans Wolff: *Adolph von Menzels Briefe*, Berlin 1914.

ZELGER 1977. Franz Zelger: *Stiftung Oskar Reinhart, Sammlungskatalog, vol. 1, Schweizer Maler des 18. und 19. Jahrhunderts*, Zurich 1977.

ZELGER 1991. Franz Zelger: *Arnold Böcklin, Die Toteninsel, Selbstheroisierung und Abgesang der abendländischen Kultur*, Frankfurt am Main 1991.

ZELGER / GLOOR 1981. Franz Zelger, Lukas Gloor: *Der frühe Hodler, Das Werk 1870-1890*, Berne 1981.

ZUMBÜHL 1980. Heinz J. Zumbühl: *Die Schwankungen der Grindelwaldgletscher in den historischen Bild- und Schriftquellen des 12. bis 19. Jahrhunderts*, Basel 1980.

Compiled:
Daniela Mondini

List of Sponsors

The exhibition has been supported by:

Union Bank of Switzerland

Swissair

Winterthur Insurance Company

Pro Helvetia, Arts Council of Switzerland

The Canton of Zurich

The City of Winterthur

An indemnity has been granted by the Federal Council on the Arts and the Humanities for the American venues, and in London by the British Government.

Index of Artists